MW00528022

PALGRAVE STUDIES IN THEATRE AND PERFORMANCE HISTORY is a series devoted to the best of theatre/performance scholarship currently available, accessible, and free of jargon. It strives to include a wide range of topics, from the more traditional to those performance forms that in recent years have helped broaden the understanding of what theatre as a category might include (from variety forms as diverse as the circus and burlesque to street buskers, stage magic, and musical theatre, among many others). Although historical, critical, or analytical studies are of special interest, more theoretical projects, if not the dominant thrust of a study, but utilized as important underpinning or as a historiographical or analytical method of exploration, are also of interest. Textual studies of drama or other types of less traditional performance texts are also germane to the series if placed in their cultural, historical, social, or political and economic context. There is no geographical focus for this series and works of excellence of a diverse and international nature, including comparative studies, are sought.

The editor of the series is Don B. Wilmeth (Emeritus, Brown University), PhD, University of Illinois, who brings to the series over a dozen years as editor of a book series on American theatre and drama, in addition to his own extensive experience as an editor of books and journals. He is the author of several award-winning books and has received numerous career achievement awards, including one for sustained excellence in editing from the Association for Theatre in Higher Education.

Also in the series:

Undressed for Success by Brenda Foley
Theatre, Performance, and the Historical Avant-garde by Günter Berghaus
Theatre, Politics, and Markets in Fin-de-Siècle Paris by Sally Charnow
Ghosts of Theatre and Cinema in the Brain by Mark Pizzato
Moscow Theatres for Young People: A Cultural History of Ideological Coercion and Artistic Innovation, 1917–2000 by Manon van de Water
Absence and Memory in Colonial American Theatre by Odai Johnson
Vaudeville Wars: How the Keith-Albee and Orpheum Circuits Controlled the Big-Time and Its Performers by Arthur Frank Wertheim
Performance and Femininity in Eighteenth-Century German Women's Writing by Wendy Arons
Operatic China: Staging Chinese Identity across the Pacific by Daphne P. Lei
Transatlantic Stage Stars in Vaudeville and Variety: Celebrity Turns by Leigh Woods
Interrogating America through Theatre and Performance edited by William W. Demastes and Iris Smith Fischer
Plays in American Periodicals, 1890–1918 by Susan Harris Smith
Representation and Identity from Versailles to the Present: The Performing Subject by Alan Sikes
Directors and the New Musical Drama: British and American Musical Theatre in the 1980s and 90s by Miranda Lundskaer-Nielsen
Beyond the Golden Door: Jewish-American Drama and Jewish-American Experience by Julius Novick
American Puppet Modernism: Essays on the Material World in Performance by John Bell

The Theatre of the Occult Revival

Alternative Spiritual Performance from 1875 to the Present

Edmund B. Lingan

First published in 2014 by
PALGRAVE MACMILLAN®
in the United States—a division of St. Martin's Press LLC,
175 Fifth Avenue, New York, NY 10010.

Where this book is distributed in the UK, Europe and the rest of the world,
this is by Palgrave Macmillan, a division of Macmillan Publishers Limited,
registered in England, company number 785998, of Houndmills,
Basingstoke, Hampshire RG21 6XS.

Palgrave Macmillan is the global academic imprint of the above companies
and has companies and representatives throughout the world.

Palgrave® and Macmillan® are registered trademarks in the United States,
the United Kingdom, Europe and other countries.

ISBN: 978–1–137–45130–9

Library of Congress Cataloging-in-Publication Data

Lingan, Edmund B., 1968–
 The theatre of the occult revival : alternative spiritual performance
from 1875 to the present / Edmund B. Lingan.
 pages cm—(Palgrave studies in theatre and performance history)
 Includes bibliographical references and index.
 ISBN 978–1–137–45130–9 (alk. paper)
 1. Occultism. 2. Performance—Religious aspects. 3. Theater—
Religious aspects. I. Title.

BF1439.L56 2014
130.9'034—dc23 2014020143

A catalogue record of the book is available from the British Library.

Design by Newgen Knowledge Works (P) Ltd., Chennai, India.

First edition: November 2014

10 9 8 7 6 5 4 3 2 1

This book is dedicated to Daniel Gerould, who pointed me in the right direction, and to Risa Beth Cohen, who helped me go there

Contents ❦

Illustrations ∼❦∽

Acknowledgments ✧

I have been able to write this book because of the help of colleagues, friends, and loved ones who have generously lent their expertise, resources, help, and support. The first debt of gratitude is to the late Daniel Gerould, who was the Lucille Lortel Distinguished Professor of Theatre and Comparative Literature at the CUNY Graduate Center and director of Publications of the Martin E. Segal Theatre Center. It was Dan's teaching and scholarship that first led me to discover the current of alternative spiritual performance that is the focus of this book.

Two other scholars and teachers who were essential to the writing of this book are Marvin Carlson and Pamela Sheingorn, who helped to shape many of the ideas that ended up in this book when I was was studying for my PhD in Theatre Program at the Graduate Center of the City University of New York.

Other significant supporters of this work include the late Grace F. Knoche (former Leader of the Theosophical Society in Pasadena, CA), Randell C. Grubb (current Leader of the same organization), and David Wietersen, who so patiently helped me sort through documents and photographs at the Theosophical Society Archives. Anna Pauli at the archives at the Goetheanum (*Documentation Goetheanum*) in Dornach, Switzerland, assisted me in the process of acquiring images, as did Peter Hewitt from the Museum of Witchraft in Boscastle, Cornwall. Bill Breeze and Kittie Palakovich provided much-needed assistance in the use of photographs of Aleister Crowley.

With the assistance of a URAF Summer Research Fellowship from the University of Toledo, I was enabled to visit several archives held in the United Kingdom. My visit to the Goetheanum in Dornach, Switzerland, was supported by a Lucille Lortel Travel Fellowship from the PhD in Theatre Program at the Graduate Center, CUNY. A Publication Subvention Award from the University of Toledo's University Research Award and Fellowships Program also supported the development of this publication.

Aepril Schaile, Sarah Jezebel Wood, Lon Milo DuQuette, Constance DuQuette, and Lillith Avalon generously gave time to conversations that provided me with insights into ritual performance, as well as esoteric ideas concerning the connections between art and spirituality. Also thank you to all of the members of the Tahuti OTO Lodge in New York City and the Blue Equinox OTO Oasis in Detroit for the opportunity to attend and participate in ritual performances.

I thank all of my supportive colleagues who work at the University of Toledo in the Toledo Department of Theatre and Film and the College of Communication and the Arts.

Thank you to Troy Acree, Kurt Taroff, Deirdre O'Leary Cunningham, Jim Cherry, Crystal Benedicks, Constance Zaytoun, Dyrk Ashton, Ben Pryor, Ammon Allred, Julian Brash, Sam Shanks, Jenna Soleo-Shanks, Amy Hughes, Frank Hentschker, Michael Cramer, Jason Winslade, Jen Danby, Barry Boehm, and Lance Gharavi for patiently dedicating time to what must have seemed, at times, rather like a one-track conversation. You all contributed more to this book than you think.

My sons, Jude and Clint, provided me with love and support as I wrote this book. I owe the deepest gratitude to my dear wife, Risa Beth Cohen. Thank you, Risa, most of all for all you have done for me.

Introduction ❧

In the late nineteenth century a wave of interest in esoteric philosophy and practice, commonly referred to today as the "Occult Revival," developed within Europe and the United States. The Occult Revival manifested as a variety of alternative spiritual movements, religious organizations, and esoteric societies, which offered methods for acquiring hidden knowledge and perceiving supernatural realms of existence. The leaders of the Occult Revival drew inspiration from old esoteric philosophies and traditions such as alchemy, Hermetic and Rosicrucian literature, spiritual Masonry, Kabbalah, ceremonial magic, astrology, and necromancy. To these esoteric traditions, the enthusiasts of the Occult Revival sometimes connected concepts such as "reincarnation" and "karma," which were primarily drawn from Buddhist and Hindu traditions. These non-Abrahamic religious traditions had gained visibility in the United States and Europe as a result of increasing interactions with India and parts of Asia. Nineteenth-century occultists also looked to the arts, philosophy, literature, science, psychology, mathematics, history, archeology, and many other disciplines of knowledge as they formulated their worldviews. It was almost universally true that the cosmologies of the Occult Revival were syncretistic in nature. Skeptics viewed the teachings of the Occult Revival as newly constructed theologies, but many occultists countered this critique by asserting that they were in fact carrying on an ancient tradition of esoteric knowledge and magical practice that had been transmitted to the present from the beginning of time by a long line of mages, adepts, and seers. There were certain occultists who claimed that some of the giants of the theatre—Aeschylus, Shakespeare, and Goethe, for instance—were actually occult adepts whose plays can reveal esoteric truths to the reader or spectator who has undergone the proper initiation.

The leaders of the Occult Revival challenged the authority of orthodox religion and the scientific method. They were often less interested in doctrine and dogma than in spiritual practice and expression. This attitude elevated the significance of art during the Occult Revival: art came to be

viewed as a means to unite human beings with the divine. In particular, the art of theatre became an important tool for expressing and disseminating alternative spiritual ideas during the Occult Revival. In fact, many occultists esteemed theatre as a sacred art with the potential to spiritually transform human beings. This valorization of theatricality within occultism has passed into the present day through the contemporary survival of Occult Revival movements as well as the emergence of neo-pagan spiritualities between the late twentieth and early twenty-first centuries. From the time of the Occult Revival to the present, practitioners of esoteric spirituality and religion have often thought of theatre and performance (as well as other art forms) as methods for bridging the physical and spiritual worlds.

The understanding of theatre and performance as a tool for spiritual transmutation that arose during the Occult Revival has impacted the development and practice of occultism and neo-paganism between the late nineteenth century and the present. This study sheds light on that religious understanding of theatre by exploring the works of several theatrically interested leaders of the Occult Revival, namely, Katherine Tingley, Rudolf and Marie Steiner, Aleister Crowley, Alex Mathews, and Gerald Gardner. Tingley was a Theosophist. The Steiners were anthroposophists. Aleister Crowley founded a religion of ceremonial magic called Thelema. Mathews was the leader of a Rosicrucian order in the United Kingdom. Gardner established Wicca, the modern witchcraft religion that is so famous today. All of these occultists disagreed with each other (vehemently in some cases) on matters of occultism, spirituality, and religion. Tingley refused to grant Crowley an audience when he went to her Theosophical community in Point Loma, California, to propose an alliance between his magical society and her Universal Brotherhood and Theosophical Society.[1] Crowley rated Steiner as a "great religious teacher" and admired the complexity of Anthroposophy, but he also labeled Steiner as a "quack."[2] Gardner followed the advice of his coven's high priestess, Doreen Valiente, by allowing her to revise portions of his rituals that were "obviously attributable" to Crowley when she convinced him that Wicca would suffer for its association with his infamous name.[3] Regardless of their differences of opinion, the occultists discussed in this book all valued theatre as a tool for promulgating their ideas and producing spiritual experience within human beings. Furthermore, every spiritual leader who is discussed in this book viewed their theatre as a continuation of a prehistoric tradition of sacred theatre by which esoteric spiritual knowledge had been passed down or by which occult initiates had received heightened spiritual consciousness.

This book shows why and how theatre earned such status among occultists at the end of the nineteenth and the beginning of the twentieth centuries, and it argues that a new current of alternative spiritual performance arose during the Occult Revival. Since that time, this current of alternative spiritual performance has remained active within new spiritual and religious movements that are primarily associated with occultism and neo-paganism. In this way, the theatre of the Occult Revival has contributed to the continued development of alternative spiritual and religious performance between the late nineteenth century and the present.

THE OCCULT REVIVAL

Although chapter 1 of this volume speaks in detail about the subject, a few introductory remarks about the Occult Revival will help to clarify the topic of this book. The Occult Revival was a hotbed of what some contemporary scholars of religion identify as "modernist" religion: that is, religion that values creative expression and spiritual experience as much as, or even more than, adherence to a specific interpretation of a sacred text.[4] One of the earliest manifestations of the Occult Revival took place in 1848, when Kate and Maggie Fox of Hydesville, New York, publicly demonstrated their self-proclaimed ability to communicate with a disembodied spirit that was said to communicate with them through mysterious rapping sounds. The Fox sisters' exhibitions were soon followed by the appearance of mediums all over Europe and the United States. Soon afterward, there emerged a new religion known as "Spiritualism." Spiritualism teaches that the disembodied spirits of those who have died have important, life-changing messages for the living.[5] Through Spiritualism, a broad interest in necromancy flourished.

Another line of the Occult Revival that was concerned with controlling supernatural forces through the use of ceremonial magic was energized through the work of Eliphas Lévi, whose 1856 book, *Dogme et ritual de la haute magie* (*The Dogma and Ritual of High Magic*) prescribed a mise-en-scène of pentagrams, altars, daggers, swords, bells, wands, and other "instruments magiques" that are still used by practitioners of ceremonial magic today.[6] From this performance-rich line of the Occult Revival, with its firm roots in spiritual Masonry, there emerged numerous societies dedicated to the study and practice of ceremonial magic.

The foundation of the Theosophical Society popularized the concepts of karma and reincarnation during the Occult Revival.

Theosophy, with its highly syncretistic nature, inspired thousands of Theosophists (and other occultists) to interpret a vast array of religious, artistic, philosophical, and scientific information through the lens of esoteric philosophy. In 1875, Helena Petrovna Blavatsky and two other colleagues founded the Theosophical Society in New York City. By connecting Western occultism with Hindu and Buddhist conceptualizations of reincarnation and karma, the Theosophical Society attracted thousands of members from all over the world[7] and became one of "the most important occult trend[s] of the late nineteenth century."[8] Theosophy was a great force for the popularization of Hindu and Buddhist religious traditions in Western culture in the nineteenth and twentieth centuries.

To explain the significant place that theatre obtained during the Occult Revival, something should be said about what it was that occultists at that time were claiming to revive. Many of the occultists discussed in this book argued that their work was somehow linked to a pre-ancient, transcultural religious tradition that predates and underpins the teachings of all the current religions of the world. As a Theosophist, Katherine Tingley believed that her particular school of occultism was a manifestation of a secret doctrine of universal religious truth that had been passed down by adepts from time immemorial to the present. Rudolf and Marie Steiner, as well as Alex Mathews, asserted the existence of a Rosicrucian tradition of initiation, by which human beings learned to perceive spiritual beings. Aleister Crowley inserted into his *Gnostic Mass* a list of ancient and modern "saints" who are presented as having passed down the basis for his teachings. Finally, Gerald Gardner claimed that the witchcraft religion that he professed dated back to the Stone Age.

Each occultist above presented his or her beliefs as a recent manifestation of an ancient, esoteric religious tradition. It was just such a religion that many spiritual leaders sought to "revive" during the Occult Revival. In *Access to Western Esotericism* (1994), Antoine Faivre describes this legendary ancient religion as the "primordial tradition":

> Representatives...posit the existence of a "primordial" Tradition—which should not be taken in an historical or chronological sense—defined...as of "non-human" origin. This treasury of wisdom and gnosis once belonged to humanity, which allowed it to be dispersed and diluted. To find the true esoteric way again, we must seek it there where alone it exists, i.e., beyond the exoteric foundations that are the religions, simply branches of a transcendent unity.[9]

Rather than presenting occult systems as new religions, most teachers of the Occult Revival suggested that their teachings were a continuation of a primordial tradition that enjoyed seniority over all of the world's traditional religions.

One of the recurring reasons given by occultists to pursue knowledge of the primordial tradition is to achieve higher spiritual consciousness. To describe this heightened spiritual state, Faivre uses the term "gnosis": that is, "a spiritual and intellectual activity that can accede to a special mode of knowledge," which transcends the scientific or rational and points toward "a grasp of fundamental relations...that exist among the various levels of reality." Faivre lists "God, humanity, and the universe" as some of those transcendent levels of reality.[10] Although they may have shared a belief in the primordial tradition and belief, each occultist in this study distinguished himself or herself from the others by the methods they prescribed for achieving gnosis. It is at this point that the term "occultism" must receive attention, for this word suggests a method by which one achieves gnosis. Because the term "esotericism" is intertwined with "occultism," that word must also enter into the following discussion.

ESOTERICISM AND OCCULTISM

My use of the terms "esotericism" and "occultism" in this book is drawn in no small part from the works of three scholars who have emerged as leaders in an academic discipline that might justly be called "Esotericism Studies." These scholars are Antoine Faivre, Wouter J. Hanegraaff, and Arthur Versluis. During the last three decades, these scholars have done a great deal to shed new light on the cultural significance of esotericism and occultism. In his 2001 book, *The Esoteric Origins of the American Renaissance*, Arthur Versluis uses the term "esotericism" to allude to an array of philosophies and practices that have existed for centuries and which have been repeatedly adopted by seekers of gnosis. Among the esoteric philosophies that Versluis lists are Hermeticism, Kabbala, Rosicrucianism, and Christian Theosophy. Esoteric practices include alchemy, card divination, geomancy, necromancy, astrology, and ceremonial magic.[11]

Such esoteric practices were a building block for those who constructed new religions during the Occult Revival. Every movement and organization that grew out of the Occult Revival had some basis in some of these esoteric practices or philosophies. The means of communicating with spirits that were used by spiritualists had their roots in the esoteric art of

necromancy. Crowley's Thelema and Gardner's Wicca drew from preexisting methods of invocation and evocation.

Wouter J. Hanegraaff views esotericism as a set of beliefs and practices that exist outside of defined religious systems,[12] but he also notes that esoteric traditions have been incorporated into new religions at various times.[13] Hanegraaff's point illustrates that esoteric practices and philosophies can either exist as stand-alone items, or they can be integrated into new spiritual and religious worldviews. During the Occult Revival, such integration became commonplace because a great diversity of occult worldviews were being developed.

Faivre offers two understandings of esotericism that are relevant here. First, esotericism suggests something secret, a "discipline of the arcane," and "restricted realms of knowledge." This understanding of esotericism helped to feed the notion of a lost but revivable mystery tradition that became so popular during the Occult Revival. Efforts to create such a revival were apparent in the work of most of the spiritual leaders discussed in the following chapters. Faivre also understands esotericism as suggesting something akin to gnosis: a "higher level of 'knowledge' that would overarch all particular traditions and initiations, which are only so many means of access."[14] Faivre points out that the higher level of knowledge he equates with esotericism transcends the sundry spiritual systems and methods that are used to achieve that knowledge.[15] It is precisely these sundry spiritual systems that are at the essence of the term "occultism," as it is used in this book.

To be more specific, "occultism" can be distinguished from "esotericism" in that the former is a means of achieving gnosis. There are many different means of doing so. For Tingley, the key to occult enlightenment involved the performance of altruistic acts with the constant understanding that all humans are related through a connection to the divine in life. For Crowley and Gardner, magical ritual could allow the magician or witch to directly experience divine or spiritual energy. For Rudolf and Marie Steiner, as well as Alex Mathews, meditative contemplation of representations of the divine world could enable the spiritual seeker to eventually perceive that world independently. This belief was rooted in the theory of correspondences between the microcosm and macrocosm that are prevalent in Hermetic literature.

As one delves more deeply into the work of those who follow the teachings of these occultists, they will also find those who practice various esoteric "sciences," such as "astrology, magic, alchemy, and the Kabbalah." For Faivre, the word "occultism" is used to describe: "a) any practice dealing

with these 'sciences'"; and "b) a current appearing in the second half of the nineteenth century...and reaching its apogee at the turn of the century."[16] To be clear, in this book the term "occultism" refers to the application of any esoteric "science" to the end of achieving gnosis or direct experience of the spiritual realm. When I use the term "occultist," I am referring to someone who does this as a spiritual or contemplative practice.

PRIMORDIAL THEATRE TRADITION

This book focuses in particular upon leaders of the Occult Revival who believed that theatre was essentially an esoteric science that could either provide human beings with a connection to the divine or lead them toward gnosis. In the chapters that follow, it will be seen that many occultists related their theatrical practices to the dramatic mysteries of a primordial tradition. Several such occultists suggested that their performance practices bore an affinity to the initiatory dramas of ancient cults, such as the ones that were so famously staged in ancient Eleusis. Others lamented the essential loss of ancient dramatic mysteries, but offered a new mode of occult drama that promised to bestow Eleusinian illumination upon human beings living in the modern era. While the existence of an ongoing primordial esoteric theatre tradition is not historically documentable, this idea inspired many of those who created alternative spiritual theatre during the Occult Revival.

During the Occult Revival, some performances were given only in the presence of fellow initiates. In other cases, performances were created for the general public. This illuminates another important aspect of the theatre of the Occult Revival: it served more than one purpose and was created in various circumstances. Like the initiatory rituals of Freemasonry, theatre created within the context of occult societies often taught "essential lessons" to initiates and constituted a form of "esoteric theatre."[17] In other instances, occultists turned to theatre for practical reasons, such as enhancing public image, building community and solidarity among members, or raising funds.

A RELIGIOUS THEATRE TRADITION

Some scholars of religious studies, journalists, and social critics have described the occult movements discussed in this book as "religions" or "religious." In some cases, the occultists in question accepted this description.

In other cases, the label of "religion" was denied. For Crowley and Gardner, for instance, the "religion" label was not problematic, because they both described the teachings they conveyed as essentially religious. Steiner and Tingley, however, did not think of Anthroposophy or Theosophy as a religion. In her 1889 book, *The Key to Theosophy*,[18] Blavatsky associated the word "religion" with a tendency toward exclusion that did not harmonize with the Theosophical Society's mission to establish a "Universal Brotherhood of Humanity without distinction of race, color, or creed." [19] Many other teachers of the Occult Revival shared Blavatsky's wariness of religion. Even those who were willing to accept religion as a label condemned what they perceived as the unsatisfactory aspects of the conventional religions. For the occultists discussed in this book, conventional religion was often seen as "a set of organized practices established by tradition." They, on the other hand, offered what they presented as a more authentic spiritual experience. These occultists offered a "more personal" approach to spirituality and promised an experiential, rather than faith-based, connection to "a higher power."[20] To refuse the label of religion during the Occult Revival amounted to a critique of established religion—especially traditional forms of Christianity. Most of the movements of the Occult Revival offered an alternative to conservative Judeo-Christian religion.

Despite the fact that many occultists did not identify their beliefs and practices as "religion," many of them engaged in activities that have been identified by religious historians and sociologists as essentially religious in nature. For instance, Eileen Barker, a sociologist of religion who studies "new religions," formulated criteria with which to identify "religious activity":

> Again, for purely heuristic purposes, new religions can be considered *religious* in so far as they *address and offer answers to some of the ultimate questions* that have traditionally been addressed by mainstream religions. I am referring to questions such as: Who am I? What is the purpose to life? Is there a life after death? Is there any meaning to my life? Am I more than my body? Is there a spiritual aspect to life? Is there a God?[21]

According to Barker, any person or group that answers questions such as these is engaging in religious activity. Likewise, any activity that presupposes the answers to such questions can be called religious action. Barker's understanding of religious action provides the foundation for my argument that the theatre of the Occult Revival is essentially a religious theatre tradition, because it generally presents or assumes the answers to questions such as those posed above.

The theatre of the Occult Revival did in fact often answer religious questions. The occultists who wrote plays and created theatrical productions to promote a specific cosmology during the Occult Revival should not be confused with theatre artists who have incorporated occultism and religious content into theatre and drama for the purpose of creating secular works of art. The theatre that is discussed in this book was created in affiliation with specific occult organizations, and it embodies and/or disseminates the teachings of those organizations. Because of this, the theatre of the Occult Revival can be viewed as a modern current of religious theatre. It is part of a living tradition of religious performance that deserves as much study as any of the world's other religious performance traditions. Hopefully, this book will only be the first of many that explore the religious aspects of occult theatre and performance because there is much to be learned about the artistic treatment of modern and postmodern religiosity from this area of study.

A SPIRITUAL THEATRE TRADITION

The term "spirituality" also deserves some attention at this point. The distinctions that many occultists make between their own beliefs and religion does anticipate commonplace contemporary distinctions that are often made between "religion" and "spirituality." Usually such distinctions are rooted in a representation of "religion" as something restrictive or organizational, and "spirituality" as a more personal experience that leads some people to perceive something that seems divine or spiritual, such as a "Higher Power" or an "inner guide."[22] In the concluding remarks to this book I delve into this distinction in more detail with the benefit of having explored not only the current of the Occult Revival but also the neo-pagan current of esoteric performance that followed it in the late 1960s and early 1970s. It is enough to point out here that the theatre of the Occult Revival can be identified as either a religious or spiritual performance tradition, depending on whether one views it as an answer to a religious question or an alternative to traditional religious practice.

FOUNDATIONAL SCHOLARSHIP

Within theatre studies, most scholarship concerning occult themes in drama and performance have been concerned with the occult as a source of cultural content for professional theatre. One such book is Robert Lima's 2005 book, *Stages of Evil: Occultism in Western Theatre and Drama*, which

provides an overview of supernatural motifs that have recurred in Western plays during various historical periods.[23] The motifs that Lima discusses in his book—representations of the underworld, hell, demons, exorcism, possession, and witchcraft—do indeed carry religious connotations. The plays that Lima discusses, however, are not officially affiliated with a specific cosmology or religious organization. Unfortunately, Lima takes an uncritical stance toward the popular association of the occult with evil.

The scholars who have produced some of the most profound scholarship on the relationship between occultism and theatre are those who studied the symbolist theatre movement that flourished in Europe during the heyday of the Occult Revival. The impact of occultism upon symbolist theatre was so profound that a deep understanding of symbolism is only possible with some knowledge of the trends of the Occult Revival. In his 2009 article, "The Symbolist Legacy," Daniel Gerould explains that symbolist theatre artists turned to the symbolism of occultism as they sought methods for representing otherworldly spheres and "supersensible perceptions of a higher spiritual reality."[24] Gerould states that occultism—especially Theosophy—helped symbolists to shape their "understanding of art" as the acquisition of "knowledge of the magical psychic powers latent in man" through the practice of occult ritual.[25] In her 1993 book, *"No Religion Higher Than Truth": A History of the Theosophical Movement in Russia, 1875–1922*, Maria Carlson comments that Theosophy was one of the most significant cultural contributions to the symbolist theatre scene of the Russian Silver Age.[26] In *Symbolist Theater: The Formation of an Avant-Garde*, Frantisek Deak explains that Eliphas Lévi's popular writings concerning a primordial tradition of ceremonial magic impacted the dramatic action and imagery within symbolist plays.[27] Esotericism scholar Jean-Pierre Laurant credits Lévi with providing symbolists with a "treasure trove of images and poetic inspiration."[28] Occultism helped symbolists to conceive and depict, as the playwright Maurice Maeterlinck described it, the impact of invisible forces, "words one cannot hear," and "thousands of mysteries" in their dramas.[29]

In his 2008 book, *Western Esotericism in Russian Silver Age Drama*, Lance Gharavi reveals social ties that existed between symbolist playwrights and occultists when he mentions that "philosophers of the new religious consciousness" and symbolists often met at salons to "exchange ideas of mutual interest" during the late nineteenth and early twentieth centuries.[30] In fact, the vast majority of symbolist playwrights, who first began to appear during the 1890s, were engaged with occultism on some level. Some were initiated believers in specific schools of occultism; others

viewed occultism as little more than a catalyst for creating art.[31] Among the dramatists who drew inspiration from occultism to create metaphysical dramas were August Strindberg, Maurice Maeterlinck, W. B. Yeats, Andrei Bely, Ramon del Valle-Inclan, Gabrielle D'Annunzio, Villiers de l'Isle-Adam, Madame Rachilde, Sadakichi Hartmann, Leonid Andreyev, Aleksandr Blok, Andrei Bely, Valerei Briusov, and Joséphin Péladan.[32]

Despite their related interests, the occultist-artists discussed in this book and the majority of the symbolists listed above were motivated by different goals when they made theatre. Symbolists sought to challenge and transcend the restrictive positivism of naturalism by creating dramatic representations of metaphysical beings and realms. The occultist-artist created similar representations in their plays, but they did so to a different end: to teach specific occult principles or to induce gnosis (the experience of the divine in life) in performers and/or spectators.

The religious nature of the theatre of the Occult Revival was not lost on the general public, which sometimes viewed occult theatre with suspicion, fear, and hostility. This perspective sometimes resulted in negative responses and, in some cases, social and physical attacks. When Tingley produced an outdoor production of *The Eumenides* in Point Loma, California, newspaper reporters "hid on the hillside" and "wrote fervid accounts of the mystic and occult rites and ceremonies of the people of Point Loma."[33] A reporter from the English tabloid *The Looking Glass* described Crowley's 1910 ritual performance *Rites of Eleusis* as a diabolical event held in support of a "blasphemous sect whose proceedings conceivably lend themselves to immorality of the most revolting character."[34] Rudolf and Marie Steiner became the victims of a severe attack on New Years' Eve 1922–1923, when an arsonist burned down their first Anthroposophical theatre.[35] Gerald Gardner's Wiccan rituals were attacked in the press as "horrible, degrading ceremonies" and "devil-worship."[36] These responses are not surprising: the general public often fears, vilifies, mocks, and attacks alternative religions.[37]

METHODOLOGIES

Because this is the first book-length study of the theatre of the Occult Revival, it has been written without the benefit of a well-established and published discourse on the topic. To find the materials that were needed to write this book, I developed a research plan that included the following methods: (i) participatory field research (by which I mean attending

performances and participating in rituals); (ii) study of special collections held by university libraries; (iii) study of collections held by organizations discussed in this book; and (iv) interviews with individual members of those organizations.

In the course of writing this book, I visited several universities and historical societies that hold collections of relevant photographs and documents. The Paul Kagan Utopian Communities Collection at Yale University's Beinecke Rare Book and Manuscript Library contains photographs and periodical publications concerning Katherine Tingley's theatrical work. The Rosicrucian Collection in the Hartley Library at the University of Southampton (UK) holds the plays and other writings of Alex Mathews. Many of Aleister Crowley's letters, plays (published and unpublished), silent film scenarios, rituals, and journals are in the Gerald Yorke Collection at the University of London's Warburg Institute. The Christchurch Local History Society in Christchurch, United Kingdom, holds several articles that provide insight into the performances of Alex Mathews's Rosicrucian Theatre. I was also very fortunate to receive permission to visit the Theosophical Society Archives in Pasadena, California, where I explored thousands of documents relating to the life and work of Katherine Tingley.

As participatory field research, I attended theatrical productions that were produced by the Anthroposophical Society in Dornach, Switzerland, and in New York. I also participated in rituals performed by the members of Tahuti Lodge of the OTO in New York City and the Blue Equinox Oasis in Detroit, Michigan. Valuable learning experiences were provided at both the Anthroposophical Society's "Reincarnation and Individuality" conference that was held in Dornach, Switzerland, between December 2000 and January 2001, as well as "NOTOCON" (the National Conference of the Ordo Templi Orientis), which was hosted by the Blue Equinox Oasis in Detroit in August 2011.

Although no previous books have focused solely upon the theatre of the Occult Revival, several articles and books published in academic and popular presses gave me the initial indication that such a book should be written. A 1978 special issue of *The Drama Review* focusing on "the occult and bizarre" contains two rare articles that directly address the theatre of the Occult Revival: J. F. Brown's "Aleister Crowley's *Rites of Eleusis*" and Rob Creese's "Anthroposophical Performance." [38] In an essay titled "The Drama of the Unseen—Turn-of-the-Century-Paradigms for Occult Drama,"[39] Daniel Gerould and Jadwiga Kosicka speak in great detail about various trends of the Occult Revival and the impact of these

upon the emergence of avant-garde theatre in Europe. Maria Carlson's *"No Religion Higher Than Truth": A History of the Theosophical Movement in Russia, 1875–1922*, speaks about connections between several occult movements and the emergence of early symbolist theatre and art. This same topic arises in Frantisek Deak's 1993 book *Symbolist Theater*.[40] Daniel Gerould's 2009 article, "The Symbolist Legacy," which is contained in *PAJ: A Journal of Performance and Art*, and Lance Gharavi's 2008 book, *Western Esotericism*,[41] dedicate significant space to the impact of the Occult Revival on Symbolist playwriting. R. Andrew White's two articles, "Radiation and Transmission of Energy: From Stanislavsky to Michael Chekhov" (2009)[42] and "Stanislavsky and Ramacharaka: The Influence of Yoga and Turn-of-the-Century Occultism on the System" (2006),[43] indicate that the trends of the Occult Revival informed the acting methods of both Stanislavsky and Chekhov. In his 2004 book *Michael Chekhov*,[44] Franc Chamberlain notes the impact of Anthroposophy upon Chekhov's work. In 2010, Anita Hammer published *Between Play and Prayer: The Variety of Theatricals in Spiritual Performance*,[45] in which she discusses the theatrical aspect of a contemporary spiritualist church.

The works that have most impacted my critical perspectives upon occultism and esotericism are Faivre's *Access to Western Esotericism*,[46] Hanegraaff's *Dictionary of Gnosis and Western Esotericism* (2005),[47] Ronald Hutton's *The Triumph of the Moon: A History of Modern Pagan Witchcraft* (1999),[48] and Eileen Barker's *New Religions and New Religiosity* (2001).[49]

Some of the most detailed information about the theatrical practices of occult movements is contained in books published by popular presses. Dr. Richard Kaczynski's expanded and revised edition of *Perdurabo: The Life of Aleister Crowley* (2010) contains detailed information about Crowley's plays and performances, and it is also the best documented and most thoroughly researched biography of Crowley. Richard Rosenheim's 1952 book *The Eternal Drama: A Comprehensive Treatise on the Syngetic History of Humanity, Dramatics, and Theatre* reveals a thorough knowledge of Anthroposophical theatre and performance practices.

The relationship that was established between theatre and occultism in the nineteenth century anticipated a shift in the relationship between religion and art that is still taking place. Victoria Nelson noted this shift in her book *The Secret Life of Puppets* (2001). While discussing religious events of the early twenty-first century, Nelson commented on "a curious reversal in the roles of art and religion." In the pre-Renaissance past, Nelson asserts, religious subject matter and material contributed to the creation of new works of art. In the contemporary era, however, artistic

subject matter and techniques sometimes contribute to the formation of new religions.[50] As will be seen, this reversal in the relationship between art and religion was already underway during the time of the Occult Revival, at which time occultists used dramatic writing, theatrical performance, and the esoteric interpretation of well-known dramas to elucidate their spiritual worldviews. As will be seen, the dynamic relationship established between theatre and occultism during the Occult Revival continues in the present within contemporary schools of esoteric spirituality.

1. The Occult Revival and Its Theatrical Impulses ❧

From the spiritualist mediums who apparently secreted ghostly ecto-plasms from their bodies to members of secret societies who prac-ticed ceremonial magic with pentagrams, candles, and swords, theatricality was central to the Occult Revival that flourished in Europe and the United States between the late nineteenth and early twentieth cen-turies. The boundaries between occultism and theatre blurred during the Occult Revival. During this time ritual, theatre and other forms of perfor-mance came to be viewed as part of a sacred tradition of mystery dramatics through which esoteric wisdom had been passed down to initiates for cen-turies. It was that idealized tradition of esoteric theatre that many spiritual leaders of the Occult Revival claimed to be reviving. This rise of interest in theatre during the occult revival was no random occurrence: it was a response to ideas about theatre and occultism that were incorporated into the teachings of some of the most famous leaders of the Occult Revival. In particular, Eliphas Lévi, Helena Petrovna Blavatsky, and Edouard Schuré did much to promote the idea of a sacred tradition of occult theatre that could be revived for the spiritual benefit of human beings.

ELIPHAS LÉVI

Eliphas Lévi (1810–1875) is sometimes identified as the inaugurator of the nineteenth-century Occult Revival in Europe, although his most famous occult books did not appear until several years after the Fox sisters' first mediumistic demonstrations in 1848. Unlike spiritualists who were con-cerned with establishing communication with the spirits of the dead, Lévi promoted ceremonial magic as the key to communing with the spiritual realm. Lévi established magical practices, offered interpretations of occult symbols, and utilized terminology that were adopted by later ceremonial magicians—including Aleister Crowley and Gerald Gardner. Lévi's ideas

about ceremonial magic continue to inform the practice of occultism today.

In his book *Triumph of the Moon: A History of Modern Pagan Witchcraft*, Ronald Hutton credits Lévi with creating "a conceptual framework and a set of practical manuals for a new generation of magicians."[1] It was Lévi who popularized the term "occultism" in his 1856 book, *The Dogma and Ritual of High Magic.*[2] He also established the convention of interpreting the five-point star—or pentagram—as a symbol of god when one point is on top, and of the devil when two points are up.[3] Lévi also argued that his writings revealed the remnants of a primordial religion that predates the establishment of all other world religions: in other words, a primordial tradition. For Lévi, ceremonial magic represented the practical aspect of this primordial tradition. He suggested that the magician who mastered ceremonial magic would be able to invoke spiritual forces and, as a result, gain supernatural knowledge and power. Lévi accused Christian authorities of banning the practice of ceremonial magic as part of an effort to suppress the primordial tradition.

Lévi supported his claim that ceremonial magic was the practical side of "one sole, universal, and imperishable dogma" that is "the parent of all others"[4] by weaving together content from medieval and early modern texts on alchemy and magic, eighteenth-century philosophy texts, and plays.[5] In his writings, Lévi uses the term "universal dogma," which can be equated with the concept of the primordial tradition. Lévi explains that this dogma existed before the dawn of recorded civilization and was passed down through the centuries by a chain of adepts. Included among these adepts are the initiates of the mystery religions of ancient Greece and Egypt, as well as the Knights Templar. Lévi claimed that the universal dogma almost disappeared due to attacks by the leaders of orthodox Christianity during the Middle Ages, but he also promised that it can be partially recovered through research into occult and the experimental practice of ceremonial magic.[6] As these claims show, Lévi linked his teachings to an idealized notion of the past that includes the mystery dramatics of the ancient era and legends concerning the magical and spiritual adeptness of the Knights Templar.

By referencing the Knights Templar, Lévi followed in the mold of "speculative" forms of Freemasonry—that is, strains of Freemasonry whose adherents were interested in esoteric practices and philosophies. Such strains of Freemasonry began to appear by the late eighteenth century. These organizations established "High" or "Side" degrees that could be achieved, in addition to the traditional "Apprentice," "Fellowcraft," and "Master Mason" degrees. Faivre suggests that Freemasons were drawn to

the Knights Templar, in particular, "because it was more possible to make use of a long dead order or to claim to be its successor, since proof to the contrary will almost always be lacking."[7] Faivre's rational comment does not disprove that many of those who promoted the idea of a Templar tradition may have sincerely believed it as an historical fact.

The Freemasonic interest in the Templars eventually became bound up with the Rosicrucian tradition, which seems to have begun with the appearances of several manifestoes published between 1614 and 1616 in Tubingen, Germany.[8] Two of the best known of these manifestoes are *The Fame of the Fraternity of the Praiseworthy Order of the Rose-Cross, Written to all the Learned and Rulers of Europe* (1614) and *The Chemical Wedding of Christian Rosenkreuz in the Year 1459* (1616). *Fame of the Fraternity* is likely attributable to "the cooperation of several authors" who were members of the Learned Christian Society, and *The Chemical Wedding* was written by Johan Valentin Andreae, who founded that society. The Rosicrucian manifestos enjoyed a broad European readership and caused controversy. Many seventeenth-century critics considered them heretical works. Others saw them as part of the traditions of alchemy, pansophy, Brahmanism, ancient Hebrew religion, and Hermeticism, the tradition of esoteric philosophy and techniques that is based upon writings attributed to the legendary, pseudo-historical Egyptian mage known as Hermes Trismegistus.[9]

Many contemporary scholars who study the history of esotericism see in Rosicrucianism the expression of "a worldview based on an analogical apprehension of God and of the world on the part of man."[10] This worldview is encased in a body of literature that blends the chivalric romance genre, symbols of ancient Greek mythology, Kabbalistic concepts, alchemical imagery, and an idealized imagining of an imaginary "Orient" that is viewed as the locus of lost spiritual wisdom.[11] Faivre and many others have presented the metaphysical journey that Christian Rosenkreutz undertakes in *Chemical Wedding* as an alchemical metaphor depicting the "interior voyage" of a human being who moves toward enlightenment by pursuing the Great Work of a sacred pilgrimage. It is through this process that Christian receives the title "Knight of the Golden Stone." This story interiorizes the notion of the "Great Work," by which the dutiful magician achieves greatness.[12]

It is not surprising that Freemasonry, with its penchant for degrees of initiation found inspiration in the rich symbolism of the Rosicrucian literary tradition, which told stories of perseverant mystics who rose to higher degrees of spiritual knowledge by surviving trials. The ceremonial magician, Lévi, also viewed the performance of rituals as the key to spiritual development. In fact, Lévi offered a mise-en-scène for ceremonial magic

that continues to inform its ritual practice to this day.[13] This mise-en-scène includes talismans, instruments, and furniture to be incorporated into the magician's temple. These objects are essential to the reconstitution of what Lévi referred to as the "universal and primeval magic."[14] Among the "instruments magiques" that Lévi prescribed are the pentagram, the wand, the sword, the oil lamp, the chalice, and the candle.[15] Arthur Edward Waite, who translated Lévi's *Dogme et ritual de le haute magie* into English (*Dogma and Ritual of High Magic*), depicted these instruments in the "magician" card of the Rider-Waite Tarot deck, which remains one of the most popular Tarot books in world. The "Magician" card shows a magician standing before an altar upon which are many of the magical tools that Lévi suggested: a pentagram, a wand, a chalice, an altar, and a sword. The arrangement of objects on the "Magician" card is similar to the arrangement of objects and talismans that Aleister Crowley used in the practice of Thelemic magic and which Gardner employed in the practice of Wiccan magic. Similar objects are still used by practitioners of ceremonial magic today, which can be seen by visiting a ceremonial magic supply store.

Lévi drew inspiration for his occult worldview from not only Rosicrucianism and Hermeticism but also dramatic literature. Lévi credited the authors of ancient Greek tragedies with making significant contributions to the revelation and preservation of the universal dogma. According to Lévi, ancient Greek playwrights integrated into their plays disturbing details about the ancient initiatory mysteries of the primordial tradition. Lévi described the "the effusion of blood" in Sophocles' *Oedipus Rex* as evidence of a frightening aspect of being initiated into the Greater Mysteries of the Tradition.[16] (Lévi offered no documentation to support this claim.) Lévi described Aeschylus as the most secretive of the Greek tragedians, because Aeschylus offered only a "weak" representation of the esoteric mysteries into which he was initiated.[17] By suggesting that Greek tragedies contained insight into a primordial tradition in *The Dogma and Ritual of High Magic*, Lévi established himself as one of the first nineteenth-century occultists to identify ancient theatre as part of a nearly vanished tradition of esoteric theatre through which the mysteries and powers of ancient pagan religions had once been passed down to initiates.

HELENA PETROVNA BLAVATSKY

References to plays and playwrights are numerous in the writings of Helena Petrovna Blavatsky (1831–1891), who cofounded the Theosophical Society

in New York City with Henry Steel Olcott and William Quan Judge.[18] Blavatsky viewed the Greek tragedians, in particular, as conveyors of esoteric wisdom who worked through the medium of theatre. Although Blavatsky agreed with Lévi that theatre played a key role in the transmission of the primordial tradition, she disagreed with him on the method for gaining that knowledge. Rather than presenting the practice of ceremonial magic as the key to gnosis, Blavatsky offered a more studious and contemplative form of occultism that was based upon a set of humanitarian principles. Blavatsky argued that studying literature, the arts, science, religion, and philosophy from the standpoint of certain occult concepts would lead one to divine knowledge. Blavatsky formed the Theosophical Society as an organization that would be dedicated to discovering the truths of a primordial tradition that she referred to as the "Secret Doctrine."[19] The Secret Doctrine, according to Blavatsky, provided the universal, theological basis for all later religions. Thus, it could also be referred to as a primordial tradition.

Blavatsky exemplified what she viewed as the ideal approach to theosophical study in her influential, two-volume work, *The Secret Doctrine: The Synthesis of Science, Religion, and Philosophy*. In *The Secret Doctrine*, Blavatsky deftly constructed links between Plato's philosophical writings, Buddhist and Vedic reincarnation theory, esoteric traditions, and many other sources. Blavatsky asserted the existence of an "Infinite Principle" from which all life originates, announced the reality of a process of reincarnation that enables human beings to evolve through countless physical incarnations, and argued that Karma (which she understood as a law that rewards the good and punishes the bad) is central to the spiritual evolution of humanity.[20] Blavatsky taught that the human soul fell from the realm of the spirit into the realm of matter through desire, and she claimed that reincarnation and karma were paths by which the soul returns to its divine place of origin.[21]

Blavatsky's references to reincarnation and karma, as well as her use of other terminology from the Buddhist and Hindu traditions, are absent in Lévi's work, which focused primarily upon Western notions of magic and esotericism. Blavatsky professed a mastery of both Western and Eastern traditions, and she distinguished herself from Lévi by offering "Eastern" explanations for many of the subjects that Lévi touched upon from a "Western" perspective.[22]

Blavatsky viewed certain plays in much the same way she did Buddhist and Vedantic writings: as occult texts that provide insight about the mysteries of the Secret Doctrine. In *The Secret Doctrine*, for instance, Blavatsky took this perspective upon the plays of Aeschylus, Euripides,

Goethe, Shakespeare, and Sophocles. She credited Aeschylus with reveal-ing insights about karmic forces in *Prometheus Bound*. She argued that Euripides revealed information about the negative and positive aspects of ceremonial magic in his *Medea*.[23] Blavatsky perceived similar theories con-cerning interactions between the Divine Principle and the physical world in Goethe's writings and the Upanishads.[24] Shakespeare, according to Blavatsky, demonstrated the Theosophical conception of a seven-staged process of physical and spiritual evolution through which the human race is progressing.[25] Blavatsky rejected the idea that Sophocles, Aeschylus, and Shakespeare could have received their inspiration from a physical process of cellular evolution, and claimed that their spiritual insights are due to their connection to a Divine Principle.[26]

Thus, Blavatsky raises the status of certain dramas from mere dramatic literature to what Faivre refers to as a "revealed text": that is, one that is created through divine transmission and which reveals "correspondences" between the divine and human realms. The notion of correspondences is quite prevalent in the Hermetic tradition, in which "everything is a sign" that "conceals... mystery" and "hides a secret" that exists on some other, corresponding plane. [27] It was in this respect that Blavatsky taught that theatre—and all of the arts—were "essentially divine."[28] Just as the mys-tic might attempt to "decode" nature in order to discover "the language of God,"[29] so may the occultist decode a play to the end of discovering esoteric insights and divine knowledge. Like many promoters of the pri-mordial tradition who would follow her, Blavatsky engaged "exegetical commentaries" of "human texts"—in this case, plays—"in order to dem-onstrate... universal verities."[30]

EDOUARD SCHURÉ

Blavatsky and Lévi spoke about drama in theoretical terms, so that they could better explain their own perspectives on the practice and philoso-phy of occultism. The writings of Theosophist and playwright Edouard Schuré (1841–1929), however, focused upon descriptions and "reconstruc-tions" of the secret and initiatory performance practices of ancient mys-tery religions. In 1889, Edouard Schuré published *The Great Initiates: A Study of the Secret History of Religions*, which, like *The Dogma and Ritual of High Magic* and *The Secret Doctrine* became one of the most enormously influential works of the Occult Revival. In *The Great Initiates*, Schuré pro-posed the existence of a primordial tradition that is the predecessor and

"synthesis of all religions." According to Schuré, a highly impressive list of famous adepts had passed the primordial tradition down through the ages. Among the great initiates of the primordial tradition that Schuré lists are Rama, Krishna, Hermes Trismegistus, Moses, Orpheus, Pythagoras, Plato, and Jesus.[31] By offering this list of initiates, Schuré presents not only the work of these adepts, but also his own occult work, "as a link in the chain of those who have preserved Truth and Wisdom through the ages." Like many occultists who followed in his footsteps, Schuré thought of himself as part of "a trans-historical 'community,' of which it is believed that all members would basically have agreed among one another, had they been able to meet."[32] Schuré believed that this community had passed down a unified belief system over several eons.

Among the key beliefs of the primordial tradition, Schuré listed the following: the origin of the soul is celestial; the earthly bodies of human beings are "fecundated by a cosmic essence"; reincarnation is the result of souls descending from the celestial to the terrestrial realm; there exists an eternal order that transcends the physical realm.[33] Schuré's descriptions of the metaphysical realm indicate that he was a Theosophist who adhered to many of same teachings concerning reincarnation and karma that Blavatsky established. Schuré also agreed with Lévi that there once existed a system of ceremonial magic that empowered its initiates with "semi-divine" powers that had "atrophied over thousands of years" due to the suppression of the Tradition by Christian authorities.[34]

One of the things that separated Schuré's *Great Initiates* from the works of Lévi and Blavatsky is the great amount of emphasis that he placed upon playwriting and theatre as factors in the embodiment and transmission of the primordial tradition throughout the ages. Schuré argued that there was no separation between the development of the art of theatre, the physical evolution of human beings, and the development of religion within human civilization. Schuré insisted that theatrical rituals had awakened supernatural enlightenment and powers within human beings within the secret temple-theatres of ancient mystery religions, and he called for the contemporary reconstruction of such a theatre in the present.

In *The Great Initiates*, performance is said to have entered religion first through the activities of prehistoric women, who, according to Schuré, were the first to sense "the spiritual" and "the unseen."[35] In an attempt to illustrate how this took place, Schuré spun a colorful tale about two prehistoric European tribes with a familial connection who are on the verge of war with one another. A woman who has had a vision in which appeared one dead ancestor from each of the tribes prevents the war. She tells the

members of the tribe that the spirit of the ancestor condemns the war and insists that the two tribes live peacefully with one another. Then Schuré described the results of this event:

> Soon this woman, and others like her, standing on rocks in the middle forest glades, call forth the diaphanous souls of ancestors before quivering crowds who, charmed by magic incantations, see them or think they see them amidst the mists drifting in the moonlight.... Thus at the very origin of social life, ancestor worship is established among the white race. The great ancestor becomes the god of the tribe. This was the beginning of religion.[36]

Schuré describes the moment of religion's birth as a performance by women for men who "group themselves" around and "peer at" the prophetess, who is in an active "deep sleep" that is enlivened by "prophetic ecstasies." These old men are said to have studied the prophetess's "divers states" and noticed how her prophesying "face is transfigured." The male elders detect something "rhythmical" in the prophetess's speech and they notice "her raised voice sings a serious and meaningful melody."[37] Thus, Schuré credited prehistoric women with blending religion and art to guide the direction of the communities in which they lived. This description also seems to anticipate the emphasis of feminine divinity and shamanism that would characterize Wicca and neo-paganism after the 1950s.

After crediting women with the creation of religion, Schuré accused the ancient priestesses of debasing their own accomplishment: he claimed they transformed this divine and sacred performance into a deceptive act designed to inspire obedience through fear. Schuré charged prehistoric women with creating false messages from the beyond and demanding human sacrifices in order to promote their own power and material gain. Although Schuré admitted that prehistoric women contributed to the establishment of religion and art, he implied that some weakness in their nature led them to use religion to concoct a system of governance based on terror. Schuré noted that men also used religion wrongfully; however, since he credited women with creating religion in the first place, he seemed to suggest that men initially inherited deplorable religious tendencies from priestesses.

Schuré argued that in prehistoric "Europe" women retained "the important role" of priestesses. He suggested that this tradition of sacred performance by women was passed from the "prehistoric clairvoyant" of Europe to the "Pythia of Delphi" and the "Thracian Bacchantes."[38]

Thus, Schuré argued that the mystery religions of ancient Greece were rooted in a primordial performance tradition that was inaugurated by women.

In the seventh chapter of *The Great Initiates*, which is titled "Plato: The Mysteries of Eleusis," Schuré attempted to describe the dramatic rituals of the Eleusinian mystery religion into which he claims Plato was initiated. He argued in this section that these mystery plays enabled spectators to have supernatural visions. Using a bit of fact and a great deal of the subjective, Schuré created what he suggested were accurate descriptions of the dramatic rituals of the mystery religion of Eleusis. Although scant evidence remains about the nature of the rituals that were performed in Eleusis—or any other ancient mystery religion for that matter—Schuré dedicated a great deal of effort to reconstructing the Eleusinian mysteries. The pinnacle of these efforts would be Schuré's play, *The Sacred Drama of Eleusis*, which Rudolf and Marie Steiner later brought to the stage at a Theosophical conference in Munich.

In Schuré's opinion, Plato gave an "imaginative and popular form" to "the primordial and universal basis of religious and philosophic truth" by writing it in dramatic form.[39] Schuré claimed that Plato learned about the primordial tradition and the religious value of theatre through his initiation into the Eleusinian mystery religion. Although Schuré stated that Plato was sworn not to reveal the occult secrets he learned at Eleusis, he believed that "nothing is easier than to discover the different points of esoteric doctrine in Plato." Schuré explained that Plato's *Banquet, Phaedo,* and *The Legend of Er* delineate the "migrations" and "evolutions" of the soul that theosophical doctrine claims take place through reincarnation.[40] Schuré identified Plato's conceptions of "the True," "the Beautiful," and "the Good" as metaphors veiling Theosophical understandings of the fate of the soul before, during, and after physical life: to be specific, the human soul passes through three realms countless times in the ongoing process of birth, death, and reincarnation. The Good is said to correspond to a realm in which disembodied souls are "purified" before reentering a new physical incarnation. The "Beautiful" correlates to the intellectual awakening of the soul within its new incarnation. "The idea of the True" is a drive to seek union with the "divine Principle," which fuels the soul's spiritual pursuits during its physical incarnation on earth.[41] Thus, Schuré argued that Plato's writings provide insights into the teachings of the primordial tradition, and also that these teachings agreed with Theosophical principles.

According to Schuré, the Theosophist who reads Plato will gain insight into the philosophical aspect of the esoteric religion that was practiced at

Eleusis. Schuré also argues that learning about the sacred performances that took place at Eleusis will provide the occultist with insight into an "old science" that induced "visions of an ecstatic and marvelous nature" within initiates.[42] Without providing documentation, Schuré claimed that Plato, Iamblicus, Proclus, and "all of the Alexandrian philosophers" provided firsthand reports of such visions, and he also proposed that these supernatural visions were induced by a mixture of theatre, ceremonial magic, conjuring, and, in some cases, narcotics.[43]

Speaking in descriptive manner that transcends the limits of available historical evidence, Schuré describes a fantastical evening during which Eleusinian initiates were trapped within a temple that had been transformed into a representation of underworld for the purpose of staging an initiation drama: with lights extinguished, the initiates are compelled to grope in the darkness of the Hall of Mysteries. Flashes of light reveal hideous monsters, human beings being torn asunder, and dragons. In a dimly lit room a priest throws "large handfuls of narcotic perfumes" onto a fire, and the initiates who breath the smoke witness the appearance and disappearance of nymphs changing into bats, the heads of youths becoming dog faces, and the transformation of other beautiful beings into hideous creatures. Schuré colorfully described initiates being thrown to the ground by invisible hands. The initiates eventually make their way into a chamber, where they see Pluto holding Persephone captive in the underworld. Only after offering adoration to Persephone do the initiates see a burst of light in a distant chamber, from which a voice invites them to enter a new room and be crowned with myrtle as new initiates of the Eleusinian mysteries.[44] Regardless of the narcotics, which some might suspect of inducing hallucinations, Schuré insisted that the visions seen by the initiates at Eleusis were supernatural in nature.[45] He firmly believed that theatre could have the same hallucinatory effect upon people in the present, if it was produced in the proper manner.

Schuré also claimed that the ancient Greek tragedies of Aeschylus, Sophocles, and Euripides bore a complementary relationship to the sacred initiatory dramas that were performed at Eleusis. According to Schuré, the "cultivated and initiated Athenian of Plato's time" saw in Greek tragedy depictions of unfortunate human beings who were blinded by their passions, pursued by their own shortcomings, and "crushed by an implacable and often incomprehensible Destiny." In tragedy, Plato and his fellow initiates are said to have witnessed a world in which terror and pity reigned.[46] In the mystery dramas of Eleusis, the horrors of life depicted in Greek tragedies were, according to Schuré, presented as a test of the

human soul that takes place in the physical realm of existence during an earthly incarnation.

The tortures of Oedipus and Antigone are only one aspect of a process through which the soul was saved, according to Schuré. Only by passing through the suffering of life many times can the initiate become pure enough to experience union with the divine. Together, the Eleusinian mystery dramas and the Greek Tragedies completed a "divine drama of the soul" that explained the reasons for human suffering and promised the potential for divine perfection.[47] Schuré claimed that the theatrical performances at Eleusis served as a portal through which the most sacred truths of the universe were passed down and preserved. Many other spiritual teachers who developed new forms of occult theatre at the turn of the nineteenth into the twentieth century followed Schuré's example by arguing the existence of an ancient tradition of esoteric drama that taught the principles of the primordial tradition to initiates and, in some cases, imbued initiates with the ability to perceive supernatural realms.

Not content to merely theorize about the spiritual power of the Eleusinian mystery dramas, Schuré attempted to reconstruct them. One of Schuré's earliest dramatic reconstructions of an Eleusinian drama is contained in the previously mentioned chapter on Plato, into which Schuré inserted a short script titled *The Rape of Persephone*. Schuré claimed that this script was performed in the courtyard of the temple of Persephone for the initiates of Eleusis. Although Schuré claimed that *The Rape of Persephone* constituted the "Lesser Mysteries" of the Eleusinian dramas, Schuré's adaptation of the script is modern in style.

The Rape of Persephone depicts Persephone's abduction by Pluto, who emerges from a cavern in the earth and pulls Persephone into his chariot. Schuré said that the performance of this play at Eleusis made it unnecessary to actually shed blood as part of the Eleusinian initiation rites. By staging, rather than enacting, human sacrifice, the art of theatre enabled members of the cult of Eleusis to achieve spiritual enlightenment through a "humane and refined" approach.[48] Schuré asserted that *The Rape of Persephone* served as a prequel to the drama of the Greater Mysteries of Eleusis. The play concluded with a mystery: the reasons for Persephone's abduction are not explained. This explanation was provided, according to Schuré, in the horrifying Greater Mysteries, which took place in the Eleusinian temple.

Schuré attempted to reconstruct the drama of the Greater Mysteries of Eleusis with his play *The Sacred Drama of Eleusis*. This play depicts

the meeting of Demeter and Triptolemos, and the latter's heroic rescue of Persephone from Pluto. According to Schuré, his straightforward retelling of this ancient myth reveals the principles of Theosophical doctrine by showing how the soul returns from the world of matter to the celestial world of the soul at the end of each physical incarnation.[49] Through *The Rape of Persephone* and *The Sacred Drama of Eleusis*, Schuré attempted to establish a connection between his own occult worldview and the beliefs of the ancient Eleusinian cult.

Throughout his career, Schuré argued that the revival of ancient mysteries such as the ones that were performed at Eleusis were essential to regaining the ability to perceive the astral and spiritual realms. These abilities, Schuré explained, had deteriorated in humans as a result of the official suppression of the mysteries, as well as the primordial tradition, by orthodox religious leaders. In a 1925 lecture series titled "The Initiatory Theatre: Its Past, Present, and Future" presented at the Société de Géographie in Paris, Schuré claimed that "the light of the Divine" can be made apparent through theatre, even if it is, at the present, dimmed. Schuré speaks of a "redemptive and initiatory theatre" that might restore spiritual might to the "crippled and abased" souls of modern human beings.[50] Schuré asserted that the development of this new theatre, or "Theatre of the Future," was part of an ongoing "evolution of the theatre" that corresponded to the "religious and philosophical evolution of humanity, wherein were manifested the spiritual powers that give it direction."[51] Theatre, for Schuré, had been an integral part of the spiritual development of human beings in the past. Schuré claimed that, if the supernatural powers of ancient forms of mystery drama were simulated in the present, theatre could once again raise human beings to new heights of spiritual knowledge and perception.

Schuré spoke of his theatre of the future on many occasions, and his publications on this topic inspired both occultists and Symbolist theatre artists. In a 1900 essay titled "The Theatre of the Soul," Schuré refers to a deeply religious "theatre of the future" that will chart "the Great Work of the soul" and "link the human to the divine."[52] The term "Great Work" was popularized during the Occult Revival by Lévi, who included a chapter titled "Le Grand Oeuvre" in *The Dogma and Ritual of High Magic.* For Lévi, the Great Work implied "the creation of man by himself," as well as the "full and entire conquest of his faculties and his future."[53] Lévi taught that the magician accomplished the Great Work through the study and practice of ceremonial magic. For Schuré, the ancient mystery theatre

was synonymous with ceremonial magic. In his essay, "The Theatre of the Soul," Schuré predicted the coming of a "divine renaissance in a new Eleusis,"[54] during which modern occultists would use theatre as a means of pursuing the Great Work.

Among Lévi, Blavatsky, and Schuré, the latter is the only one to have established a reputation as a professional playwright and theatre theorist. In *Theories of the Theatre*, theatre historian Marvin Carlson describes Schuré as an "explorer of the occult," who "follow[ed] the example of Maeterlinck" and engrossed Symbolists with his theories concerning a theatre of the future that might "tie the human to the divine."[55] Nevertheless, Schuré is best known as the author of *The Great Initiates*, and his fame as an occultist has always overshadowed his fame as a theatre artist. Schuré's passion for theatre, however, was linked to his passionate belief in playwriting and performance as tools that might spiritually transform and awaken special powers within human beings. Schuré transcended Blavatsky's and Lévi's perspectives on drama as an occult text waiting to be decoded. Moving beyond the esoteric interpretation of dramatic texts, Schuré wrote dramas that he hoped would serve as blueprints for performances designed to awaken supernatural perception within human beings. This is an interest that would occupy Rudolf and Marie Steiner throughout their entire career.

CONCLUSION

The works of Lévi, Blavatsky, and Schuré contributed to the development of a dynamic relationship between theatre and occultism that arose during the Occult Revival. Theatre became what Faivre describes as a "mediation":

> The idea of correspondences presumes already a form of imagination inclined to use mediations of all kinds, such as rituals, symbolic images, mandalas, intermediary spirits.... the esotericists appears to take... interest in the intermediaries revealed to his inner eye through the power of his creative imagination.

> It is the imagination that allows the use of these intermediaries, symbols, and images to develop a gnosis... to put the theory of correspondences into practice and to uncover, to see, and to know the mediating entities between Nature and the divine world.... it is a kind of organ of the soul, thanks to which humanity can establish a cognitive and visionary relationship with an intermediary world.[56]

This idea, that the use esoteric signs, symbols, and rituals can enable humans to peer into supernatural truths, entities, and realms, lies at the basis of all of the plays, theatrical productions, pageants, and ritual performances that are described in the pages that follow. As will be seen, the theatre of the Occult Revival was a complex set of intermediaries designed to awaken the esoteric imagination so that it might acquire gnosis and/or a direct connection to a divine aspect of life.

2. Katherine Tingley and the Theatre of the Universal Brotherhood and Theosophical Society ❧

P oint Loma, California, which is a few miles west of San Diego, was once the site of what could justifiably be considered the most elaborate US experiment in occult theatre. Between 1897 and 1929, this multi-acre plot of land was developed and overseen by Katherine Tingley (figure 2.1), the leader of the Universal Brotherhood and Theosophical Society (UBTS). Tingley had hundreds of followers who chose to live on the property of the UBTS headquarters, which the residents lovingly referred to as "Lomaland." In addition, Tingley had hundreds of followers in the United States and abroad who participated in other lodges of the UBTS. The residents of Lomaland enjoyed a breathtakingly beautiful landscape located on cliffs that overlooked the Pacific Ocean. One of the most-striking buildings at Lomaland was the Greek Theatre, which was most likely the first replica of an ancient, outdoor Greek theatre to be constructed in the United States. This theatre, which still stands on what is now the campus of Point Loma Nazarene University, is a Parthenon-like structure with a round orchestra and hillside bench seating. This is only one of several architectural wonders and sites of performance that once graced the UBTS headquarters in Point Loma. The Greek Theater is an aesthetically beautiful reminder of the centrality of theatre, drama, and performance within the daily life and spiritual practices of Katherine Tingley and her followers between the late nineteenth and early twentieth centuries.

Tingley was inspired by the idea that drama, theatre, and performance had been used since pre-ancient times to pass down many of the secrets of the Secret Doctrine that Helena Petrovna Blavatsky talked about in her book of the same title. In fact, Blavatsky's *Secret Doctrine*

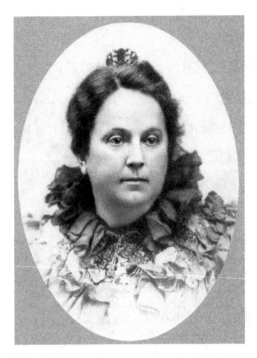

Figure 2.1 Katherine Tingley. Photo Courtesy: Theosophical Society Archives (Pasadena, California)

may be considered the foundational text of the modern Theosophical movement worldwide. Tingley was merely practicing conventional Theosophy by referring to the Secret Doctrine. What was unconventional about Tingley was that she made theatrical productions a key method for sending messages about the Secret Doctrine to the public. Throughout her career, Tingley invested a large portion of her time (as well as a huge portion of the funds and resources of the UBTS) toward the creation of Theosophical theatre. Tingley's theatre actively promulgated the Theosophical concept of Universal Brotherhood. The principle of Universal Brotherhood, as Tingley understood it, proposed that all human beings originate from a single, divine source and that this divine relationship obligates each human being to attend to the well-being of others. For Tingley, this meant not only spiritual well-being, but also physical well-being. Tingley taught that the path to gnosis and occult knowledge is rooted in altruism.

Accordingly, the proceeds from Tingley's theatrical productions often funded the philanthropic causes of the UBTS. Profits from Lomaland productions sometimes funded aid projects for war veterans, orphans of war, flood victims, and destitute women and children. Sometimes Tingley produced original plays called symposia, in which famous Greek philosophers appeared in togas and espoused their agreement with the pro-peace and antiviolence principle of Universal Brotherhood. At other times, Tingley directed classic plays by famous authors such as Aeschylus and Shakespeare. Even when Tingley directed canonical plays, she presented them as works written by occult adepts whose teachings anticipated Theosophical tenets. Tingley shared with Edouard Schuré the belief that certain playwrights of the past were adepts whose purpose was to promote the universal truths of a primordial tradition. To bring this idea home to the noninitiated audience member, Tingley often supplemented her productions with lectures, articles, and notes that highlighted philosophical similarities that she perceived between the play she was directing and Theosophical teachings.

At Lomaland, theatre was also central to the curriculum of Raja Yoga Academy, which was the UBTS's private school. Raja Yoga Academy included preschool, elementary, middle school, and high school programs. Theatre held a high place in the Raja Yoga Academy because Tingley viewed it as a spiritual method for developing qualities of the soul that would enable human beings to contribute to the coming of a future era of peace. This promised new era was presented as one in which Universal Brotherhood would conquer war, violence, and diverse cruelties. Tingley was one of many spiritual leaders who linked her teachings to the coming of a future era of utopian peace.

This chapter explores Tingley's career and beliefs, in order to demonstrate how she linked her occult worldview to her theatrical activities. Tingley's theatre was not only motivated by her religious purposes but also informed by some of the most current theatrical trends of her day. Tingley was, in fact, a pioneer of the Greek Revivalist theatre movement of the United States. In addition, she was aware of the avant-garde European trends in theatre before the Little Theatre Movement began to alert Americans to it in the first and second decades of the twentieth century. As far as theatre history is concerned, one of the most intriguing aspects of Tingley's story is that she was spoken of positively by respected US theatre critics in the early twentieth century—despite the fact that her work is generally unknown to theatre scholars today. This examination of Tingley's work will remind readers about a large and complex project of religious theatre that drew regional, national, and international attention

from theatre critics, artists, supporters, and opponents during the early twentieth century.

TINGLEY: EARLY LIFE, BELIEFS, AND THEOSOPHY

In 1898, Katherine Tingley was named "Leader and Official Head" of the Theosophical Society in America "for life."[1] By her own admission, Tingley was "unknown to all save perhaps one or two members of the Society"[2] when she was elected as its leader. In fact, Tingley did not become a member of the Theosophical Society until 1894. When she emerged as the leader of the society four years later, she was a mysterious figure to many Theosophists who had been members of the organization for longer than she had. By the end of her career, however, Tingley was one of the world's most famous Theosophists, and she was especially known for her theatricality, philanthropy, and predictions of the coming era of Universal Brotherhood.[3] The concept of Universal Brotherhood was so important to Tingley that she changed the name of the Theosophical Society in America to the Universal Brotherhood and Theosophical Society in 1898.[4] Through her leadership, persuasiveness, and marketing skills, Tingley inspired others to provide her with enough support in the form of money and volunteer service to create the luxurious, fantastical, and sophisticated Lomaland settlement in Point Loma, California.

Tingley was born as Catherine Augusta Westcott in 1847 in Newbury, Massachusetts. Her parents, James P. Westcott and Susan Westcott,[5] were "well-to-do," and they enabled her to enjoy a lifestyle that "knew nothing of poverty."[6] The peacefulness of Tingley's sheltered life was shattered, however, when Tingley witnessed the arrival of Irish immigrants to Newburyport. The immigrants lived in deplorable conditions, and young Tingley felt "an urging to change these conditions."[7] Later, when her father was serving as a captain in the Northern Army during the Civil War, Tingley and the rest of her family visited her father in Alexandria, Virginia. There, Tingley was horrified to see the condition of mauled federal troops. To the horror of her father and mother, their daughter disappeared: she was later found "attempting to care for the wounded."[8] Tingley retained her interest in providing aid to the needy, sick, and wounded throughout her life. She made such activities a central purpose of the Theosophical Society when she became the leader of the organization.

Tingley showed an early interest in esotericism. As a young girl, she was not interested in the Christianity of her parents. Rather, "she preferred

the company of her maternal grandfather, whose Masonic teachings fascinated her by their esoteric nature."[9] Had Tingley attempted to learn these teachings through traditional Masonry, she would have been denied access to them because only men were allowed to be members of Masonic groups. Throughout her career, Tingley would advocate that women, as well as men, should have access to esoteric knowledge. Tingley's early inclinations toward esotericism were also shown in her view of nature. Talking about her childhood in Newburyport, Tingley stated:

> I always felt that my real teacher [...] was within myself [...] which led my father to believe that by the time I was twenty-one years of age I would be somewhat demented! [...] When I was four or five years old, I used to disturb my people by telling them that I heard the trees sing and many things along that line, which seemed very uncanny to people of those days in New England, where the power of dogmatism and convention was very strong. So all through my childhood I led quite an isolated life, except for the inspiring companionship of my grandfather.[10]

Tingley spoke of staying away from church and going to the woods with her dog, where she "learned some of the great secrets of life" and "found the little spiritual strength that I had."[11] Tingley's perspective on nature bore much in common with the esoteric philosophies of Romantic thinkers such as Jacob Boehme and Emmanuel Swedenborg. For thinkers such as these, all of creation and everything that happens within it are "emblems of the divine" that "provide symbolic or analogical knowledge of the links" or "correspondences" that exist "between divinity, the self, and the world."[12] There is no way to prove that Tingley was immersed as a youth in reading the works of esoteric Romanticists. Tingley was certainly familiar with Romantic esotericism, however, when she spoke about her childhood as the leader of the UBTS in the 1890s.

It has been suggested that Tingley initially had interest in Spiritualism, but the degree to which she was involved in it has been contested. In his 1955 book, *The Point Loma Community in California 1897–1942*, Emmett A. Greenwalt suggests that Tingley was a rather devout Spiritualist before she became a Theosophist.[13] Greenwalt's documentation, however, does not support his claim that Tingley "succumbed completely" to the "spell" of Spiritualism.[14] More convincing is Greenwalt's argument that Spiritualism, which had a "confusing" message, could not "supply" her with "a spiritual, psychological, and philosophical basis for reform."[15] According to Greenwalt (and Tingley herself), Theosophy, not Spiritualism, satisfied this need.

When Tingley first heard of Theosophy is uncertain. It is likely that she would have been to some extent familiar with this international movement when, in the winter of 1892, she met William Quan Judge. Judge was one of the original cofounders of the Theosophical Society. At the time that he met Tingley, Judge was the leader of the Theosophical Society in America. As Tingley tells the story, Judge asked to meet Tingley after quietly watching her feed the hungry at a Do-Good Mission that she founded on the East Side of New York City. [16] At this meeting, Judge convinced Tingley that Theosophy points the way "to the right treatment of the downtrodden and outcast of humanity" and offers "the real remedies for poverty, vice, and crime."[17] Regarding Judge, Tingley said:

> It was he who first gave me glimpses of the power of thought and made me realize what it will do to build or ruin the destiny of a human being. And in doing so, he showed me how to find in theosophy the solution of all the problems that had vexed me: how it points to the right treatment of the downtrodden and outcast of humanity, and to the real remedies for poverty, vice, and crime. On all these subjects the first word of theosophy is this: he who would enter upon the path that leads to truth must put new interpretations on the failings and mistakes of his fellow-men. He must come to understand the law of eternal justice—karma, [which states] that "whatsoever a man soweth, that shall he also reap"—and to know the necessity it implies for unconquerable compassion, because those who fail and fall short do so always through ignorance, and there can be no cure for it until it is recognized.[18]

Judge taught Tingley the Theosophist's understanding of reincarnation, karma, and the relationship of both to human being's "unlimited capacity for improvement."[19] Theosophy provided Tingley with a comprehensive system of belief upon which she could base all of her future efforts in philanthropy, the arts, and spirituality.

Central to Tingley's understanding of Theosophy was the concept of Universal Brotherhood, which had been professed by the earliest founders of the movement. In her book *The Key to Theosophy*, Blavatsky asserted that the first object of Theosophy was "to form a nucleus of the Universal Brotherhood of Humanity without distinction of race, color, sex, caste, or creed." [20] To make Universal Brotherhood more than a utopian dream, Blavatsky recommended "Practical Theosophy," which she described as acts of charity that constitute palpable examples of Universal Brotherhood.[21] Tingley's predecessor Judge had taught that all people originate from a divine "Cause" and are part of a "Human Brotherhood."[22] When Tingley

described unselfish "work for humanity" as "the first step to be taken in Occultism,"[23] she was continuing a line of thought that had been shared by her predecessors, Blavatsky and Judge.

Tingley differed from her predecessors, however, by using Universal Brotherhood as the justification for all UBTS endeavors.[24] This is why she saw fit to insert the phrase "Universal Brotherhood" into the name of the Theosophical Society.[25] Tingley also felt compelled to prophecy about the realization of Universal Brotherhood. Promising the coming of "a true peace on earth and wisdom among mankind" that her followers' children would "live to see in the coming century," Tingley announced:

> When Theosophy has liberated all men [...] there can be no room for sorrow. The prisons will be emptied, wars will cease; hunger and famine will be unknown; the spectacle of men utilizing their brains and all their resources to make engines of destruction will appear no more; bigotry, superstition, and religious persecution will disappear; disease, which often springs from evil acts and thoughts, will pass away; hate will be supplanted by charity; selfishness, by self-sacrifice; the day will take the place of night on our world, and under the shadowing wings of the great brotherhood, all mankind will abide in peace, unity, and love.[26]

Tingley argued that her optimistic prophecy was not a "Utopian Dream" but an emerging reality that would arise out of a current of wisdom that had been passed down to the present not only by adepts but also by the forefathers of the United States of America. Tingley claimed that the forefathers had promoted the Universal Brotherhood principle and had passed it on to later Americans, who they charged with "the making of the future."[27] Tingley thus advocated for a spiritualized form of patriotism in which philanthropy and tolerance were more important than concerns of establishing or preserving a national identity for the United States. Thus, Tingley linked her ideas about esoteric philosophy with her ideas about US nationalism and patriotism.

By the time Judge passed away in March 1896, Tingley was known to a few Theosophists as one of his closest and most trusted collaborators. By her own admission, however, she was not well known among the broader membership of the Theosophical Society in America.[28] Tingley's first public appearance to the membership as a leading Theosophist was on April 26, 1896, at a Theosophical Society convention in New York City. Here Tingley announced her plan to establish a mystery school that would revive the teachings and practices of the ancient mysteries of many ancient cultures via the comparative study of science, religion, philosophy, and the arts. By the end of the conference, Tingley had raised $5,000 for this project.[29]

Two months later, in June 1896, Tingley had raised enough financial support to leave with a group of leading Theosophists to conduct a world crusade for Theosophy. The purpose of the crusade was to raise funds for the establishment of the aforementioned "great school in the West,"[30] which would be part of a community dedicated to "the Theosophical way of life."[31] Over a period of eight months, Tingley and the other Theosophists traveled to England, Ireland, France, Holland, Austria, Italy, Greece, Egypt, India, and Australia. During this journey, Tingley purchased one hundred and thirty acres of land in Point Loma, California.[32] In February, Tingley and others returned to the United States, and soon thereafter arrived in Point Loma. There, on February 23, 1897, Tingley conducted an elaborate ceremony at which she unveiled the foundation stone of the great school that she promised to establish: namely, the School for the Revival of the Lost Mysteries of Antiquity (SRLMA). The SRLMA cornerstone was located on the grounds of the Point Loma property, which later became known as Lomaland and served thereafter as the headquarters of the UBTS.[33] A photograph taken of this event shows Tingley in a long cloak standing between several well-dressed members of the world crusade. Above them hangs a banner upon which are printed Blavatsky's words: "There is no religion higher than truth." In the photograph, Tingley is anointing the cornerstone of the SRLMA.[34]

The SRLMA had three purposes: discovering the teachings of the Secret Doctrine as they had been revealed through ancient religions, teaching the principles of Theosophy to students of all ages, and pursuing a socially liberal program of altruism and spiritual education. The SRLMA charter lists a series of methods for achieving these goals, including (1) the revival of "a knowledge of the Sacred Mysteries of Antiquity"; (2) the promotion of "the physical, mental, moral and spiritual education and welfare of the people of all countries, irrespective of creed, sex, caste or color"; and (3) the teaching the laws of "universal nature and justice." The charter states that the work of the SRLMA will illuminate "the wisdom of mutual helpfulness."[35] At the cornerstone ceremony, Tingley expressed hope that the school would teach people to "become compassionate lovers of all that breathes" and enable them to use their strengths "for the good of the whole world."[36] Tingley's descriptions of the functions and goals of the SRLMA echoed the principle of Universal Brotherhood, which she held aloft as the central teaching of "Theosophy, the wisdom religion."[37]

To achieve the goals of the SRLMA, Tingley established several new departments within it. In 1897, she founded the International Brotherhood League and charged it with the task of educating children "of all nations

in the broadest lines of Universal Brotherhood"; providing aid and sup-
port to destitute women, convicts, and ex-convicts; promoting "a better
understanding between so-called savage and civilized races by promoting a
close and more sympathetic relationship between them"; sending relief for
war and disaster sufferers; and abolishing capital punishment.[38] Tingley
also established the International Theosophical League of Humanity and
Work in Prisons. Under Tingley's leadership, the UBTS became a multi-
faceted organization that pursued a wide array of philanthropic, educa-
tional, and cultural activities. By linking these political and social agendas
to the principle of Universal Brotherhood, Tingley sacralized political and
social activism as a religious act.

Tingley received praise from government officials and prominent busi-
nessmen for her philanthropic work. President McKinley praised Tingley for
the aid the UBTS provided to American veterans of the Spanish-American
War in 1898.[39] Business tycoons such as A. G. Spalding of Spalding Sporting
Goods and Clark Thurston of the American Screw Company testified to
Tingley's leadership and business sense by providing her with funds to pur-
sue her various projects.[40] When a San Diego reporter asked Thurston how
Tingley could hold "the support of such men," Thurston replied that she
had more business ability than all of her colleagues together.[41]

One of the most dramatic changes Tingley made was relocating the
headquarters of the Theosophical Society in the United States from New
York to Point Loma in 1900. The establishment of Lomaland involved
the migration of hundreds of Theosophists to California and a swift
wave of construction that had transformed the landscape of Point Loma
by 1901. Between 1900 and 1901, Tingley purchased more property at
Point Loma, and the boundaries of Lomaland expanded from one hun-
dred and fifty to almost five hundred acres.[42] The locals of San Diego and
other nearby areas were puzzled, amused, and, in some cases, disturbed by
the sudden appearance of Lomaland on the cliffs overlooking the Pacific
Ocean. During the Lomaland construction boom, Tingley was sometimes
attacked by Christian ministers, who pejoratively labeled her organization
a non-Christian cult. Not all of the locals disapproved of Lomaland, how-
ever, because the unique buildings that were constructed there generated a
new market for tourism in the San Diego and Point Loma areas.[43]

Some of the first Lomaland buildings were topped with illuminable,
monochromatic, stained-glass domes (figure 2.2), the colors of which were
said to have "occult significance."[44] Such domed buildings included the
Temple of Peace, which was a circular structure bejeweled with an ame-
thyst-colored dome; Spalding's residence, which was adjoined by a nine-

hole golf course; and the "Homestead."[45] The Homestead was a sanitarium that already stood on the grounds of Point Loma when Tingley purchased it. The Homestead ultimately became Raja Yoga Academy.[46]

Other Lomaland buildings included several round, canvas-topped, homes that were about 30 feet in diameter. These buildings, which would later be rebuilt as wooden structures, served as group homes for the children arriving in Point Loma from the Lotus House, which was a UBTS-operated home for destitute children that had previously been located in Buffalo, New York. On a slope leading toward the Pacific Ocean was a group of dwellings known as "Esotero," which was home to adult students studying "the Eastern and Esoteric School of Theosophy." [47]

Out of all of the buildings that were built on Lomaland, the only one that would continue to be used for its original purpose until the present time was the outdoor Greek Theater, which was completed in 1901. With a seating capacity of about 2500, the outdoor Greek Theater made UBTS entertainments accessible to the entire population of Lomaland (which reached 357 in 1910 and over five hundred by 1911),[48] in addition to many outside guests. The Greek Theater served as the central location for UBTS

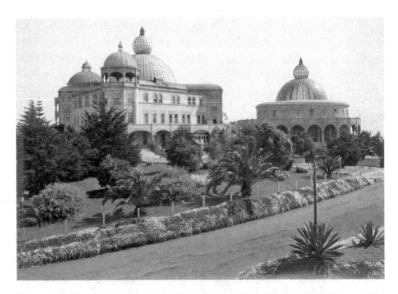

Figure 2.2 Domed buildings on the Universal Brotherhood and Theosophical Society grounds (Point Loma, California). Photo Courtesy: Theosophical Society Archives (Pasadena, California)

theatrical productions, concerts, and conferences as long as the UBTS kept its headquarters in Point Loma.

The construction and maintenance all of these buildings required a great deal of cash and labor, and even though Tingley had many generous supporters—some of whom were quite wealthy—donations alone were not enough to realize Tingley's grand plans for Lomaland. Tingly therefore employed a variety of methods to generate income from within the Lomaland community. Some income was created through residential fees, rent, and tuition. Families and individuals who moved to Point Loma were charged a 500-dollar residence fee that would enter all the members of each incoming party. The entrance fee was graduated according to financial need. Sometimes poorer members were allowed to enter at a discounted rate, or even at no cost.[49] In addition to this, some of those living in Lomaland housing paid rent. One of the steadiest streams of income in Lomaland was the tuition that parents paid so that their children could attend Raja Yoga Academy. Raja Yoga tuition ranged from four hundred to one thousand dollars, which was, according to Point Loma historian Emmet A. Greenwalt, "about the same as that charged by any good private school."[50] Like residence fees, the tuition costs were graduated: the rich paid the most and the poor paid less.[51] Other income was generated from theatrical productions, the profits of which often supported either specific philanthropic activities undertaken by the UBTS or the organization's operational expenses.

Tingley was able to avoid expenses because of the labor and services that were donated by the Lomaland residents. In the case of Raja Yoga Academy, for instance, teachers worked for free. By 1906, 60 teachers worked at Raja Yoga Academy, but none of them were paid. In a 1907 article published in *The American Magazine*, Ray Stannard Baker asserts that none of the residents of Point Loma received payment for the work they did.[52] Baker goes on to say that Tingley would have had to spent a huge fortune for the facilities and educational and cultural programs undertaken at Lomaland without volunteer-based support.[53] Tingley's theatrical productions also benefited from the army of volunteers who united to bring them to the stage.

UBTS THEATRE

The importance of Theatre to Tingley's plans for the UBTS became apparent from the time that she founded the SRLMA in 1897. Tingley's

secretary, Joseph H. Fussell, stated that some of the educational goals of the SRLMA would be pursued through the art of theatre, which, "if rightly studied" can be a factor in "the development of soul qualities."[54] In 1898, Tingley founded the Isis League of Music and Drama, which existed to move "the people to a knowledge of the true philosophy of life" through the "the revival of ancient drama as an educative factor."[55] (It is interesting to note the connection between Tingley's Theosophical theatre project and ancient Egyptian religion. Spiritual masons, esotericists, and occultists have claimed connections to ancient Egyptian religion for centuries. This is not surprising since so many of them have incorporated the correspondence theories of Hermeticism into their teachings.) The Isis League's first task was to revive Aeschylus's *Eumenides* at the Carnegie Lyceum in Manhattan.[56]

Another SRLMA division that Tingley created was the Woman's Exchange and Mart, which made and sold textile arts and crafts. When the UBTS headquarters moved to Point Loma, the Woman's Exchange and Mart designed and constructed the costumes for Tingley's productions.[57] Tingley also organized the Theosophical Publishing Company, which published Theosophical pamphlets, play scripts, and theatrical programs. Many of the SRLMA divisions had duties that were directly related to theatrical production.

Tingley remained focused on theatre after she moved the UBTS headquarters to Point Loma in 1900. At Point Loma, theatre and drama were infused throughout the *raja yoga* system of education, which taught the principles of Theosophy to students of all ages.[58] From the beginning to the end of her career, Tingley viewed theatre as a sacred endeavor that was crucial to the mission of the UBTS and the SRLMA. Throughout her life, she continued to use theatre as a central modality for teaching audiences about Universal Brotherhood.

Tingley's faith in the power of theatre was made apparent by the money she allocated to the construction and acquisition of theatrical spaces. In 1900, the construction of the Greek Theater was completed. In addition to this, Tingley purchased the 1,400-seat Fisher Opera House in San Diego for $65,000[59] and renamed it the Isis Theater. In these performance spaces, Tingley and the members of the UBTS created performances that suggested a future "era of Enlightenment and Happiness" that "is the child of both Past and Present."[60] Tingley viewed theatre as a harbinger and fosterer of this new era of spiritual enlightenment

Tingley published articles concerning the occult basis of her plays and productions in three UBTS periodicals: *New Century, Universal*

Brotherhood Path, and the *Theosophical Path*.[61] With these publications, Tingley explained the spiritual purposes of her theatrical activities and argued that her theatrical practices were linked to a primordial occult drama tradition through which the Secret Doctrine had been passed down throughout the ages. For instance, Tingley published an article by Basil Crump in *New Century*, in which Crump lamented the crumbling of Greek artistic culture, the degradation of the practices of ancient mysteries, and the transformation of drama from a sacred act to a base pastime. At the same time, Crump predicted that a bright future exists for theatre at Lomaland, where the mysteries would be "reborn...to radiate their divine influence throughout the world" and "the people will begin to understand the true nature of Art as the handmade of Religion."[62]

In a 1901 edition of *Universal Brotherhood Path*, Tingley published an editorial that was written in response to a production of an original Theosophical play titled *The Conquest of Death*. Regarding the spiritual significance of this work, the author writes:

> The instruction gained by the students in this sacred dramatic work, which is conducted with such extreme care by the Leader herself, is of the most valuable nature.... This dramatic work is now the most important activity that can be done by the members, for through it a world-wide work is being opened out. No limit can be put to the extension of this saving power, for by its means the minds of men are being gradually permeated by the fundamental ideas of Brotherhood; later on the results will be seen in the attitude of the masses when opportunities for striking out new lines of action occur in social and political life.[63]

No doubt the lines of social and political action that the author of this editorial was referring to are the same ones pursued by the members of the UBTS membership, such as opposing war, promoting peace, feeding the hungry, opposing vivisection and cruelty to animals, and decrying the death penalty. Using language that seems to anticipate Bertolt Brecht's theories about the ability of epic theatre to promote political action, this editorial argues that Tingley's theatrical techniques will encourage audience members to not only embrace the values of the UBTS but also take social and political actions that align with the spiritual values of Theosophy. Tingley's motivation for social change is not only religious, but also political.

Equipped with her understanding of theatre and drama as a tool for teaching occult knowledge and practice, Tingley incorporated theatre into many of the educational enterprises of the UBTS. In September 1897,

while the UBTS was still located in New York City, Tingley sent a commu-
nication to the Children's Department of the International Brotherhood
League explaining that the future education of the needy children of the
Lotus Home would be executed "largely by means of symbolism and alle-
gorical plays" designed to teach children that they are "immortal souls"
and a true part of nature.[64]

In 1904, Tingley opened the Raja Yoga Academy, which included pre-
school, elementary, middle school, and high school programs. Tingley
translated the Sanskrit term "*raja yoga*" to mean "kingly union," and, as
Tingley's personal secretary explained, the *raja yoga* system had a basis in
Theosophical tenets:

> The School of Antiquity [another name for the SRLMA] shall be an Institution
> where the true "Râja-Yoga," the laws of universal nature and equity govern-
> ing the physical, mental, moral and spiritual education will be taught on the
> broadest lines. Through this teaching the material and intellectual life of the
> age will be spiritualized and raised to its true dignity.[65]

The *raja yoga* system of education is based on the idea that human beings
are torn between a higher, divine self and a lower, non-divine self. The
curricular goal of *raja yoga* is teaching students to transmute everything
within human nature that is "not divine" through the practical application
of Theosophy.[66]

Theatre and theatricality were a central aspect of the *raja yoga* system
of education. All Raja Yoga Academy students began every morning in the
Greek Theater, where they listened to Theosophical readings and speakers.
In the evenings, many *raja yoga* students participated in theatre rehearsals.[67]
If a large-scale production was in development, the entire day's schedule of
classes and training might be "interrupted by an all-community effort to
make costumes, build and paint settings, and rehearse for a play."[68] Theatre
was an ever-present pedagogical instrument within the Raja Yoga Academy.

Tingley and her followers believed that theatre could point toward "the
real life of the soul" and act as a redemptive force for the modern age.[69] It
was for this reason that the UBTS community produced a wide range of
theatrical events, including theatrical lecture tours, tableau vivant exhibi-
tions, plays by Aeschylus and Shakespeare, and elaborate Theosophical
plays set in ancient Greece. In 1897, Tingley sponsored a series of lec-
tures given in the United States and Europe by Basil Crump and Alice L.
Cleather—both of whom were affiliated with the London Wagner Society.
In these lectures, Crump and Cleather spoke about Wagner as the reviver

of an ancient tradition of mystery theatre, and they suggested that this the-
atrical tradition would continue at Point Loma. The Wagner lectures were
couched within the larger context of an entertaining event that included a
musical recital and magic lantern illustrations.[70]

The list of subjects discussed in the Wagner lecture make clear that
Cleather presented Tingley as an adept of the mystery theatre tradition
mentioned above. Some of the subject headings listed in programs from var-
ious Wagner lectures include: "Wagner's Ideal of Brotherhood";[71] "Modern
Opera and the Re-Birth of True Drama"; "From Aeschylus to Sophocles to
Shakespeare, Beethoven and Wagner"; "The Brotherhood of Man, and of
Arts and Religions"; "Work of the Mystery Play"; "Ancient Schools of the
Mysteries and their modern Revival at Point Loma, California."[72] When
viewed alongside each other, these subject titles suggest the story of a mys-
tery theatre tradition that passes from the Greek tragedians to Shakespeare
to Wagner to Tingley.

An article in the *New Century* concerning one of Cleather's lectures
states that she described Wagner not only as a dramatic poet to be placed in
the same line as Aeschylus and Shakespeare, but also as a mystic who taught
messages about karma and reincarnation that were similar to Tingley's own
teachings.[73] Cleather presented Wagner's dramas as a revival of "ancient
Mystery Plays" performed "under the direction of Mystics" in "the Schools
of the Mysteries." Cleather lamented that these ancient religious mysteries
had degenerated as a result of the increasing acceptance of materialistic
thought, but predicted that the ancient mysteries—including the theatri-
cal aspects of these mysteries—would be "revived in their pristine purity"
at the School for the Revival of the Lost Mysteries of Antiquity.[74] Tingley
used this mission of religious reconstruction as a lofty motivation for all of
the theatrical projects that she undertook during her career.

The manner in which Cleather spoke of Wagner evidences connec-
tions between Tingley's theoretical approach to theatre and artists who
were part of the first Parisian wave of Symbolist theatre during the 1890s.
Many Symbolist theatre artists looked to Wagner's 1882 work, *Parsifal*, as a
model for modern occult dramas.[75] In *Symbolist Theater: The Formation of
an Avant-Garde*, Deak notes that Wagner's works were embraced as occult
texts by both Symbolist artists and occultists (including Theosophists).[76]
Joséphin Péladan (1859–1918), the French Symbolist director and play-
wright, for instance, emulated Wagner by adopting Wagnerian principles
of dramatic composition and music and to his own writing and taking on
the role of "redeemer of French culture."[77] Edouard Schuré, who helped to
popularize Wagner among Parisian symbolists, was of the opinion that the

beginning of Wagner's operatic career marked a lifelong entry into "the occult," and he described Wagner as a "master magician" holding equal sway over the "terrestrial, the astral, and the divine worlds."[78] Tingley's Wagnerian interests were in keeping with those of the Symbolists.

Tingley publicly acknowledged her respect for Symbolism by publishing an essay about Maurice Maeterlinck in *Universal Brotherhood Path*, in which she credits Maeterlinck with being a mystic-dramatist who, like so many other Symbolists of the time period, was stamped with derogatory labels such as "decadent" and "degenerate" by "ordinary" critics.[79] Later, the author suggests that the ideas in the work of Symbolist playwrights like Maeterlinck are akin to the teachings espoused by Theosophists, even though he, according to the author of the article, conveys "a touch of uncertainty as if he was still seeking light."[80] Tingley's interest in European Symbolism anticipated the rise of the Little Theatre Movement in the 1910s by more than a decade.

In her own time, Tingley was one of several pioneers of the experimental wave of Greek Revivalist theatre that began to arise in the United States during the early nineteenth century and continued to strengthen during the first years of the twentieth century. Greek Revivalism became apparent in the United States when designers of buildings, clothes, vases, and furniture began to exhibit a "pervading enthusiasm for things Greek."[81] According to Greek Revivalism art curator Joseph Downs, many American-born architects began to show the fruits of Greek Revivalist thought as early as 1800, when they rejected English-style architecture for the architectural qualities of ancient Greek structures. Downs suggests that this design choice corresponded to a growing US desire to distance the young nation from its English roots and celebrate the "ideal of a new and vigorous democracy," which many Americans viewed as something akin to the democracy of ancient Athens.[82] Greek Revivalism quickly expanded beyond the realm of architecture as designers of furniture, clothes, and decorative arts began to create works rooted in the aesthetic trends of ancient Greece.

By the late nineteenth century, a Greek Revivalist theatre movement emerged, and some theatre critics recognized Tingley as a part of that movement. Sheldon Cheney, one of the first theatre critics in the United States to champion avant-garde theatre, identified Lomaland's Greek Theater as the first Greek Revivalist theatre to be constructed in North America[83]—it was built three years before the Hearst Greek Theatre of the University of Berkeley and 13 years before the Lewisohn Stadium of New York City. In an article titled "Some American Experimental Theatres," which was published in the July 1916 issue of the *Texas Review*, W. L. Sowers

compared Tingley's work with that of Greek Revivalist actor Margaret Anglin. Sowers noted that Tingley's directorial style "gains much of its effect through color and grouping and movement."[84] Professional theatre critics recognized Tingley's theatre as a significant contribution to Greek Revivalist performance in the United States.

Tingley staged a Greek Revivalist production in 1898, when she directed Aeschylus's *The Eumenides* at the Carnegie-Lyceum theatre in New York City. In notes concerning this performance, Tingley wrote that *The Eumenides* contains esoteric secrets that any earnest spiritual seeker "would go to the ends of the earth to find."[85] Tingley held *The Eumenides* aloft as one of the "superb religious dramas" of ancient Greece with the potential to raise human minds "to a higher contemplation of life." Tingley juxta-posed *The Eumenides* to unspecified forms of modern theatre, which she described as "trash" and accused of dragging down the minds of the young through senselessness.[86] By viewing *The Eumenides* as part of "a primordial fountainhead" of spiritual knowledge upon which to build "a new sys-tem of personal belief," Tingley revealed her agreement with the views of Symbolists upon the significance of ancient Greek drama and art.[87] What sets Tingley apart from the Symbolists and Greek Revivalists who worked in professional theatre is that she created her theatrical productions with the intention of propagating a specific spiritual worldview. She sought to create convincing pictures to embody her Theosophical teachings, and she hoped that her productions would inspire others to embrace Theosophy and the principle of Universal Brotherhood.

With the 1898 production of *The Eumenides* at the Carnegie-Lyceum in New York City, Tingley tried to portray the positive transformation of the soul via the Theosophical path. How Tingley attempted to do this is indicated in notes that she wrote to prepare a follower named Mrs. Butler to present a lecture about *The Eumenides* to the members of the Bridgeport Art Club in Connecticut. In those notes, Tingley wrote that the transfor-mation of the Furies at the end of *The Eumenides* should be understood as a group of souls escaping the domination of the "lower nature" as a result of having their "Higher Selves" awakened by "vibration or higher thought."[88] In other words, *The Eumenides* illustrated a moment of spiritual enlighten-ment and development.

Tingley tried to illustrate this moment of transformation through color, costume, and dance. By having the Furies change from black to white cos-tumes, Tingley tried to show the conquering of the lower nature by the higher nature. Anticipating ideas that avant-garde visual artist and playwright Wassily Kandinsky (who was deeply impacted by Theosophy) would propose

13 years later in his influential work of art theory, *Concerning the Spiritual in Art*,[89] Tingley asserted that "each color corresponds to a certain quality in one's nature." Tingley also incorporated heightened movement and dance into *The Eumenides* in her efforts to depict occult apotheosis. Before the Furies underwent their positive transformation, the actors' movements were grotesque, spasmodic, and crooked, in representation of a "perverted good." After the transformation, the actors' movements became graceful, rhythmic representations of "truth and virtue" by moving silently to a sweet melody.[90]

Tingley admitted that her symbolic concept is simple, but she proposed that her representation of the transformation of the Furies is harmonious with the original meaning that Aeschylus tried to put forth when he wrote *The Eumenides*. Tingley claimed that her reasons for taking this approach to *The Eumenides* were the same as those that inspired Aeschylus to write his play in the first place. According to Tingley, Aeschylus wrote *The Eumenides* to "attract the attention of the masses by the Lesser Mysteries." Tingley asserted that Aeschylus was an enlightened occult adept who had to lower himself to his audience's level of understanding "in order to...bring them up to a higher...state of consciousness."[91] By connecting her own production of *The Eumenides* to this image of Aeschylus as the edifier of noninitiates, Tingley suggests that she, like Aeschylus, is using a simple story to awaken the higher occult nature of her audience.

Among the photographs held at the Theosophical Society Archives are shots of productions of *The Eumenides* that took place in the Greek Theater in both 1922 and 1924. These photographs show that Tingley adhered to the same conceptualization of the Furies' transformation that she employed in the 1898 production. In one photograph, Orestes cowers as the Furies, who are dressed in dark, hooded robes, lean forward on one foot and threateningly extend serpents in his direction (figure 2.3). In another photograph, we see the Furies in the moment of transformation: the actors are in the process of dropping their hooded robes to reveal white Grecian gowns and flower garlands (figure 2.4).

Tingley adhered to her Theosophical understanding of the transforma- tion of the Furies throughout her directorial career. In 1922, only seven years before Tingley's death, Fussell responded to her 1922 production of *The Eumenides* with an article titled "'The Eumenides' of Aeschylus—A Mystery drama" that was published in the November 1922 issue of the *Theosophical Path*. In this article, Fussell explains that the moment of transformation in Tingley's 1922 production embodies the primary lesson of any occult initiate—the need to recognize and conquer "the lower pas- sional nature." [92] Tingley adhered to her 1898 approach to *The Eumenides*

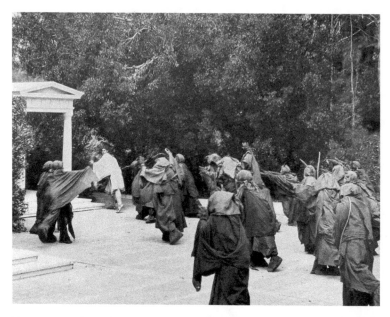

Figure 2.3 The Furies torment Orestes. *The Eumenides.* Directed by Katherine Tingley. Location: Greek Theater (Point Loma, California). Date: 1924. Photo courtesy: Theosophical Society Archives (Pasadena, California)

in this later production by using the Furies to symbolize her understanding of the lower nature as the source of war, materialism, and cruelty that must be overcome through the power of the higher nature.[93]

Just as Tingley viewed Aeschylus as a theatrically inclined occult adept, she also viewed Shakespeare as an occultist who wrote mystery dramas that depict "the soul's experiences," could correctly interpret "Higher Law," and could illuminate "life's diviner aspects."[94] Tingley disseminated her esoteric interpretation of Shakespeare's works in several articles that she published in UBTS periodicals. Many of these articles presented Shakespeare as an occult teacher whose teachings anticipated those of the Theosophists. In a *New Century* article titled "Lessons in Occultism," F. M. Pierce used one of Puck's famous statement, "What fools these mortals be!" to distinguish between the deeds of "self-hypnotized astral voyagers" and those of Theosophists such as Blavatsky, Judge, and Tingley, whom Pierce esteemed as "object lessons and practical demonstrations of true occultism."[95] Elsewhere, the author of a *New Century* editorial described *The Tempest* as a technically accurate

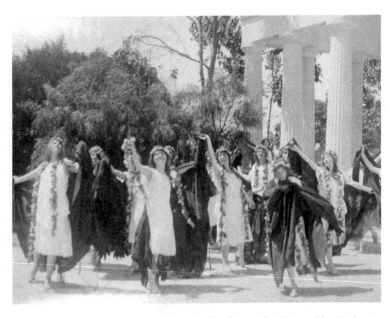

Figure 2.4 The Furies are transformed. *The Eumenides*. Directed by Katherine Tingley. Location: Greek Theater (Point Loma, California). Date: 1922. Photo courtesy: Theosophical Society Archives (Pasadena, California)

depiction of ceremonial magic pitting the witch—"the pendant in the World of Darkness"—against the honorable magician, who dwells within the "World of Light."[96] (This author presents a conservative view of the witch as "evil" that would later be challenged by Alex Mathews, Gerald Gardner, and many other Wiccans and modern witches.) A 1916 *Theosophical Path* article claims that both *As You Like It* and *Macbeth* contain insight into the mysteries of reincarnation.[97] In an essay titled "Hidden Lessons in Shakespeare," Kenneth Morris argued that Shakespeare was inspired by "universal and spiritual sources" when he wrote plays. Morris also asserted that "Karma, not fate," affects the lives of Shakespeare's characters.[98] Morris is interpreting Shakespeare's plays as occult texts that contain esoteric mysteries, which were revealed to the author by nonhuman sources.

Tingley attempted to reveal the occult information contained in Shakespeare's plays through illustrated lectures and performances. Between December 10 and 11, 1897, a committee of the International Brotherhood League organized a Shakespearean spectacle that took place in the Scottish

Rite Hall of New York City as part of a "Great Bazaar and Entertainment." The Shakespearean entertainment took place over a period of two days, and it explained "the plot and...esoteric meaning" of the *The Winter's Tale*.[99] The entertainment included a variety of attractions. Two of these were a lecture by Mrs. H. K. Richmond Green concerning the mystical meaning of *The Winter's Tale* and a reading of *The Winter's Tale* illustrated by tableaux vivants that had been created by artist Albert Operti.[100]

The Shakespearean entertainment was structured in the following way. After Mrs. Green's lecture, musicians played an overture for act 1. After the overture, a portion of the first act of *The Winter's Tale* was recited, followed by a *tableau vivant* titled "Keynote of the Drama." After the tableau, the remainder of the first act was read. This pattern was followed until the end of the fifth act, after which a tableau titled "Higher and Lower Self" was presented with music in the background. The purpose of the "Higher and Lower Self" tableau was to "show the duality of man's nature." Next came a tableau titled "In Old Egypt" and a parade of performers representing different nations of the world. Finally, stereopticon views of photographs taken by Tingley and the crusaders during their trip around the world were exhibited. Among these were photographs of pyramids in Egypt and stone-carved temples in India, Athens, and Rome. Within the context of the other events at the Great Bazaar, the Shakespearean tableau entertainment reinforced the idea that Theosophy was a spiritual tradition that had roots leading back to ancient Egypt and Greece, and that Theosophical theatre was the continuation of a mystery theatre tradition whose pedigree was equally ancient.

Photographs of some of these tableaux vivants and excerpts from Green's lectures concerning the mystical content of *The Winter's Tale* were published as a series in *The New Century* between January 15 and February 18, 1898.[101] Among these are three tableaux from *The Winter's Tale* in which performers clad in ancient Greek costumes convey the onset of King Leontes's mad jealousy and the subsequent arrest of Queen Hermione. Other tableaux include the arrival of the King Leontes's messengers at the Oracle of the Delphi, the reading of the oracle's message to Leontes and Hermione, and, finally, the moment when Hermione becomes reanimated at the end of the play. By featuring the creation of ancient Greek clothes and the oracle of the Delphi in these tableaux, Tingley visually reinforced Green's assertions that *The Winter's Tale* contains insight into an ancient religion.

In an article titled "A Fair View," E. Whitney, who attended the Shakespearean entertainment, claimed that the juxtaposition of *The Winter's Tale* with the march of the world's nations and the tableaux of

ancient Egypt strengthened her understanding of Universal Brotherhood and the idea that all human beings have sprung from a single Divine Source. For Whitney, the Shakespearean entertainment at the Great Bazaar visually and dramatically illustrated that all human beings, regardless of the time and place in which they live, are but "aspects of One."[102] Another audience member hopefully suggested that the Shakespearean entertainment represented the "the tentative introduction of the ancient picture drama by means of which the nature and evolution of the soul was taught."[103] This commentator believed that the tableaux exemplified what an ancient picture drama might have been like. Despite the fact that historians know very little about the specifics of the rites and practices of ancient mystery religions, Tingley and her followers viewed Shakespeare's plays as the continuation of an ancient dramatic tradition that promoted an esoteric doctrine that was similar to their own.[104]

Between 1907 and 1929, Tingley directed *A Midsummer Night's Dream* eight times and *As You Like It* seven times. Tingley also directed *Twelfth Night* and *The Tempest*.[105] Even though Tingley believed Shakespeare's plays contained important spiritual lessons, she was not content to turn Shakespeare's plays into simple and didactic works. She strove to create Shakespearean productions that had wide audience appeal and high standards of artistic excellence. Tingley's success in appealing to non-Theosophists is evidenced in some newspaper reviews. In 1907, she took a production of *A Midsummer Night's Dream* from Point Loma to Los Angeles. The critics of the *Los Angeles Examiner* and the *Los Angeles Herald* admired the costumes, scenery, and spectacle of the play. The *Herald* critic gave Tingley's production a fairly positive review:

> In rich garb of dazzling beauty, enhanced by the magic lighting effects, Lysander and Demetrius turned eyes upward to express their love for Hermia. She, a picture of classic beauty in lavender Grecian draperies, pointed her chin high in describing strong emotion and when she was sad let her head sink gracefully forward on her chest.[106]

The *Los Angeles Examiner* described the world of the fairies in *A Midsummer Night's Dream* "as pretty a stage picture as any audience could desire." [107] The details of costume, set, prop, and lighting design often pleased critics.

Tingley's actors received a more mixed response. The *Herald* review describes the voices of some of the Point Loma performers as unpleasant.[108] A critic from the *Los Angeles Graphic* praised the singing and dancing of

fairies in "the lovely setting of the forest glade." The fairies were played by child actors dressed in "tasteful filmy costumes."[109] (Photographs from the production reveal costumes made of multilayered material and decorated with embroidery.) The *Los Angeles Examiner* critic spoke with gentle honesty about the adult actors:

> The acting of the elder participants was conscientiously performed, with both the grace and the faults of non-professionals, but evincing an earnestness and careful training that secured for them a respectful and sympathetic hearing.
>
> Looked at from the viewpoint I usually take in a theater, the lad who played Puck deserves sincere recognition as being thoroughly imbued with the fantastical spirit absolutely needed to give this delightful vagrant mood of the Bard a degree of verity. . . . I'll wager an astral dollar to the Mahatma of a dime that he will grow up to be a star actor. [110]

Although the *Examiner* critic was more complimentary about *A Midsummer Night's Dream* than the *Herald* reviewer, he concludes his favorable comments with a light jab at Theosophy: he makes fun of the concept of the spiritual teachers known as Mahatmas, which several Theosophical leaders say are the guides of the Theosophical Society.

Photographs of Tingley's Shakespearean productions reveal rich costumes and, in some cases, creative set design. In the 1926 production of *The Tempest*, the entire Greek theatre was transformed into an island cave with layers of dark cloth, and Caliban was clothed in a bodysuit of dark fur. Photographs of *The Tempest* show this fur-covered Caliban cowering beneath the upraised and chastising arm of Prospero, who is dressed in long flowing robes. For those who were familiar with Tingley's understanding of the dual nature of humanity, this pose could easily represent the conquering of the Lower Nature by the Higher Nature.

The Theosophical interpretations of Shakespeare published in Tingley's periodicals show that Tingley's followers interpreted her productions along Theosophical lines. Many of those who did not agree with Tingley's spiritual worldview appreciated her artistic vision—especially the scenery, props, and costumes in her productions. Tingley's Shakespearean productions drew many non-Theosophist audience members from the Point Loma and San Diego areas. For Tingley, Shakespeare served not only to illuminate Theosophical teachings but also to form friendly connections between the membership of the UBTS and the other communities surrounding Lomaland. Such positive relationships were important to the residents of the UBTS headquarters at Point Loma, since they, like the

members of other new religions, were viewed with suspicion and hostility by many of those who lived near them.

Although Tingley thought of the plays of Aeschylus and Shakespeare as occult texts, she only managed to relate these famous playwrights' works indirectly to Theosophy and Universal Brotherhood as she understood them. In order to make the connections between these plays and her teachings more clear, Tingley found it necessary to comment upon the plays in notes, lectures, and articles. Tingley sought to create a theatrical form that was born of and based upon Theosophy, and she succeeded in creating such a theatrical form when she developed what came to be known as "symposia." The UBTS symposia were noticeably didactic; they clearly stated the UBTS's opposition to violence and war, depicted visions of a Theosophical afterlife, and elucidated the Theosophical doctrines of reincarnation, karma, and, of course, Universal Brotherhood.

Symposia were always set in an ancient time and place—usually Greece. The symposia took the form of extended philosophical conversations concerning the principles of modern Theosophy. These conversations were broken up by a series of theatrical episodes, as well as other performance elements, including music, song, dance, and other forms of performance. Like Tingley's conceptual approach to *The Eumenides*, the mise-en-scène, costume, and movement of the original Theosophical symposia seem to have been rooted in Greek Revivalism. Many of the costumes and props were reconstructions of ancient objects and clothing that appear in ancient paintings. The symposia differed from *The Eumenides*, however, because they were written from the Theosophical perspective, and their spiritual messages were obvious to all audience members—even those who knew nothing of Theosophy.

The symposium was first developed in 1899 by members of the Isis League of Music and Drama who had gone to Point Loma before the official relocation. At first, symposia were private and informal discussions conducted in "classic Greek costume."[111] Tingley and the members of the Isis League saw in the symposia the potential to promote the goals of the SRLMA. By 1900, the Point Loma symposia were based on prepared scripts, rehearsed, and presented publicly.[112] Tingley taught that the performance of symposia "carried an extraordinary force upon" a "quickened wave of human thought and impulse" that was transforming humanity and ushering in the New Cycle of peace. She promoted symposia as a means to "embody" UBTS "teaching in dramatic form."[113]

Tingley was so enthusiastic about this new dramatic form that she organized an international festival of symposia called the New Cycle

Unity Congress, which took place during April 13–15, 1900. On Saturday, April 14, lodges in the United States, Australia, England, and Sweden participated in the Unity Congress by presenting Greek symposia.[114] Tingley's directorial contribution to the Unity Congress was a symposium that she wrote, which was titled *The Travail of the Soul*. It premiered at night under the glass dome of Lomaland's Temple of Peace. In *Travail of the Soul* Tingley depicted the trials and triumphs of a human soul acquiring wisdom as it passes through physical incarnations. One *Universal Brotherhood Path* article written by an audience member claimed that the "spiritual meanings" of the Tingley's play were accentuated by "true-type," "old-time" settings, which included ancient-looking vessels, temple pillars, and richly colored fabrics that awakened "within one the deeper thought and feeling under which the highest and keenest appreciation of Soul-life is felt and made it possible for "the larger thoughts of the author and actors" to be "beneficently used."[115] According to this audience member, *Travail of the Soul* portended the "coming revival of a truly educative Mystery-Play" that gave the occultist the key to their "own spiritual Temple" and provides the solution to many of life's problems.[116] Descriptions of the symposia that were performed in other areas of the United States, the United Kingdom, Sweden, and Australia revealed that many of Tingley's followers emulated the Greek style of their leader's performance.

After the New Cycle Unity Congress, Tingley continued to promote symposia as a means of promoting Universal Brotherhood and teaching Theosophy. In 1901 she published a series of copyrighted symposia scripts that she offered to the UBTS lodges for performance; in this series was *A Promise*, or *The Conquest of Death*.[117] The title page of *A Promise* credits an anonymous student of Esotero with authorship and notes that the play was "issued by the approval of Katherine Tingley, Official Head of the Universal Brotherhood and Theosophical Society."[118] By giving her approval, Tingley endorsed this symposium as an expression of UBTS teachings and values.

A Promise is filled with famous Greek characters who espouse the tenets of Theosophy. Aeschylus speaks of the evolution of the soul as it was understood by Blavatsky and Tingley. He explains that the soul makes moral and spiritual progress by traveling "from height to height until the stone becomes a plant, the plant an animal, the animal a man, and man a god, radiant, beautiful, divine."[119] Pythagoras speaks about "the power of music to purify the life and awake the soul," and Aspasia extends the power that Pythagoras attributes to music to all other arts when she states that the

end of art is the awakening of that which makes "men divine, immortal as the gods."[120] In this symposium, well-known thinkers, philosophers, and artists of ancient Greece were represented as devoted Theosophists, who would willingly lend their authority to support the goals of the UBTS. Thus, *A Promise* presents all of these famous thinkers as members of a transhistorical community of adepts who transmitted the ancient Wisdom Religion to modern Theosophy.

The instructional and religious nature of symposia were not lost on non-Theosophists, as is clear from statements made by a *San Diego Union* reviewer who saw a performance of *A Promise* at the Fisher Opera House on April 8, 1900. The reviewer states:

> Pythagoras, Plato, Phidias, Diotama, Athene, Pericles, Socrates, and Aspasia hold philosophical discourse, and when one asks shall the earth ever again have a golden age, there is a glorious prophecy that the ancient mysteries shall once more be studied and a god-like race of men and women shall illuminate the world from the high summit of our own beautiful Loma Land.[121]

The exact nature of the reviewer's response to this didactic moment of the performance is unclear. It is hard to tell whether amusement, disapproval, or appreciation is being expressed. What the reviewer makes clear is the effectiveness with which Tingley added theatricality to the philosophical discussion upon which *A Promise* is based. The reviewer appreciatively recounts that "shifting lights, exquisite music and choruses" were inserted into an ongoing dialogue concerning the future of humanity and "the mysteries of life and death, reincarnation, immortality." While the aforementioned prophecy was uttered, a priestess of Apollo was attended by a train of young women and robed children. The final moment of the play included a "tableau of surpassing beauty" and an ancient hymn to Apollo. [122]

Not all of the messages in symposia were of a spiritual nature; some messages concerned social issues that would have been of interest to Lomaland residents as well as people in nearby communities. This was the case with *The Wisdom of Hypatia*, which was another symposium in the series of scripts that were distributed to lodges in 1901. The principal character of this symposia is Hypatia, the fourth-century, female mathematician, philosopher, and astronomer who was killed by a Christian mob because she was perceived as a political and social threat. In her dissertation, "Domesticating Universal Brotherhood: Feminine Values and the Construction of Utopia, Point Loma Homestead, 1897–1920," Penny

Brown Waterstone argues that Tingley directed *The Wisdom of Hypatia* to juxtapose the attacks made against Hypatia with attacks against Tingley by the popular press and Christian religious leaders. Waterstone points out that *The Wisdom of Hypatia* was published shortly after Tingley successfully sued the *Los Angeles Times* for a slanderous article that claimed that Tingley and her followers held "insane ceremonies" and engaged in immoral activities.[123]

Certain points of action in *Hypatia* do seem to resemble Tingley's battle with the *Los Angeles Times*. For instance, scene 2 opens in Hypatia's lecture room, where Solarion, a prominent citizen, openly questions her wisdom and the appropriateness of her status as a teacher of men:

> I have nothing to say against Philosophy. But, look you: all this talk of love and Brotherhood, it wearies me, and then, between ourselves, this adulation of Hypatia. This following of a Leader—is this freedom? Is this the independence which alone can make a man respect himself?[124]

Solarion's comments resemble the attacks made against Tingley's male followers by Mr. Shortridge, who was the defense attorney for the *Los Angeles Times*. Shortridge questioned the intelligence of men who would "surrender themselves to the dictation of a woman such as this."[125] Resembling the zealous nature of the Christians who so fervently opposed Hypatia's religious worldview, Shortridge argued that halting Tingley's activities at Lomaland was an act that must be performed "in the name of society and civilization, and in the name of the Savior of Nazareth who upon Calvary shed his blood that we might live."[126] In the symposium, Hypatia is presented as an advocate of Brotherhood, and this would have made it easy for Tingley's followers to view their leader as a spiritual teacher who, like Hypatia, suffered political and physical attacks for living by her convictions.

To effectively promulgate Theosophical teachings, shape her public image, and make money for the UBTS, Tingley knew that her symposia should be as beautiful and entertaining as possible. With her most elaborate symposium, *The Aroma of Athens*, Tingley attempted to please audiences with a directorial style that was elegant and pictorial. The extent to which Tingley succeeded and faltered in her efforts to please large audiences is evidenced in the reviews and photographs of productions of *The Aroma of Athens* that she directed between 1911 and 1923.

In the *Theatre Magazine*, columnist Bertha Hofflund wrote a critique of a 1911 production of *The Aroma of Athens* that took place in the outdoor

Greek Theater in the same year. Hofflund describes a mise-en-scène that she considers "the fabric of a dream":

> From the level, sanded floor of the amphitheater, softly lighted with encircl-ing torches, rises the sweet, pungent scent of incense, mingling with the fresh odors of the night, and over the brow of the hill comes the laughter of children at their games, the only sound in the stillness. Brooding in the peace of the eve-ning, on an elevation to the right, are the groups of the Theosophical buildings of the strange, almost Oriental, architecture, their walls gleaming like alabas-ter, their glowing domes of pearly incandescence adding a fairy fantasy to the scene. In a neighboring temple are seated a group of musicians. High on a cliff above stands another small temple, with groups of young warriors on the out-look, leaning easily on their long bows. At a nearby fountain, classically draped women, bearing on their heads graceful water urns, leisurely fill and depart with their burdens. Near and more remotely, statuary, the woodland deities, Apollo, Diane, Venus, and Pallas Athene, glimmer among the shrubbery.[127]

It is apparent from Hofflund's description that when Tingley directed *The Aroma of Athens* in the outdoor Greek Theatre at Point Loma she incor-porated not only the Greek Theater but also several of the other Point Loma buildings into her mise-en-scène. This directorial decision provided Hofflund with the impression that the performance was taking place within an alternative civilization existing outside of the cultural bounds of early twentieth-century California.

Hofflund describes colorful and interesting costumes: religious devo-tees dressed in "blood red robes," Spartans in clanging metal armor, and a seer "clad in the folds of a spotted leopard skin" who predicts the revival of the ancient Greek mysteries in Point Loma. Above all, Hofflund admires the performances given by the child-performers of Point Loma—*raja yoga* students ranging from toddlers to teenagers—who danced and invoked Pan with song.[128] Hofflund was less enthusiastic about the adult perform-ers, in whom she perceived a "naïve seriousness," and although she was appreciative of Tingley's attempt to reconstruct the sound of ancient Greek music upon ancient instruments, Hofflund found the music to be shrill and weird.[129] It would seem that this critic's response to Tingley's pro-duction was somewhat mixed, but, in spite of her misgivings, Hofflund viewed *The Aroma of Athens* as an experimental form of theatre invoking images of the past within the present.

Hofflund was not alone in her admiration of the elements of theatrical design within Tingley's symposia. Sheldon Cheney thought of the UBTS symposia as a new form of "decorative drama" that was more dependent

upon beautiful costumes, natural settings, composition, dance, and poetry than "emotional appeal"; in Cheney's opinion, the revival of the "Greek spirit" was at the heart of Tingley's theatre.[130] For Cheney and Hofflund, Tingley was a significant figure in the Greek Revivalist theatre movement of the United States.

Tingley herself encouraged the readers of *Century Path* to associate *The Aroma of Athens* with European avant-garde theatre. In a *Century Path* supplement, Tingley republished a review of the premiere performance of *The Aroma of Athens*, which originally appeared in the *San Diego News* on March 23, 1911. Tingley describes the author of this critique, who uses the pseudonym "Horatio," as a "contributor" working on behalf of the UBTS.[131] Horatio lauded what s/he perceived as the historical accuracy of *The Aroma of Athens*, and declared the task of analyzing *The Aroma of Athens* "worthy of the pen of a Maeterlinck."[132] By publishing these statements, Tingley depicted her production methods as the offspring of theatre's past and present, and, at the same time, a theatre of the future that might raise the minds of occultists to a higher plane of thought.

Some symposia were written for casts made entirely of child performers; one such symposium was *The Little Philosophers*, which was written by Tingley and performed by the Raja Yoga preschool students who were aged between two and five years. The young actors wore false beards and togas while they portrayed ancient philosophers who called all men, "rich and poor, wise and ignorant, selfish men and good, and children" to be "warriors." These warriors were not to fight physical battles; rather, they would remove from humanity's path "stumbling blocks" such as ignorance, selfishness, jealousy, careless teaching and education (which teaches human beings that they are not "Souls divine"), uncontrolled appetite, cruelty to animals, indifference, and, finally, "preaching and not doing." The little philosophers encouraged the audience to confront "the evil in our natures" and to embrace the teaching of Theosophy by replacing fear with love.[133]

The peaceful message of *The Little Philosophers* was presented at Point Loma during a reception and entertainment to the veterans of the Civil War on May 7, 1914,[134] and this production anticipated peace work that Tingley would do during the years of World War I. This propagation of the principle of antiviolence demonstrates that UBTS theatre was not simply a matter of producing spiritually insightful plays and giving the proceeds to humanitarian causes. Sometimes, Tingley created performances to critique policies and practices that she considered to be unjust or inhumane.

Prior to World War I, on March 3, 1913, Tingley established The Parliament of Peace and Universal Brotherhood as an "international

permanent organization for the promotion of peace and Universal Brotherhood." In 1915, Tingley held a Congress of the Parliament of Peace that was attended by many prominent people, including Prof. Osvald Sirén, professor of History of Art at the University of Stockholm; Mrs. Josephine Page Wright, president of the San Diego Woman's Press Club; Hon. Geo. W. P. Hunt, governor of Arizona (represented by an ambassador); Hon. James E. Ferguson, governor of Texas (also represented); and Rev. Howard B. Bard of the First Unitarian Church of San Diego. Representatives of the Swiss International Bureau of Peace, the Swedish Peace and Defense Society, the United Daughters of the Confederacy, the American Humane Association, and the New York Anti-Vivisection Society presented addresses at this function. This event featured diverse theatrical events, including a Grand International Pageant that included music, a procession of international flags and antiwar banners, a Peace Symposium performed by students of the Raja Yoga College and Academy, and performances of *A Midsummer Night's Dream* and *The Aroma of Athens*.

The most photographed event of the Congress of Peace was a pro-peace, theatrical procession that was based on a Swedish legend of world peace concerning seven kings from seven nations who sign a treaty of enduring peace. The primary banner of the pageant of the Seven Kings, which was carried by students of the Raja Yoga College, tells a brief version of the legend:

A PROPHECY OF PERMANENT PEACE—VADSTENA'S LEGEND OF THE SEVEN KINGS: SEVEN BEECH TREES WILL GROW FROM ONE ROOT; SEVEN KINGS WILL COME FROM SEVEN KINGDOMS.

UNDER THE TREES THEY WILL ESTABLISH PERMANENT PEACE. THIS WILL BE AT THE END OF THE PRESENT AGE.

Other banners in this procession bore slogans such as "Universal Peace—A Protest against War," "Win Peace by the Sword of Knowledge," "Universal Brotherhood is the Lost Chord in Human Life," and "Helping and Sharing is What Brotherhood Means."[135] The portrayers of the Seven Kings marched through the streets of San Diego, followed by the *raja yoga* students with their banners (figure 2.5). They entered the Lomaland grounds on horseback through a large entry gate from an adjoining boulevard, where they came together under several trees and signed a contract of peace.

The goal of the Pageant of the Seven Kings was to contemplate and dramatize the possibility of permanent world peace, which Tingley believed could not be achieved without the understanding that, as human beings, "our responsibilities are not for ourselves alone, not for our own countries alone":

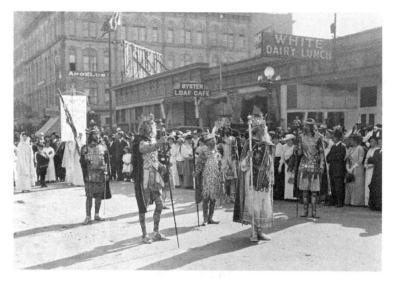

Figure 2.5 The Procession of the Seven Kings. Staged by Katharine Tingley (San Diego, California). Date: 1914. Photo courtesy: Theosophical Society Archives (Pasadena, California)

But for the whole human family. Territory and trade may be much, national honor may be much, but the general salvation of human society here in this world—that is *all*.[136]

The image of the Seven Kings urged spectators to reassess their cultural differences and national identities by embracing a larger kinship rooted in the idea of a shared connection to the Divine Principle. Tingley believed that when all human beings recognized this affinity Universal Brotherhood would result and the New Cycle would begin.

Until the New Cycle arrived and transformed human nature, Tingley believed that war would continue to occur, and, although Tingley protested World War I, she did not condemn soldiers or attempt to dissuade people from joining the armed services. In fact, she regularly invited officers and enlisted men to see Lomaland productions. Rather than criticizing America's involvement in World War I and turning a great deal of the public against her, Tingley encouraged all people to envision ways in which they could contribute to the development of a more peaceful world in the future.

CONCLUSION

Like Greek Revivalists, Tingley was interested in creating new forms of theatre based on ancient Greek aesthetics, performances techniques, and mythologies. Like the Symbolists, Tingley longed to create modern mystery dramas rooted in occult principles. Theatre critics living during the early twentieth century acknowledged Tingley's status as an experimental theatre artist and recognized her work as part of the early experimental theatre scene of the United States. In the years preceding the onset of the Little Theatre movement, Tingley was one of the first US theatre directors to incorporate Symbolist theory into her work. She helped to thrust the Greek Revivalist movement forward by building the first Greek-inspired outdoor theatre and by producing an English-language production of *The Eumenides* during the late nineteenth century. As the last decade of the nineteenth century gave way to the first three decades of the twentieth century, Tingley's directorial interests anticipated and coincided with the early flourishing of experimental and avant-garde theatre in the United States. Tingley's theatrical work proves that experimental trends of the European avant-garde began to impact theatre in the United States even before the onset of the Little Theatre Movement, and it also provides insight into the development of Greek Revivalism as an American school of experimental theatre.

Tingley's theatrical experimentations did not arise from purely artistic interests: they had religious undertones. Tingley did offer answers to the ultimate questions of existence. She believed that there was a divine source from which all life came, and she argued that that relation demanded that humans treat one another with care and humaneness. Tingley's spiritual beliefs were openly tied to her political and social concerns. Tingley's spiritual advice was given from the perspective of a modern Theosophist who struggled to legitimize her place as a leader of men, in the face of attack from the press. By presenting figures such as Hypatia and Diotima as the intellectual and spiritual equals of Pythagoras and Socrates, and by naming theatre leagues and theatres after goddesses, Tingley became one of many female spiritual leaders of the twentieth century who "would acknowledge and affirm female spirituality and empower women as full participants, priests, and leaders."[137] This, Tingley did more than 60 years before an explosion of new religions in the United States that would represent and invoke a divine feminine through dramatic ritual and sacred theatre. What is more, Tingley used theatre to critique institutions and activities that she perceived as

morally questionable, such as war, the death penalty, and vivisection. While holding aloft the violent tendencies of the present in which she lived, Tingley used performance and theatre to point to a more peaceful world of the future, in which male-dominated evils would cease, and all human beings would be enlightened through Universal Brotherhood, reject violence, and dedicate their lives to the spiritual and physical nurturing of the communities of the world.

It is likely that many audience members were aware of the political and social critiques that were raised in Tingley's theatre. As Waterstone asserts, it is probable that the audiences of *The Wisdom of Hypatia* drew parallels between the attacks against Hypatia's male followers, and the same sort of attacks that were raised against Tingley's male followers in a California courtroom. Perhaps some of the audience members who saw that performance accepted her assertion that women were qualified to lead men and looked forward to a time when women could be public leaders without being attacked and criticized. Tingley's theatre seems to have been concerned with both spiritual and political matters, and it demonstrates the difficulty of separating political concerns from religious ones. On the one hand, Tingley used theatre to convey Theosophical messages. On the other hand, she used theatre to incite people to contemplate political and social activism as a sacred duty rooted in the principle of Universal Brotherhood. By doing this she anticipated later groups of neo-pagans who would view ecological activism and feminist reform as a sacred obligation.

Theatre was an important part of Tingley's career as the leader of the UBTS. It created a set of shared goals and social activities for UBTS members. It promoted and embodied Theosophical beliefs and brought attention to the political and social concerns of the UBTS. When Tingley died from wounds she sustained in an automobile accident in 1929, the theatrical activities of the UBTS virtually ceased. The stock market crash and the depression made it financially impossible to produce lavish theatrical productions, and G. de Purucker, who succeeded Tingley as the leader of the UBTS, was not as passionate about theatre as his predecessor. De Purucker changed the name of the UBTS back to The Theosophical Society, and, in 1942, relocated the organization to Covina, California. After another move, the headquarters of the Theosophical Society moved again to Pasadena, where the documents relating to Tingley's theatrical achievements are currently held. Tingley's theatrical work can now be recognized as one of the earliest and most complex examples of the theatre of the Occult Revival.

3. The Anthroposophical Theatre of Rudolf and Marie Steiner ᴏ

lthough Rudolf Steiner (1861–1925) never used the term "religion" to define his occult worldview, Anthroposophy, his four Anthroposophical mystery dramas were written to achieve a religious purpose: they represented Steiner's descriptions of a supersensory world peopled with spiritual beings. Steiner taught that human beings can develop the power of clairvoyance and perceive this supersensible realm.[1] For Steiner, theatre was an intermediary that, as Faivre puts it, serves to reveal the *mundus imaginalis*, "render the invisible visible," and enlarge the initiate's "prosaic vision."[2]

The headquarters of the Anthroposophical Society is located in Dornach, Switzerland. The marvelous structures there include an 1100-seat theatre, which is the largest room in the *Goetheanum*. The *Goetheanum*, designed by Rudolf Steiner, is an international meeting place for Anthroposophists. It is named after Johann Wolfgang von Goethe, whom Steiner considered an occult adept. The structure is decorated with several large, monochromatic, stained glass windows that contain images of Lucifer, Ahriman (a dark spiritual entity that is part of the Zoroastrian religious tradition), human souls, angels, and Jesus. The characters in the *Goetheanum* glass windows reveal aspects of Steiner's understanding of the human spiritual struggle: that is, the struggle to balance the influence of Lucifer and Ahriman within one's life. According to Steiner, supersensory perception is the key to establishing contact with beneficial spiritual beings and recognizing the influence of dangerous beings, such as Lucifer and Ahriman. Steiner claimed that maintaining balance between the influence of Lucifer and Ahriman is the key to avoiding a catastrophe of both microcosmic and macrocosmic proportions.

Theatre was important to Steiner, because he used it to depict the beings and realms that he claimed to observe while in a clairvoyant state. Steiner taught that accurate representations of the spirit world stimulate the

capacity for supersensory perception within human beings who have not yet seen spiritual beings or realms. Within Anthroposophy, all of the arts are a means of representing spiritual realities that transcend the limitations of "simple thoughts and words."[3] Throughout his career, Steiner made it a priority to represent the spiritual realm in theatre and performance. In collaboration with his wife, Marie (von Sivers) Steiner (1867–1948), he worked "to bring to life artistically the great spiritual insights which he imparted."[4] (For the sake of clarity, I will hereinafter refer to Marie Steiner with the hyphenated name "Steiner-von Sivers.") For Steiner, conventional theatrical methods seemed insufficient to fully represent spiritual realms and beings. It was to the end of developing a spiritually realistic form of performance that he and Steiner-von Sivers developed a vocal recitation technique called Speech Formation (*Sprachgestaltung*) and an art of movement and gesture called Eurythmy (*Eurythmie*). In addition, Steiner wrote four *Mysteriendramen* (mystery dramas) that embodied and elucidated his teachings concerning spiritual beings and realms.

At the *Goetheanum*, Eurythmy and Speech Formation became essential to the performance of Steiner's four mystery plays: *The Portal of Initiation* (1910), *The Soul's Probation* (1911), *The Guardian of the Threshold* (1912), and *The Soul's Awakening* (1913). These four dramas provide insight into Steiner's understanding of the relationship between the spiritual world and the physical world by following the adventures of several human characters. These characters use Anthroposophical methods to develop supersensible perception, remember their past lives, and recognize the spiritual beings who impact their lives in positive and negative ways.

The *Goetheanum* houses the School for Spiritual Science, which offers programs of study in Anthroposophical dramatic techniques, Speech Formation, and Eurythmy. Graduates of these programs perform Steiner's mystery dramas on the *Goetheanum* stage. The seriousness with which Anthroposophists view Steiner's mystery plays was made clear to me when I saw them performed at the *Goetheanum* between December 25, 2000, and January 1, 2001, as part of the Anthroposophical Society's *Weihnachten 2000: Reinkarnation und Individualität* conference. These plays have been continuously produced at the *Goetheanum* since the 1920s.

Although Steiner maintained that his mystery dramas contained accurate pictures of the astral world and the spirit world, the performances that I saw at the *Goetheanum* brought to mind the theatrical techniques of European Symbolists who created theatre in Paris during the late nineteenth and early twentieth centuries. In particular, the use of transparent scrims and slow poetic recitation in the *Mysteriendraman* resembled

descriptions of Symbolist performances that took place in Paris during the late nineteenth and early twentieth centuries.[5] In fact, Steiner worked with Symbolist theatre before he developed Anthroposophical modes of performance: he codirected a production of Maeterlinck's *The Intruder* with Otto Erich Hartleben for a "free Dramatic Society" in Germany, whose mission was to produce "misunderstood" plays.[6]

Steiner and Steiner-von Sivers impacted the development of professional theatre when they introduced Anthroposophy and Eurythmy to the public. Andrei Bely, one of the most prominent Symbolist playwrights of the Russian Silver Age, wrote an "Anthroposophical drama." Russian playwright Nadezhda Nikolevna Bromlei, who produced work at the Moscow Art Theatre's experimental wing, known as Studio II, also wrote two Anthroposophical dramas.[7] Acting teacher Michael Chekhov (1891–1955), who headed the Moscow Art Theatre's Studio I and II from 1918 to 1928, "incorporated Steiner's concept of the 'Higher Self'"[8] and the study of Eurythmy[9] into his acting method. Chekhov was forced to flee Russia when he was accused of "using the Studio to disseminate Anthroposophical doctrines."[10] Today, teachers of Chekhov's acting technique still reference Eurythmy and Rudolf Steiner.

Steiner and Steiner-von Sivers influenced Symbolist theatre and appreciated its spiritual themes. They shared Edouard Schuré's opinion that Symbolist theatre was more concerned with artistic experimentation than exploring spiritual truths. In fact, Steiner distinguished his mystery dramas from Symbolist plays. Steiner associated Symbolist theatre with theatrical experimentation and a collection of spiritual interests and ideas. Steiner differentiated such drama from his own plays, which he said transcended the realm of artistic symbols through the representation of spiritual worlds and beings that actually exist.[11] In order to understand the spiritual realities that Steiner claimed to have revealed in his mystery dramas, it is necessary to become acquainted with the basic tenets of Anthroposophy.

ANTHROPOSOPHY: BELIEFS AND PRACTICES

Before becoming an occult teacher, Rudolf Steiner sought a career in academia. He received a PhD in philosophy from the University of Romstock in 1889,[12] and he spent seven years in Weimar, where he worked in the Goethe-and-Schiller archives as an expert on Goethe's writings on nature.[13] Steiner believed that Goethe's writings reveal a starting path for any human being who seeks to develop a "mode of cognition for...spiritual world-content."[14]

Steiner never achieved lasting success in academia, but the rigor of his scholarly training informed his spiritual ideas as well as the manner in which he expressed those ideas.

Steiner drew inspiration from Blavatsky's Theosophy as he formulated his conceptualization of Anthroposophy. In fact, Maria Carlson describes Anthroposophy as "a refinement and redirection" of Theosophy.[15] Many of Steiner's statements on karma, reincarnation, the astral plane, and the spiritual world bear similarities to ideas that Blavatsky proposed in *The Secret Doctrine* and *The Key to Theosophy*. Regarding similarities between Anthroposophy and Theosophy, Maria Carlson writes:

> Both movements sought to achieve clairvoyance through the use of intellect and reason; both sought to overcome materialism and return the spiritual dimension to human life; both desired to heal the rift between religion and science.[16]

Between 1909 and 1913, Steiner served as the leader of the German section of the Theosophical Society.[17] He separated from the society when Annie Besant—who became the leader of the International Theosophical Society in 1907[18]— withdrew the charter of his German section on January 14, 1913.[19]

The rift between Besant and Steiner developed, in part, due to a difference of terminology. Most Theosophists used a great deal of Hindu and Buddhist vocabulary to discuss spiritual matters, but Steiner mostly used Christian terms and symbols to discuss such things. This language difference constituted a division between Steiner and many European Theosophists, because so many of them believed that Theosophy was based on a primordial tradition with firm connections to Eastern religious traditions. In a letter to a fellow Theosophist, Besant expressed her disagreement with Steiner's "esoteric practice":

> He does not know the Eastern path and, for that reason, cannot teach it. He Teaches the Christian-Rosicrucian path, which is of help for some people, but is different from ours. He and I...work in different directions.[20]

According to Carlson, Steiner incorporated Christian symbolism into his discussions of karma, reincarnation, and the spiritual world because he sought a Western alternative to the "Hindu gnosis" of Blavatsky's Theosophy.[21] Even though Steiner used Christian traditions and symbolism in his writings, lectures, and art, he rejected literalist and conservative forms of Christianity as overly "simple" creeds designed to inspire faith and suppress independent spiritual thought within "naïve" Christians.[22]

When Steiner connected Anthroposophy with Christianity he was not talking about mainstream Christianity, but the Rosicrucian tradition, which draws a great deal of its imagery from Christianity. According to Roland Edighoffer, the beginnings of the Rosicrucian tradition in the early seventeenth century grew in part out of a desire for a "return" to a "practice of Christian piety" that is "aloof from the dogmatic squabbles of orthodoxy" and prepared to "reconcile with the advancement of science and learning."[23] Faivre notes in Rosicrucian literature a blend of Christian, alchemical, and Hermetic symbolism that presents a process by which a spiritual seeker achieves "creative movement upon the spiritual plane" by means of an initiatory "pilgrimage."[24] When Steiner spoke of the Christian-Rosicrucian tradition, he was referencing a blend of Christian symbolism and occultism that allowed for the existence of a spiritual world peopled by spiritual beings, spiritual forces, and souls. Like many other teachers of the Occult Revival, Steiner proposed a new understanding of the relationship between human beings and a spiritual aspect of existence, but it was important to Steiner that this understanding be linked to Christianity and Rosicrucianism. By describing the Anthroposophical worldview as a Christian-Rosicrucian path of knowledge, Steiner was taking part in an ongoing current of interest in legends that grew out of the anonymous publication of *The Fame of the Fraternity of the Praiseworthy Order of the Rose-Cross* (1614), *Confession of the Fraternity* (1614), and *The Chemical Wedding of Christian Rosencreutz* (1616). No historical evidence suggests that Rosicrucian orders such as those described in early Rosicrucian literature actually existed, but the Rosicrucian manifestos have proven attractive to many esotericists who long for a tradition of occult knowledge rooted in both esotericism and Christianity.

In the nineteenth and early twentieth centuries, several magical and occult organizations claimed to be a continuation of the original Rosicrucians. Among the best known of these was Max Heindel's Rosicrucian Fellowship, which was founded in 1909 and defined its philosophical perspective as both "esoteric" and "entirely Christian."[25] The Ancient Mystical Order *Rosae Crucis* was founded in 1915 and encouraged the practice of all religions.[26] While Anthroposophy is by no means a copy of either of these orders, by the time Steiner became an active Theosophist, the term "Rosicrucian" had come to imply for many modern occultists a Western school of occult knowledge that descended from the practices of the Fellowship of the Rosy Cross and harmonized with a body of esoteric Christian teachings. In fact, Steiner described *The Portal of Initiation* as a *Rosenkreuzermysterium* (Rosicrucian mystery drama).[27]

Despite the opposition of Annie Besant and many other European Theosophists, Steiner was "compelled" to pursue the Rosicrucian path of "Western-Christian mysticism."[28] By 1913, about three thousand people[29] had accepted Steiner's assertion that Anthroposophy was the "real Christianity,"[30] as well as his self-proclaimed ability to perceive and "describe the spiritual world."[31] Steiner's followers absorbed his Anthroposophical teachings and the disciplines of spiritual science in hopes of developing a "higher organ" that makes "supersensible perception" possible—much like an eye operation might make vision possible for a blind person.[32]

Perhaps it was in part due to his academic background that Steiner came to believe that the key to developing supersensible perception is "strenuous mental exertion."[33] To develop the ability to perceive the spiritual realm, Steiner recommended that Anthroposophists study complex descriptions and artistic representations of the spiritual realm. Many Anthroposophists consider Steiner's 1904 book, *Theosophy: An Introduction to the Supersensible Knowledge of the World and the Destination of Man*, to be one of the core texts of Anthroposophy. [34] In this book, Steiner provided detailed descriptions of spiritual beings and realms. Steiner also argued in *Theosophy* that descriptions of such beings and realms are essential to spiritual development:

> Descriptions of the kind given here present a thought picture of the higher worlds, and they are in a certain respect the *first step* towards personal vision. Man is a thought being, and *he can find his path to knowledge only when he makes thinking his starting-point....* This force...will awaken slumbering capacities.... Thought is a living force.... thought is present as a direct expression of what is seen in the spirit, so the imparting of this expression acts in the one to whom it is communicated as a germ that brings forth from itself the fruit of knowledge.[35]

According to Steiner, accurate descriptions of the spiritual world inspire thoughts that eventually enable the thinker to interact with the spiritual world as "a reality" that is as certain as the physical world.[36] Such perception requires more than the limited perception of the human being; Steiner taught that "the thought that makes its appearance through a human brain is related to the being in the spiritland that corresponds to this thought."[37] Just as shadows are related to the object that casts the shadow, so is accurate spiritual thought thrown into the mind by beings in the spiritual world. Steiner taught that it is spiritual influence such as this that provides supersensible perception to humans who are prepared to receive it.

Steiner is suggesting that viewing accurate descriptions of the spiritual world (which is what he claimed his mystery dramas were) can awaken a slumbering part of the human organism that will provide the ability to perceive the spiritual world. This is an old esoteric idea. Faivre discusses this visionary capacity as "a kind of organ of the soul" and as an "eye of fire," which renders "the visible invisible."[38] Steiner utilized this esoteric idea by suggesting that human beings possess an organ of supersensible perception that can be awakened by viewing accurate representations of the spiritual world that this mysterious organ was created to perceive.

Keeping the above in mind, it should come as no surprise that Steiner dedicated a great deal of time in *Theosophy* to descriptions of spiritual realms. Among the topics that Steiner covered in *Theosophy* are the physical and spiritual anatomy of the human body. Steiner divided the human body into three separate, yet interrelated, parts: the physical body, the soul or astral body (hereinafter always referred to as the "astral body"), and the spirit body. Steiner described the physical body as a "mineral structure" that is limited to a single physical incarnation. The power of thought manifests itself through the physical body in response to physical sensations, and both spiritual and physical entities may "reveal themselves" through the physical body as well.[39] The physical body is the most temporary part of the human being, but it is essential to the evolution of the incarnated human spirit, because it is the medium through which spiritual thought is manifested, according to Steiner.

Steiner explained in *Theosophy* that the person who becomes a seer by developing a "spiritual eye" will gain the ability to perceive the two other bodies that extend beyond the borders of the physical one.[40] These two bodies are the astral body and the spirit body. The astral body provides the human being with the capacity to generate "independent thought" in response to sensory input that it receives from the physical world, as well as the ability to resist the base urges of the lower self by practicing self-control and establishing a connection with "the eternal spirit."[41]

The "spirit body"[42] includes the Higher Self of the human being— otherwise known as the "I" or "ego"—that is inhabited and stimulated by the eternal spirit (or, as Theosophists put it, the Divine Principle) from which all life comes. The eternal spirit enables human beings to "perceive the spiritual" through "intuition." Steiner described "intuition" as the spirit body's response to sensory input received from the spiritual world. Intuition is a spiritual action that corresponds to thought and movement: that is, the physical body's responses to sensory input from the physical world.[43] Steiner identified the transmission of spiritual and physical

sensations within the human body as two lines of energy moving in oppo-
site directions:

> And in the "I" the spirit is alive. The spirit sends its rays into the "I" and lives
> in it as a sheath or veil, just as the "I" lives in its sheaths, the body and soul.
> The spirit develops the "I" from within, outwards; the mineral world develops
> it from without, inwards.[44]

Throughout many incarnations, the eternal I inhabits many dif-
ferent physical bodies and thereby gains spiritual knowledge. The
physical body transmits sensations to the soul body, which, in turn,
allows the I to contemplate these worldly sensations with indepen-
dent thought.

From within, the eternal spirit sends sensations to the I via the
spirit body. This process of spiritual development continues until the I
"recognize[s] himself" [45] as part of the eternal spirit while still sheathed
in a spirit body, soul body, and physical body during a physical incarna-
tion. When this occurs, the I has achieved what Steiner believed to be the
true meaning of Plato's imperative to "Know thyself."[46] Enlightened with a
complete understanding and perception of self in relationship to the physi-
cal world, the soul world, and the spirit world, the I stops seeking "what
profits himself" or herself. Instead, the I pursues "what ought to happen
according to the right course of the world," and describes what happens in
the spiritual world in order to help other human beings gain similar powers
of supersensory perception.[47]

The physical body, astral body, and spirit body live in the physical,
astral, and spirit worlds, respectively. The process of spiritual evolution
demands that the I learns to recognize itself within all three of these
worlds by living through countless incarnations. During each of these
incarnations, the I amasses karmic responsibilities that must be fulfilled
in later lives. In addition to collecting karmic responsibility, the I must
use the knowledge it gains during the physical incarnations to move
through the astral and spirit worlds, which are each divided into seven
regions. By moving through the astral realm, the soul body learns to
free itself from the tangles of earthly desires. In the spirit realm, the soul
body learns to recognize its individuality as well as its connection to the
eternal spirit.

The I that attains conscious perception in the seventh region of the
spirit world gains a consciousness of the continuity of life between incar-
nations. In other words, the I that gains conscious perception remembers

the time that it spends in the spirit world between the moment of physical death and its rebirth into a new physical incarnation. This memory enables the enlightened I to set goals that harmonize with the will of the eternal spirit and pursue these goals during its next physical incarnation. An I that possesses this ability is dedicated to the betterment of the universe and the will of the eternal spirit, rather than to personal and worldly desires, because the cares of the physical must be overcome to reach the seventh region of the spirit world.[48] Rising through the astral and spirit worlds is the Anthroposophist's goal, and a depiction of this journey of spiritual development drives the action of Steiner's mystery dramas. The idea of achieving supersensible perception by means of a spiritual journey brings to mind the depictions in Rosicrucian literature of mystics who achieve spiritual enlightenment by undergoing an initiatory pilgrimage.

To Anthroposophists, gaining clairvoyance means more than personal development. It is the key to preventing a cosmic disaster that is being arranged through the unbalanced influence of Ahriman and Lucifer. According to Anthroposophical eschatology, these two spiritual beings are working to gain control of human minds by confusing them with Luciferian delusions and Ahrimanic materialism. If their plans succeed, the world will become a dystopia. Humans will wage meaningless war against one another and have no access to the eternal spirit. If, however, humans gain supersensible perception of the benevolent beings and forces that exist beyond the physical plane, they may gain the power to perceive and balance the influence of Ahriman and Lucifer. By doing so, the human race will avoid disaster and gain spiritual enlightenment. Steiner thus proposed two eschatological visions of the future: one a dystopian nightmare and the other an optimistic vision in which Anthroposophists overcome the problems of war and xenophobic nationalism. Steiner's optimistic picture of the future bears a resemblance to the era of Universal Brotherhood that Tingley foresaw. Both Steiner and Tingley taught that true occult enlightenment would lead to the emergence of a more humane and tolerant phase of human existence. Also, both of them linked their political and social agendas to their spiritual practices.

In the Zoroastrian tradition, Ahriman is identified as a "hostile spirit" that seeks to lead human beings away from the path of spiritual wisdom.[49] Similarly, Anthroposophists perceive Ahriman as a trickster who seeks to lead humans astray, but, unlike Zoroastrians, they do not write him off as a purely evil being. Anthroposophists believe that Ahriman has a rightful place in the universe: he is the overseer of the natural forces of the physical

world and the laws of numerical calculation. From Ahriman comes the power to understand the workings of nature and the laws of mathematics. However, Ahriman greedily desires the spiritual energy that emanates from human beings due to their connection to the divine spirit. Ahriman tries to gain this energy by making humans unconscious of the spiritual aspect of life. Ahriman attempts to convince human beings that the root of all human existence is purely physical. He is a staunch positivist. Ahriman is fond of materialist science—especially the sort that rejects the possibility of god or spirits. Ahriman even wants humans to doubt his own existence.

In *The Influences of Lucifer and Ahriman*, Steiner claimed that Ahriman's ultimate plan is to incarnate as a human being and take over the world. In order to do this, Ahriman casts thoughts into the minds of those who do not recognize him. With this method, Ahriman is said to establish "trends in evolution" to prepare for his incarnation. Among these trends are: the belief that "mechanistic and mathematic conceptions...explain what is happening in the cosmos"; the valorization of economic and material (as opposed to spiritual and cultural) needs as the key to maintaining public welfare, nationalism, and other systems that "separate people into groups"; fundamentalist, literalist interpretations of the Gospel; intellectual knowledge and research that does not improve life; and faith in statistics and figures as indicators of truth.[50] In fact, Anthroposophy's antinationalist stance and multinational membership made the group "suspect" in Munich during the 1910s. This is one of the reasons why Munich authorities refused to allow Steiner to build the *Goetheanum* in the city and labeled his mystery dramas an "outrage to morals."[51] Like so many other new religions, the Anthroposophical Society's views on politics and religion inspired fear and suspicion among members of the broader community in which it existed. Steiner and other German Anthroposophists were sometimes subjected to official roadblocks, and, in the case of the first, ill-fated *Goetheanum*, a devastating attack in the form of arson. Steiner interpreted such persecution as manifestations of Ahrimanic influence in the physical world.

Like many Christians, Anthroposophists view Lucifer as a spirit ruled by pride and reckless aspiration who seeks to rise in power and glory through improper means. Anthroposophists believe Lucifer convinces human beings that the delusions of their personal fantasies and desires are revelations from the highest region of the spirit world. Those who fall prey to Lucifer's tricks believe they perceive lofty spiritual realms, when they actually wallow in illusion. As Steiner explained it, Lucifer and Ahriman had "a kind of pact":

Ahriman keeps people learning about the sciences and such in such a way that does not further the spiritual state of human beings, and in return, these people, completely unaware of the soul and spirit realms, partake of the forms of the spirit realm by experiencing and eating. But instead of being nourished spiritually by this, the power from it goes to Lucifer.[52]

Anthroposophist author Georg Hartmann describes the pact between Ahriman and Lucifer more succinctly, when he writes that Ahriman disguises "the spiritual in the outer world" and Lucifer leads the human being "to the illusion of his own ego."[53] Ahriman gains strength as human beings work and live only to experience the material aspects of the physical world. Lucifer, on the other hand, gains spiritual strength from people as they consume and experience the natural elements of the physical world with no knowledge of the spirit world that has caused these physical elements to come into existence.

Although they are both capable of destructive excess, Ahriman and Lucifer have legitimate purposes that benefit the world. Ahriman oversees the physical aspects of life and facilitates "human thought." Lucifer is "the power of Will that tears human beings away from the world of the senses" so they can be "creative, imaginative, and artistic." The utter rejection of Lucifer and Ahriman is as destructive as surrendering entirely to their will. The great challenge of life for Anthroposophists, therefore, is to keep Luciferic and Ahrimanic impulses in balance. Without balance, Lucifer and Ahriman are little better than the devil. Too much Luciferic influence leads to extreme "passions, emotions, desires, and impulses," and too much Ahrimanic influence leads to "obsessive materialism and a blind faith" in science, materialism, and positivism.[54] To let such an imbalance spread over the world would one day lead to an apocalypse of "war and destruction" next to which, Steiner promised, World War I would pale in comparison.[55] The balance of the Luciferic and Ahrimanic currents, however, would provide the "salvation of human evolution" [56] in the physical, astral, and spirit worlds.

The struggle with Lucifer and Ahriman is a central part of Anthroposophical life, and it represents a battle of both individual and cosmological proportions. Some Anthroposophists invoke Christian eschatology by associating Ahriman with the antichrist.[57] Steiner himself linked Christian mythology to his perspectives on Lucifer and Ahriman by claiming that Jesus Christ is an ally in the Anthroposophist's effort to use spiritual perception to embrace what is useful and reject what is detrimental about the influence of Ahriman and Lucifer. Steiner referred to the

story of Jesus contained in the New Testament as the "Christ Event," but he argued that the traditional Christian interpretation of the Jesus story as one that concerns a god who takes the form of a man to save humanity through personal sacrifice is an oversimplification of Jesus's accomplishment. Steiner believed the story of Jesus concerns the activities of an enlightened I who gained total consciousness in the seventh region of the spirit world by recognizing itself as part of the eternal spirit. By doing this, Jesus was able to demonstrate through his life that the physical body of human beings could be directly "linked...to the spiritual world." Jesus's life proved that a human being could live in complete accordance with the will of the eternal spirit during a physical incarnation. The people who witnessed the life of Jesus, or who learn of the story of his life through literature or art are recipients of "divine wisdom." Through that wisdom they move closer to establishing a link with the spiritual world.[58]

In a lecture contained in *The True Nature of the Second Coming*, Steiner claims that Christ will return to earth one day in a spiritual body such as the one he describes in his book, *Theosophy*. Steiner believed that he and his contemporaries were living at the beginning of an era in which more and more human beings would develop the ability to perceive the spiritual body of Christ. In effect, Steiner's idea suggests that Christ never left: the idea of his "return" suggests the eventual development of that organ within human beings—the eye of fire—which will enable them to see spirit bodies, much as they perceive physical bodies. Steiner argues that when this happens, Christ's spiritual body, which has been there all along, will suddenly be visible to men and women. By communicating with the spiritual body of Christ, human beings will discover ways to save themselves and others from the destructive effects of Ahrimanic materialism and Luciferic delusion. According to Steiner, Anthroposophists may one day save the "wisdom of the future" from "the clutches of Ahriman" and use it in the service of Christ, who works in collaboration with the will and plan of the eternal spirit.[59]

ANTHROPOSOPHY IN THE MYSTERY DRAMAS

Steiner's four mystery dramas tell the story of several Anthroposophists who strive to make contact with beneficial spiritual beings and struggle to balance the influence of Lucifer and Ahriman in their lives. The mystery dramas contain "pictorial representation[s]" of the "supersensible truth" that Steiner spoke about in *Theosophy*.[60] As early as 1911, two

years before Steiner established the Anthroposophical Society, he decided that "ordinary theatres were unsuitable for staging the mystery dramas that had become an integral part of his spiritual work." On September 20, 1913, Steiner laid the foundation stone for such a theatre on a hill in Dornach, Switzerland, a few miles outside of Basel.[61] Steiner officially named the theatre the *Goetheanum* in honor of Goethe's artistic and spiritual accomplishments. The *Goetheanum* also had a nickname: *Johanessbau* (Johannes's building). Johannes is the central character in Steiner's mystery dramas, and it is primarily the story of his spiritual development that drives the action of the four mystery dramas. This nickname identifies the *Goetheanum* as a home for the performance of Steiner's mystery plays. Analyzing the mystery dramas alongside Anthroposophical teachings that were discussed earlier will show how Steiner's mystery plays reinforced his ideas about relationships between human beings and the forces and beings in the supersensible worlds.

Steiner's four mystery dramas—*The Portal of Initiation* (1910), *The Soul's Probation* (1911), *The Guardian of the Threshold* (1912), and *The Soul's Awakening* (1913)—premiered in the year that they were written as part of the program of an annual summer Theosophical congress that took place in Munich.[62] Steiner began writing each of the mystery dramas about two months before rehearsals began. Rehearsals took place during the day, and Steiner wrote additional scenes during the evening. Between rehearsals, Steiner led and supervised carpentry, painting, modeling, sewing, and embroidery workshops to make sure that every aspect of the production matched his vision.[63] For anyone who has read Steiner's lectures, essays, and books—especially *Theosophy* and his lectures on the eschatological significance of Ahriman and Lucifer—the mystery dramas prove to be a detailed tapestry that provides visual insight into Steiner's conceptualization of the physical, astral, and spiritual realms.

The mystery dramas constitute what Anthroposophical actor Hans Pusch refers to as an act of "spiritualization." For Pusch, "spiritualization" means creating a medium with the "mobility and transparency through which spirit realities can reveal themselves."[64] There is no doubt that Steiner intended his plays to be perceived as an attempt to represent the realities of the spiritual and supersensible realms through his dramas: he stated this clearly in the introductory material of the three dramas. In the cast list of *The Soul's Probation*, Steiner explained that Philia, Astrid, and Luna (three spiritual beings who "form the connection of the human soul forces with the cosmos") are "not allegories" but "realities for spirit cognition."[65] In the cast list of the third mystery drama, *The Guardian of*

the Threshold, Steiner stated that the "spiritual beings" in the play are "the equivalent of physical persons" for human beings who have developed the supersensible organs necessary for "spiritual perception."[66] In the final mystery drama, *The Soul's Awakening*, Steiner wrote that "the spirit reality here depicted presents itself to the soul as convincingly as the objects of physical observation."[67] In his comments and his depiction of the spiritualization of art through the character of Johannes, Steiner argued that the artist with the power of supernatural vision can observe and represent the spirit world, just as a naturalist or realistic playwright can observe and represent the physical world. The Anthroposophist who creates art through spiritual perception tries to "bring something spiritual in the world, so that it lives in the spirituality of the world."[68] In the mystery dramas, that "something spiritual" that Steiner brings into the physical world includes insight into the laws of karma, reincarnation, the human capacity for supersensory perception, and recognition of the influence of Ahriman and Lucifer.

As far as dramatic structure is concerned, the mystery dramas are as complex as the ideas that they contain. The plays are written in a combination of prose and verse, but the verse greatly outweighs the prose. The only scenes written in prose are the prelude and interlude in the first play, *The Portal of Initiation*. The language of the verse is mystical. It often speaks of spiritual experience in Anthroposophical terms. Steiner set the mystery dramas in his own era, and they were set in Steiner's era when I saw them performed at the *Goetheanum* in late December 2000 and early January 2001. Time, however, is flexible in the mystery dramas, because the characters travel to the astral and spirit worlds, which do not operate according to the temporal laws of the physical world. In the play, characters also travel to the distant past through the technique of past-life retrospection.

The depictions of supersensible realms, spiritual beings, and past lives in the mystery plays are motivated by several human characters' ongoing efforts to gain spiritual perception. The names of these characters are Johannes Thomasius, Maria, Professor Capesius, Doctor Strader, Theodora, Felix Balde, and Felicia Balde. These students of occultism are developing their spiritual faculties with the guidance of their mystical teacher, Benedictus. Impeding these characters' search for spiritual sight are Lucifer and Ahriman. Working to help the humans overcome Lucifer and Ahriman are the previously mentioned "soul forces," Philia, Astrid, and Luna.[69]

Physical, astral, and spirit bodies are represented in the mystery plays. Steiner describes costumes to establish visual differences between these bodies. In the mystery plays, Steiner describes the appropriate costumes

for the astral body with less detail than other types of bodies. Scene 4 of *The Portal of Initiation*, for instance, takes place in the astral world ("soul world"), and Steiner states that all of the characters in this scene appear in "soul form." In the case of one character named "The Other Maria," who is deeply entrenched in the life of earth, this means that she must look as if "the rock" of the earth "had given birth to her."[70] For the most part, however, Steiner does not provide much guidance in the mystery dramas for the design of the astral body costume.

Steiner describes the spirit body costume in greater detail than he does the astral body. Some of his most vivid descriptions for representing the spirit body through costume are contained in scene 5 of *The Soul's Awakening*, which is set in the spirit realm. In this scene, Maria uses supersensory perception and retrospection to remember the time between her last physical incarnation and her present life. By doing so, she discovers knowledge about her karmic relationship to Capesius and Johannes in her current incarnation. In this scene, Steiner is quite specific about the appearance of each human character's spirit body. Only the head of the scientist Strader is visible in the spirit realm, but it is decorated with "a yellowish-green aura with red and orange stars."[71] Strader's friend Capesius also appears as a head with no body, but his aura is blue "with red and yellow stars."[72] The entire spirit body of the enlightened mystical teacher Benedictus is visible. Benedictus wears a robe that gets broader and broader as it reaches the stage. The bottom of Benedictus's robe is decorated in shades of blue-green, and his aura is "red, yellow, and blue."[73] Maria, who is also a spiritually advanced character, is an "angelic figure" with "light violet wings" whose robe moves smoothly from shades of yellow to gold.[74]

The aura headdresses that Capesius and Strader wear are visual representations of Steiner's descriptions of the human aura. In *Theosophy*, Steiner claims that that the nature of human thought can be clearly discerned by the color of the human aura. For instance, Steiner describes Strader's aura as a yellowish-green cloud that is flecked with red and orange stars. In *Theosophy*, Steiner states that yellow within an aura suggests that a thinker is rising "to higher knowledge" and red suggests thoughts that rise out of the "sensual life."[75]

Steiner also mandated specific colors for the scenic representation of the spirit realm in *The Soul's Awakening*. The set description at the beginning of scene 5 indicates:

THE SPIRIT REALM. *The scene is set in floods of meaningful colour, reddish deepening into fiery red above, blue merging into dark blue and violet below.* [Italics in the original][76]

The lower realms of the spirit world are depicted in hues of blue, which signify the expansion of the spirit world beyond the boundaries of the physical world. The higher regions of the spirit world are set in red tones, which indicate the impulse of the I to gain spiritual perception.[77] Steiner notes that the characters who appear in the spirit world should "seem to blend into a complete whole with the colors" of the spirit world.[78] This blending of costumes and bodies into the scenery parallels Steiner's teaching that there are no true divisions between humans and the spiritual realms. While humans can be distinguished from the spirit world as a whole, they are also a part of a unified and "divine world order" that includes all three worlds.[79] Steiner's specifications for color correspondences in *The Soul's Awakening* visually represents the mystical concept that the human body is a microcosmic reflection of the macrocosm, and that the body is simultaneously separate and inseparable from a divine creative force from which all things come.

Steiner taught that the ability to perceive supersensible bodies and realms can be developed through rigorous thinking, and the adventures that each of the characters in the mystery dramas have in supersensible realms is a result of the disciplined contemplation of spiritual truths conveyed to them by occultists with supersensible perception. The power of spiritual description to induce heightened thinking is asserted in *The Soul's Probation* by a disembodied voice, known as the "Spirit Voice," which explains to Capesius during a vision that his spirit body has risen to "cosmic grounds," where it is "drinking" in spiritual sensations. The Spirit Voice explains that this trance-like state has enabled Capesius to "live in thinking."[80] The characters who manage to live in thought, as Capesius does, usually do so through exposure to words, art, or ideas that describe the mysteries of the spirit world.

The spiritual teacher Benedictus is the most advanced occultist in the mystery plays, and his status as an adept is demonstrated through the power of his words, which enable his students to have supersensory experiences. By listening to his spiritual statements, Benedictus's students are propelled into the spiritual realm, where they have astral and spiritual visions. In *The Portal of Initiation*, the troubled artist Johannes asks Benedictus to help him discover the root of a spiritual rift that has affected his relationship with Maria. In response, Benedictus assures him that his words can help him both understand and heal the karmic cause of this problem:

BENEDICTUS: In the spirit you will find her.

I can still further give you direction:

> call forth the fiery power of your soul
> with words which, uttered through my mouth,
> give you the key to spirit heights.[81]

This is only one of many places throughout the mystery plays when Benedictus awakens occult powers within his students that send them hurtling into the astral and spirit worlds. It is, by the way, difficult not to see in the character of Benedictus a self-portrait of Steiner and the function he tried to serve for his followers. After all, Benedictus's words are representations of the spirit world, and, as such, have the power to awaken spiritual perception in those who hear them.

Words are not the only means by which the characters in the mystery plays gain supersensible perception. The representation of spiritual realities through the arts is a central topic in *The Portal of Initiation*, in which the artist Johannes possesses the ability to create representations of his own observations of supersensible realms. In *The Portal of Initiation*, Johannes performs the primary function of Anthroposophical art: he uses it to "reveal in the world of sense" what he "can consciously perceive in spirit."[82] By looking at a portrait painted by Johannes, Strader, who feels disconnected from the spirit world, comes to realize that physical knowledge is "illusion," and he loses himself in a brief trance that Capesius describes as "the thinker's calm."[83] Strader's view of this painting marks a turning point in his spiritual development, and he comes to esteem Johannes's art as a medium through which spiritual truth reveals itself. In *The Soul's Awakening*, Strader seeks Johannes's counsel as an "artistic adviser," as he tries to develop a mystical machine that will link the daily duties of human beings to the spiritual realm.[84] Johannes's work lives up to Steiner's standards for great art because it brings something of the spiritual realm into the physical world and, by doing so, enhances the spiritual condition of human beings.

In *The Soul's Awakening*, Strader's efforts to develop the mystical machine that is mentioned above helps his occultist colleagues to strengthen their understanding of the spiritual realm. The appearance and physical qualities of Strader's machine are never described, but its function is: "to join what spirit in itself can do to earthly labor in the world of sense."[85] Despite his earnest desire for spiritual perception, Strader cannot consciously perceive the spiritual realm like Benedictus. Nevertheless, Benedictus knows through clairvoyance that "the spirit wisdom" is "the source of" Strader's ideas.[86] Strader, who received insight about supersensible realms by observing nature, seems to resemble

Steiner's descriptions of Goethe as a spiritually intuitive person who observed and wrote about nature in an effort to "to discover, beyond knowledge, a foundation for the conceptions of Freedom, of Immortality and of the Divine World Order." [87] Strader's idea to improve labor conditions by linking it to spirituality points toward Steiner's own explorations of the relationship between the political, economic, and religious spheres in 1918.[88]

Some of the characters in the mystery dramas learn to detect karmic ties between themselves and others through a process of retrospection that allows them to peer into their past lives. In the second and fourth mystery dramas, past-life-retrospection scenes reveal the karmic connections that were established between Maria, Johannes, and Capesius. In *The Soul's Probation*, Maria experiences a vision of a past life from early fourteenth century. In this vision Maria learns that she drove a rift between the people she knows in her current incarnation as Johannes and Capesius. In this past life, Maria was a Catholic monk who encouraged one of her spiritual pupils (an earlier incarnation of Johannes) to turn against his father (an earlier incarnation of Capesius). Capesius was at that time the First Preceptor of a body of Knights Templar whose members practice esoteric religion in a castle in Germany. The monk (Maria) turned the pupil (Johannes) against the Preceptor by convincing him that the Templars' beliefs were satanic. By alluding to the Knights Templar, Steiner was once again drawing from an old tradition of esotericism, which found within Templar legend a trove of esoteric meaning and symbolism that was charged with "history and mystery."[89]

The karmic results of the monk's actions carried forward into Maria's present incarnation. As the monk, Maria did not believe that the stories of the Bible "support" the esoteric teachings of the Knights Templars, who she viewed as heretics.[90] Unbeknownst to the monk, by teaching Christian principles to the pupil, he helped to set the student on the path toward spiritual perception and, by doing so, established a cosmic teacher-student relationship. At the same time, the monk's misunderstanding of the spiritual secrets contained in Christianity resulted in the creation of a chasm between the pupil and his father that would need to be rectified in future incarnations. By gaining the trust of the pupil in this previous incarnation, Maria established a karmic responsibility to guide Johannes spiritually in future incarnations. Because Maria prevented Johannes from receiving spiritual instruction that he needed from Capesius in the past, she also received the karmic responsibility to reunite Johannes and Capesius in the present, so that all three of them might seek spiritual knowledge together.

After going with Maria on this past-life journey, Benedictus explains to her that she is bound by the laws of karma to "heal and turn into the good those forces" that bind her life to Johannes's. Benedictus thus assigns to Maria the task of guiding Johannes further on the "path into light."[91] *The Soul's Probation* ends with a conversation in which Benedictus helps Maria to come to this understanding of the significance of her past life in the medieval era. In *The Guardian of the Threshold*, Maria helps Johannes pass the threshold between the physical and the spiritual worlds. Because of this, Johannes gains new powers of spiritual perception. Thus Maria repays a portion of her karmic debt to Johannes.

In *The Soul's Awakening*, Maria and Johannes share another past-life-retrospection scene in which Maria is discovered as a neophyte being initiated into an ancient Egyptian mystery religion via an elaborate ritual held within a gilded temple that is decorated with two large Sphinxes. (With its Egyptian symbols and costumes, as well as its ritualistic action, this scene brings Hermes Trismegistus and Egyptian Masonry to mind.) As Johannes has this vision, he sees an ancient Egyptian woman (an earlier incarnation of himself) who is in great distress because the neophyte, whom she loves, will be lost to her forever once he is initiated into the ancient Egyptian mystery religion. In a moment of lamentation, the woman hopes desperately that she might one day be "close in spirit" to the neophyte through the "revelation of a dream."[92] In other words, this woman is willing to interfere with the neophyte's sacred duty to pursue spiritual development by sending her astral body to meet with his in the astral world. This woman is guided toward the astral realm by her own personal desires, rather than the influence of the eternal spirit.

The neophyte is also fettered by desire. In a dramatic scene, his lust profanes the sacred initiation ritual that he undertakes in the temple. As part of the ritual, the neophyte must gaze into the fire until his soul rises into the spiritual realms. After this, the neophyte is expected to deliver a message from the beyond to the priests of the temple. Upon returning from the spiritual realm, the Chief Hierophant asks the neophyte to "come out of the cosmic vision" and to "declare what can be read as cosmic Word." Instead of delivering a sacred message, the neophyte describes looking at his "earthly sheath with longing and desire." Instead of bringing insight back from the spirit world, the neophyte carried "earth's desires ... as offering to spirit heights." In response to this message, the officers of the temple aborted the initiation rite, which they lamented as an act of sacrilege.[93]

The scenes depicting past lives in the mystery plays do more than visually represent Steiner's teachings about the relationship between

reincarnation and karma. They visually link Anthroposophy to ideas concerning a primordial tradition. In the mystery dramas, the primordial tradition is depicted as having been practiced openly in ancient Egypt, only to later be suppressed by the Church authorities who condemned the Knights Templar in the early fourteenth century. The Knights Templar in Steiner's play speak to one another as if they are the members of a secret, mystical society that is similar to the ones described in the early Rosicrucian manifestos. At the same time, they express views that parallel Steiner's Anthroposophical ideas. The Templars speak about spirituality in Anthroposophical, rather than medieval, terms. The Grand Master of the Templar Order, for instance, proclaims the important task of pursuing "spirit goals through sense-world revelation."[94] In other words, the Templars share the Anthroposophists' belief that the spirit world can be intuited by perceiving the world with the five senses. Like Steiner, the Templars in *The Soul's Probation* frown upon traditional Christian interpretations of the Bible. They complain that understanding the spiritual world is impossible if one adheres only to the interpretations that are mandated by the authorities of the Catholic Church. Steiner's representation of the Knights Templar not only suggested a link between Anthroposophy and Rosicrucianism, but also presented Anthroposophy as a part of an ancient religious tradition that predates and exists outside of exoteric Christianity.

Steiner also dramatized the evil plot of Ahriman and Lucifer in the mystery dramas. The inauguration of these two beings' collaborative plan to gain wrongful control of human beings is depicted in the Egyptian reincarnation scene in *The Soul's Awakening*. Shortly after the neophyte profanes the sacred ritual, Ahriman and Lucifer take spiritual possession of the Sphinx statues in the gilded temple and speak aloud through them. Ahriman expresses his desire to "capture" the soul that "unduly seeks the light" and keep it firmly chained to the physical world. Lucifer wants to "carry off" the entire human being into his astral realm, so that his own false revelations, rather than those of the eternal spirit, might become "the light of earth."[95] Thus, Steiner depicted a karmic chain of events that goes back to the very moment in time when Ahriman and Lucifer determined to make the world serve their interests. As Steiner stated in the introduction to *The Soul's Probation*, the reincarnation scenes in these plays indicate "turning points in time," when significant shifts in the karmic destiny of the entire human race occurred.[96] The birth of the Ahrimanic and Luciferic intrigue is the turning point that is revealed in the Egyptian reincarnation scenes.

In the mystery dramas, Lucifer and Ahriman work together to pro-
mote spiritual unconsciousness in human beings. Steiner described spiri-
tual unconsciousness as the gravest danger to humanity's spiritual future
in *The Influence of Lucifer and Ahriman*.[97] In *The Portal of Initiation*,
Johannes describes the process by which Lucifer and Ahriman promote
such unconsciousness when he states that Lucifer brings not spiritual
truths but "the soul's delusions" before supersensory eyes and Ahriman
"dulls" the spiritual "gaze" by diverting the focus of the human being
"toward outward things."[98] Despite his knowledge of the plot of Lucifer
and Ahriman, Johannes still falls prey to Lucifer's influence in scene 12 of
The Soul's Probation. In this scene, Lucifer appears to Johannes and warns
him that he has gained access to spiritual revelations too soon, because his
"will" is not strong enough to turn the spiritual power that he gains into
profitable "deeds in life." Lucifer also warns Johannes that penetrating
the spiritual world too early might lead to a complete loss of his identity.
In order to prevent this, Lucifer slyly proposes to help Johannes retain
and strengthen his "inmost self" while, at the same time, bringing his life
"into accord with the whole universe." With his sense of self strengthened
through Luciferic influence, Johannes is convinced that, for now, he must
abandon the conscious pursuit of "spirit knowledge" and surrender his
will to that of Lucifer, who he believes is "much wiser than the human
soul." [99] In the next play, *The Guardian of the Threshold*, Johannes man-
ages to recognize that Lucifer is providing him not with spiritual truth
but illusions that are rooted in personal insecurity. As a result of this rec-
ognition, Johannes gains a higher level of spiritual enlightenment.

Whereas Lucifer raises the human soul above the physical plane and
fills them with astral illusions in the disguise of spiritual truth, Ahriman
strives to convince souls that their spiritual perception is a mad fantasy
and that the natural laws of the physical world, as well as rational thought,
are the only trustworthy guides for navigating one's way through life's
mysteries. By diverting the human mind away from spiritual thought,
Ahriman weakens the human capacity for supersensible perception. As
the capacity for supersensory perception atrophies in the human race,
Ahriman gains strength and power in the world. Ahriman's system for
undermining spiritual perception in human beings is visually repre-
sented in scene 12 of *The Soul's Awakening*, in which Ahriman induces
thought within a spiritually unconscious soul in order to convince Strader
to wrongfully doubt that the idea behind a machine has arisen through
divine "spirit vision."[100] Because Ahriman fears that Strader's invention
will help many humans to escape his grasp, he summons the blindfolded

soul of Ferdinand Fox, who is a friend of Strader's, and instructs it to "undermine the trust that Strader up to now has in himself" by convincing him that his "mechanism is faulty." Unaware that these dark thoughts are being placed in his head by Ahriman, Fox's unconscious soul believes itself to be independently inspired with the idea to warn Strader that a "mystic fog" has caused him to design a machine that will never function properly. Ahriman succeeds in his plans to stop Strader, who suddenly abandons his project and then dies.[101]

Anthroposophists believe that humans progress through many different incarnations, so Strader's death is not his ultimate end. In fact, the mystic Benedictus asserts that, even after death, Strader's soul will continue to collaborate with the "mystic group" of which he was a beloved member. Shortly after Benedictus makes this observation, he is given a note that Strader wrote to him on his deathbed. While trying to read Strader's note, Benedictus finds himself overcome by a feeling of "chaos." At this moment, Ahriman appears and offers to reveal a message that Strader wanted to deliver "for your own good and also for your pupils' mystic path." At first, Benedictus does not know who Ahriman is, but he feels wary and demands that Ahriman make himself "recognizable to spirit sight." Benedictus's demand causes Ahriman to leave just as suddenly as he appeared, because he knows that Benedictus possesses spirit sight and works in alliance with "the power that slowly will destroy me." Benedictus thus recognizes and drives away Ahriman through supersensible perception. This heroic act protects Benedictus's spiritual students from being misguided by the trickster Ahriman's influence for the moment.

Although Strader is dead at the end of the last mystery drama, Benedictus claims that Strader's disembodied soul will continue to work with his physically incarnated friends to thwart Ahriman's plan to "spread Chaos' gloomy night" all over the earth.[102] In *The True Nature of the Second Coming*, Steiner wrote that collaborations between the living and the dead would be possible in the future through the power of the spiritual presence of Jesus. As has been explained, Steiner interpreted the idea of the second coming of Christ as the ability to perceive Christ's spiritual body in a "new age" to come.[103] During this new age, a "new Christ Event" will occur that will differ markedly from the first "Christ Event," when Jesus supposedly entered the world as a man, was crucified, and resurrected. The new Christ Event would take place when Anthroposophists perceive the spirit body of Christ and gain knowledge from him that will enable them to avoid the pitfalls set for them by Lucifer and Ahriman. Steiner asserts that those who develop the ability to see Christ's spirit body will also be able to see the

soul bodies of others who have passed away. Regarding this development, Steiner said:

> Through the new Christ Event, this communion between souls who are incarnated here on the physical plane and souls already in the spiritual world will become an increasingly conscious communion. Active co-operation between human beings in incarnation and spiritual beings will then be possible.[104]

Benedictus's assertion that Strader's disembodied soul will in the future fight against Ahriman with his physically incarnated friends[105] harmonizes with Steiner's vision of a new age in which Anthroposophists with supersensible perception collaborate with disembodied souls.

Steiner viewed Goethe as an occult adept who possessed supersensible perception, and he viewed some of Goethe's writings as revealed texts with occult meaning. Steiner's first mystery drama, *The Portal of Initiation*, was based upon such an understanding of Goethe's fairy tale, *Das Märchen*. In his 1899 essay "The Character of Goethe's Spirit as Shown in the Fairy Tale of the Green Snake and the Beautiful Lily," Steiner asserts that Goethe wrote *Das Märchen* to explore two spiritual insights: (1) the connection between "the events of...life that cannot be explained by the laws of the physical world"; (2) the capacity of the human soul to free itself "from the ideas which come only from the perceptions of the senses and of grasping a supersensory world in a purely spiritual contemplation." [106] About *Das Märchen*, Steiner writes:

> Goethe is moving with the personalities of his story, not in the realm of abstract concepts, but among *supersensory* perceptions. What is to be said here about these figures and their experiences is not intended as if it were asserting: This or that has this or that *meaning*. Any such inclination toward a symbolic explanation is utterly remote from these studies.[107]

Steiner stressed the need for the reader to acquire "the organs through which the student can share in the same air that Goethe breathed spiritually when he wrote the story." Steiner asserted that the characters who appear in *Das Märchen* are not "philosophical ideas," but, rather, real spiritual forces and beings that existed in Goethe's soul.[108] Steiner's claims for the characters in *Das Märchen* are identical to those he made for the spiritual beings appearing in the mystery dramas.[109] Goethe, in Steiner's opinion, could perceive the same spirits that he and other Anthroposophists sought to perceive. Steiner viewed his own plays as a continuation of an

exploration of the supernatural realm that he believed Goethe undertook when he wrote *Das Märchen*.

Steiner's interpretation of *Das Märchen* is religious in nature, because it asserts that Goethe is writing about a spiritual realm that is a fact of nature. There are many other translations that do not consider Goethe's characters to be representations of spiritual visions. In his 1972 translation and adaptation of *Das Märchen*, Waltraud Bartscht states that, "as much as Goethe delighted in hearing or telling such stories [fairy tales], he did not take them very seriously."[110] However, the accuracy of Steiner's assertions about Goethe's ability to perceive spiritual realms and beings is less relevant here than the reasons that he made such assertions: to argue that Goethe and he both were both artists who used art to represent supersensible realms and beings that actually exist. Establishing these ideas was important for Steiner, whose authority as a spiritual teacher was based in large part upon his professed ability to perceive supersensible realms and beings.

Steiner based a great deal of his first mystery drama, *The Portal of Initiation*, upon *Das Märchen*. In "The Character of Goethe's Spirit" Steiner defines what he believes to be the inner essence of each character in *Das Märchen*. The wise old man with the lamp in Goethe's tale "is the one upon whose guidance and leadership everything depends." It is the old man who knows all the secrets and mysteries that will affect the other characters in the story. Steiner associates the character of the Green Snake that appears in *Das Märchen* with the sensory realm; he associates the character named Lilie with the supersensory realm. The young man in *Das Märchen* is viewed as "the aspiration toward the condition really worthy of humanity": a condition made possible by the correct relationship between the sensory and the supersensory that results in a "soul that is free." [111] Finally, Goethe's Will-o'-the-Wisps possess a wisdom that is detached from the sensory world and "wandering in superstition or confused thought."[112]

Steiner adapted the characters from *Das Märchen* in *The Portal of Initiation*. This association between Goethe's characters and those in *The Portal of Initiation* is made apparent within a character list from an early draft of the play. In this draft, Steiner gives each character two names: the first name is the name of the character as it appears in the final version of *The Portal of Initiation* and the second is the name of one of the characters in Goethe's *Das Märchen*:

Johannes Thomasius
Mensch

Maria
Lilie

........

Professor Capesius
Erstes Irrlicht
Doktor Strader
Zweites Irrlicht
Felix Balde...
Der Mann mit der Lampe

.........

Die Andre Maria...
Schlange[113]

If one is familiar with the characters listed above, the action of the mystery dramas, and Steiner's interpretation of the characters from *Das Märchen*, one can gain a deeper understanding of the mystery dramas. For example, because Johannes is also called *"Mensch"* by Steiner, we know that, according to Steiner's interpretation of the young man in *Das Märchen*, Johannes is trying to develop a balance between the sensory and the supersensory in order to free his soul.[114] Lilie's effect on the young man in *Das Märchen* is mirrored by Maria's effect upon Johannes in *The Portal of Initiation*. In *Das Märchen*, the young man describes this effect:

> Is it not much sadder and more frightful to be paralyzed by her presence than to perish by her hand?...I am just as naked and needy as any mortal, for so fatal is the influence of her beautiful blue eyes that they take away the strength from every living creature; and those who are not killed by the touch of her hand feel reduced to the condition of living shadows.[115]

Similarly, in the early draft of *The Portal of Initiation*, Johannes laments the simultaneously draining and mesmerizing effect that Maria's presence has upon him.[116]

The characters named Strader and Capesius in Steiner's play are referred to as *Irrlicht* in the cast list above, which shows that they are analogous to Goethe's Will-o'-the-Wisps. Capesius and Strader wander about in a state of confused thought, intentionally detaching themselves from the sensory world. Steiner attributed such behavior to the Will-o'-the-Wisps in *Das Märchen*.[117] Like *Der Mann mit der*

Lampe (the man with the lamp), Felix Balde is a person who under-
stands many mysteries and upon whom everyone depends for guidance
and leadership.[118] Finally, the snake in *Das Märchen* proclaims her
wish: "to sacrifice myself before I shall be sacrificed."[119] For Steiner,
this serpent is connected to the sensory realm and life experiences
that must be sacrificed if one is to perceive the supersensory world.[120]
After sacrificing itself, the snake is transformed into "a beautiful circle
of luminous gems."[121] Steiner adapts this sacrifice in *The Portal of
Initiation* through the actions of the character known as "The Other
Maria," who is the counterpart to Maria's supersensory nature. The
Other Maria sacrifices herself so that Maria can enter the supersen-
sory realm. H. Collison writes that during the 1910 production of *The
Portal of Initiation* in Munich, the Other Maria emerged "from the
rocks, covered with precious stones"[122] after sacrificing herself. This
representation resembles the transformation of Goethe's snake in *Das
Märchen*.

 The Portal of Initiation is not only a response to Goethe's fairy tale.
Like the other three mystery dramas that Steiner wrote, these plays are
artistic representations of Anthroposophical understandings about the
spiritual condition of human beings. The Anthroposophical terminology
and concepts that interpenetrate Steiner's mystery dramas are so dense
and complex, that it is almost impossible to come to any understand-
ing of them without some familiarity with Anthroposophical teachings.
For those who have knowledge of and faith in Steiner's teachings, the
plays provide insight into what is perceived as the true nature of the
spiritual world. Steiner imbued his mystery dramas with a complex
web of Anthroposophical ideas. Perhaps it was because of the complex-
ity of what Steiner sought to convey to audiences that Steiner rejected
any high-speed action within his mystery dramas. His plays do not
move at a quick pace; rather, they move at a slow and steady speed that
allows the reader/spectator to carefully contemplate the spiritual ideas
within the play. As a playwright, Steiner reveals no interest in indulg-
ing the audience's taste for the suspense, rising action, and climaxes of
Aristotelian dramaturgy. Instead, Steiner's plays encourage meditative
and contemplative consciousness by means of incantatory verse, deliber-
ate slowness, and a disorienting line of action that moves back and forth
between the past and present, the physical and the nonphysical. In other
words, Steiner designed a particular mode of writing that seemed to suit
the religious purpose of the mystery dramas: namely, to create realistic
representations of the spiritual world that would help elevate audience

members toward eventual spiritual enlightenment through direct experience of the astral and spiritual realms. Steiner was so dedicated to this purpose that he eventually designed and oversaw the construction of a special theatre in which to house his mystery dramas. In collaboration with Steiner-von Sivers, Steiner also developed special modes of recitation and movement that were well suited to the deliberate pacing of the mystery dramas.

ANTHROPOSOPHY ON THE STAGE

After producing the first four mystery dramas in conventional theatres between 1910 and 1913, Steiner came to the conclusion that he needed to construct a new kind of theatre for them. This project resulted in the construction of two separate theatres, both of which were called the *Goetheanum*. The first *Goetheanum* was completed between 1913 and 1922. It was a structure with two intersecting domes at the top and a seating capacity of nine hundred. Unfortunately, an arsonist destroyed the first *Goetheanum* on New Year's Eve 1922–1923 and Steiner never had the opportunity to stage his mystery dramas there. Details concerning the first *Goetheanum* can be found in the book *Eloquent Concrete*, which includes interior and exterior photographs.[123] Soon after the burning of the first *Goetheanum*, Steiner began planning the second *Goetheanum*, which did not open until three years after Steiner's death in 1928.[124] Unfortunately, Steiner never received the opportunity to direct his mystery dramas in either *Goetheanum*. It was Steiner-von Sivers who became the first director of the mystery dramas at the second *Goetheanum*. Since Steiner-von Sivers's staging of the mystery dramas, they have continued to be performed in the second *Goetheanum*.

In March 1924, Steiner created the design for the exterior of the second *Goetheanum*, and his specifications were closely followed when the theatre was constructed.[125] Although Rudolf Steiner died before the building was completed and opened to the public, Steiner-von Sivers and the *Goetheanum* architects strove to create a theatre space that would, like the mystery dramas, reveal the aims of Anthroposophy.[126] When one walks into the *Goetheanum* on a sunny morning, the colorful effect of the sunlight pouring through the stained glass windows is striking. The images in the windows deal with "the experiences of the human being" who is "searching for spiritual knowledge on his path of cognition."[127] As one takes the stairs to enter the auditorium, one sees a large triptych made of

deep-red window panes. On the left is an image of a man peering into the depths of an abyss, where he sees monstrous beings. In the middle pane is a close-up of the man's face, with angels influencing him from above, and on the left pane, the man is being lifted to spiritual heights by angels. These images convey a pictorial narrative concerning the Anthroposophist's path to supersensory perception.[128]

Upon entering the *Goetheanum* auditorium, one sees four pairs of colored windows that face each other from the north and south walls, and are separated from each other by the seats in the orchestra. If one views these windows from the back row of the auditorium, the sets of windows are green, blue, violet, and peach-pink. The green window in the north contains a representation of a human soul struggling with Ahriman's efforts to obscure the spiritual aspects of life. The green window in the south shows a soul dealing with Lucifer's delusional influence.[129] In the book *The Goetheanum Glass-windows*, Hartmann identifies the green glass windows as a spiritually accurate work of art when he explains that the Anthroposophist who sits between the green windows is put in the place of the "the human soul" that "must hold itself with its own strength and be able to go forward in its development."[130] For Anthroposophists such as Hartmann, sitting between the green windows not only reinforces but also embodies Steiner's teachings about the relationship between the human soul, Lucifer, and Ahriman.

The blue window in the north shows the forces of the universe that make spirit vision possible through the "powers of perception and thought."[131] The blue window in the south shows "forces in the cosmic periphery" that inform the human will to act.[132] The process by which the soul leaves its body at death and learns valuable lessons by reliving its life backwards (from the moment of death to the moment of birth) is the subject of the violet window in the north. The violet window in the south shows angels leading the soul into the body it will inhabit during its next physical incarnation.[133] The highest realms of spiritual attainment are portrayed in the peach-pink windows. The one in the south shows a person working to spiritualize the entire earth through the study of spiritual science. In the north pink window the spiritual body of Christ appears, thus presenting the optimistic picture of that future era in which human beings can perceive spiritual bodies.[134] The images in the north peach-pink window suggest that in this new era, the Christ Event will not only bestow spiritual sight upon human beings but also free Ahriman and Lucifer from their own unhealthy impulses. In this peach-pink window, Christ is shown releasing Ahriman and Lucifer from the binds that limit their minds. Thus, the

colored windows of the *Goetheanum* show the Anthroposophist's path of spiritual development and promise a future in which the salvation of all physical and spiritual beings is possible. The ideas conveyed by the images in the glass windows in the auditorium visually reinforce the central ideas of the mystery plays, when they are performed on the *Goetheanum* stage.

Steiner and Steiner-von Sivers created two Anthroposophical modes of performance that have become an essential part of mystery drama productions at the *Goetheanum*: Eurythmy and Speech Formation. Eurythmy (which is unrelated to the movement system known as eurhythmics that Swiss musician and teacher Émile Jaques-Dalcroze developed) is an expressive movement system that emphasizes the arms and hands. Speech Formation is a formal and stylized mode of vocal recitation. Eurythmy and Speech Formation were created to give expression to activities of the soul and the spirit. They are not naturalistic in style because Steiner believed that spiritual art is rooted in "an impulse for a creative activity transcending the merely natural."[135] In a 1926 lecture on Eurythmy, Steiner noted that Anthroposophists who master Eurythmy and Speech Formation learn to reveal "living spiritual impulses" through movement and speech.[136] Like the mystery dramas, Eurythmy and Speech Formation are not only art forms but also a means of spiritualization, because they reveal spiritual truths through the voice and the body.

The Speech Formation artist approaches declamation and recitation with the idea that speech is born from the spiritual and physical aspects of the human being simultaneously. According to Steiner, "every vowel sound" expresses "some shade of the feeling-life of the soul," while the consonant "represents, paints, as it were the things of the external world."[137] Steiner describes the process of simultaneously representing the life of the soul and of the physical world through speech as making spiritual "gestures in the air."[138] The distinction that Steiner makes between vowels and consonants corresponds to other dichotomies of the spiritual and the physical that he discusses in many of his lectures and publications.

Like Speech Formation, the movements of Eurythmy also correspond to the spiritual aspects of the human being. While discussing Eurythmy, Rudolf Steiner explains that the "E sound" (as in "me") causes a picture to form in the soul that "expresses" an "assertion of self" that "must be expressed" through "stretching of the muscles." In contrast to this, Steiner explains that the sound of "A" (as in "mate") "reveals itself to our imagination as flowing in two crossed currents."[139] While Steiner-von Sivers worked to refine Eurythmy, she also developed a codified system of correspondences between movement and the sounds of the German language.

Smooth and gentle movements of the arms and hands are the primary mode of expression in Eurythmy, but other parts of the body can be used to strengthen gestures during Eurythmy performances. Between 1912 and 1928, Eurythmy and Speech Formation had become so complex that mastering them required a great deal of practice. Steiner-von Sivers worked for two years with the artists who performed Eurythmy and Speech Formation in the 1928 *Goetheanum* premiere of the mystery dramas.[140] Training in Anthroposophical performance has become more formalized in the present. The *Goetheanum* currently offers a four-year training program in Eurythmy.[141] There are such training programs in several other countries as well.

Since 1928, the mystery dramas have been performed regularly at the *Goetheanum*. Speech Formation and Eurythmy continue to be an integral part of mystery drama performances in Dornach. Thus Steiner-von Sivers and the other Anthroposophists have worked to realize Steiner's vision of a theatre that provided "pictures of the higher worlds."[142] This dedication to the original goals of Anthroposophical performance has continued into the present. In fact, one could say that the performance methods established by Steiner and Steiner-von Sivers have been carried into the present with a sense of religiosity. After all, *religio*, which is the Latin root of "religion," refers not only to faith in spiritual realms and beings but also to an "insistence on the exact detail of ritual."[143] Anthroposophists who perform the mystery dramas today utilize many of the methods that Steiner and Steiner-von Sivers created in the 1910s and 1920s. Contemporary Anthroposophists still believe the Steiners' methods are a means to create realistic pictures of the supersensible realm.

This continuation of the Steiners' performance methods was apparent to me when I attended the Anthroposophical Society's *Weihnachten 2000: Reinkarnation und Individualität* conference, which was held at the *Goetheanum* between December 25, 2000, and January 1, 2001. By reading each mystery play just before seeing it performed, I discovered connections between the text and the performance that demonstrate how contemporary Anthroposophists adhere to Rudolf Steiner's original vision for the mystery dramas. In several scenes, Steiner's suggestions for scene painting and costuming were followed carefully. One of the most striking examples of this was during the performance of scene 5 from *The Soul's Awakening*, which is set in the colorful spirit realm. In this scene, Steiner allocates "meaningful colors" to various levels of the spirit world. Steiner associates "reddish and fiery-red" with the highest regions of the spirit world and various shades of blue and violet

with the lowest spiritual regions.[144] In the production that I saw, the colors used to paint the set of the spirit realm in scene 5 of *The Soul's Awakening* were chosen according to Steiner's specifications. The spirit realm was composed of a three-leveled system of ramps that led from the floor of the stage to higher areas of the performance space. Facades cut in waving lines were attached to the front of the ramps, and these were painted with swirling color patterns. The lowest of these facades was painted in the darkest hues of blue, which lightened into violet and lighter shades of blue on the middle ramp. The highest ramp was adorned with the fiery reds, which indicates the highest areas of the spirit world.

Steiner provided descriptions for the spirit body costumes and he specified how much of each character's spirit body should be visible in scene 5 of *The Soul's Awakening*. In accordance with Steiner's specifications, the actor who played Benedictus in the 2001 production of *The Soul's Awakening* was the only actor whose entire body was visible in the spirit realm. This visibility demonstrated that his character was fully conscious within the spirit world. In accordance with Steiner's specifications, Benedictus's robe encompassed all of the colors of the spiritual realm, to show that his soul had risen from the lowest to the higher regions of the spirit world.

In the same scene, other characters on the stage were only partially visible. Maria was dressed as an angelic figure with light violet wings whose feet were hidden behind a facade on the stage, just as Steiner specifies in *The Soul's Awakening*.[145] Making the majority of Maria's body visible in the spirit world shows that she has risen to great spiritual heights, but her hidden feet show that she still has some attachments to the physical world that must be overcome before she can be fully conscious in the spirit world, as Benedictus is. Only the heads of Strader and Capesius were visible in the spirit world. Their bodies were hidden behind a tall facade on the lowest ramp. The heads of the actors who played these two characters were decorated with large, oval auras that had been painted with various colors and stars, just as they are described in scene 5 of *The Souls Awakening*.[146] At the production of *The Soul's Awakening* that I attended, the correspondences of the set, colors, costumes, scenery, and actors' bodies was clearly based upon the descriptions of sets and costumes that Steiner included in the script.

Comparing the design elements of the 2000–2001 mystery dramas with photographs of the mystery drama productions that Steiner-von Sivers directed between the late 1920s and the early 1930s, we

can see that she established an aesthetic style that continues to be used in *Goetheanum* productions. In *Marie Steiner, Her Path through Anthroposophy to the Renewal of the Art of the Stage: A Documentation*,[147] there are photographs of scenes from Marie Steiner's productions of *The Portal of Initiation* (1928), *The Soul's Probation* (1928), *The Guardian of the Threshold* (1929), and *The Soul's Awakening* (1930). The photographs of sets for these earlier productions reveal a swirling and curvilinear style of painting and construction that greatly resembles the sets of the 2000–2001 performances that I saw in Dornach. The curved lines of the sets in Marie Steiner's productions also resembled the shapes that Rudolf Steiner proposed for the exterior of the second *Goetheanum*. Steiner-von Sivers integrated Steiner's architectural style into her productions of the mystery dramas because Rudolf's art amounted to representations of the spiritual realm.

The photographs of previous performances also show that the figure of Ahriman has not changed much since he first appeared on the *Goetheanum* stage. Scene 8 of *The Guardian of the Threshold* takes place in Ahriman's realm. A 1929 photograph of a moment from this scene that is contained in the previously mentioned book about Marie Steiner-von Sivers shows the actor who played Ahriman dressed in a long, loose tunic that is covered with layers of ragged material. The photograph also shows that his head, chin, and ears have been lengthened with prosthetic effects. In the 2000–2001 performance of the mystery dramas, the head, ears, and chin of the actor who played Ahriman were similarly lengthened, and his costume was nearly identical to the one that Steiner-von Sivers used in the 1929 production. The long head, chin, and ears of these two actors also resemble the representation of Ahriman in the green window in the north side of the *Goetheanum* auditorium. The photograph of the 1929 production is in black and white, but in the production of the mystery drama that I saw, the actor who played Ahriman wore a green costume and was painted with green makeup. The 2000–2001 mystery dramas also used a set design to establish a visual connection between the actor playing Ahriman on the stage and the image of Ahriman in the green, north window of the *Goetheanum* auditorium: when Ahriman was first discovered in his realm, he was seen through a transparent, green screen that cast an atmospheric haze over the stage picture. On this screen was the same image of Ahriman that is etched into the green glass window in the north.

There are also similarities in set and costume style in the Egyptian Temple scene (scene 8) of *Soul's Awakening* and the Subterranean Rock

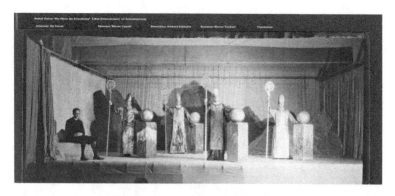

Figure 3.1 *The Portal of Initiation* (scene 5). Directed by Marie Steiner. Location: The Schreinerei Hall at the Goetheanum (Dornach, Switzerland). Date: 1926. Photographer: Otto Rietmann. © Dokumentation Goetheanum.

Temple scene (scene 5) in *The Portal of Initiation*. A comparison of photographs of performances from the late 1920s with photographs of performances that took place in 2010 reveal a great deal of consistency between costumes, placement of performers, props, and sets. I witnessed the same continuity when I saw these scenes performed at the Goetheanum (figures 3.1–3.4).

Speech Formation and Eurythmy are also an integral part of the mystery dramas. I noted during the 2000–2001 performances that the nature of vocal recitation in the mystery dramas differed according to the type of character speaking, the character's state of consciousness, and the realm in which the character was discovered. When firmly rooted in the physical plane, human characters spoke much in the manner that a well-trained Shakespearean actor might speak. Their rhythms were carefully controlled, and their enunciation was crisp and clear. When characters entered a trance state or spoke in the soul world or spirit world, they lengthened the pronunciation of vowels. This emphasis of the vowels relates to Steiner's theories concerning the function of vowels within Speech Formation: in Speech Formation vowels emphasize the spiritual nature of a character.

Speech Formation and Eurythmy intersected in the 2000–2001 performances whenever the benevolent soul forces named Philia, Astrid, and Luna appeared to assist Benedictus's students as they perceived supersensory worlds. Two separate performers portrayed each of these three soul forces: one performer was a Speech Formation artist, who recited the character's lines, and the other was a Eurythmist, who performed the character's

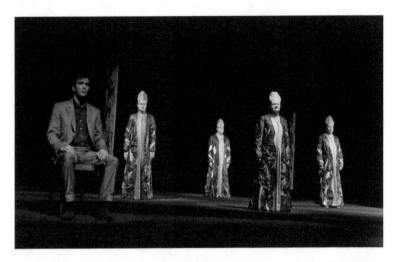

Figure 3.2 The Portal of Initiation (scene 5). Location: The Hall of the Goetheanum (Dornach, Switzerland). Date: 2010. Photographer: Jochen Quast. © Dokumentation Goetheanum.

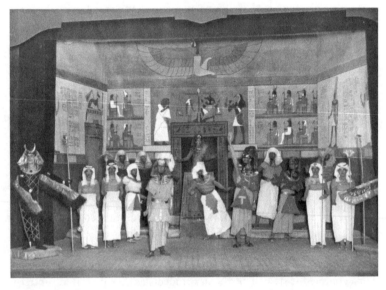

Figure 3.3 *The Soul's Awakening* (scene 8). Directed by Marie Steiner. Location: The Schreinerei hall at the Goetheanum (Dornach, Switzerland). Date: 1927. © Dokumentation Goetheanum.

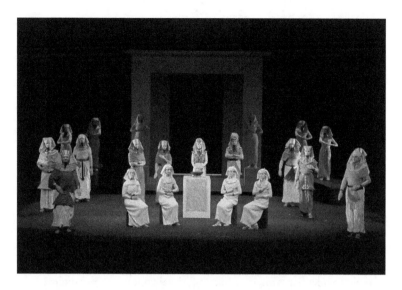

Figure 3.4 *The Soul's Awakening* (scene 8). The Hall of the Goetheanum (Dornach, Switzerland). Date: 2010. Photographer: Jochen Quast. © Dokumentation Goetheanum.

movements and gestures. The first appearance of Philia, Astrid, and Luna occurred in scene 7 of *The Portal of Initiation*. The eurythmists playing these characters were three women dressed in light, long gowns, and a pastel-colored layer of translucent, wind-resistance silk that fell from their arms like wings. The eurythmists' heads were adorned with oval head-dresses such as those worn by other characters when they appeared in the astral realm. The Speech Formation artists, who were also women, wore grey tunics, and recited Philia's, Astrid's, and Luna's lines from the far left and right sides of the stage apron, where they did not interfere with the stage picture. The Eurythmists used their feet, legs, and hips to glide smoothly and gracefully across the floor, but the most dynamic movements were created with their arms and hands. The seemingly weightless silk moved slowly through the air, like traces of colorful light following closely behind the trajectory of the Eurythmists' graceful arms. In this way, the contemporary Anthroposophists who performed the mystery dramas that I saw carried on a tradition of theatrical performance and design that was inaugurated by Rudolf and Marie Steiner in the early years of the twentieth century.

The Steiners dissuaded applause, because they believed it worked against the spiritual purpose of these mystery dramas, which "were never intended for entertainment of society."[148] The Steiners did not want their audiences to passively take in the mystery dramas; rather, they wanted their audiences to engage with Anthroposophical performances in a heightened state of consciousness. Richard Rosenheim, who wrote passionately in the 1950s about the spiritual efficacy of Steiner's dramas, suggests that to "appreciate the specific character" of the mystery dramas "one first has to seek for a right interpretation of what in the esoteric language of all times and zones was known as meditation."[149] Indeed, Rudolf Steiner hoped that the spectator would meditate on the mystery dramas to such an extent that they would achieve "complete identification with the chosen object."[150] Steiner believed that the spectator must *be* the character in order to experience the initiation process by watching his plays.[151] This idea of complete identification with characters bears some similarity to the later efforts of Crowley and Gardner to create methods through which magicians could completely identify with an invoked spiritual entity, god, or goddess.

Steiner and Steiner-von Sivers did not approve of applause because they interpreted it as a sign that the audience was receiving a form of entertainment rather than a communication to the higher self. In a letter that Marie wrote to Rudolf on October 9, 1924, she interpreted an outburst of applause that followed a performance in Hanover as evidence that the audience might have been populated by "opponents" of their dramatic work.[152] At the 2000–2001 performances, the audience refrained from applause until the end of the final drama—and even then they applauded quietly.

CONCLUSION

Although Rudolf and Marie Steiner claimed that the mystery dramas, Eurythmy, and Speech Formation were occult modes of performance that portrayed spiritual realities, their theatrical practices were not developed in a cultural vacuum. They drew a great deal of inspiration from Edouard Schuré's call for a theatre of the future that would contribute to the spiritual development of the human race. Their respect for Schuré's teachings inspired them to translate and stage his *Sacred Drama of Eleusis* before they began producing original Anthroposophical dramas. Schuré anticipated Steiner's efforts to theatrically dramatize astral and spiritual worlds: he described his *Sacred Drama of Eleusis* as a reconstruction of an ancient play depicting the soul's travels through spiritual

and physical "worlds" during and in between incarnations. In Schuré's play, the soul leaves "the natal sphere of the Archetypes," enters "the lower world of dense matter," and then returns to "heaven."[153] In their discussion of Symbolist occult drama, Daniel Gerould and Jadwiga Kosicka view Schuré's *Sacred Drama of Eleusis* as theatrically flawed because it does little more than espouse presupposed doctrinal assumptions.[154] It should be remembered, however, that Schuré would not have viewed this aspect of his play as a failure. After all, Schuré did not hold a high opinion of the spiritual vagueness of symbolist theatre. He accused Maeterlinck of using the occult to make the spiritual aspect of life more of a puzzle than it should be, and he strove to write plays that solved spiritual mysteries, rather than leaving them unresolved. Like Schuré, Steiner did not want to be viewed as a vague symbolist who leaves behind open questions about the mysteries of life. On the contrary, he wanted his audiences to walk away from his dramas with some understanding of the Anthroposophical perception of the spiritual realm. This desire for spiritual clarity separated the religiosity of plays by Schuré and Steiner from the occult-inspired, but nondogmatic, plays of most of symbolist playwrights.

Although Rudolf and Marie Steiner did not want to be identified as Symbolists, they were familiar with the theatrical techniques of French Symbolism. This is made apparent by the extant photographs of past productions of the mystery dramas, as well as the design elements and performances that I saw at the *Goetheanum*. In *Symbolist Theater: The Formation of an Avant-Garde*, Frantisek Deak discusses descriptions of Symbolist theatrical productions in Paris that audience members wrote in the late nineteenth century. Among the Symbolist staging techniques that these audience members noted were: a "recitational acting style," the use of transparent scrims to add a mystical atmosphere to the mise-en-scène, slow and ritualized movements, evocative verse, an emphasis upon the hidden and spiritual aspects of life, and representations of "ideas of mysticism."[155] All of these aspects of Symbolist theatre were used in the productions of the mystery dramas in the 1920s and 1930s, and they were also used in the performances that I saw at the *Goetheanum* between 2000 and 2001.

It is clear that Steiner recognized the similarities between his mystery dramas and Symbolist theatre because he made it a point to distinguish his mystery dramas from Symbolist theatre in his lectures concerning drama. In *The Arts and Their Mission*, Steiner condemns Symbolism as "inartistic" and asserts that "we must become artists, not symbolists and allegorists,

by rising, through spiritual knowledge, more and more into the spiritual world."[156] Steiner would have been absolutely dissatisfied if his audiences had perceived his dramas as something akin to the aesthetic explorations and confusing mysticism contained in much Symbolist drama. Regardless of Rudolf and Marie Steiner's objections to the symbolist label, the methods that they established for the performance of the mystery dramas have continued for over 80 years at the second *Goetheanum*. Because of this, several aspects of early Symbolist theatre have also been preserved through Anthroposophical theatre in Dornach.

Steiner was correct when he distinguished the mystery dramas from Symbolist plays. Although Symbolists often drew from occultism when they created their plays, their ultimate goal was artistic: they wanted to create a form of theatre that bucked against the positivistic, nonspiritual philosophy upon which naturalist theatre was based. Steiner, on the other hand, had a religious goal in mind when he wrote the mystery dramas. He created images of what happens to human beings when "higher spiritual impulses play between them" and when they "are crossed by paths of...karma, active through millennia in repeated lives."[157]

The Steiners used drama, Eurythmy, and Speech Formation to represent a spiritual landscape that many Anthroposophists believe to be a perceivable reality. The dedication of both Rudolf and Marie Steiner to spiritual theatre and performance resulted in the creation of a rather sophisticated system of actor training and performance. To this day, the *Goetheanum* still houses all forms of Anthroposophical performance, and the work that the Steiners created together in Dornach led to one of the most enduring theatrical traditions of the Occult Revival.

4. Aleister Crowley's Thelemic Theatre ❧

leister Crowley's (1875–1947; see figure 4.1) *Rite of Saturn* premiered at London's Caxton Hall in 1910. This was the first of seven magical rituals that were performed between October 19 and November 30, as part of a larger work titled *Rites of Eleusis*.[1] Crowley's *Rites of Eleusis* were a mixture of poetry, ecstatic dance, music, and ceremonial magic that he had developed with the initiates of the *Argenteum Astrum*, a secret society whose members studied and practiced ceremonial magic. The elements of ceremonial magic were plentiful within the *Rites of Eleusis*: the performers were actual magicians who performed incantations and magical gestures, the costumes included hooded robes, the stage was decorated with an altar bearing a collection of occult symbols, and the audiences were encouraged to wear specific colors that corresponded to the nature of the god being evoked in each of the rituals. Some audience members were sympathetic to Crowley's theatrical aesthetic. For others, the performance, which was staged in semidarkness, suggested something diabolical or perverse. A critic from one periodical, the *Penny Illustrated Paper*, accused Crowley of using the *Rites of Eleusis* to "suggest an elusive form of Phallicism or sex worship" and to compel audiences to witness a "Black Mass."[2] Where some saw whimsical, Symbolist theatre, others saw the public exhibition of blasphemous and gratuitous practices that formed the liturgy of a sex cult.

Aleister Crowley and his followers would face numerous attacks from the press and the public as they promulgated the controversial and often misunderstood Law of Thelema: "Do what thou wilt shall be the whole of the Law."[3] This phrase is the central motto of Thelema: a religion that Crowley established in 1904 when its foundational text, *The Book of the Law*, was, according to Crowley, revealed to him via dictation from a superintelligent being named Aiwass.

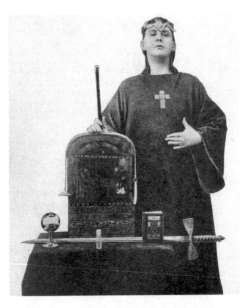

Figure 4.1 Aleister Crowley. Publicity photograph for *The Rites of Eleusis* (London, England). Date: 1910. Photo courtesy: Ordo Templi Orientis Archives.

Crowley taught his followers that the Great Work in life is to discover one's "True Will," and that "Magick" (as Crowley spelled it) was "the means of discovering one's Will." Once discovered, the "Thelemite" was challenged to pursue his or her will "to the exclusion of all else." Some Thelemites theorize that "if everyone were to do one's Will, there would be no conflict in the world."[4] The phrase "Do what thou wilt" is often misinterpreted by non-Thelemites as "do whatever you want to do." This interpretation has fueled depictions of Crowley as a deviant black magician. Crowley's notoriety was further exacerbated by his promotion of free love, bisexuality, and the use of sex and drugs in ceremonial magic.

Crowley considered theatre and ritual to be an effective means of attaining spiritual experience and knowledge. He therefore identified theatre, drama, and ritual as key practices of Thelema. Crowley was a prolific author who wrote many plays and ritual performance texts. Among the most important of these are the aforementioned *Rites of Eleusis*, as well as another dramatic ritual called the *Gnostic Mass*. Thelemites today continue to perform these works as a form of Thelemic devotion and Magickal

practice. In addition to Magickal rituals, Crowley wrote closet dramas that dramatized the overthrow of conservative, fundamentalist religion—especially Christianity—in a future age.

ALEISTER CROWLEY: CAREER AND BELIEFS

Like Nietzsche, Crowley believed that all established religions have the potential to become "slave moralities": that is, systems that abandon critical views of morality and ethics in exchange for an agreed-upon "good" and "bad" that is used to control human behavior.[5] (In fact, Nietzsche was so central to the shaping of Thelema that Crowley lists him as one of the "saints" of Thelema in his *Gnostic Mass*.) Although Crowley would criticize many world religions in his writings, he took a particularly antagonistic perspective toward Christianity. Crowley's attitude toward Christianity is not shared by all Thelemites, and it is not necessary to the practice of Thelema to take an anti-Christian stance.

Israel Regardie, Crowley's onetime secretary and friend, observed that the founder of Thelema's "hatred of Christianity was not a blind unreasoned prejudicial emotion" but a response that was "indelibly rooted in his own personal experience."[6] As a child, Crowley's first religious memories have to do with a fundamentalist Christian sect known as the Plymouth Brethren, in which he was raised. When Crowley's beloved father, Edward Crowley, was diagnosed with an operable form of cancer, he accepted the guidance of his fellow Plymouth Brethren by turning down surgery and submitting to an alternative form of treatment. This decision proved fatal.[7] After the death of his father, 12-year-old Crowley was sent to a Plymouth Brethren school. There he was falsely accused of having been drunk at home during the Christmas break and subjected to severe corporal and psychological punishment, which took the form of a diet of bread and water and isolation from his fellow students for "a term and a half." This punishment resulted in trauma to his kidneys. As a result of his illness, Crowley had to leave school for two years in order to recuperate.[8] By the time Crowley entered university training he loathed fundamentalist Christianity, and he denied the authority of conservative Christian codes of morality.

After entering college, Crowley began a lifelong pursuit of magic and the occult that would last the rest of his life. For Crowley, occultism offered an alternative to the sort of restrictive Christianity that he viewed as one of the primary sources of human suffering. In 1898,

he was initiated into London's famous ceremonial magic society, the Hermetic Order of the Golden Dawn, which at that time was headed by Samuel Liddell MacGregor Mathers. The Hermetic Order of the Golden Dawn was an initiatory society whose members took degrees as they progressed through the system, much as members of Masonic organizations do. The members of the Golden Dawn focused primarily upon esoteric philosophies and practices such as the performance of magical ritual, tarot card divination, astrology, and Kabalistic symbolism. One of the most well-known occult societies of its time, the Golden Dawn included stars of theatre and the occult, including Abbey Theatre founders William Butler Yeats and Annie Horniman, actress and occult playwright Florence Farr, and the renowned occultists Arthur Machen, Dion Fortune, and A. E. Waite.[9]

As a member of the Golden Dawn, Crowley received training in ceremonial magic and began a lifelong course of study and spiritual practice. Throughout the rest of his life Crowley devoured a body of writings from the esoteric literary tradition, including the legends of King Solomon and Hermes Trismegistus and numerous works associated with Gnosticism, Neoplatonism, Alchemy, Rosicrucianism, and Freemasonry.[10] Many of Crowley's magical practices were based upon what he learned as a member of the Golden Dawn; however, his involvement with that order was troubled.

Tension mounted in the Golden Dawn in 1900 when Crowley took Mathers's side in response to a dispute over his authority to lead the order. The anti-Mathers faction was driven by Yeats and other Golden Dawn members. In response to this rebellion, Mathers asked Crowley to enter the Golden Dawn headquarters and take important ritual texts. Mathers told Crowley to be prepared for resistance and to use force, if necessary. The details of this confrontation are colorful. Yeats, who was expecting Crowley's arrival, waited at the top of a stairway with a Golden Dawn member who happened to be an amateur boxer. When Crowley tried to storm past them, wearing "a black mask, a MacGregor tartan kilt, a gilt pectoral cross, and a dagger at his knee," Yeats and his companion threw Crowley down the stairs.[11]

Over the next few years, Crowley grew distant from his mentor Mathers, and the final separation between the two men was the result of the most decisive religious event in Crowley's life. Between April 8 and 10, 1904, Crowley received the *Book of the Law*. Crowley believed that Aiwass, the being he claimed dictated the text, was "superior to any of the human race" and "entitled to speak with authority."[12] After Crowley completed *The Book of the Law*,

he sent a copy to Mathers with a letter stating that the "Secret Chiefs"—the unseen adepts whom Mathews claimed had given him the authority to lead the Golden Dawn—had now made Crowley "the official head of the order." Mathers responded by expelling Crowley from the Golden Dawn.[13]

After his separation from the Golden Dawn, Crowley dedicated himself to professing Thelema as the religion of a new eon that was dominated by the nature of the child (Horus), as opposed to the father (Osiris) or the mother (Isis). For Crowley, Thelema was a law of the universe by which seekers of occult wisdom were obligated to abide, if they wanted to succeed in life. It was *The Book of the Law* that first announced the Law of Thelema, which is now familiar to anyone knows anything about Crowley:

"Do what thou wilt shall be the whole of the Law."

"Love is the Law. Love under Will."

"There is no law other than Do what thou Wilt."[14]

Crowley tried to clarify the extent of the freedom implied by the Law of Thelema. In the introduction to *The Book of the Law*, Crowley wrote that human beings, or "stars," have a "true orbit."[15] Crowley assigned to the Thelemite the responsibility to discover and live according to his or her "True Will," the nature of which is determined by the "order of the Universe."[16] As long as one is guided by the True Will, two principles remain in effect. The first principle is that, in theory, all actions performed in agreement with the Will are "equally lawful" and necessary. The second principle is that, "in practice, only one act is lawful for each one of us at any given moment." Crowley concludes that the duty of Thelemites is to determine the right action from moment to moment[17] by discovering and living in accordance to their True Will.[18] The website of another magical society that Crowley lead during his lifetime—the *Ordo Templi Orientis*, or OTO—argues that the Law of Thelema is "not to be interpreted as a license to indulge every passing whim, but rather as the mandate to discover one's True Will and accomplish it, leaving others to do the same in their own unique ways."[19] Rather than existing outside of morality, Thelemites try to hold themselves to the dictates of what they understand to be the morality of True Will.

Crowley taught that the "technical methods" for connecting with the True Will are to be learned in the practice of "Magick."[20] Crowley preferred this spelling, which has since become commonplace among people who adhere to numerous other traditions of ceremonial magic. According

to Crowley, Magick is "the science and art of causing change to occur in conformity with Will." Crowley asserted that every act performed by a human being "who is doing his True Will" and has established "his right relation with the Universe" is a "Magickal act."[21] For Thelemites, the practice of Magick leads to discovery of the True Will.

One way that Magick is said to promote harmony with True Will is by placing the magician in contact with benevolent spiritual influences. According to Crowley, one of the primary purposes of Magick is to help human beings gain communication with a superhuman intelligence or guide referred to as the "Holy Guardian Angel." In 1921, Crowley wrote a ritual titled *Liber Samekh*, the purpose of which was to establish contact with this Holy Guardian Angel. Lon Milo DuQuette—a prominent author and lecturer on the topic of Thelema—states that "no aspect of the Magick of Thelema is more important than the Knowledge and Conversation of one's Holy Guardian Angel," which DuQuette identifies as the "universal personal religious experience."[22] Crowley likewise considered *Liber Samekh* to be "the most powerful and exalted" of all of his ritual texts.[23]

In addition to establishing communication with one's Holy Guardian Angel, Crowley also suggested that the Thelemite use Magick to exercise power over his or her darker nature. This is effected through rituals that involve the evocation of dark spiritual energies or forces. DuQuette explains that, although the magician must be in contact with the divine force of his or her Holy Guardian Angel, he or she must also "transmit that same grace to the world beneath" him or her:

> If you fail to redeem, control, and train the menagerie of your lower nature, those "demons" will resurface as soon as the glow of the Angel's presence has faded, and literally "play Hell" with you.[24]

DuQuette mentions that Crowley's incorporation of the names of demons in his rituals—especially his incorporation of phrases such as "Satan, my lord!"—have inspired clergy, the popular press, and members of the anticult movement to denounce Crowley as a Satanist.[25] Crowley denied that he was a Satanist, and his followers also deny this label. DuQuette informs us in *The Magick of Thelema* that Crowley viewed the term "Satan" as one of many names of gods that "imply the qualities of courage, frankness, energy, pride, power, and triumph." For Crowley, the name Satan is an expression of "the creative and paternal will."[26] It is not surprising that Satan should be reassessed in Thelema,

because Crowley presented Thelema as something that stands "in direct opposition to" extremely restrictive forms of Christianity.[27] Of course, Crowley's reassessment of Satan bears a certain similarity to Rudolf Steiner's sympathetic representations of Lucifer as a misguided being who can be reformed. Crowley's use of Magick to control potentially "demonic" or "Satanic" energies does not seem conceptually far from the emphasis that Steiner places on controlling the influence of Lucifer in Anthroposophy.

DuQuette's statement about angels, demons, and the placement of demons "beneath" the True Will of the magician also illustrates a thematic parallel with the Theosophical idea concerning the human being's need to establish the dominance of the "higher nature" over the "lower nature." In fact, Crowley was influenced by Theosophy. In 1915, Crowley sought to create an alliance with Katherine Tingley and the Universal Brotherhood and Theosophical Society, but she refused to speak with him when he showed up in Point Loma.[28] In his autobiography, Crowley admits that he "agreed with much of Blavatsky's teachings."[29] This is high praise from Crowley, who was not slow to state his disagreements with other occult teachers.

Regardless of his interest in Theosophy, Tingley would certainly have disapproved of Crowley's violent diatribes against Christianity and his self-identification with "the Beast 666."[30] After all, Tingley wanted her organization to enjoy good social standing. Crowley, on the other hand, was not apparently concerned with social acceptance. Crowley identified himself with the Beast in order to present himself as a "Savior of the Earth" whose proclamations would destroy Christianity and ring in a new eon of Thelemic freedom.[31] Such a tack is not taken by a religious leader who is seeking general social acceptance in Western culture. Crowley's understanding of the Beast of the Revelation differs dramatically from the Christian depiction of the character as an enemy of humanity and Christ. For Crowley, the Beast 666 was the inaugurator of a new religion that would overthrow the dominance of slave moralities that block access to True Will.[32]

Through their lifestyle choices, Crowley and some of his most ardent followers challenged norms of family, sexual, and social life. Sex, for instance, was central to Crowley's personal magical practice. Early in his magical career, he began using "sex magic" as a method for invoking, visualizing, and communicating with spirits. In 1912, Theodor Reuss—who was the head of the OTO—called upon Crowley at his home in London and accused him of publishing one of the OTO's sex magic mysteries. (Specifically, Reuss was referring to a section in Crowley's *Book of Lies* that

urges magicians to be "armed" with a "magic rood" and a "mystic rose." Reuss interpreted this passage as a coded reference to the practice of sex magic.) [33] As a result of their meeting, Reuss made Crowley the head of the British chapter of the OTO. Eventually, Crowley became the head of the entire organization.

Another radical practice that contributed to Crowley's notoriety was his incorporation of intoxicating substances into his Magickal practices. For one of his first public performances, *The Rite of Artemis*, libations containing opiates were offered to audience members as a means of inducing ecstasy.[34] Crowley was, by no means, the first to use narcotics and hallucinogens in this way. On the contrary, the use of such substances in spiritual ritual is an ancient practice. Regardless of this heritage, Crowley's use of such substances in ceremonial magic anticipated the increase of this practice among occultists in Western culture between the late twentieth and early twenty-first centuries. Performance scholar Anthony Kubiak, in particular, has noted that between the late 1960s and the present there has been an increase of "New Spiritualities" that use "hallucinogenic substances toward...spiritual ends."[35]

By the time Crowley produced *The Rites of Eleusis*, he abandoned the use of mind-altering substances in public rituals. Crowley never, however, lost his belief in the power of drama, theatre, and performance as a means for producing occult knowledge and spiritual experience. Crowley's enthusiasm for drama was apparent in the earliest years of his career as a spiritual leader. Shortly after writing *The Book of the Law*, Crowley used a portion of money from his sizeable inheritance to create a publishing house called the Society for the Propagation of Religious Truth. Under this name, Crowley published a three-volume collection of his own plays, poems, and essays that contained the essence of his occult teachings.[36] In his self-described "autohagiography," *The Confessions of Aleister Crowley*, Crowley wrote that his "activities as a publisher" with the Society of for the Propagation of Religious Truth were, in part, "a sort of practical joke" and, in part, an effort to amuse himself by shocking and bewildering people. He also explained that, during the years in which his collected works were published, his "occult life" was the only thing that he took seriously.[37]

Although Crowley said that he was only joking and trying to shock his audiences when he first began publishing his plays, his lifelong dedication to the propagation of Thelema suggests that the Society for the Propagation of Religious Truth was more than a joke. Crowley himself suggested that a jocular and mirthful attitude was essential to true religiosity

when he wrote in the epilogue to *The Works of Aleister Crowley* that "the pagans must have been more spiritual" than their successors "because they openly scoffed at mythology without in the least abandoning the devout performance of its rites." Crowley made a negative comparison between this pagan, jocular religiosity, and what he described as the humorless religiosity of Christianity that clings to "irrelevant historical falsehood" as the basis for spiritual expression.[38]

Crowley's sincerity as a spiritual teacher has been affirmed by several authors who have written about him. In *Holy Madness: The Shock Tactics and Radical Teachings of Crazy Wize Adepts, Holy Fools, and Rascal Gurus*, Georg Feuerstein credits Crowley as one of "the most advanced magi to emerge in the West." Feuerstein ranks Crowley with Lévi and Blavatsky. At the same time, Feuerstein acknowledges that Crowley became notorious through his "liberal advocacy of drugs" and his "(Tantra-like) philosophy."[39] Even Crowley's most hostile biographer, John Symonds, credited Crowley with making a sincere effort to "bring Oriental wisdom to Europe and . . . restore paganism in a purer form."[40] Scholars, critics, and enemies have repeatedly expressed faith in Crowley's sincerity as a promoter of Thelema, even though their assessments of Crowley's character differ.

For Crowley, performance and dramatic writing were essential to the effective practice of Magick. In fact, Crowley equated theatrical practice with spiritual practice in his book, *Magick in Theory and Practice*. In a section of this book that is titled "The Principles of Ritual," Crowley lists three "methods of invoking any deity." The first method is devotion to the deity. The second is "straightforward ceremonial invocation," which involves the execution of various required actions, including the exaltation "of the mind by repeated prayers or conjurations to the highest conception of the God" until "in one sense or another" it "appears to us and floods our consciousness."[41] The third method is "the Dramatic," in which the celebrant achieves complete identity with the deity by losing "himself completely in the subject of a play."[42] Crowley identifies the dramatic method as "unquestionably the best" of all three of the invocation techniques that he lists.

Among the works that Crowley considers to be dramatic invocations are the Catholic Mass, Euripides's *The Bacchae*, and "many of the degrees [rituals of advancement] in Freemasonry." Crowley explains that, in order to perform a dramatic invocation, the magician must arrange a ceremony in which he "takes the part of the lead character [i.e. the invoked deity], undergoes all his or her trials, and emerges triumphant." The result of

a successful dramatic invocation, Crowley argues, is that the magician becomes aware of his or her True Will.[43] This result is, of course, the primary goal of Thelemic Magick.

Crowley proposed that one of the advantages of dramatic invocation was that it could include many roles, which could be performed by "a large number of people." Crowley argued that the authors of dramatic rituals should be "well-skilled" poets. He warned that "lengthy speeches and invocations" detracted from a dramatic ritual's power. Plentiful action, on the other hand, increased the effectiveness of dramatic ritual. Crowley advocated for a combination of careful rehearsal and improvisation for the development of dramatic rituals. While Crowley advised that the majority of a ritual should be conventionally rehearsed, he proposed that, in those rehearsals, "care should be taken to omit the climax, which should be studied by the principal character in private." Preventing the other participants from seeing the development of the principal character's climactic moments would prevent the ceremony from becoming "mechanical or hackneyed" and preserve "the element of surprise." In this way, the ritual might enable the "lesser characters to get out of themselves at the supreme moment." Finally, Crowley taught that dramatic rituals should conclude with "an unrehearsed ceremony," such as a dance, which might be fueled by "appropriate libations."[44] For Crowley, every aspect of theatre was essential to the practice of Magick.

THELEMIC PLAYS

Crowley's many plays give expression to his spiritual ideas and critical perspectives on established religion. Crowley published some of his earliest plays in the aforementioned *Works of Aleister Crowley*, which appeared between 1905 and 1907. Crowley presents all of the materials contained in this collection as a documentation of the religious transformation that he underwent between 1898 and 1907. 1898 is the year in which Crowley was initiated into the Hermetic Order of the Golden Dawn. By 1907, Crowley had written *The Book of the Law*, and his hostility toward restrictive Christianity had increased.

The preface to *Works of Aleister Crowley* explains that the collection represents a communication from "an unconventional mind brought up in conventional surroundings" whose "views on religious matters will be found unpalatable in some quarters." The preface describes Crowley as a

person who has "revolted" against religious norms and "investigated the religious beliefs of many nations" in order to give expression to his own religious perspective.[45] Crowley never mentions *The Book of the Law* or Thelema in his *Works*. Nevertheless, the nature of the ideas that Crowley explores in this collection mirror both the calls for social freedom and the rejection of restrictive religion that are contained in *The Book of the Law*, as well Crowley's later Thelemic writings.

An introductory statement in the first volume of *Works of Aleister Crowley*, explains that "the poems collected in Volume I comprise the whole of the first period of Crowley's life; namely that of spiritual and mystical enthusiasm."[46] Crowley, it is written, views these works as "Juvenilia," and has destroyed most of the manuscripts that he wrote during this time period.[47] The works that Crowley chose to include in this section acknowledge the debt that he owes to the Golden Dawn for his religious development. Volume I contains a play titled *Jephthah* (1899), which is based upon a story in *Judges* (Ch. 11) that concerns a warrior who leads Israel to victory in a war against the tribe of Ammon. In *Jephthah*, the title character must sacrifice his daughter, Abdulah, to keep a vow with God. In response to this fate, Abdulah declares:

My father, O my father! I am passing

Into the night. Remember me as drawn

Into the night toward the golden dawn[48]

In a footnote in the text of the play, Crowley explains that he was still an active member of the Golden Dawn when he wrote *Jephthah* and that, at this time, the term "Golden Dawn" meant to him what "Christ" means to an evangelical Christian.[49] In other words, Crowley viewed the teachings of the Golden Dawn as a messianic force that saved him from damnation.

In *Tannhäuser* (1901), Crowley promotes the Golden Dawn tenet that "all the main religious and mystical traditions of the globe" reflect a single "primal wisdom."[50] In this preface Crowley states that he blends Hebrew and Egypto-Christian symbolism in his works to familiarize his readers with the "one thing of any importance," which is, the "Origin of Religions."[51] Crowley further clarifies what he means when he discusses the origin of religions:

I take it there have always been on earth those … "great spiritual giants" … and that such persons, themselves perceiving Truth, have tried to "diminish the

message to the dog" for the benefit of less exalted minds, and hidden that Truth (which, unveiled, would blind men with its glory) in a mass of symbols often perverted or grotesque, yet to the proper man transparent....Now, regarded in this light, all religions...are contemptible.[52]

When one looks past Crowley's jab at religion in general, the above quotation suggests that the traditional religions of the world have intentionally concealed the truths of a primordial tradition. Crowley's claim to revive aspects of that lost esoteric religion with his plays was not unique. This was a project that he shared with Blavatsky, Tingley, Steiner, Schuré, Lévi, and many other leading figures of the Occult Revival.

In the second and third volumes of *Works*, Crowley wrote several dramas that represent Christianity as a religion designed to enslave human beings.[53] In *The God-Eater* (1906), Crowley used jokes and blasphemous language to attack Christianity, which is a dramaturgical approach that he would continue to employ in later plays. In an opening statement to *The God-Eater*, which is contained in volume 2 of his *Works*, Crowley writes:

> The idea of this obscure and fantastic play is as follows:—By a glorious act human misery is secured (History of Christianity). Hence, appreciation of the personality of Jesus is no excuse for being a Christian. Inversely, by a vile and irrational series of acts human happiness is secured (Story of the play).[54]

The act by which human happiness is secured is nothing less than the overthrow of Christianity, which is represented by an inversion of the resurrection story. In the play, a human victim is killed, mummified, displayed, and revered as a god by her followers. This ceremony parodies the story of Jesus' resurrection, and it also paints Christianity as a religion that worships and celebrates death, rather than the beauty of life.

Why Jesus Wept (1905) is a comedy that attacks Christianity more harshly than any of Crowley's previous plays. The play is preceded by a "Dedicatio Extraordinaria," which is a response to G. K. Chesterton, who critically reviewed a collection of poetry titled *The Soul of Osiris* that Crowley published in 1901. Although Chesterton proclaimed Crowley a gifted poet, he lamented Crowley's status as a decadent poet who, like so many other decadent poets, sought "alternative forms of spirituality" and "import[ed] religions." (By describing Crowley as a "decadent," Chesterton uses terminology that, at that time, was regularly applied to Symbolist dramatists.) Chesterton described Crowley as "a strong and

genuine poet" and predicted hopefully that he would "work up from his appreciation of the Temple of Osiris to that loftier and wider work of the human imagination, the Brixton chapel."[55] For Crowley, Chesterton's representation of him as a wayward Christian who might one day return to the fold was repugnant.

Crowley felt the need to respond to Chesterton's pro-Christian statements. In the "Dedicatio Extraordinaria" to *Why Jesus Wept,* he wrote:

> Dear Mr. Chesterton,
>
> Alone among the puerile apologists of your detestable religion you hold a reasonably mystic head above the tides of criticism. You are the last champion of God…
>
> The occasion of this letter is the insertion of a scene equivalent to an "appreciation of the Brixton Chapel" in my masterpiece "Why Jesus Wept." You asked me for it; I promised it; and I hope you will like it. Can I do more than make your Brixton my deus ex machinâ? [56]

Crowley finishes the "Dedicatio Extraordinaria" by announcing himself the "young warrior" of a "new religion" whose "number is the number of a man."[57] Crowley's letter to Chesterton is written from the perspective of a religious opponent of Christianity. Chesterton is a champion of god, and Crowley is prepared to face him in conceptual battle to promote his own religious worldview.

Why Jesus Wept is a play that exhorts people "to choose the evil and avoid the good—i.e. as judged by Western, or 'Christian' standards."[58] The play depicts the activities of several characters who confront one another as they struggle to maintain and subvert Christian morality. In scene 6, a character named Sir Percy Percivale encounters the young and lovely Molly Tyson, and they fall in love instantly. However, Lady Angela Baird, who is a 63-year-old temptress who hates Percy and Molly for their innocence, quickly ends their budding romance by offering Sir Percy immediate sexual gratification as an alternative to Molly's virginal love. Percy chooses fornication over chaste love. Percy represents this decision as a magical act of transformation when he states:

> He who doth not know
> And fears and hates,
> Is not as he who cares not, but creates
> A royal crown from an old bonnet string,
> A maiden from a strumpet: that is to be

like God,
who from all chaos, from the husks of
matter,
Crusts shed off putrefaction, shakes a wing
And flies; bids flowers spring from the dull
black sod.[59]

Percy views his romance with Lady Baird as a chance to create his own moral virtues, rather than passively accepting the virtues of Christianity. Even after Lady Baird dismisses the disappointed Percy as her lover, he continues to reject Christian values. Later in the play, for example, Percy meets Molly who laments that she is pregnant and her honor is at stake. Rather than saving Molly's reputation by marrying her, Percy begins a morphine habit and wanders about town trying to find a chemist to refill his prescription. Molly becomes a prostitute, and seeks clients among the people leaving the theatres at night. While both characters are in grave physical and social danger, they are free of conservative Christian restriction.

Christianity, however, arises again in the final scene of *Why Jesus Wept*. In the final moments of the play, Percy and Molly have been transformed from sickly addict and prostitute to physically healthy humans through the divine power of the Christian God. Crowley presents this state of affairs as misfortune. A character named "The Poet" describes Percy's previous drug habit as a means of escape from England's conservative Christianity, and, therefore, "something to be envied of ye all."[60] The Poet, who is none other than Crowley himself, shakes Britain's Christian dust from the soles of his feet, and enters life as the proselytizer of an alternative system of religion, in which complete mental and physical freedom is the key to gnosis.

By referencing the name of a famous knight in *Why Jesus Wept*, Crowley invokes the esoteric literary tradition of Rosicrucianism, which is often concerned with the pilgrimage of a Christian mystic. The mystic undergoes a spiritual transformation by means of a pilgrimage. In *Why Jesus Wept*, the ethics of this story are inverted. Unlike Rosicrucian initiation tales that depict the spiritual improvement of the pilgrim, the lead character of *Why Jesus Wept* is spiritually and physically degraded as a result of his contact with Christian piety.

For Crowley, Pan symbolized the combination of sexuality and religion that were essential to his understanding of the practice of sex magic. Crowley's fascination with Pan coincided with a literary cult of Pan that

emerged in England in the works of Romantic English poets such as Wordsworth, Keats, and Shelley. In this literary current, Pan figured as the "personification and guardian of the English countryside" and "the deity of shady nooks in which humans could lie in the heat of the day." Between 1895 and 1914, Pan reached the height of his popularity with the English, and was perceived as "the one fashionable subject upon which every minor poet thought that he could turn out a ditty." For Crowley, Pan became a symbol of the Eon of the Child: that point in the future when humans would be freed to live according to Will and escape the parental eye of Christian morality. By the time that Crowley made Pan one of the central characters in his 1910 play, *The World's Tragedy*, the deity had emerged as "the liberator of those types of sexuality that were either repressed or forbidden by convention," including homosexual sex. [61]

As understood by English authors such as Crowley and Victor Neuburg—who for a time was Crowley's lover and magical partner— Pan was a divine force with the power to reveal as sacred what conservative Christians often labeled as abomination. Crowley represented Pan as the sexual liberator of humanity and the sacred enemy of Christianity in his play *The World's Tragedy* (1910). In *The World's Tragedy*, Crowley reshaped the structure and symbols of the medieval passion play. In the play, Christianity is an oppressive force and the playwright gleefully predicts the religion's future downfall.

In the preface to *The World's Tragedy*, Crowley speaks at great length about his childhood within the Plymouth Brethren. After revealing the abuse he suffered while a student at the Plymouth Brethren school, and his subsequent rejection of Christianity, Crowley describes himself as a benevolent anti-Christ set on overthrowing an evil, religious regime:

> What I am trying to get at is the religion which makes England to-day a hell for any man who cares at all for freedom. That religion they call Christianity; the devil they honour they call God. I accept these definitions, as a poet must do, if he is to be at all intelligible to his age, and it is their God and their religion that I hate and will destroy.[62]

In its entirety, *The World's Tragedy* presents the central characters of Christianity—including god and Jesus—as diabolical beings that must be defeated by the revival of a more ancient and pagan tradition.

In *The World's Tragedy*, Crowley represents the conflict between the religion of Pan and Christianity by representing the Judeo-Christian god as a filthy vulture. The vulture hides in a tree and watches "with intense

envy and disgust" as Pan's worshippers participate in a sacred orgy that includes both heterosexual and homosexual sex.[63] The vulture, who is named Yaugh Waugh, loathes the manner in which the joyous revelers worship their god, because he views sex as an abomination.

In contrast to the beautiful bodies of the pagan revelers, the vulture god's repugnant nature is revealed through bodily sounds and an irregular, staccato form of verse that is peppered with belches and squawks. Yaugh Waugh's process of creation is crude and disgusting, as is shown when the god gives birth to the Christ-figure, Issa:

> VULTURE: Coagulated yolk of the addled egg
> Of chaos! Hatch it out!...
> Ga! Ga! I've got a son:
> What will it be?
> O heaven—a lamb!...
> Uck! Uck! The morning's carrion
> Bubbles in my paunch...
> For the windy vomit of me
> Shapes itself into a sorry
> And bedraggled pigeon.[64]

Issa the lamb is formed from rotten egg yolk, and the pigeon, who is the holy spirit, emerges from Yaugh Waugh's vomit. The vulture, pigeon, and lamb form an evil trinity that fills the heavenly realm with bile and suppresses the sacred sexual rites with which Pan is invoked and worshipped.

In a later episode of the play titled "The White Wind," Crowley depicts Yaugh Waugh's creative corruption with a repulsive revision of the Christian story of the divine conception. Unlike the biblical Mary, who is informed that she is pregnant with a child from God, the character of Miriam, who is the mother of Issa in *The World's Tragedy*, is driven by lust to sneak about the outskirts of her squalid village near a stagnant lake in search of sexual encounters.[65] Simultaneously obsessed with and repulsed by sex, Miriam is incapable of the sacred, magical sex that Pan demands from his followers. Because of her corrupt sexual nature, Miriam is a suitable vessel for Yaugh Waugh's plan to debase sex and, thereby, to prevent human beings from experiencing the divine aspect of life. Yaugh Waugh sends a group of personified anti-virtues to rape Miriam: among them are Fear, Piety, Hypocrisy, Pity, Charity, Bigotry, Chastity, and Cunning.

The World's Tragedy also contains a revision of the Christian Nativity story. In this scene, the three wise men bring the infant messiah gifts that

will help him to enslave mankind. King Govinda brings gold so that Issa can "buy the souls of priests." King Chau offers Issa frankincense to "dull…the sense of his slaves" and make them "docile in their slavery." King Alexander, the priest of Pan, brings myrrh to represent the "sorrow black and sinister" that Issa and his religion will bring to the human race.[66] Unlike the painless birth of Jesus that is described in some versions of the Nativity, Miriam feels great pain during childbirth in *The World's Tragedy*:

MIRIAM: Oh dogs, kings, gods begone!
Bone splits from bone.
I am ripped up like a sweating sow
On the horn of a buffalo!
What care I for your gifts, unless
They might relieve this wretchedness?
God! I am split asunder
Like a cloud by a clap of thunder![67]

Miriam's pain is accompanied by disturbing omens. In the moments before Issa's birth a hoard of frogs "issue from the maid" and "hop off croaking into the darkness."[68] The birth of god's son in *The World's Tragedy* is an infernal event, indeed.

As the play continues, the figure of Christ is negatively parodied through the activities of Issa. Issa is found in one scene lying naked with a character named "Magda," who corresponds to the biblical Mary Magdalene. The relationship between Issa and Magda is physically violent. When Issa is dissatisfied with Magda's attitude "he fists her in the abdomen." Issa's brutal nature contradicts traditional depictions of Christ as a peaceful being.

Issa also exhibits dishonesty. When talking with his disciple John, Issa confides that his "unnatural father" has sent him to die and be resurrected in order to "spoil life for everyone."[69] John, who is in the process of writing the New Testament, offers to change the facts so that human beings would perceive Yaugh Waugh's evil plan as a salvific gift. Issa approves of this idea.

It is only Pan's priest, King Alexander, who realizes with clarity that Issa's mission will wreak havoc upon the world, but Alexander also predicts the coming of "a lion" that "shall rise and swallow" the legacy of this false messiah's actions.[70] Lest there should be any confusion about the relationship between Alexander's prophecy and Thelema, Crowley made a clear connection between the two in the preface to the play:

We should end the play in despair were it not that Alexander comes forward and obligingly prophesies the arrival of Aleister Crowley—the savior of the

Earth. So that the reader need only turn back to the title-page to see that the Light hath indeed arisen in the darkness.[71]

Crowley's representation of the Judeo-Christian god as an evil and petty deity is not something that he invented out of thin air. This concept has roots in the Gnostic theology of late antiquity. In *Artaud and the Gnostic Drama*, Jane Goodall discusses the work of the second-century Gnostic theologian, Valentinus. According to Goodall, Valentinian theology argues that "Biblical accounts of creation...came in on the second act" by failing to recognize that the creator of the earth described in Genesis is "not the original God" of life and the universe. The being who created earth was created by an original god who does not stoop to work in matter. Valentinian Gnostics believe that the original god should not be confused with the god who used matter to create earth because the latter is an "abhorrent, excessive manifestation of form" whose physical creations are contaminated by inferior passions. Among the passions that Gnostic theologians sometimes perceived in the god of the Old Testament are anguish, terror, bewilderment, ignorance, and jealousy. It is jealousy, for instance, that drove this god to become "jealous" and proclaim that "there is no other god beside me."[72] In *The World's Tragedy*, Yaugh Waugh bears an affinity to Valentinian representations of the god of the Old Testament.

THELEMIC PERFORMANCE

There is no evidence that any of the plays written above were ever performed during Crowley's lifetime. For the most part, Crowley's plays were experienced as literature. There is one exception to this rule: a play titled *The Ship*. Crowley wrote *The Ship* while touring Moscow in 1913 as the impresario and producer of a musical entertainment titled *The Ragged Ragtime Girls*, which comprised a group of women dressed in "diaphanous gowns" who played "ethereal music while dancing."[73] There does not seem to have been any religious intention behind *The Ragged Ragtime Girls*. It was part of a temporary exploration of professional theatre that Crowley undertook in the first half of the 1910s. Crowley quickly abandoned this line of work, which he finally concluded was "a sickening business."[74] Despite the failure of Crowley's impresario career, when Crowley wrote *The Ship* during the 1913 *Ragged Ragtime Girls* tour, he included within that script a portion of text that would prove central to the most sacred and the most often performed public ritual of the OTO: *The Gnostic Mass*.

The Ship is a play that depicts the death of a masculine magical force, and its resurrection through a feminine magical force. In the play, the masculine force is associated with the sun and located in the body of John, who is the "high priest of the Sun." The feminine force in the play is Julia, who is a priestess whose power is associated with the moon. In the play, Julia oversees a magical ritual with a young virgin that brings John back to life after he has been slain by invaders of his occult temple. On one level, the story of *The Ship* is one of a god who is destroyed by enemies and brought to life once again through divine intervention. As such, *The Ship* references all religious narratives that involve the death and resurrection of a god. On another level, this play references a central mystery of Thelema: the conception and birth of a magical goal—be it a physical project or spiritual knowledge—through the "mystic marriage" of male and female magical energy.[75]

The final, climactic moments of *The Ship* include a series of poetic phrases that speak in overt language about the blending of male and female energy during the moment of Magickal creation. The following is an excerpt from that section of the play:

> FIRST SEMI-CHORUS: Glory to Thee from gilded tomb! Glory to Thee from waiting womb!
> SECOND SEMI-CHORUS: Glory to Thee from virgin vowed! Glory to Thee from earth unploughed!
> FIRST SEMI-CHORUS: Glory to Thee, true Unity of the eternal Trinity!
> SECOND SEMI-CHORUS: Glory to Thee, thou sire and dam and self of I am that I am!
> FIRST SEMI-CHORUS: Glory to Thee, beyond all term, thy spring of sperm, thy seed and germ![76]

In 1913, Crowley inserted this portion of *The Ship* into his *Gnostic Mass*. Now referred to as "the anthem" this passage celebrates the successful outcome of a Magickal process that has involved the blend of feminine and masculine energies. In the *Gnostic Mass*, "the Office of the Anthem" is recited before the preparation of cakes and wine that are later consumed by *Gnostic Mass* participants.[77] Crowley wrote *The Gnostic Mass* so that members of the OTO could have a shared ritual experience that embodies the principles of Thelema. Among Thelemites, the *Gnostic Mass* is not considered a "Class A" document: that is, a sacred document that represents "the utterance of an adept" and is beyond all criticism. In Class A documents, "not so much as the style of a letter" may be changed.[78]

Neverthless, when OTO lodges perform official versions of the *Gnostic Mass*, they are required to closely follow the specifications for altars, magical instruments, directional positioning, costumes, accessories and gestures within the text. The *Gnostic Mass* calls for "a High Altar" in the East, that is "7 feet in length, 3 feet in breadth, 44 inches in height." This altar is to be "covered with a crimson altar-cloth," and placed between two standing pillars or obelisks. Three stairs covered with "black and white squares" should provide access to the altar.[79] It is upon this altar that the priestess sits when she and the priest symbolize the moment of magical consummation by thrusting the tip of a lance into a goblet of wine.[80] The Priest must be dressed in a red robe and headpiece, as well as a gold or platinum crown with "the Uraeus serpent twined about it."[81]

The *Gnostic Mass* also calls for two properties that are related to the origins of Thelema: *The Book of the Law* and the "Stele of Revealing." One of the officers of the ritual—the Deacon—carries a copy of *The Book of the Law*. It is the Deacon who opens the door of the temple to allow the "congregation" to enter. The Deacon's place is a small altar that stands between the High Altar in the east and an "upright tomb" in the west, where the Priest remains until the Priestess resurrects him. The Deacon's first line is the Law of Thelema: "Do what thou wilt shall be the whole of the Law." [82]

The *Gnostic Mass* text states that the High Altar in the east should be decorated with a replica of "the Stele of Revealing." This is an eighth-century, Egyptian funerary stele that is held in Cairo's Egyptian museum. In 1904, when Crowley's first wife, Rose, claimed to have a message for him from the Egyptian god Horus, Crowley tested her by taking her to the Cairo museum and asking her to show him an image of Horus. (He did this because he was under the impression that Rose knew little or nothing about Egyptian mythology.) To Crowley's surprise, Rose pointed to a glass case with this stele, which contains an image of Horus. Crowley was amazed to discover this object was catalogued as exhibition number 666. It was shortly after this event that Crowley wrote *The Book of the Law*.[83]

Nudity is required in the *Gnostic Mass*, but it is not required that the audience see the nudity. At one point in the ritual, the Priestess sits on the High Altar and is hidden by a closed curtain or "veil." While hidden, the Priestess recites an invocation of a divine feminine force. During this portion of the ritual, the Priestess is required to divest "herself completely of her robe." Thus, anyone who has read the *Gnostic Mass* knows that the Priestess is nude when she recites her speech from behind the veil.[84] The nudity in the *Gnostic Mass* raises the possibility of sexual objectification.

The Priestess may choose to remain nude throughout the rest of the ritual, and, if she does, the congregants may look at her body while they communicate. It should be noted, however, that the Priestess is not required to reveal her body to the congregation. The text of Crowley's *Gnostic Mass* allows the Priestess to put her robe on before the Priest opens the veil again.[85] In other words, the Priestess is required to be nude behind the veil, but nudity is not required once the veil is opened. It is the Priestess who decides whether or not to incorporate ritual nudity into the remaining portion of the ritual. The use of nudity in *The Gnostic Mass* predates the incorporation of nudity into the rituals of Gardnerian Wicca and other forms of neo-pagan ritual in the late twentieth and early twenty-first centuries.

The *Gnostic Mass* is the most often performed ritual of the OTO. Every official lodge of the OTO is required to perform *The Gnostic Mass* on a monthly basis. In some instances, it is performed for the general public, and, in other cases, for OTO members only. The latter situation poses much less risk of misunderstanding or disapproval from the audience. Although Crowley insisted that the *Gnostic Mass* be presented to non-Thelemites, he learned during his career to be careful about presenting Thelemic rituals to the public. Crowley's ideal audience for ritual performance was one populated for the most part by "initiates of the same mysteries, bound by the same oaths, and filled with the same aspirations."[86] Crowley learned about the potential hazards of blurring the line between private and public ritual when he produced *The Rites of Eleusis*.

The Rites of Eleusis was a series of seven magical rituals that were performed on consecutive Wednesdays at nine in the evening in London's Caxton Hall between October 19 and November 30, 1910. According to the publicity that Crowley published before *The Rites of Eleusis* opened, these performances were not created as an attempt to reconstruct the original Eleusinian rites, as Schuré's *Sacred Drama of Eleusis* had been. Instead, Crowley's *Rites of Eleusis* were "religious services" that would "induce religious ecstasy" through the invocation of Saturn, Jupiter, Mars, Sol, Venus, Mercury, and Luna. These dramatic invocation rituals involved a combination of dance, music, and poetic recitation.[87]

The formula for ecstatic invocation in *The Rites of Eleusis* was based upon ritual experiments that Crowley had conducted in the earlier part of 1910. These ritual experiments took place in the home of Commander G. M. Marston, who was hosting a rite to summon "Bartzabel, a spirit of Mars." During the performance of this ritual, Victor Neuburg "entered a trance, rose to his feet, and danced an unscheduled dervish," after which

point he began to speak as Bartzabel.[88] Marston was so impressed by these events that he suggested Crowley and Neuburg should convert a ritual of this sort into "some type of public spectacle" and charge admission to those who want to see it. Crowley took this suggestion to heart.[89]

Later, Crowley determined that poetic recitation and music should play a part in the public ritual that he planned to perform. Crowley discovered what he believed to be the appropriate intersection between these two art forms one evening when he and his disciple Leila Waddell were socializing with other guests at his London apartment. During the evening, Crowley challenged Leila to a call-and-response game: he would recite a poem and she would respond to it by playing a piece on the violin that reflected the mood of the poem. This interdisciplinary dialogue excited the people who were present to witness it.[90] Thus, Crowley established a formula of dance, poetry, and music that would form the practical basis of *The Rites of Eleusis.*

Before producing *The Rites of Eleusis* at Caxton Hall, however, Crowley staged a smaller experimental production titled *The Rite of Artemis* for an invited audience. The performance took place in a spacious apartment at 124, Victoria Street, that served both as Crowley's home and as the head-quarters of Crowley's magical order, the *Argenteum Astrum.* The invited audience included members of the order, some of their friends, and a few press people. The reviews of this performance described a semidark space lit by "dull-red light," that was peopled by "various young men clad in robes of white, red, or black."[91] Some of the performers held swords, and one brother recited the "Banishing Ritual of the Pentagram," which is a Thelemic ritual that is performed just before the start of a ritual in order to clear the space of lingering energies that might cause interference.[92] The audience of *The Rite of Artemis* was invited to take a drink from a "Cup of Libation," which contained a beverage that was infused with "alkaloids refined from the peyote plant."[93] In 1910, it was not illegal to purchase and use such substances.[94]

The use of these substances perhaps contributed to the sense of ecstasy that was experienced by several of the performers and audience members. A reporter from *The Sketch* wrote enthusiastically:

> Again a Libation; again an invocation to Artemis....A young poet, whose verse is often read, astonished me by a graceful and beautiful dance, which he contin-ued until he fell exhausted in the middle of the room, where, by the way, he lay until the end. Crowley then made supplication to the goddess in a beautiful and unpublished poem. A dead silence ensued....the figure enthroned took a violin

and played an *Abendlied* [evening song] so beautifully, so gracefully, and with such intense feeling that…most of us experienced that Ecstasy which Crowley so earnestly seeks.[95]

More than meaning or the propagation of a specific Thelemic teaching, it seems that the inducement of religious ecstasy was the principal goal of *The Rite of Artemis*. Crowley was not interested in conveying heady occult principles. Instead, he sought to provide a spiritual experience that transcends the rational.

Crowley was encouraged by the positive response to *The Rite of Artemis*. He replicated the combination of music, poetry, and dance in the seven *Rites of Eleusis*. He did not, however, incorporate the Cup of Libation into *The Rites of Eleusis*. The public response to *Rites of Eleusis* was quite different than the response to *The Rite of Artemis*. The press's response ranged from indifference to hostility. In fact, the relationship between Crowley and his followers would be significantly damaged by statements made in some of the *Rites of Eleusis* reviews.

The texts of *Rites of Eleusis* do not readily reveal what it was exactly that so disturbed certain reviewers. Each of these texts is a conglomeration of poetry by Swinburne and Crowley, which is interlaced with secret knocks and magical gestures that bring the recognition gestures of Freemasonry to mind. Altogether, *The Rites of Eleusis* read like a series of dramatic invocation rituals such as those that Crowley describes as ideal in *Magick in Theory and Practice*. In his autobiography, Crowley describes *The Rites of Eleusis* as invocations of deities that are called upon to "solve the Riddle of Existence." In each play the invoked god or goddess is proven incapable of arriving at a solution to this riddle. It is not until the final "Rite of Luna" that Pan appears and "displays the hope of humanity, the Crowned Child of the Future."[96] This child is the previously mentioned offspring of the mystic marriage who is brought to life through the union of the masculine and feminine divine.

Every aspect of *The Rites of Eleusis* was utilized to induce spiritual ecstasy. Swinburne's poetry was likely featured because of this author's assertions that verse could "induce in the reader a visionary state that opens the mind to the realms of symbolist mystery."[97] Crowley was even ecstatic in his memorization of poetry: he learned hundreds of lines of verse every week during the run of *The Rites of Eleusis*.[98]

Critics commented upon the extreme abandon in Victor Neuburg's dancing in *The Rites of Eleusis*. Neuburg apparently made a powerful effect upon the audience. Crowley describes this aspect of the performance in his autobiography, when he states that Neuburg

gave the impression that he did not touch the ground at all, and he would go round the circle at a pace so great that one constantly expected him to be shot off tangentially....The idea of his dance was, as a rule, to exhaust himself completely. The climax was his flopping on the floor unconscious....when he succeeded the effect was superb. It was astounding to see his body suddenly collapse and shoot across the polished floor like a curling-stone.[99]

The purpose of Neuburg's dance was to manifest the forces being invoked with his body. In other words, he used ecstatic dance to achieve a state of trance.[100]

Ecstasy was also promoted through the musical instrumentation of *The Rites of Eleusis*, which included tom-toms and Leila Waddell's violin. Crowley had gained an interest in the tom-tom through the research of Commander Marston, who was interested in its sexual effects upon Englishwomen.[101] Marston's ideas about the ecstatic effect of the tom-tom inspired Crowley to dedicate *The Rites of Eleusis* to him.[102] In *The Rite of Luna*, the last of *The Rites of Eleusis,* Pan carries a tom-tom. Thus, Crowley identified the tom-tom's sexual influence with the sexual power of Pan.[103]

Leila Waddell was reportedly an excellent violinist. She was most likely born in Australia or New Zealand. She began learning to play the violin at the age of seven from a local barber, who was also an accomplished musician. After her first tutor died, Leila went to a new tutor, who discovered that she knew nothing about the theory of music, could not locate notes on the instrument, and could not read a score. She had learned everything she knew about the instrument through observation and imitation. Although Waddell's new tutor taught her how to read music, her ability to play from memory proved quite valuable in *The Rites of Eleusis,* because she often had to play in semidarkness.[104] Although Waddell composed many of the pieces for these productions, she and Crowley selected other well-known compositions that they thought were appropriate for the performances. Some of the reviewers who responded with general hostility to *Rites of Eleusis* made positive comments about Waddell's skills as a violinist.[105]

Publicity photographs of *The Rites of Eleusis* show a mise-en-scène that was inspired by the practices of ceremonial magic established by Eliphas Lévi and the practices of the Golden Dawn.[106] All of the participants wore robes of various colors. These colors corresponded to the nature of the deity being evoked. Black corresponded to Saturn, blue to Jupiter, red to Mars, whitegold (leopard skin) to Sol, green to Venus, iridescent violet or mixed colors to Mercury, and silver to Luna.[107] Some of the robes

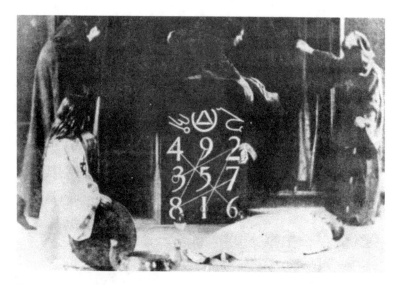

Figure 4.2 Newspaper photograph from *The Rites of Eleusis*. Directed by Aleister Crowley. Location: Caxton Hall (London, England). Date: 1910. Photo courtesy: Ordo Templi Orientis Archives.

had hoods that could be adjusted to either reveal or conceal the face of the performer. The robes were also decorated with special symbols such as the Rosicrucian rose and the cross, the Star of David, and the pentagram. In one photograph, Leila Waddell leans over the body of Aleister Crowley, which is stretched out upon an altar that has been painted with cabalistic numbers and a circle within a triangle. Behind them a curtain is being opened by two hooded figures with concealed faces (figure 4.2).[108] The altar is just one of the instruments of the ceremonial magician that appears in other Thelemic rituals such as *The Gnostic Mass*. The wand, cup, sword, and disk that are present in the photographs are the same tools of Magick that Crowley recommends to the initiates of the OTO and the *Argenteum Astrum*.[109] Eliphas Levi recommended these instruments for the practice of ceremonial magic in *The Dogma and Ritual of High Magic*.

A ticket allowing entry to all seven of the *Rites of Eleusis* cost over five pounds—a sum that is equal to about $200 in the present.[110] Members of the *Argenteum Astrum* received complimentary tickets to the production. They were expected to wear appropriate robes and "assist the Great

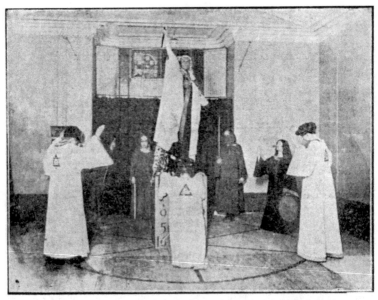

Crowley with members of the A∴A∴ performing his *Rites of Eleusis* at Caxton Hall, 1910 (from *The Liverpool Courier,* Oct. 28th, 1910).

Figure 4.3 Newspaper photograph from *The Rites of Eleusis.* Directed by Aleister Crowley. Location: Caxton Hall (London, England). Date: 1910. Photo courtesy: Ordo Templi Orientis Archives.

Officer" in the performance. Crowley asked the members of his order to "make the rites known among [their] friends" and to "induce them to take tickets."[111] Crowley also sought to increase the audience by publishing a full-length article on *The Rites of Eleusis* in the September issue of *The Occult Review.* He took publicity photos at a tryout performance given for *Argenteum Astrum* members, which appeared before the premiere in the October 12, 1910, issue of *The Bystander* (figure 4.3).

Rites of Eleusis was received to reviews that ranged from expressions of mild appreciation to vicious attacks against the character of Crowley and his associates. The first major review of *Rites of Eleusis* appeared one week after *The Rite of Saturn* inaugurated the series on October 19. The review, which appeared in *The Sketch,* complained that the auditorium was too dark to see the performance clearly. The text of *The Rite of Saturn* calls for blue light, red light, and, in one moment, complete darkness.[112] The initial *Sketch* review was followed quickly by others that either took the

production seriously or treated it with good humor "as an occasion for mild whimsy."[113]

A more scathing tone was contained in a review from *The Looking Glass* that was titled "An Amazing Sect." This review suggests that Crowley and his followers were "a blasphemous sect whose proceedings conceivably lend themselves to immorality of the most revolting character." The reviewer suggested that "young girls and married women" should not be allowed to attend "such performances under the guise of the cult of a new religion."[114] On November 5, 1910, the *P. I. P.* attacked the performances with an article titled "The Black Mass Idea," which suggests that Crowley's point in producing *The Rites of Eleusis* was to provide pornographic pleasure by giving audiences the opportunity to leer at "flappers in queer garments."[115] Most damaging was an article in the *John Bull* from November 5 written by a woman who attended *The Rite of Saturn*. The journalist described the performance as a patchwork of "barbaric dances [and] sensational interludes of melodrama, blasphemy, and erotic suggestion." Although similar descriptions had been offered by the other hostile journals, the author of the *John Bull* review offered "proof" that *The Rites of Eleusis* were immoral: she claimed that at one point, while the auditorium was plunged in darkness, someone put his arm around her and kissed her.[116] The *John Bull* even made a personal attack against one of Crowley's friends, George Cecil Jones, who was also a member of the *Argenteum Astrum*. The author intimated that Jones had had homosexual sex with Crowley and other members of Crowley's circle. Although Crowley chose not respond to this attack, George Cecil Jones sued *The Looking Glass* for defamation of character. The British Court of Law determined two things: (1) Jones had been defamed, but not damaged by the defamation; (2) Crowley was a "loathsome and abominable creature." In response to this, Jones and other prominent members withdrew from the *Argenteum Astrum*. The credibility of Crowley's order was thereafter damaged, and the *Argenteum Astrum* subsequently suffered a dramatic drop in the number of new members seeking memberships.[117]

Richmond suggests that one of the problematic aspects of *The Rites of Eleusis* was that, as magical ceremonies, they were "essentially a private undertaking." It was for this reason that the noninitiated public audience was for the most part unable to view the performances with "total support and understanding."[118] If the hostile journalists in the audience had been replaced with initiates, the damaging attacks against *The Rites of Eleusis* would most likely not have appeared. Crowley's negative experience with

The Rites of Eleusis is what prompted him later to urge other Thelemites who sought to produce rituals as theatrical events to make sure that their audience was peopled with initiates and other people who were already sympathetic to the principles and practices of Thelema.

THELEMIC PERFORMANCE AND THEATRE TODAY

Today, *The Gnostic Mass* and *The Rites of Eleusis* have become central rituals of the OTO. In 2005, I visited the home of Lon Milo and Constance DuQuette, and they were kind enough to allow me to view their private collection of photographs. These photographs included images of productions of the *Gnostic Mass* and *The Rites of Eleusis* that they staged from the 1980s till recent times with the Heru-ra-ha Lodge of the OTO. The photos revealed that the OTO members handle these two texts in different ways. Because *The Gnostic Mass* is an official ritual that cannot be changed, the language and descriptions contained in this text are followed down to the smallest details. The Priest carries his sacred lance and wears his crimson robe and headdress, as well as a headpiece decorated with a snake. In 2011, I attended public performances of *The Gnostic Mass* that were staged by the members of the OTO Blue Equinox Oasis in Detroit. Every effort was made at these performances to reconstruct the ritual exactly as Crowley wrote it down in 1913.

The DuQuettes have also produced many versions of *The Rites of Eleusis* over the last 30 years. DuQuette is not alone in his restaging of *The Rites of Eleusis*: many bodies of the OTO continue to produce them "in numerous locations all over the world." Regarding the experiences he and his wife have had with *The Rites of Eleusis*, DuQuette writes:

> We discovered first hand that these little collections of poetry, music, and dance are more than plays with a magical theme. In the purest tradition of the *Eleusinian* mysteries, they really are initiatory experiences in which both cast and audience are treated to a highly personalized change of consciousness.[119]

Among the photographs of *The Rites of Eleusis* that I saw were images of gods in pinstriped suits, Mexican sombreros, and elegant black dresses. These photos indicate Thelemites feel free to adapt *The Rites of Eleusis*.

Crowley's *Gnostic Mass* and *The Rites of Eleusis* were prominently featured at the eighth annual "Notocon," which is the national conference of the OTO. This event took place in Detroit, Michigan, on August 5–7,

2011. I attended this conference as a guest of the Blue Equinox Oasis, and there I saw another text-true production of *Gnostic Mass*, in which Sabazius, who is the current head of the OTO in the United States, played the part of the Priest.

Notocon included an exhibition of filmed performances of *The Rites of Eleusis*. These video-recorded performances were produced by OTO bodies across the country. They had been submitted to the Grand Lodge of the OTO as part of a celebration of the hundredth anniversary of 1910 premiere of *The Rites of Eleusis* in Caxton Hall. This celebration of *The Rites of Eleusis* was first announced in the Spring 2010 issue of *Agape*, which is a newsletter that serves as "the official organ of the U.S. Grand Lodge of Ordo Templi Orientis." One of the purposes of this festival was to "show the diversity with which these rites may be produced."[120] One performance group blended *The Rites of Eleusis* with costumes and melodies from Andrew Lloyd Webber's rock opera, *Jesus Christ Superstar*. Not only do the contemporary members of the OTO share Crowley's belief in the "magical potential of drama,"[121] but they also share his jocular approach toward the practice of Thelema.

Like the occult theatre produced by Rudolf and Marie Steiner, Crowley's theatre has connections to European Symbolist theatre. In *Magick in Theory and Practice*, Crowley notes the success of a dramatic ritual that included excerpts from the beheading scene of Oscar Wilde's dark, Symbolist drama *Salomé*.[122] In reference to the premiere performance of *The Rite of Saturn*, Crowley wrote that "nothing of Maeterlinck's ever produced so overpowering an oppression as this invocation of the dark spirit of Time."[123] Of course, Crowley knew Yeats's Symbolist dramas, since they were both members of the Hermetic Order of the Golden Dawn. Crowley, however, rarely said anything kind about Yeats, whom he regarded as an artistic and spiritual rival. For instance, Crowley condemned Yeast's Symbolist play *The Shadowy Waters* as monotonous in his review "The Shadowy Dill-Waters; or Mr. Smudge the Medium."[124] Despite the connections that exist between Crowley's theatre and the drama and performance of European Symbolism, his plays differ from those of Maeterlinck and Yeats, because they existed to propagate Thelema, not entertain enthusiasts of avant-garde theatre. Crowley presented himself as the conqueror of Christianity and the prophet of a new eon of religious, sexual, and social freedom in *The World's Tragedy*. He sought to induce religious ecstasy with *The Rites of Eleusis*, and he presented the unionization of male and female energies as the key to Magick in his *Gnostic Mass*. Crowley was interested in

creating great works of art. His drama and theatre, however, were created first and foremost to advance the mission of Thelema by empowering human beings to reject oppressive restrictions and to live in accordance with their Will. Crowley's work was perhaps the most iconoclastic theatre of the Occult Revival.

5. Rosicrucian Theatre and Wiccan Ritual ꙮ

This chapter concerns the theatrical aspects of two related occult movements that were established in England near the middle of the twentieth century: Alex Mathews's (1890–1942) Rosicrucian Order Crotona Fellowship (ROCF) and Gardnerian Wicca, which is a modern witchcraft religion that Gerald Brousseau Gardner (1884–1964) revealed to the public in 1951. Gardner became one of the most influential occultists of the current era, and it could be argued that Wicca is one of the most successful esoteric religions in the history of Western culture.

Before Gardner established Wicca, however, he was a member of Alex Mathew's ROCF. During his time with the ROCF, Gardner saw and performed in occult dramas that Mathews produced in the Rosicrucian Theatre that the ROCF had built in Christchurch, United Kingdom. Gardner claimed that his involvement with Mathews's Rosicrucian Theatre led him to the person who first initiated him into an ancient religion of witchcraft.[1] Both Mathews and Gardner valued theatre as an art form that could spiritually transform human beings, but each of them had different opinions about the ideal purpose, form, and effect of occult theatre and performance.

ALEX MATHEWS AND THE ROSICRUCIAN ORDER CROTONA FELLOWSHIP

Actor, playwright, and occultist George Alexander Sullivan, who also went by the pseudonym Alex Mathews, founded the ROCF in 1911. (I will use the pseudonym Mathews throughout this chapter.) The ROCF became a presence in the community and public press of Christchurch in 1937, when Mathews moved his organization's headquarters from Liverpool to

this town in southern England. After his move, Mathews soon oversaw the construction of a Rosicrucian Theatre, in which he presented plays that taught his perspective on the reality of ghosts, karma, and reincarnation. Mathews also sought to establish a national theatre festival dedicated to the production of Shakespearean and modern plays that he hoped would become a tourist attraction. By proposing the festival, Mathews tried to persuade the citizens of Christchurch to view the members of the ROCF as friends. Despite his efforts, the Christchurch community did not respond to the Rosicrucian Theatre with much enthusiasm, and some members of the community slandered Mathews. Like every other occult movement discussed in this book, a portion of the Christchurch community viewed the ROCF with suspicion. After struggling for acceptance and popular success in Christchurch between the 1937 and 1942, Gerald Mathews died of heart disease. In the early 1950s the ROCF headquarters moved from Christchurch to Southampton. Today, little physical evidence remains of the ROCF. Most of the relevant documents are held in the Rosicrucian Collection of the University of Southampton's Hartley Library, and also in the newspaper archive of the Christchurch Local History Society. I visited both of these collections in the summer of 2011.

Gardner described Wicca as the survival of a "Stone Age" cult[2] that uses the performance of "sacred drama" to facilitate communion with the divine and to raise magical power within human beings.[3] As will be seen, Gardner's equation of ritual and sacred drama bears less in common with the theatrical practices of the ROCF than with the perspectives on theatre and ritual that were espoused by Aleister Crowley, whom Gardner knew and considered an occult adept. (In fact, Gardner was a member of Crowley's *Ordo Templi Orientis*, and he incorporated Crowley's writings into his Wiccan rituals.) Many of Gardner's Wiccan theories about occult performance broke away from the theatrical trends that were established during the Occult Revival. In particular, Gardner's promotion of the creative composition and adaptation of magical rituals anticipated a new, flexible, and self-reflexive approach to occult performance that has gained momentum between the 1950s and the present.

ROCF: HISTORY AND BELIEFS

Gerald Gardner: Witch—which is actually an autobiography that Gardner dictated to Sufism author, Idries Shah, who wrote the book under the

pseudonym J. L. Bracelin—discusses Gardner's days as a member of the ROCF and his involvement in a production of Mathews's play, *The Demon Monk*, which was staged at the Rosicrucian Theatre.[4] Ronald Hutton discusses Gardner's involvement with the ROCF and its theatre in *Triumph of the Moon: A History of Modern Pagan Witchcraft*. Esotericism scholar Joanne E. Pearson also discusses these subjects in her section on neo-paganism in *Dictionary of Gnosis and Western Esotericism*. In his 2000 book, *Wiccan Roots: Gerald Gardner and the Modern Witchcraft Revival*, Philip Heselton argues that some of the teachings of the ROCF have survived "through...modern Wicca," but Heselton does not discuss ROCF teachings in his book. Indeed, the early development of Wiccan theology and ritual does have some connections to the teachings and theatrical practices of the ROCF. To better understand these connections, the teachings and theatrical practices of the ROCF and the Rosicrucian Theatre should be considered in detail.

Before Alexander Mathews moved to Christchurch and founded the Rosicrucian Theatre, he established the ROCF in his hometown of Liverpool. According to Mathews, he first founded the order in 1911 under the direction of a mysterious "ancestor" named "J.S." Mathews said that J.S. charged him with the "reestablishment of an Occult Society... on the pattern of the old Rosicrucian Fraternity in the nature of a Society with Secrets."[5] The first ROCF seems to have ceased operations during World War I. There are no records of the ROCF before World War I, but Mathews claimed that the appearance of the ROCF in the 1920s represented the reestablishment of an older order, rather than the foundation of new one. By 1926, the ROCF was publishing pamphlets and operating the "Liverpool College of Psychotherapy and Natural Therapeutics," which taught correspondence courses that explored connections between the mental, physical, and spiritual aspects of human existence.[6] Although Mathews claimed that his teachings were rooted in a Rosicrucian tradition of occult wisdom that was passed to his order from the medieval and ancient Egyptian eras, it is clear from reading his pamphlets and plays that he drew many of his ideas from Spiritualism and the teachings of Rudolf Steiner. A brief overview will demonstrate this.

There are two ideas concerning the "human individuality" that are virtually universal among Spiritualists: (1) the human individuality can survive death and (2) it can "communicate from the afterlife."[7] One member of the ROCF writing under the name Maitre L' Inconnu suggested this idea in a pamphlet titled *The Rosicrucians* when she wrote that the human

being "can live without a body."[8] Mathews expressed the idea of death as a change, rather than an end, of the human individuality with greater specificity in his plays and short stories. Some of Mathews's plays are primarily concerned with promoting the spiritualist idea that ghosts exist and can communicate with the living.

Mathews did not identify the ROCF as a spiritualist society. He described it as part of a Rosicrucian tradition that predates modern Spiritualism. Mathews placed a plaque listing a line of Rosicrucian adepts who are the spiritual ancestors in the ROCF Ashrama that was eventually built in Christchurch. This plaque includes the names of several legendary and historical figures from esoteric history, including Rudolf Steiner, Christian Rosencreuz (the legendary founder of the first Rosicrucian brotherhood), Cornelius Agrippa, Jacob Boehme, Dr. John Dee, and Cagliostro. An overview of Mathews's teachings will reveal that Mathews drew a great deal of inspiration from Steiner's Anthroposophy.

Like Steiner, Mathews was interested in the relationship between the physical body and the spiritual world. He agreed with Steiner that the ability to perceive spiritual beings and realms was essential to spiritual development. Hints of Steiner's teachings are apparent in an ROCF pamphlet titled *Rosicrucian Philosophy: The Invisible World*, the title of which brings to mind Steiner's book, *Theosophy: An Introduction to the Supersensible Knowledge of the World and the Destination of Man*. Steiner's *Theosophy* speaks about the physical, spiritual, visible, and invisible aspects of human existence in specific detail. Mathews speaks in detail about similar issues in *Rosicrucian Philosophy: The Invisible World*, but his concepts are simpler than Steiner's.

Like Steiner, who claimed that the supersensible world can be perceived by those who develop clairvoyance through "Rosicrucian Initiation,"[9] Mathews asserted that "the aim of all Rosicrucians" is to "contact" the "great invisible world and its entities."[10] In language that is reminiscent of Steiner's description of the eternal "ego" or "I" that facilitates the human being's connection to the eternal spirit,[11] Mathews claims that the Rosicrucian initiate's goal is to "find a world of reality and permanence in which the true self, the eternal ego, ... may abide in unison and concord with all other egos."[12] Much like Rudolf Steiner, who described Anthroposophy as a spiritual science of Rosicrucian descent that would enable the initiate to perceive supersensible realms, Mathews claimed that the teachings and practices of the ROCF constituted a "Rosicrucian spiritual science that teaches the students how

to awaken higher faculties of the mind so that he may know not only the physical side of life but also the mental and spiritual."[13] Practically restating Steiner's assertion that anyone who "steeps his thoughts" in "the views of spiritual science" will have "visions of his own,"[14] Mathews taught that, in order to perceive the invisible aspects of the "Kosmos," the human being must "think into it"[15] with rigorous study under the guidance of a Rosicrucian teacher.[16]

Initially, Mathews conducted most of the educational work of the ROCF from his hometown of Liverpool. He published several pamphlets during the early 1930s concerning the history of the Rosicrucianism, human anatomy and its relationship to the spiritual aspects of human existence, and the hierarchies and governmental beings of the spiritual world. These pamphlets were mailed to students who took correspondence courses in other areas of England. During the late 1920s and early 1930s, the ROCF kept its headquarters in Liverpool and seems to have dedicated most of its energies to these esoteric correspondence courses.

Initially, the ROCF gained visibility in Christchurch through the work of Catherine Emily Chalk (1861–1931) who joined the ROCF in 1930 and encouraged several others to join the organization. By 1935, there were enough ROCF members in Christchurch to warrant the construction of a permanent venue. In 1936, Chalk offered the grounds surrounding her house on Somerford Road in Christchurch to the ROCF as the site for a wooden building that became known as the Ashrama Hall.[17] The Ashrama, which was a 1,200 square foot, one-story structure with a pitched roof, was the central meeting place of the ROCF in Christchurch. It included a private theatre that served as "the spiritual center of the Order." In the theatre, the ROCF members performed rituals, held graduation ceremonies, gave performances and lectures, and held meetings and discussions.[18] This first theatre was less complex than the Rosicrucian Theatre that the ROCF would build on Somerford Way in 1938.

The activities of the ROCF in Christchurch were divided into esoteric and public categories. The esoteric activities were conducted in secret and were not revealed to the public. The public arm of the ROCF was known as the *Academia Rosae Crucis*, which seems to have been designed as a school of ancient mysteries. This mystery school was less complex than Tingley's School for the Lost Mysteries of Antiquity in Point Loma and Steiner's School for Spiritual Science in Dornach. The aims and scope of the *Academia Rosae Crucis* were laid out in a *Christchurch Times* article, which appeared shortly after Mathews moved the ROCF headquarters from Liverpool to Christchurch. According to the article,

the ROCF is a "society... that is of ancient order and has had some of the greatest scholars of the centuries" within its membership.[19] Like so many other occultists, Mathews presented his new religion as part of a primordial tradition that had been preserved and transmitted throughout the ages. [20]

The "aims and ideals" of the ROCF are described in the article as "very high" and "lofty." The author notes that each member of the order is expected to "render good service to his fellow men without fear, favour or profit."[21] This valorization of philanthropy brings to mind the principle of Universal Brotherhood that was taught by Tingley. In fact, Mathews had a close relationship to people who would have been quite knowledgeable about Theosophy. Among the membership of the ROCF was Mabel Besant-Scott, [22] whose mother, Annie Besant, was for a time the leader of the Theosophical Society in Adyar, India.

According to the *Christchurch Times* article, all members of the ROCF underwent "thorough training in whatever course of study they desire[d] to embrace" in order to fulfill their duty to benefit their fellow humans.[23] In order to facilitate this training, the *Academia Rosae Crucis* established seven departments. Some of the specifics of these departments were listed in the ROCF's journal, *The Uplifting Veil*. A 1936 issue of the journal listed the seven departments: the Masonic department; the Ordo department, which taught "Occult Science" and "Mental Science"; the Temple, which focused on studies in "comparative religion, mysticism, and Latin; the Brotherhood of Healing (B.O.H.), whose adepts concerned themselves with "therapeutics, healing, and magic"; the College of Psychology; the Drama department, which focused on "elocution, plays, oratory [skills], and the arts"; and the "School of Adepts."[24]

In another *Christchurch Times* article, Mathews refers to the students of the Drama department as "The Players." Also known as the "Rosicrucian Players," the students of the *Academia Rosae Crucis* drama department were said to be "well-grounded in elocution and dramatic art." They received what Mathews described as "a psychological training which helps them to speak verbatim on any subject they have studied." Mathews listed prerequisites for those who wished to become Rosicrucian Players in the ROCF Drama department:

> Each player must be a member of the society and each one is well and carefully chosen. He or she must have obtained a diploma of the society indicating that the student has taken one of the Academia degrees.[25]

According to *The Uplifting Veil*, the *Academia Rosae Crucis* offered three degrees: "the Lincentiate, Bachelor, and Doctor." These degrees were conferred "after examination" in the following subjects:

1. Principles of Rosicrucian Philosophy and History
2. Mythology, Symbology, Archaeology, Architecture, the Arts
3. Comparative Religion, Oratory, and the Drama
4. Principles of Alchemy
5. Therapeutics (Religio-Therapy)
6. Psychology (Mental Science, Soul Science, etc.)
7. Mysticism
8. Occult Science and the Kabbalah
9. The Principles and Laws of Magic[26]

In the ROCF, theatre was viewed as one part of a complex study of occult knowledge.

According to Mathews, the plays produced by the Rosicrucian Players ranged "from Shakespeare to mysticism."[27] To make his plays entertaining, Mathews turned to genre conventions, special effects, and comic elements. To make his plays educational, he made his characters speak in detail about ROCF teachings. Mathews taught that his doctrines reached back to the era of Francis Bacon, who, according to Mathews, was a great Rosicrucian adept and the actual author of the plays attributed to William Shakespeare. Mathews also asserted that he was the reincarnation of Bacon.[28] This statement indicates that Mathews believed he had a hand in the writing of Shakespeare's plays. It is not surprising, therefore, that Mathews emulated Shakespeare's style in some of his own poetic dramas and wrote sequels to Shakespeare's plays. By doing so, Mathews seemed to suggest that he was continuing an educational tradition of occult theatre that he had participated in as Francis Bacon during England's early modern era.

THE THEATRE OF THE ROCF

The first documented account of ROCF theatrical activity took place in 1937.[29] From this time until 1940, a series of articles in the *Christchurch Times* show that Mathews and the ROCF ambitiously sought to create a theatre that was spiritually enlightening and commercially successful. Mathews attempted to replicate Shakespeare's writing style in his plays

Pythagoras and *Henry VII* (his two-part sequel to *Richard III*). Mathews wrote several short comic plays and also a vampire play. Despite Mathews's efforts to capitalize upon these popular forms, the theatrical activities of the ROCF slowed to a trickle by 1941, after which point no more articles about ROCF theatre appeared in the *Christchurch Times*. After 1942, the year when Mathews passed away, the theatrical impulse of the ROCF seems to have expired.

In 1937, however, hopes for a Rosicrucian theatre were high in Christchurch, and there was apparently enough money and energy among the membership to produce Rosicrucian mystery dramas for the general public. On September 4, 1937, Mathews publicly announced his intention to establish a "Christchurch Drama Festival" that would "accord Christchurch a very distinctive niche in the popular news" and enhance the city's tourist market by attracting "the art and intelligentsia of a very wide field." Mathews also asserted that the ROCF plan for a theatre festival was inspired by "the appreciation" that was expressed by audiences who "attended our production of...*Pythagoras*."[30] *Pythagoras* is one of Mathews's most ambitious works. It is a full-length play written in iambic pentameter that presents Pythagoras as an adept of the occult tradition that the members of the ROCF claimed to carry on in Christchurch.

During the Occult Revival, Pythagoras enjoyed a surge of popularity among occultists who thought of his philosophy as a precursor to their own teachings and claimed him as part of the line of adepts from whom they received their own teachings.[31] In the text of *Pythagoras*, we follow the hero as he rises in fortune, establishes a famous academy of learning, is burned out of Crotona by an enemy, and, finally, dies of a sudden heart attack. The play contains monologues that provide an overview of the same occult principles that were published in the ROCF correspondence course pamphlets.

Pythagoras opens with a prologue that praises Pythagoras as a "man of wisdom, justice, [and] lenity" who "set a seed which since has taken root and...will yet outgrow all other trees of life, religion and philosophy."[32] After establishing that Pythagoras established an ongoing tradition of spiritual knowledge, the prologue describes the religious import of this tradition in terms that mirror statements made in ROCF publications. For example, the prologue states that the story of Pythagoras contained in the play will "help the world to reason Kosmik truths."[33] In his tract "Rosicrucian Philosophy: Pointers for Students," Mathews speaks of the Kosmos as a massive space that is governed by the most high-ranking of

all entities: the "Absolute."[34] When the prologue declares that Pythagoras's teachings convey "Kosmik truths," it is suggesting that Pythagoras's teachings affirm the understanding of the Absolute and the Order of the universe that is taught in the ROCF.

In Mathew's play, Pythagoras gives an overview of ROCF tenets. Pythagoras speaks this monologue from a temple in Crotona to a crowd of students and curious onlookers. He informs the audience that their faith in pagan "gods, daemons, and heroes" is more complex than necessary, and assures them of the existence of a "simpler faith" that can help them to gain self-knowledge and transcend what they mistake for destiny.[35] Pythagoras recites a series of maxims that delineate the values, beliefs, and principles of this simpler faith, which bears a striking resemblance to the ROCF philosophy. Pythagoras's first point is that there is one god that can be discovered by making "search within yourselves" and obeying "the laws of nature from which so many have oft departed."[36] This idea echoes Mathews's understanding of the need to "obey" the Order of the Kosmos, and his warning that anything which "does not work orderly suffers."[37] Mathews thus makes Pythagoras agree with his teachings concerning the Order of the Kosmos.

Later in the monologue, Pythagoras urges the crowd not to "be dismayed at death" because "it is but life with wider bounds than mortal." This statement resembles Mathew's claim that "there is no death in God's great Kosmos." [38] Pythagoras's statement on the continuation of life after death reflects the opinions of modern spiritualists, who argued that death did not promise "judgment" or "hell" but, on the contrary, "continued life" in another form.[39] Mathews, as it turns out, was one of many occultists who would incorporate aspects of modern Spiritualism into their teaching. In fact, the ROCF entertainments competed with the Christchurch Spiritualist Church that offered lectures, exhibitions of spirit photography, and mediumistic demonstrations to the public.[40]

Pythagoras also paraphrases Mathews's description of the ideal modes of communication and decorum that Rosicrucian initiates should strive to emulate in their daily lives. Pythagoras urges his students to "be honest" and warns that "a slandering tongue is friend to no one." He promises that the one who is "temperate" and "kindly" in words and action will "command respect," and suggests that his followers be "listeners, rather than talkers."[41] In ROCF tracts, Mathews gave similar advice to his students. Arguing that every trait we exhibit is a warning of the "future unfoldment" of the "higher faculties," Mathew urged ROCF members to "replace bad" traits "with good ones."[42] Among the chief of these good traits is

honesty. Mathews taught that "the student must be as honest with himself as with any other person."[43] Just as Pythagoras condemns slander in the citation above, Mathews dissuaded his students from "gossip," "talking behind backs," and "character defaming" language.[44] Perhaps Mathews's aversion to derogatory language and slander was rooted in the fact that he apparently suffered it in his own life. In *The Uplifted Veil*, Mathews threatened to take legal action if unnamed individuals continued to damage his image with "scurrilous and defamatory statements."[45] This statement also shows that the ROCF lived in a certain amount of tension with the greater Christchurch community, as did all of the other occult movements discussed in this book.

The Rosicrucian Players performed *Pythagoras* on at least two occasions. On August 21, 1937, the *Christchurch Times* notes the ROCF "lately produced" *Pythagoras* to entertain and to instruct audiences in the philosophy of "the Grecian Master."[46] Almost one year later, in early August of 1938, the Rosicrucian Players staged *Pythagoras* again—this time in the recently constructed Rosicrucian Theatre, which was a "comfortable and well-spaced" proscenium theatre with a seating capacity of 350.[47]

At the time of the second production of *Pythagoras*, the new Rosicrucian Theatre was less than four months old, but it had gained the attention of Christchurch locals and the residents of other nearby towns. Among those who were interested in the Rosicrucian theatre was the future founder of Wicca, Gerald Gardner, who was driven by "his interest in odd people and strange things" to book tickets for his wife, Donna, and himself to see the August 1938 production of *Pythagoras*.[48] Donna Gardner, who was an amateur actress, "hated" the production and vowed never to return to the Rosicrucian theatre. Gardner's opinion of the production was little better than Donna's, as is made clear by the story that he dictated to Bracelin for the book *Gerald Gardner: Witch*.

> All the costumes were home-made, and not very professional. Many of the parts were rather badly acted. Pythagoras was played by a short, sturdy, black-haired individual. He was no actor, and the lines which he had to say were little better.[49]

Bracelin writes that the actor playing Pythagoras was none other than Mathews himself.[50] Although Gardner did not appreciate the performance or the play, he did appreciate the effort and the subject matter. He eventually joined the ROCF and took a role in one of the Rosicrucian Theatre's plays.[51]

Not all of the reviews of the Rosicrucian players were negative. In a *Christchurch Times* article concerning the production of a two plays— *As Ye Sow* and *The Window of Hudson's Pagoda*—Mathews is described as a "veritable tower of strength to his company," who "possesses in no small measure histrionic ability" and deserves "the laurels" for his work "as writer, director, and producer." [52] Other members of the Rosicrucian Players who were credited with "playing well" were Kenneth Stubbs, Ms. Filligree, Ailsa Hall, Miss Orr, Ernest Mason, Lady de Biere, and Peggy Baker.[53] The *Christchurch Times* review credited the Rosicrucian Players with the creation of a "theatre innovation": a theatrical "serial thriller" that beckons the audience to return by ending with the phrase "to be continued."[54] In fact, this was one of many times that the ROCF used the conventions of popular entertainment genres to attract people to the Rosicrucian Theatre.[55]

Even in very simple plays, Mathews used drama to explain the spiritual philosophies of the ROCF. *Mind Undying*, for example, is a short comedy that concerns the visit of a character named Francisco Hogg to an inn in the English countryside. Hogg's name reveals information about one of his past lives: he is the reincarnation of Francis Bacon. The play begins with Hogg walking along a path. Hogg stops when he recognizes an inn called the "Old Fox" that he frequented in his former life as Bacon. Entering the inn, Hogg starts up a conversation with the innkeeper, Jim.[56] The conversation between Hogg and Jim was written to offer a humorous contrast between a sophisticated, spiritual thinker and a simple country man whose interactions with the world are rooted primarily in practicalities and natural intuition. On another level, however, this comic conversation provides an opportunity for Hogg to speak in some detail about Mathews's belief in the human capacity to perceive ghosts through extrasensory perception. In *Mind Undying*, Hogg draws a comparison between seeing ghosts and the radio. He tells Jim the innkeeper that a person who sees ghosts is simply tuning into the past, much like a transistor radio receives signals:

INKEEPER: That's impossible, Sir, how could anyone tune into a place, say like this Inn, without a wireless set? You must have music, people, electricity and the like to do it, if it can be done.
HOGG: I said tune in with the mind.
INKEEPER: Tune in with the mind? Do you mean read people's thoughts? Tel—telly—
HOGG: Telepathy you mean.

INNKEEPER: Telly-pathy, that's it. . . . it's telly-pathy through the air, is'nt [*sic*] it?

HOGG: True, my friend, but your set is not sufficiently powerful to tune into foreign stations, therefore you are limited in your appreciation of what is transmitted through the air, as you say. So it is with your mind; it is not powerful enough to tune into records which may be here in this Inn, or even elsewhere. It is through the Ethers that sound is transmitted, and through those self same Ethers are transmitted the thoughts of men, and so they have been transmitted since the world began.[57]

This comic banter operates on two levels simultaneously. As a comic technique, it creates a humorous, if somewhat shallow and obvious, distinction between the sophisticated visitor and the innkeeper. On the other hand, it justifies Hogg's pedantic discussions of telepathy and the nature of ghosts.

During the course of *Mind Undying*, a teacher-student relationship is established between Hogg and Jim. Hogg is the teacher and Jim is the student. Hogg proceeds to teach Jim the ROCF's tenets concerning reincarnation and spirit communication. Jim confesses during their conversation that he has seen a ghost in the inn that bears a striking resemblance to Hogg, and Hogg assures Jim that this means that he temporarily "tuned into the past" and "witnessed an event which actually took place in this Inn" centuries earlier.[58] Hogg assures Jim that he should not "be surprised or frightened by anything that he sees that is not physical," and he explains to Jim that "occultists" make it their business "not only to see" ghosts, "but to communicate with them," in order to gain spiritual knowledge and learning.[59] By the end of the play, through a series of comical passages concerning pigs and "rashers of bacon," Hogg finally reveals to Jim the innkeeper that the ghost he saw in the past was none other than an etheric image of his own past life as Francis Bacon.[60] The religious purpose of *Mind Undying* did not go unnoticed by the general public. The *Christchurch Times* reported that Francisco Hogg, played by Mathews himself, taught that "waves of sounds, conversations, and happenings of the past can be 'picked up' by a perceptive mind."[61]

According to Gardner, Mathews claimed to be the reincarnation of Francis Bacon to those who knew him, and, because Mathews asserted that Bacon had written the plays attributed to Shakespeare, this implied that Mathews had written Shakespeare's masterpieces in his past life.[62]

(Mathews did not create this idea about Bacon. This theory was popularly known as the "Baconian movement,"[63] and, by coincidence, Gerald Gardner's mother was a member of this movement.)[64] Mathews and his followers credited Bacon with founding an English tradition of Rosicrucianism that, "contrary to what certain outside historians have believed, has continued in this country in unbroken succession to the present day."[65] Subsequently, Mathews and other ROCF members came to view Shakespeare's dramas as Rosicrucian texts containing esoteric secrets. Because Mathews regarded himself as the reincarnated Shakespeare, he felt free to write *Henry VII, Parts I and II* as a sequel to Shakespeare's *Richard III*.

Several characters from *Richard III* reappear in Mathews's *Henry VII, Part I*, including Richard III, Henry VII (previously Richmond), Stanley the Earl of Derby, and the Bishop of Ely. Richard III is one of the first characters to appear in *Henry VII*, and his words and actions invoke the closing moments of *Richard III*. Richard is discovered moments before his demise complaining of "sinister and troubled dreams" that are inspired by his fear of the "dread Earl of Richmond, who, like a demon whirlwind sweeps the countryside with his horses and men."[66] It is clear that Mathews wanted his play to be viewed as one that filled a gap within Shakespeare's oeuvre. A *Christchurch Times* review of a performance of *Henry VII, Part I* that took place in the newly constructed Rosicrucian Theatre on August 2, 1938, shows that Mathews succeeded in impressing some audience members. The reviewer praises every performer with excellent performances, and commends the costume and set designs for the production. Showing particular interest in the monetary value of accessories, props, and costumes used in the production, the reviewer applauded the use of "theatrical properties that are . . . more generally found in dealer's showrooms devoted to the sale of articles of art." The reviewer noted a "wealth of detail . . . certainly never before seen in any stage presentations made in this borough."[67] Mr. W. Newby Stubb's scenic design is praised as "effective and imaginative," and one Mrs. C. Barnes is credited in the review with designing a "most convincing" suit of armor that Mathews wore for the roles of Prologue and Interludus. In the end, the review describes *Henry VII, Part I* as a "lofty play" that "reflects what mighty and profound thoughts revolve in the brain of the author."[68]

Among the author's thoughts were the principles of the ROCF, which *Henry VII, Part I* was written to promote. The play's instructional purpose was apparently clear to audiences. The previously mentioned

reviewer commented that Mathews himself "spoke Rosicrucian tenets and teachings" from the stage during the play's prologue and interlude. [69] The interlude section of *Henry VII, Part I* includes terms and concepts that are found in the ROCF pamphlets. The interlude declares the existence of a "Kosmik Law" that demands that the eternal life force of the human being return "again unto the Unknown Space" to begin the reincarnation process anew. [70] *Henry VII, Part I* was didactic enough for the *Christchurch Times* reviewer to describe "the whole production" as "an artistic way of disseminating Rosicrucian teachings." [71] Perhaps the propagandistic aspect of the play limited its appeal, because only "small audiences" came to see *Henry VII, Parts I and II*, or any of the other plays that the Rosicrucians put on as part of the first theatre festival in the Rosicrucian Theatre. [72]

Gerald and Donna Gardner came to see the August 6, 1938 revival of *Pythagoras*. This performance peaked Gerald Gardner's interest in the ROCF and the Rosicrucian Theatre. He soon joined the ROCF, began attending meetings, and finally took a part in a performance of Mathews's play, *The Demon Monk*, which premiered in January 1940. (The January 27 issue of *Christchurch Times* notes that Gerald Gardner played one of the monks in this production.) [73]

The Demon Monk tells the story of a vampire named Liveda ("a devil" spelled backwards) who wreaks havoc upon a medieval English monastery. Liveda appears at the monastery as a road-weary and ill friar. The kind and unsuspecting Abbot takes Levida in to help him recover his health. As the diabolical identity of the visitor is revealed, the Abbott and one of his monks are forced to take up the tools of vampire hunting. The Abbot's discussions of how to kill a vampire resemble the lectures on the methodologies of vampire killing that Edward van Sloane delivered in the role of Van Helsing in Todd Browning's 1931 film, *Dracula*. Although a monk and the Abbott are killed by Liveda, the vampire's body is eventually destroyed and his soul is freed.

The Demon Monk contains a positive reassessment of the witch that bears much in common with the way that Gardner later represented witches in Wicca. In *The Demon Monk* is a character named Mrs. Halsall, who is a wise woman with occult powers. Mrs. Halsall is mistaken by the Christians in her community as a lunatic and a dangerous witch. The tension that exists between Mrs. Halsall and those who live around her is clearly expressed at the end of the play, when she rejoices over the death of the monk Liveda as the demise of an evil being. The brothers living at the monastery did not reveal to the surrounding townspeople that there

was a vampire in their midst, but Mrs. Halsall discovered the circum-
stances through supernatural perception. When she expresses happiness
over Liveda's death, other women describe her as being "strange" and
"bereft of reason."[74] Despite her neighbors' doubts, Mrs. Halsall defends
her perceptions:

> MRS. HALSALL: Ye would behind my back say I am mad,
> And children in the street do mock and cry
> "Old Mother Halsall, witch," and spit at me,
> But yet my eyes are keen enough to see
> What make's another's blind…[75]

Proclaiming that "God has willed to give gifts withal to hear and see those
things most hidden," Mrs. Halsall urges her persecutors to "think upon
my words." Halsall warns her neighbors against judging her by her appear-
ance, and explains that God uses beings who are "stranger" than most "to
make his presence felt amongst mankind."[76] In this way, Halsall presents
the concept of the "witch" as a wise occult adept who is misunderstood by
mainstream society.

A similar reassessment of the witch was central to Gardner's 1954
book, *Witchcraft Today*, in which he first revealed details about what he
believed to be a primordial witch religion. According to Gardner, the
members of this cult used "processes" that were essentially the same
practices as those used by the initiates of the ancient mystery religions of
Greece, Rome, Egypt, and other parts of the world.[77] Gardner explained
that during the "time of persecution"—most notably the medieval and
early modern eras—the adepts of this witch cult were tortured for reli-
gious and political reasons. This violent marginalization of witches had
driven them underground to practice their religion in secret. This was an
unfortunate situation, according to Gardner, because, by driving witches
underground, the witch hunters of Europe deprived human society of the
benefits they had to offer. Gardner asserts that the clairvoyant powers of
witches enabled them to offer visions of the future that would "calm down
the most dangerous politicians," cure illnesses, and provide "divine illu-
mination" through the performance of "sacred dramas."[78] For Gardner,
the misunderstanding of the witches' practice and beliefs was rooted in
an oppressive Christian orthodoxy that accused witches of "denying or
repudiating Christianity," raising storms, conducting human sacrifice,
performing parodies of sacred Christian services and sacramental acts,
committing acts of immorality, practicing devil worship, and eating

human carcasses.[79] According to Gardner, none of these accusations were true. In *Witchcraft Today* he represents the witch as a benevolent person with extraordinary "powers" who is "useful to the community" in which she or he lives.[80]

THE ROCF-WICCA CONNECTION

Academic and Wiccan historians have noted Gardner's connection with the ROCF in several publications. Hutton notes that Gardner claimed that it was through members of the Rosicrucian Theatre that he met the woman who initiated him into Wicca in September of 1939.[81] In *Gerald Gardner: Witch*, this woman is identified as "Dorothy Clutterbuck."[82] Hutton explains that Dorothy Clutterbuck did exist, but he adds that her memoirs reveal no evidence of witchcraft. On the contrary, Clutterbuck seems to have been a political conservative of some status who might have disapproved of the practices of Gardner and his fellow witches. After all, they often performed rituals in the nude.[83]

What is uncontested by scholars is that Gardner was involved with the ROCF and the Rosicrucian Theatre before he publicly established Gardnerian Wicca. This connection has led some authors to consider the impact of Mathews and the ROCF upon Gardnerian Wicca, which Hutton describes as the "only religion England has given the world."[84] For example, an article contained in a 2009 edition of *Journal of Christchurch Local History Society* suggests that the connection between the Rosicrucian Theatre and Wicca allows Christchurch to claim the honor of being "the birthplace for a world religion."[85] Hutton argues that Gardner's experience of new occult movements, including his time with the ROCF, contributed to the development of "unrivaled" qualifications to become the "founder of a modern pagan religion."[86] The following overview of Gardnerian Wiccan teachings and performance practices will show that Gardner did share some ideas with the ROCF, but it also shows that other occultists—especially Aleister Crowley—contributed to Gardner's understanding of sacred drama and magical ritual.

GERALD GARDNER AND THE SACRED DRAMA OF GARDNERIAN WICCA

In *The Dictionary of Gnosis and Western Esotericism*, Joanne E. Pearson—a UK-based professor whose work critically examines the development,

beliefs, and practices of neo-paganism—notes that "it is largely undisputed that the development of Wicca was initiated by Gerald Brosseau Gardner."[87] According to Hutton, the "foundation story of modern pagan witchcraft" is *Gerald Gardner: Witch*, which

> told the story of long and relatively uneventful working life, spent first as the owner or manager of tea and rubber plantations in Ceylon, North Borneo, and Malaya, and then as an inspector in the Malay customs service.... His [Gardner's] memoirs...are resolutely unheroic...The impression is given of a self-contained individual, whose lonely existence came to an end when he married a nurse, Dorothea (usually called Donna), in a whirlwind romance when he was forty-three; the partnership lasted until her death four years before his own.[88]

Gerald Gardner: Witch emphasizes Gardner's keen interest in the supernatural, occultism, and magic. This interest led Gardner to seek the company of other people who shared his interests, and to seek firsthand experience of Freemasonry, spiritualism, Buddhism, and tribal religions. This book also discusses Gardner's antiquarianism, which propelled him to study Malay archaeology, numismatics, maritime history, and folklore, and also to become an author of respected monographs in these fields.[89] Gardner also strayed off the beaten social path by practicing "nudism," or, more accurately, "naturism" as a way to maintain his health.[90] Bracelin's biography depicts Gardner as an independent learner guided by an undying interest in the esoteric, the antiquarian, the indigenous, and the unusual.

The Bracelin biography was published only six years after Gardner caused something of a public sensation in England by introducing Wicca to the press as the survival of a prehistoric witchcraft religion. Gardner went public with the witch religion in 1951, the same year in which the United Kingdom repealed the Witchcraft and Vagrancy Act. Gardner's response to this governmental move was to open the Museum of Magic and Witchcraft in Castletown, Isle of Man. He also contacted several academics, and told them that he had discovered several active covens in the United Kingdom whose members practiced the witch religion.[91] *Gerald Gardner: Witch* makes it clear that Gardner not only studied witchcraft, but also practiced it. Gardner claimed to have been initiated into a coven about 12 years before he revealed Wicca. Through his description of his initiation, Gardner creates a link between the ROCF and the Rosicrucian Theatre. After all, it was a subgroup of Mathews's organization that allegedly led Gardner to the witch cult in the first place.[92]

Even though Gardner credited ROCF members with leading him to Wicca, he did not speak very highly of Mathews. Gardner was perplexed and amused by Mathews's claim to be able to see others as they once appeared in their past lives (just as the innkeeper does in *Mind Undying*). Gardner did not believe Mathews's claim to be the reincarnation of Pythagoras, Cornelius Agrippa, and Francis Bacon. Gardner also came to the conclusion that Mathews believed he was immortal and "had to slip away every few score years to make another name in a fresh place."[93] Although Mathews may have made such "claims of immortality" from time to time, it is also possible that Gardner misunderstood what Mathews meant when he spoke of immortality.[94] In ROCF tracts and plays, physical immortality is not discussed; rather, immortality is attributed to a nonphysical aspect of the individual that "re-incarnates" within many different bodies throughout the ages.[95] Gardner did not disagree with the concept of reincarnation. In *Witchcraft Today* he writes that the primary male god of Wicca is a god of reincarnation.[96] Regardless of their shared ideas, Gardner distanced himself from the ROCF when he became the leader of Gardnerian Wicca.[97]

GARDNERIAN WICCA: BELIEFS

In 1954, Gardner published his influential book titled *Witchcraft Today*, which discussed the beliefs, practices, and history of a primordial tradition that stretches back to the prehistoric era. Gardnerian Wicca, as Gardner's witch religion is called today, differs from the other Occult Revival movements discussed up to this point. In Wicca, it is all witches—as opposed to a select list of famous adepts—who are presented as the historical keepers and transmitters of occult religion and knowledge. Gardner also differed from the other movements discussed in previous chapters in that he did not offer any unchangeable documents, such as Crowley's *Book of the Law* and *Gnostic Mass*. Rather, Gardner encouraged witches to challenge and correct his teachings, to adapt his ritual texts, and to create entirely new ones. Gardner's glorification of "G"—the unnamed goddess of Wicca—spearheaded the proliferation of goddess-worship religions that has occurred between the middle of the twentieth century and the present. Finally, Gardner's interest in indigenous spirituality and religion anticipated a surge of interest in indigenous religion, spirituality, and shamanism that continues to thrive today.

Wicca, according to Gardner, was first established in the Paleolithic era. He wrote that the members of this cult celebrate seasonal changes, worship a god and a goddess, and practice ceremonial magic. Gardner came to the conclusion that this prehistoric witch religion was the primal source of all worldwide systems of magic—from the seasonal rituals of the most isolated, tribal populations to the heady and intellectualized occultism of Western adepts like Lévi and Crowley. Gardner believed that witches had preserved the witch religion to the best of their ability in the face of oppression by Christian and governmental authorities. As Gardner stated, the witch religion provided the foundation for the mystery cults of Greece, Rome, Egypt, and other civilizations in which initiatory religions made use of dramatic ritual for spiritual advancement. Gardner also asserted that the witch religion, as well as its sacred dramas and rituals, are still practiced in the present.

In *Witchcraft Today*, Gardner refers to the practitioners of the witch religion as "Wica," which he defines as "wise people." Gardner depicts the Wica as supernaturally gifted people who "work for good purposes and help those in trouble."[98] The word "wica" appears in the *Chambers Dictionary of Scots-English*, where it simply means "wise," but after the 1960s the word came to be spelled in modern witchcraft circles as "Wicca." This new spelling refers not only to Gardnerian Wicca but also to other strains of modern witchcraft that began to emerge in later years.[99]

To support his claims about the antiquity of Wicca, Gardner relied heavily upon a 1921 anthropological report titled *Witch Cult in Western Europe: A Study in Anthropology*. This report was written by Margaret Alice Murray, professor of Egyptology at University College in London. In *Witch Cult in Western Europe*, Murray argues that the witchcraft for which thousands of people were condemned between the Middle Ages and the early nineteenth century in Europe was a "definite religion with beliefs, ritual, and organizations as highly developed as that of any other cult in the world."[100] Hutton explains that many later scholars cast serious doubts upon Murray's thesis and "no academic historian has ever taken seriously Gardner's claim to have discovered a genuine survival of ancient religion."[101] Murray's theory, however, was still considered plausible by scholars when Gardner published *Witchcraft Today*. In fact, Murray wrote the introduction to the original version of *Witchcraft Today*.[102] Although there is no firm documentation to prove that Gardner did discover the survival of a prehistoric religion when he was initiated into witchcraft in 1939, it is, Hutton asserts, "not implausible" that Gardner was "initiated into an existing religion" by his companions at the ROCF.[103] Perhaps less

important than the historical accuracy of Gardner's claims are the values, beliefs, and practices that developed within Gardnerian Wicca because many of these have become a part of contemporary witchcraft and neo-paganism.

Gardner's belief that the witch religion was the primordial fount of just about every form of magic and religion in the world led him to celebrate religious diversity. In *Witchcraft Today*, Gardner encouraged witches to show "tolerance" for the religious spectrum of the world.[104] When Gardner asserted that he is "content" if "anyone finds true paradise in Buddhist rites, the Sabbat, or the Mass,"[105] he expressed a perspective that harmonizes with many contemporary Westerners who, as religious studies scholar Robert C. Fuller explains, "describe themselves as 'spiritual' rather than 'religious'" and believe that "curiosity, intellectual freedom, and an experimental approach to religion" is more important to spiritual development than a personal affiliation with a specific organized religion.[106]

In keeping with this contemporary perspective on nonaffiliated spirituality, Gardner never suggested that the ancient witch cult is an organized religion with a specific set of beliefs. Unlike Christians, who can publicly become members of numerous denominations and look for guidance from countless books, witches, according to Gardner, "have no books no theology." For that reason Gardner found it "hard to say" exactly "what the present-day witch believes."[107] Gardner attempted to reveal these teachings in *Witchcraft Today* with anecdotal evidence from English witches he met, evidence from other publications, and his own knowledge of indigenous spiritual practices that he encountered while living in South Asia and during his travels.

Gardner asserted that Gardnerian Wiccans believe "firmly" in reincarnation[108]—a belief that is shared not only with Mathews and the ROCF but also with every single other Occult Revival teacher and spiritual movement discussed in this book. Gardner's faith in reincarnation was developed not only through his exploration of Western systems of occultism, but also by making direct contact with people who held such beliefs while living in "the East."[109]

Gardner described witches as polytheists who emphasize two dichotomous deities: a horned, male god, and a goddess who is associated with the flowering of life on earth. The male god is "the god of...death and resurrection." According to Gardner, witches "gladly" go to the realm of this god "for rest and refreshment" when they die because this helps them to prepare for the "time to be reborn on earth again."[110] Rather than an ominous vision of death, the "cult god" of Gardnerian Wicca is a "comforter"

and "consoler" with the power to return you to those you loved most in previous lives.[111] Although the horned god is important in Gardnerian Wicca, he is but a supporting role in the Wiccan myth. The lead character of Gardnerian Wicca is the goddess.

Gardner wrote that "it is easy to give the central...myth" of Wicca, which concerns the journey of a goddess whom Gardner refers to as "G" (because he was forbidden by an oath to reveal her name).[112] In this myth, the goddess takes a journey into the realm of the horned god to find out why he causes aging, suffering, and death. When the goddess arrives at the gate of the god of death, she is compelled to remove her clothes because no one is allowed to bring anything from the physical world into the realm of death. When the death god sees the goddess, he falls in love with her and asks to touch her, but the goddess refuses to allow this until he explains why he causes everything she loves in life to age and die. The god explains that he gives all those who die "rest and peace and strength so that they may return."[113] The god then asks the goddess to stay with him forever, but she refuses the invitation because she does not love him. The goddess learns that she will only be allowed to leave with the new knowledge that the death god has given her if she allows herself to be scourged and, by doing so, learns to discern "the pangs of love."[114] When the goddess agrees to this, the horned god says "blessed be"—which is a sacred salutation among Wiccans.[115] After the scourging, the god of death

> taught her all the mysteries, and they loved and were one; and he taught her all the magics. For there are three great events in the life of man—love, death and resurrection in the new body—and magic controls them all. To fulfill love you must return again at the same time and place as the loved ones, and you must remember and love her or him again. But to be reborn you must die and be ready for a new body; to die you must be born; without love you may not be born, and this is all the magic.[116]

The statement "you must return again at the same time and place as the loved ones, and you must remember" reveals another similarity between Wiccan thought and the teachings of the ROCF: great significance is placed upon remembering past lives because such remembering is considered key to spiritual advancement. The remembering of past lives was emphasized as essential to spiritual development in ROCF journals. For instance, a 1939 issue of *The Uplifting Veil* asserts that highly developed souls can not only recognize those with whom they have shared past lives in later incarnations, but also determine whether they want to be male or female before they enter later incarnations.[117] As has been mentioned,

Mathews admittedly received inspiration from Rudolf Steiner, who also argued that human souls that reached a certain point of spiritual develop-ment would discover the ability to set goals for next incarnation while waiting for rebirth.[118] In fact, this understanding of reincarnation and past-life remembrance appealed to many occultists during the Occult Revival. It is unlikely that Gardner, with his long-standing interest in occultism, would have first discovered this understanding of past life recollection from Mathews or the ROCF. Certainly he would have been familiar at the very least with Helena Blavatsky's ideas on this topic. At the same time, Gardner's discussion of reincarnation is far simpler than discussions offered by Blavatsky and Steiner. This simplicity of concept bears more in common with Mathews's style of talking about such topics.

As far as the future direction of Western esotericism is concerned, the relationship of the horned god to reincarnation is less important than the goddess as a symbol of feminine divinity. The horned god is not the dominant deity in Gardnerian Wicca; rather, he willingly gives his "power over magic to the goddess."[119] For Gardner, the goddess is "obviously the Great Mother" who "rules spring, leisure, feasting, and the great delights," and who is often associated with the moon.[120] In the performance of Gardnerian Wicca rituals, the goddess often enjoys a prominent place. The place of the goddess in Gardnerian Wiccan ritual has contributed to new currents of Wiccan and neo-pagan ritual that offer a female conceptualiza-tion of the divine as an alternative to representations of god as a male entity in Abrahamic religious traditions.

GARDNERIAN WICCA: RITUAL AND PERFORMANCE

In *Witchcraft Today*, Gardner explained that he must hide the details of rituals that are considered sacred and secret by the witches with whom he has conducted his research.[121] Regardless of this restriction, Gardner still managed to say a great deal about the ritual practices of Gardnerian Wicca, as well as his own theories concerning the meaning and efficacy of ritual and magic. Although Gardnerian Wiccan ritual can be compel-ling to participants and observers, they transcend the purpose of entertain-ment. Wiccan performance provides witches with the sense of being "one with their god."[122] Thus, Wiccan ritual seeks a trans-rational gnosis that is rooted in an internal response to an external experience. In this way, Wiccan magic resembles the purpose of Crowley's Magick more than the intellectual, studied gnosis of Theosophy or Anthroposophy. In *Witchcraft*

Today, Gardner links the magical principles of Wiccan ritual—which is usually performed in small groups by members of the same coven—to a grand and pre-ancient tradition of sacred drama that sometimes involved thousands of ritual participants.[123] Gardner's claims are not document-able, but what is certain is that dance and performance are essential to the practice of Gardnerian Wicca.

In *Witchcraft Today,* dance is described as a bodily method through which the witch rises to "a hyperaesthetic state."[124] The term "hyperaes-thetic" suggests extreme sensitivity, and, in the case of Gardnerian Wicca, this means sensitivity to the presence and indwelling of the divine. In her introduction to *Witchcraft Today,* Murray states that the "wild prancing" of witches is rooted in a desire to be "Nearer, my God, to Thee."[125] For Gardner, dance served many functions: it invoked the powers of fertility; it celebrated the Sun's return (or "rebirth"); it raised magical powers within the body of the dancer; it produced pleasure, enjoyment, and entertain-ment at the end of a ritual.[126] Gardner associated the "wild dance" of those who worshipped Bacchus with "processional dances" of ancient times. He also believed the dance practices of modern witches correspond to the ecstatic dance practices of ancient mystery religions.[127] Gardner's emphasis upon dance resembles the significance of dance in Aleister Crowley's *The Rites of Eleusis,* the title of which also suggests a connection between mod-ern Magick and ancient religious mysteries.

The members of Gardner's Hertfordshire coven incorporated ecstatic dance into many rituals, including those dedicated to seasonal holy days: at Halloween and February Eve the high priest invoked the horned god; at the eves of May and August the high priestess invoked the goddess; and each of the yearly solstices and equinoxes were celebrated with dance and ritual.[128] Public controversy followed when Gardner revealed that he and his fellow witches danced and performed rituals in the nude. In 1951, the journalist Cecil Williamson wrote a series of articles in the *Sunday Pictorial* that were published in response to England's repeal of the Witchcraft and Vagrancy Act. One of the articles in this series discussed the use of ritual nudity by Gardner and his fellow witches.[129] Doreen Valiente, who was the high priestess of Gardner's coven before she established her own strand of Wicca, remembered a ritual in which Gardner appeared "stark naked, with bold white hair, a sun-tanned body, and arms that bore tattoos and a heavy bronze bracelet," while holding a magical sword and his handwritten "Book of Shadows."[130] (A Book of Shadows is a book of rituals that each witch collects and composes for her/himself. Gardner urged witches to keep a Book of Shadows in his or her own handwriting for the purpose of

spiritual learning and in order to protect the secrecy of the coven. Gardner urged witches to memorize as much of the Book of Shadows as possible. He claimed that memorization became essential to the practice of witchcraft during the days of the European witch trials. During this time, Gardner claimed, witches were required to "destroy" the Book of Shadows if and when "danger threatens.")[131]

Gardner offered explanations for the place of nudity within Wiccan ritual and performance. According to Gardner, the nudity stems from the time of the European witch craze, when witches did not bring "incriminating clothing" to the witches' Sabbath, so that there would be no evidence if they were raided by the authorities. Gardner also wrote that raiding "soldiers would usually let a naked girl go, but would take a clothed one prisoner," but he does not mention where he finds evidence to support this claim.[132] Gardner also asserts that ritual nudity is "the command of the Goddess."[133] The most practical explanation that Gardner offers for ritual nudity relates to Wiccan theories concerning magical powers: witches' bodies contain magical powers that can be "released in various ways" and this power is most efficiently released when the body is nude.[134] This idea was seconded by Valiente, who writes in *Witchcraft for Tomorrow* that when a "circle of naked or loosely robed dancers gyrates in a witchcraft ceremony, the power from their bodies rises upwards toward the centre of the circle, forming a cone-shape which is called the Cone of Power."[135] Valiente associated this bodily power with the concept of the aura. Gardner suggested that this power constituted what many identified as the astral body.[136]

In *Witchcraft Today*, Gardner tried to dissuade the reader from interpreting the use of nudity in Wiccan ritual and dance as a sign of perversion or immorality. He notes that witches are not "perverts" and asserts that nudity is one of the sacred mysteries of the witchcraft tradition.[137] There is some tension, however, between Gardner's assertion of the religious quality of the nudity of witchcraft and the erotic, jocular tone that he uses to describe ritual nudity at certain points in *Witchcraft Today*. Discussing witch Sabbath raids in the medieval and early modern era, Gardner notes that witches often oiled their bodies as a survival technique: the witches had learned that their "slippery, oiled bodies...were hard to catch hold of" when they were set upon by attackers. In another part of the book, Gardner admitted that some witches may be uncomfortable with ritual nudity and proposes that bikinis might reveal enough of the body to effectively release magical powers. He then proposed an experiment to discover the truth of this theory:

I should think that slips or Bikinis could be worn without unduly causing loss of power. It would be interesting to try the effect of one team in the traditional nude and one in Bikinis.[138]

Regardless of his intentions, Gardner's descriptions of "beautiful young witches" who are performing "wild dances in the moonlight" with oiled, naked bodies or in bikinis is sure to seem erotic to some readers.[139]

It should be understood, however, that Gardner firmly believed in and practiced naturism: the practice of exposing the naked body to the sun to improve general health. Valiente learned to appreciate naturism through her association with Gardner. She asserted that several psychologists and psychiatrists believe that "communal nudity is healthy and beneficial both mentally and physically."[140] Valiente describes Gardner as a "pioneer naturist," and notes that his "naturist beliefs coloured his ideas about witchcraft."[141] Gardner's first interest in the healing effects of outdoor nudity occurred when exposure to direct sunlight helped him to overcome synovitis within his knee.[142] In later years, when Gardner was living in the United Kingdom again, a doctor advised him to take up nudism for health reasons, and Gardner decided to do so, in part because of the success of the synovitis cure.[143] For Gardner, naturism offered not only health benefits, but also enabled him to meet people who shared his interests in occultism, magic, and alternative medicine.[144] Regardless of whether or not Gardner had any ulterior motives for incorporating nudity into Wiccan rituals, his belief in the therapeutic effects of private and public nudity predate the use of nudity in his magical practices.

Gardner believed that the rituals of witchcraft included practices that had been developed through many eons via the performance practices of initiatory religions. Gerald attempted to make this point in *Witchcraft Today* by illuminating parallels between Wiccan initiation rituals and an ancient initiation drama that is thought by some to be represented in a fresco in Pompeii. Vittorio Macchioro wrote one of the first of such interpretations of the Pompeii fresco in his 1931 book, *The Villa of the Mysteries in Pompeii*.[145] Macchioro interprets the various panels of this fresco as scenes from the "sacred drama" of an ancient mystery religion. In *Witchcraft Today*, Gardner cited Macchioro's interpretation of this fresco at length as an illustration of part of what he refers to as the "witches' processes."[146] In particular, Gardner is referring to the witches' process of initiation.

Stating that "all the mysteries operated after the same manner"—a generalization that is not supportable through historical documentation—

Macchioro describes the mysteries as a "sacred drama and a series of ritual acts, which reproduced the gestures and actions attributed to the Divinity." As an example of such a "subjective" drama, Macchioro suggests the Christian Eucharist, in which the participants repeat "that which according to tradition had been wrought by God."[147] For witches, Gardner asserted, this repetition serves to achieve "*palingenesis*," which he describes as a state of benign possession that causes the ritual celebrant to become filled "with the personality of the god" being invoked.[148]

Gardner suggests that the initiation ritual described by Macchioro is very similar to the initiation ritual of the witch cult. Macchioro argues that the images in the fresco reveal "a series of liturgical ceremonies" by which a young woman "is initiated into the Orphic Mystery." At the beginning of this ritual, the woman is dressed in a ritual veil by priestesses in preparation for her "communion" with Dionysus. Once the ritual of dressing is completed, the initiate is led to a nude, male youth, who wears boots that identify him as a priest of Dionysus. The priest reads a "charge" to the initiate, which reveals the rules and significance of the ritual. After the charge, the initiate is crowned in myrtle and eats a meal of sliced fruit and bread called the *agape*. The *agape* must be taken before the initiate's communion with Dionysus can occur.[149]

After taking the *agape*, the initiate participates in the performance of an allegorical scene representing the process of being "born again." With the initiate are two performers dressed as a satyr and a satyra. The satyr moves to the satyra with the intention of suckling from her breast, which she willingly offers. (According to Macchioro, this scene alludes to the myth of Dionysus, which recounts that he was "transformed into a kid" in order to hide him from the vengeful Hera. Macchioro believes this symbol of the child Dionysus represents the new life and birth of the initiate as a member of the Orphic mystery.)[150]

The tone of the initiation ritual suddenly changes when the initiate is compelled to stare into a "magical mirror" with Dionysus. Within the mirror, the initiate sees a vision of the life of Dionysus, and from this vision she learns that, like Dionysus, she must suffer death. The initiate is horrified by this realization, but she remains steadfast in her devotion to Dionysus. It is this devotion in the face of death that makes her worthy to become the god's bride.[151]

The initiate's new status as "the mystical bride of Dionysus" is symbolized when she uncovers "a huge phallus...in a sacred basket." This she places on the ground. Afterwards, Dionysus' daughter, Talate, who, like the young man, wears Dionysian boots, approaches her. Talate is "the

personification and executrix of the initiation." She inflicts upon the initiate "ritual flagellation" that "replaces and symbolizes death," while the priestess "kneels bewildered and terrified with her face well-nigh hidden in the lap of a compassionate priestess."[152] After this symbolic and mystical death, the initiate is "born again" as a bacchante:

> No more a woman but a divine human being. We see her now nude and frenziedly dancing, aided by a priestess who holds the thyrsus, the symbol of the new Dionysian life.
>
> The spirit of Dionysus has descended upon her. Man has become God, and Dionysus is present unseen at the miracle.... contemplating with divine indifference all that man may suffer for him. Thus the mystery is wrought.[153]

Gardner claims to have shown a picture of these frescoes to a fellow witch, who responded to the images by saying, "So they knew the secret in those days."[154] By mentioning the witch's response to the images in the Pompeii frescoes, Gardner attempted to demonstrate that the current practices of Gardnerian Wicca are a continuation of the ancient practices that Macchioro described in his book.

Several of the practices mentioned in Macchioro's description are, in fact, practiced in Gardnerian Wicca. Among these are the reading of a "charge" to initiates, the allegorical representation of communion between a male and female deity, the representation of such deities through a priest and priestess, ritual flagellation, and, of course, nude and ecstatic dancing. One Wiccan initiation ritual, for example, includes flogging. In this ritual, the initiate is bound, blindfolded, and suffers an "ordeal," which is administered with the scourge—the "ritual agent of suffering and purification." The use of ritual flagellation in Wiccan initiation was also confirmed by Colin Wilson, who wrote in *The Occult* that Gardner's use of the scourge inspired critics to accuse him of sadomasochistic fetishism and excess.[155]

Gardner modeled his Wiccan rituals, in part, upon Macchioro's description of the sacred dramas of ancient Greek mysteries; however, Gardner also drew ideas from the practices of the modern Occult Revival. The earliest versions of Gardner's rituals were impacted by the ritual texts of Aleister Crowley, which caused dissention and tension among later Wiccans. In *Witchcraft Today*, Gardner quoted a portion of an early version of "the witches' charge," which he dated "to the time when Romans" came into the witch religion.[156] One of the phrases in the passage from this charge states the following:

I give joy on earth, certainty, not faith, while in life; and upon death, peace unutterable, rest and the ecstasy of the goddess. Nor do I demand aught in sacrifice.[157]

The above is virtually identical to line 58 from the first chapter of Crowley's *Book of the Law* (1904), which reads:

I give unimaginable joys on earth: certainty, not faith, while in life, upon death; peace unutterable, rest, ecstasy; nor do I demand aught in sacrifice.[158]

In *Witchcraft Today*, Gardner identified Crowley as "the only man I can think of" who could have invented the rituals of the witch religion. Gardner argued that Crowley may have borrowed phrasing that already existed within the witch religion, or that a witch who wrote down the charge might have borrowed phrasing from Crowley. Despite any similarities, Gardner assured his readers in *Witchcraft Today* that there is "much evidence" that shows that the rituals of Gardnerian Wicca were in existence long before Crowley was born or established himself as a teacher of Magick.[159]

Another apparent connection between Gardnerian Wicca and Crowley's teachings is revealed when one compares the "Wiccan Rede" to the Law of Thelema. The Rede states: "an it harm none, do what ye will." The Law of Thelema reads: "do what thou wilt shall be the whole of the law; love is the law, love under will."[160] Hutton writes that Gardner visited Crowley shortly before the latter's death.[161] Valiente confirms that Gardner visited Crowley in *Witchcraft for Tomorrow*. Although Valiente states that Crowley was no witch and paints him as an entirely vile person, she acknowledges that the Law of Thelema is not an invitation to do whatever one wants to do, but, on the contrary, to act in obedience to a just and divine Will.[162]

For the most part, however, Valiente had little positive to say about Crowley. She was so troubled by Crowley's reputation and philosophy that she urged Gardner to distance himself from the self-proclaimed Beast 666. Gardner granted her permission to revise his Wiccan rituals, and she removed most of the traces of Crowley's writings from the rituals of Gardnerian Wicca. According to Hutton, Valiente's "greatest single contribution to Wicca" was her revisions to the Wiccan "Charge," which she made in part to distance Gardnerian Wicca from Crowley.[163] Thus, Crowley is linked to the development of Gardnerian Wicca. Gardner met Crowley, corresponded with him, and was an initiate of the OTO. While studying the Gerald Yorke collection at the University of London's

Warburg Institute, I read a letter from Gardner to Crowley that reveals he was a seventh-degree member of the OTO.[164]

CONCLUSION

Gardner acknowledged that he drew inspiration from multiple sources when he developed the rituals of Gardnerian Wicca. The impact of Alex Mathews, Aleister Crowley, and many others is no secret among contemporary Wiccans.[165] It would be a mistake, however, to overemphasize the influence of any single person, group, or source upon the development of Gardnerian Wicca. Although Gardner claims to have been introduced to Wicca by members of the ROCF's Rosicrucian Theatre, the witch is a peripheral figure within Mathew's occult system. It is true that Mathews presented witches in a positive light in his play, *The Demons Monk*, but he was far more interested in clairvoyance, spiritualism, and reincarnation than the practice of witchcraft and magical ritual, which is central to Gardnerian Wicca.

The ROCF and the Rosicrucian Theatre had something to do with the development of Gardnerian Wicca, but, as has been demonstrated, so did Crowley. Gardner's time in South Asia also provided him with knowledge of indigenous religion that transcended the experiences of many of his Occult Revival predecessors. Gardner's involvement with early twentieth-century scholarship concerning ancient mystery religions and medieval witchcraft also proved formative to Wicca. Christchurch and the ROCF were an important part of Gardner's experiences, but it would be an overstatement to say that the beliefs and ritual practices of Gardnerian Wicca owed more to Mathews and the ROCF than any of the other Occult Revival teachers, organizations, or spiritual currents that might have impacted Gardner's religious worldview.

Comparing the differences between the ROCF and Gardnerian Wicca can illuminate how Gardner's performance techniques moved away from some of the trends of the theatre of the Occult Revival and toward new trends of occult performance that would become more prominent within later currents of feminist witchcraft and neo-paganism that appeared between the second half of the twentieth century and the present.

Mathews's theatre, unlike Gardner's, was firmly rooted in trends that had been established since the nineteenth century through the theatre of the Occult Revival. Mathews viewed his theatre as an opportunity to expose audiences to his teachings. By encouraging the members of his

order to take parts, design sets and costumes, and participate in other aspects of the production process, theatre served to bind the ROCF community together with a shared goal. By creating what he believed to be socially acceptable and artistically conceived productions, Mathews used theatre to establish a positive relationship with the community in which he lived. Like Tingley and Steiner, Mathews oversaw the construction of a performance space, the Rosicrucian Theatre, to house his plays. Mathews shared with all of the occultists discussed in this book the idea that there once existed a sacred tradition of theatre that transmitted the mysteries of a primordial tradition. Mathews presented his theatrical endeavors as a continuation of that tradition. These aspects of Mathews's Rosicrucian Theatre bears many of the identifying characteristics of the theatre of the Occult Revival.

Gardnerian Wiccan performance also exhibits some of the characteristic traits of the theatre of the Occult Revival. Gardner described Wiccan ritual as the dramatic remnants of a primordial tradition. Gardner agreed with Occult Revival theatre-makers that theatrical performance can, if properly created, transform human beings spiritually. In the case of Wiccan ritual, this transformation amounts to the complete identification of a witch with a deity. A sense of community and a shared goal is established for those who collaborate on Wiccan rituals.[166] Like all of the other occultists discussed here, some outsiders viewed Gardner's religious performances as a social danger. Bracelin notes that Wiccan performance was condemned in the popular English press as a form of devil worship.[167] Colin Wilson notes in *The Occult* that the use of flogging, bondage, and nudity in Wiccan rites earned Gardner a reputation as "a sado-masochist with both a taste for flagellation and marked voyeuristic tendencies."[168] The theatre of the Occult Revival often drew such attacks as a response to what seemed to be a contradiction of commonly held ideas about religion, politics, government, the family, gender roles, or sexual behavior.

In some ways, however, the performance practices that Gardner established differed from the theatrical trends of the Occult Revival. One of the most striking differences is that Gardner did not use performance as a tool for spreading or teaching his ideas to the general public. (For Gardner, interviews, articles, books, and tours of his Witchcraft Museum were tools for disseminating Wiccan teachings.) Mystery dramatics, on the other hand, were a private affair for coven members. In Gardnerian Wicca, sacred drama serves the Wiccan initiate: it is used in initiation rites and magical operations that are open only to coven members. There

is never any distinction between magical ritual and sacred drama within Gardnerian Wicca, as there often is in the occult traditions of Tingley, Rudolf Steiner, Marie Steiner, Crowley, and Mathews. With the post-modern artist's penchant for blending elements that were once kept in separate categories, Gardner dissolved the distinction between theatre and magical ritual that had been maintained during the modern Occult Revival.

Gardner was unwilling to establish an unchanging list of Wiccan rituals or beliefs, as Crowley did when he identified some Thelemic rituals as unalterable, "Class A" documents. Gardner asserted that even the highest Wiccan rites were subject to revision. He stood behind this principle when he granted Valiente's request to remove traces of Crowley's writings from the Wiccan Charge and rituals. Gardner taught that the Wiccan initiation rituals had been adapted for centuries,[169] and he encouraged people to challenge his own teachings when he proclaimed that "discussion and criticism is the only way to arrive at a satisfying conclusion."[170] Gardner's attitude toward his teachings differed from that taken by the other occultists discussed in this book. Tingley, Steiner, and Mathews claimed that they received wisdom from nearly immortal adepts who possessed super-human knowledge and powers. Crowley said that he received the tenets of Thelema from the otherworldly being, Aiwass. Gardner, on the other hand, presented himself as the recipient of the fragmented remnants of a Stone Age cult that could only be incompletely reconstructed through magical practice and research. While Gardner claimed to have discovered the surviving practices of a primordial tradition, he did not claim to have received these mysteries from a divinely inspired, spiritual, or superhuman intelligence. Rather, Gardner said that he gained his knowledge through research, practice, and interaction with others who learned what they knew through equally non-fantastical means, such as the study of esoteric literature or initiation rituals.

By abandoning any claims to spiritual authority and by advocating for the constant modification and adaptation of Wiccan rituals, Gardner contributed to the rise of a more individualized and decentralized current of occultism that arose in the 1960s and continues in the present. During this time, new schools of modern witchcraft appeared, along with Goddess religions, nature worship, neo-paganism, Druidism, and other new currents rooted in magic, occultism, and esotericism. Many of those who are involved with new religions such as these consider the composition and performance of ritual to be a central part of spiritual practice, just as Gardner did. Hutton uses the term "neo-pagan" to describe such new religions, and

he distinguishes them from many of the movements of the Occult Revival because of the degree to which they emphasize "the creative performance of ritual" as the central means for creating "a direct and personal experience of the divine."[171] Within neo-paganism, official statements of belief are uncommon, which brings to mind Gardner's resistance to the idea of an official Wiccan creed. By establishing Wiccan performance practices, Gardner took a small step away from the theatre of the Occult Revival and moved toward a contemporary neo-pagan current of performance that is still growing and transforming today.

6. The Neo-Paganism Performance Current ❧

Some historians credit Gardner with the inauguration of a new and performance-rich current of esoteric spirituality that began to bloom and diversify in the 1960s. This twentieth-century current of esotericism bore many connections to ideas and practices that thrived during the Occult Revival of the late nineteenth and early twentieth centuries, but it also moved in new directions and exhibited even more diversity of religious form and content than had the other movements of the Occult Revival. After Wicca appeared, there emerged many new groups of ceremonial magicians and esoteric philosophers, such as witches, Druids, neo-shamans, and goddess-worshippers.[1] By the 1970s, many of these new esoteric groups and movements were being categorized under the now-familiar label of "neo-paganism."

It should be noted that not all contemporary practitioners of occultism and esotericism identify as neo-pagan. Many claim Occult Revival categories such as Thelemite, Anthroposophist, Theosophist, Rosicrucian, or Wiccan. This is no surprise, since these turn-of-the-century occult movements never passed away, but, rather, continued into the present. However, the emergence of neo-pagan currents in the late twentieth century moved in new directions that distinguished it from the currents of the nineteenth-century Occult Revival. Still others who participate in spiritual activities that would seem to have a link to the neo-pagan current do not claim any affiliation with neo-paganism at all. The purpose here is not to identify any particular artist or esotericist as a neo-pagan, but, rather, to discuss manifestations of spiritual performance that seem to be linked to practices and ideas that initially rose to prominence in connection with the neo-pagan current.

One of the most noticeable characteristics of neo-paganism is that it has allowed more opportunity for women to be spiritual leaders. The valorization of the feminine within neo-paganism led to new intersections

between various forms of feminism and conceptualizations of the divine. This is why the idea of the Goddess has become so prevalent within certain forms of neo-paganism. Interest in indigenous spirituality and shamanistic practices dramatically expanded within neo-paganism. Neo-paganism has also contributed to a rise of interdisciplinary festivals and gatherings, at which neo-pagans, occultists, witches, and other practitioners of alternative spirituality and religion come together to exchange ideas and share sacred art and performance.

THE EMERGENCE OF THE NEO-PAGAN CURRENT

Gardner's impact upon neo-paganism was particularly profound. Neo-paganism scholar Joanne E. Pearson states that "Neopaganism in the strict sense originated in the 1940s Britain in the form of... [Gardnerian] Wicca."[2] Gardner's agreeable nature seems to have contributed in no small way to the emergence of neo-pagan practices. When coven members sought to question, alter, and, in some cases, abandon certain aspects of Wicca, Gardner often adopted their suggestions. Doreen Valiente, the high priestess of Gardner's Hertfordshire coven, altered the future course of Gardnerian Wicca when she removed Crowley's verbiage from the original version of the initiatory Wiccan Charge.[3] Valiente made these changes to avoid association with Crowley's controversial reputation, the flames of which were fanned by the publication of John Symonds's scathing biography, *The Great Beast: The Life and Magic of Aleister Crowley* (1952).[4] Gardner seems to have followed Valiente's anti-Crowley instincts as his career developed. In *Witchcraft Today* (1954) Gardner credited Crowley with deep knowledge of the witch religions, but in his ghost-written "biography," *Gerald Gardner: Witch* (1960), Gardner describes Crowley as a "charlatan."[5]

Gardner also anticipated the development of contemporary neo-paganism when he agreed to change his approach to the celebration of seasonal Wiccan holy days. Initially, Gardner's coven observed four seasonal rituals: the main Sabbat of the horned god on Halloween and February Eve; the Goddess' main Sabbat on May and August Eves; the solstices; and the equinoxes.[6] In 1958, some of the members of Gardner's coven found it undesirable that the solstices and equinoxes were not being celebrated at the exact moment of the natural occurrence. Instead, they were observed "at the nearest monthly meeting, which was pegged by the full moon." In response to this complaint, Gardner began celebrating solstices and

equinoxes on their exact days and times.[7] Gardnerian Wicca is the first new religion of the twentieth-century known to have made the celebration of these natural events a central aspect of religious practice. Now many neo-pagans from various traditions celebrate these events—even those who do not identify as Wiccans.

The honored place of the goddess in Gardnerian Wicca was even further enhanced by the emergence of a number of new schools of witchcraft whose members valued the goddess above all other deities. By the 1970s, various schools of "feminist witchcraft" began to appear in the United States. Feminist witchcraft "developed out of the feminist consciousness movement, as female witches took part in the Women's Movement and began to influence the nascent Goddess Movement."[8] A group called Women's International Conspiracy from Hell (WITCH) formed in New York in 1968. WITCH promoted the idea that the witch hunts of the early modern period had been an attack by patriarchal Christian authorities against a feminist religion whose practitioners were brave and liberated.[9] In 1971, Zsuszana Budapest established the Susan B. Anthony Coven No. 1 in Hollywood. Soon thereafter she moved away from Wiccan terminology. By 1980, Budapest had changed the name of her system of witchcraft from "Wicca" to the "Dianic tradition," and she claimed to have initiated 800 women. Budapest asserted that the spiritual liberation of women depended upon the willingness to "abide in an all-female energy environment, to read no male writers, to listen to no male voices, [and] to pray to no male gods."[10] Budapest applied radical, separatist feminism to her spiritual practice.

Another highly influential witch, Starhawk, offered a less divisive feminist witchcraft in her 1979 book, *The Spiral Dance: A Rebirth of the Religion of the Great Goddess.*[11] Although Starhawk retains many of the elements of Gardnerian Wicca—such as the eight seasonal holidays, the goddess, and the horned-god—she revises the significance of these elements. Starhawk claims that the goddess exists and gives her primacy, but she also defines the goddess as a being that is experienced through interaction with nature. Starhawk writes that human beings connect with the goddess by experiencing the moon, the stars, the ocean, the earth, trees, animals, other human beings, and themselves.[12] Starhawk's reverence for nature (which is conceived as an expression of the goddess) led her to commit acts of ecological activism. In the 1980s, she was "arrested and imprisoned for non-violent direct actions undertaken in protest against installations where nuclear weapons were made or stored."[13] Although Starhawk claimed that her beliefs could be dated back to the Neolithic

period, the antiquity of her form of the Craft was less important to her than the spiritual and psychological benefits that she believed resulted from practicing it.[14] The work of Budapest and Starhawk serve as only two examples of a wide range of feminist witchcrafts, goddess-worship religions, and nature religions that reject patriarchal notions of the divine as "dry, dead, meaningless, and outdated," according to Elizabeth Puttick's book, *Women in New Religions: In Search of Community, Sexuality, and Spiritual Power.*[15] North America has a rich history of women such as Starhawk and Budapest who have referred to their understanding of the goddess as a motivation for sociopolitical activism, "ecospirituality," and alternative conceptualizations of gender power structures.[16] This pattern of development is driven by women who assert the right to be full participants and leaders in religion, despite centuries of male domination in Western religious culture.

By 1970, there were so many different forms of neo-paganism that an organization called the Pagan Front was created to increase neo-pagan communication and solidarity. The Pagan Front

> was open to all who accepted the concepts of paired female and male divinity, of the Wiccan ethic "do what you will as long as it harms none," of reincarnation with reward or punishment for behavior in life.[17]

The Pagan Front was originally supported by three coven leaders—one dedicated to Gardnerian Wicca and the other two to other forms of modern witchcraft. In 1981, the Pagan Front changed its name to the Pagan Federation to "reflect better the organization's nature as an affiliation of different groups."[18] The networks established by the Pagan Federation contributed to even more crossover of beliefs and practices among neo-pagan groups and, subsequently, to the increased diversification of neo-paganism.

Between the 1970s and the present, neo-paganism has come to represent "many different traditions, practices and beliefs."[19] Past attempts to determine the size of the worldwide neo-pagan community have proven inconclusive, but it is certain that there are thousands of neo-pagans throughout the world. In his 1991 book, *Crafting the Art of Magic*, Aidan Kelly estimates that there were two hundred thousand neo-pagans in the United States.[20] Ronald Hutton estimates there are thousands of neo-pagans in Canada and Australia, and that "most European countries have populations ranging from a few hundred to a few thousand."[21] Shahrukh Husain asserts that there were only 100 thousand neo-pagans in the United States

in the early 1990s and that in 1996 the Wiccan Church of the United Kingdom alone had almost twelve thousand members. Husain also notes the worldwide expansion of neo-paganism, which can now be found in Latin America, India, Africa, and Europe. [22]

Although there is a great diversity of neo-pagan beliefs and practices, these different groups often note affinities between one another. Perhaps because neo-pagans tend to operate in small groups, they seek broader solidarity by establishing festivals and conferences at which they come together to engage in various social and spiritual activities—including performance. The first Pagan Festival of Europe was held in West Germany in 1988.[23] The Starwood festival has become the "largest pagan/magickal/consciousness gathering in North America."[24] In July 2014, the 34th Starwood Festival was held in Pomeroy, Ohio. The Starwood Festival website reveals the significance of the place of creativity, art, and performance within neo-paganism:

> The Starwood Festival, a seven-day exploration of mind, body and spirit, of creativity and possibilities, features over 20 performances of music, drumming, dance and theater by world-renown and local artists on four stages. It's a multiversity featuring over 150 classes, workshops and ceremonies offered by prominent teachers from many fields, disciplines, traditions and cultures. It's a family-friendly camping event with tenting and hiking, food vendors, co-op child care, swimming, hot showers, a Kid Village and multimedia shows. Starwood is also a social event with costume parades, jam sessions, merchants, parties, giant puppets, all-night drumming and much more, including our huge and infamous Bonfire![25]

There are, in fact, many neo-pagan festivals that take place throughout the year worldwide. One website (www.faeriefaith.net) offered a list of over 60 neo-pagan festivals in the United States that were scheduled for the year 2014.[26]

NEO-PAGAN BELIEF

Although differences of beliefs and practices are numerous among the occultists, magicians, Druids, witches, goddess worshippers, heathens, etc. who are numbered among the world's "neo-pagan" population, there are, in fact, some recurring beliefs within the neo-pagan current. The current Pagan Federation website, for instance, lists the following beliefs "to which its members are expected to subscribe": (1) the natural world is inherently

divine and exists through no force other than its own; (2) there is no single divine law by which to govern human behavior, and an individual may pursue what he or she wishes within the limitation of avoiding bringing harm to others; (3) divinity can be either male or female.[27] Like many of the figures of the Occult Revival, as well as the Romanticists who came before them, neo-pagans tend to hold nature as sacred. Some neo-pagans, such as Starhawk, not only view nature as sacred but also sacralize ecological activism. This is comparable to practical Theosophists, such as Katherine Tingley, who sacralized other forms of activism (such as pro-peace activism) and humanitarian work (such as caring for war veterans). In the case of neo-pagan belief, ecological activism is not only a matter of caring for the natural environment but also an affirmation of belief in spiritual correspondences that exist between the human being, nature, and the divine realm.[28]

Pearson states that most neo-pagans revere "nature as sacred, ensouled, or alive;" they study and gain inspiration from "pagan beliefs and practices of the past"; and they are particularly interested in the spiritual practices of classical and indigenous civilizations. Pearson also explains that neo-pagans "tend to be polytheistic, pantheistic and/or duotheistic rather than monotheistic," and that they accept "the divine as both male and female." Rather than forming large organizations such as the Theosophical Society, Anthroposophical Society, and the Ordo Templi Orientis, neo-pagan groups work in smaller groups with few members. These might be called covens (Wicca), groves (Druidry), hearths (Heathenism), or even small "magical lodges." The right to participate in these exclusive groups may or may not involve a formal process of initiation. [29] In most cases, neo-pagan groups "like to keep their numbers small in order to maintain the intensity of group working"; in most cases, neo-pagan groups have 12 or fewer members.[30] Pearson notes almost all neo-pagan groups "use ritual" and celebrate the "eight seasonal festivals" that are practiced within Gardnerian Wicca.[31]

The value that neo-pagans place upon "indigenous peoples and the paganisms of the ancient world revealed through archeology, classics, myth and history" has inspired many attempts to revive these lost beliefs and practices "in the context of modern-day life" by way of a "continual creative process."[32] This desire to revive indigenous culture and ancient religious wisdom is linked to a neo-pagan "critique" of Christianity. Although there is no uniform rejection of Christianity within neo-paganism, Christianity has been painted within that current as a force that repressed women, denied feminine divinity, erased esoteric culture and

wisdom, drove paganism underground, and contributed to the destruction of the environment by ignoring the sacredness of nature.[33]

There is much that resembles the trends of the Occult Revival in Pearson's descriptions of neo-paganism, such as (1) the practice of ceremonial magic and ritual, (2) the interpretation of mythology as the revelation of spiritual truth, (3) the critique of Christianity, (4) the use of initiation rituals, and (5) an avid interest in reviving and carrying on an ancient tradition of ceremonial magic. At the same time, there are notable differences between neo-paganism and nineteenth-century occultism. Neo-pagans are less likely than their Occult Revival predecessors were to seek to establish large organizations driven by a "central authority."[34] Neo-pagans are far less inclined than occultists such as Crowley, the Steiners, Tingley, or Mathews to present their belief systems as universally true or as the harbinger of a new era in which all of humanity will be spiritually transformed. On the contrary, many neo-pagans refrain from claims of universal spiritual truth, and foster an environment of religious diversity in which "each person has the freedom to choose their own religion."[35] (This is not to say that spiritual and religious tolerance was absent during the Occult Revival. Religious diversity is, for instance, highly valued in Theosophy and Anthroposophy. In neo-paganism, however, aversion to religious universals is a defining characteristic.) While many neo-pagans share with nineteenth-century occultists a belief in the existence of a primordial tradition, they are more likely than their predecessors to seek insight into that tradition by studying indigenous cultures. This is quite different from groups such as the Hermetic Order of the Golden Dawn, the Ordo Templi Orientis, and the Anthroposophical Society, who sought insight into the primordial tradition primarily through the esoteric practices and philosophies (such as Hermeticism, Rosicrucianism, alchemy, astrology, and spiritual Freemasonry). The place of women as spiritual leaders is more firmly positioned within neo-paganism than it was during the Occult Revival. These special characteristics have informed many of the performance practices that have developed within neo-paganism between the mid-twentieth century and the present.

NEO-PAGAN PERFORMANCE

The central place and purpose of performance within neo-paganism was already apparent to sociologist of religion Robert S. Ellwood in 1973, who wrote:

> These Neo-Pagan groups have in common a particular emphasis on...the "practical"—rite, gesture, ceremonial act. It is through corporate "work" that the magical cosmos is evoked; it is "made" by ritual actions that demarcate and celebrate it, and by acts done as if it were present.[36]

Hutton asserts that one of the key characteristics of neo-paganism is its "essential reliance upon the creative performance of ritual." Spiritual teachers have passed some of these rituals down, but many others are original compositions created by individual practitioners.[37] The variety of forms that neo-pagan ritual takes is even more diverse than the variety of neo-pagan movements that exist. Some insight into this diversity of neo-pagan performance is demonstrated in the brief survey of contemporary esoteric performance that follows.

Serpentessa

Serpentessa (Gretchen Brown) is a belly-dancing "Snake Priestess" who has danced with snakes for 20 years. Serpentessa gives workshops in temple belly dance, and produces works of performance, dance, and theatre that focus on "reclaiming the Sacred Feminine in mind, body, and soul."[38] One of Serpentessa's workshops is called Basic Snake Handling, and the participants include men, women, and children. Serpentessa's perspectives upon the spiritual efficacy of performance, the sacred and spiritual correspondence between nature and human beings, and the sacred feminine are akin to many of the central beliefs of neo-paganism.

In 2002, Serpentessa performed in an off-Broadway production titled *Goddessdance*, which ran at the American Theatre of Actors at 314, 54th Street, in Manhattan. The *Goddessdance* website describes the production as "a lavish Middle Eastern fantasy that celebrates women—their beauty and sensuality, and their changing roles in history." *Goddessdance* comprised a series of vignettes, including a harem scene in which "a new concubine" was "murdered by rival wives," a dance vignette in which Serpentessa performed with a python, and a traditional belly dance by an artist named Jehan, who trained Serpentessa in the art of belly dancing. Jehan composed and arranged live music for *Goddessdance* that blends traditional and modern melodies with instruments such as flutes, didgeridoos, Middle Eastern drums, and hand clappers.[39] The very title of this performance invokes a feminine deity, and the musical score is rooted in indigenous instrumentation. Trends of the neo-pagan current were apparent in *Goddessdance*.

The spirituality of *Goddessdance* was apparent to *Village Voice* dance reviewer, Eva Yaa Asantewaa, who stated that Jehan's production "celebrated the primal spirituality of belly dancing and the atomic power of women's sexuality." With the exception of a performer whom Asantewaa deemed too serious to convey the humor contained in certain parts of the text, her review was positive. She praised Serpentessa for her "riveting wriggles with a snake that calmly, elegantly draped itself around her head and neck."[40] Apparently, the spiritual purpose of Serpentessa's performance did not interfere with its entertainment value for Asantewaa.

Serpentessa asserts that the form of sacred theatre that she practices has the power to heal and that she experienced this healing power in her own life when she began dancing with snakes as a private ritual practice. From the time of puberty, Serpentessa struggled with endometriosis, which eventually resulted in infertility and ovarian failure (immediate menopause).[41] Serpentessa associated her suffering with the triple "Moon Goddess," which Shahrukh Husain speaks about in her 2003 book, *The Goddess: Power, Sexuality and the Feminine Divine*:

> In the mythology of...modern pagan feminist thought, the Goddess represents three phases of the female lifespan, which correspond to the lunar cycle. The new moon is the virgin, the full moon is the sexually productive woman, usually described as either a mother or a whore, and the old moon is the crone. Goddess worshippers have given this threefold manifestation the title of triple Goddess.[42]

Initially, Serpentessa viewed the influence of the Triple Moon Goddess over her life as a tyrannical force. Her understanding of the Moon Goddess began to change slowly after she received a gift—a red-tailed boa constrictor that she named Sofia.

Serpentessa began doing improvisational dance with Sofia at home, and she was particularly fascinated by the animal's ability "to move into any shape." At one point, Sofia shed her skin, and Serpentessa viewed this process as "a metaphor of letting go and beginning anew." This revelation led Serpentessa to view the moon "as a mirror influence for her monthly cycle." She began to offer prayers to the moon and seek answers from it. Eventually, she came to view dancing with snakes as a way of "healing her Triple Goddess nature" and "coming into her Crone through the death of Motherhood and the rebirth of [her] commitment to living."[43] After having this revelation, Serpentessa turned to belly dancing and theatre as a way to realize and communicate the spiritual revelation she experienced in front of an audience.

The performance that Serpentessa ultimately created was titled *Shedding a Skin*. This production was the "final catalyst" for Serpentessa to "fully reunite and heal the Sacred Feminine" within herself. *Shedding a Skin* was performed in moonlight. Serpentessa first appears in the performance as a bag lady named "Mad Hettie," who explains that for many centuries she has been "planting the seeds of renewal from the compost in [her] bag." (This blend of humor and the sacred is characteristic of the alternation of "reverence and mirth" that Hutton lists as characteristic of neo-pagan spirituality.)[44] Serpentessa then performs a "humorous" and "erotic" striptease that reveals the "sacred theatre underlying the spectacle." After the striptease, Serpentessa reveals her snake, Sofia. As Serpentessa explains the performance, she, Sofia, and the Moon Goddess dance together in *Shedding a Skin* "as yet another incarnation of the Triple Goddess—Serpent, Moon, and Goddess energies."[45] Serpentessa's performance reflects the exalted place of the goddess within the neo-pagan current.

This is not to say that everything in Serpentessa's work is solely attributable to contemporary neo-paganism. One need only consider the history of belly dancing to know that Serpentessa is working with very old forms. Some of Serpentessa's ideas and techniques were already present during the Occult Revival of the late nineteenth and early twentieth centuries. The notion of the Triple Goddess to which Serpentessa refers—and which has become so prevalent among neo-pagans—was popularized by 1903.[46] The display of the female body as a representation of feminine divinity was also a common practice in the rituals of the Occult Revival. In the rituals of Gardnerian Wicca and in Crowley's *Gnostic Mass*, participants are encouraged to view the body of a female performer as the "likeness of the Goddess."[47]

Serpentessa's ideas, and the trends of neo-paganism in general, are not disconnected from the Occult Revival of the previous century. They even bear some similarities to the trends of professional theatre of the early and late twentieth century. The interest in indigenous performance forms that is apparent in Serpentessa's work bears a certain similarity to Antonin Artaud's exploration of, and Eugenio Barba's interest in, Balinese dance, Kabuki, and Odissi dance.[48] Serpentessa's view that theatre can heal[49] resembles Artaud's idea that theatre, if properly created, can alleviate negative aspects of human existence.[50]

Serpentessa's performance techniques show that there is no clear division between the theatre of the Occult Revival and the more contemporary currents of performance that have emerged since the rise of neo-paganism.

What seems neo-pagan about Serpentessa's performance is not so much the performance practices or the symbols, but rather the strong emphasis that is placed upon the goddess and indigenous practices.

ALCHEMIFIRE RITUAL AND THE VEGAS VORTEX

The sacredness of earth and the art of magic are at the root of the Alchemical Fire Circle ritual, or, as the current members of the Vegas Vortex call it, the AlchemiFire Ritual (hereinafter AFR). Jeff and Abigail McBride are leaders of the Vegas Vortex, and they are facilitators of the AFR, which often takes place in the Valley of Fire State Park in Nevada, United States. According to www.vegasvortex.com, the Vegas Vortex is "a community of friends, artists, musicians, performers and wisdom-keepers centered in Las Vegas, Nevada. We host an ongoing series of fire circles, magickal events, concerts, playshops, drum circles, dances and empowering weekend retreats." Elsewhere, the Vegas Vortex members are described as "a bunch of friendly, fun-loving folks who like to get together to make music, art, dance, and ritual theatre celebrations."[51] Jeff McBride and his wife, Abigail, have posted theoretical and practical articles about fire circle work on the Vegas Vortex website. The McBrides describe the AFR as "a microcosm of the daily world we live in," and they promote the ritual as a way to "engage artfully with others, evoke healing energy, pray, do personal magic, or simply celebrate the multitude of blessings in life." The McBrides emphasize that it is through performance that one experiences the benefits of the AFR. They list four performance-based "portals" that allow entry into the magical aspect of the AFR. These portals are "voice," "music," "movement," and "service." [52]

The Vegas Vortex website describes each of these portals in further detail. Among the performance forms that take place at the AFR are chanting, singing, trance dancing, invocation, recitation of poetry, and sacred theatre. The prime rhythmic driver of the AFR is drumming. While the Vegas Vortex website makes it clear that the AFR is not a simple drumming circle—in fact, many different instruments are played during the ritual[53]—it is also clear that drumming is central to this event, which involves many participants moving, chanting, and performing in various circular orbits around a bonfire. The significance of drumming in the AFR is an evidence of its relationship to the neo-pagan current. Drumming and ecstatic dance are both recurring practices in North American neo-paganism.[54]

AFR involves a series of planetary "orbits," each of which relates to a planet or astrological body. In the center of all of these rings is a fire, which is called "Sol."[55] Sol is the visual and spatial center of the fire circle, upon which the participants focus their concentration while they orbit. Each Planetary ring is designated for specific types of performances and activities. The Mercury orbit, which is the closest to Sol, is the space where the fastest, most vigorous dancing takes place. The participants in this ring are in a state of continuous orbit. The next orbit, Venus, concerns relationships with oneself and others. In the Venus orbit, there is dance, sensual movement, and singing. The Earth track, which is "demarcated with corn meal or flour," is a place of "slow and deliberate orbit" that is usually peopled by "those deep in trance." The Mars orbit is a place from which participants face Sol, as well as the Venus, Earth, and Mercury orbits. Those in the Mars orbit provide "sonic guardianship" and "energetic support" to those in the inner rings. The Jupiter Ring, which surrounds Mars, is a place where participants embrace, feed and water one another, and serve each other's needs. Jupiter is a stationary, rather than dancing, orbit.

In an online article titled "The Magic of the Fire Circle," Jeff and Abigail McBride write that alchemical fire circle work has developed over a period of about 15 years, and they liken the ritual to the Alchemical Magnum Opus—the creation of the Philosopher's Stone:

> We see the primary goal of staying up all night, drumming, dancing and singing at a fire circle as an alchemical process. Each one of us is involved, on some level, in the great work. We accelerate the processes of personal growth by accelerating the fire of Nature, which transforms the lead of our lives into the gold of Spirit. One of the basic ideas behind many alchemical traditions is that of transmuting or purifying one thing from a "lower" form into a "higher" form.[56]

The McBrides acknowledge that every AFR is different due to the spontaneity and improvisation that takes place during the ritual, but they claim that what every fire circle has in common is the effect of moving the human being from a lower to a higher form. The power of the fire circle ritual is credited to the natural power of fire, which the McBrides perceive as an alchemical force that can purify human beings.[57]

The AFR is aligned with a very old esoteric tradition: alchemy. In their coauthored article, "The Magic of the Fire Circle," Jeff and Abigail McBride divide the temporal phases of the AFR into alchemical phases. There are the "Nigredo" phase, during which the participants "burn

away...egos and agendas"; the *Albedo* phase, during which trances are most likely to occur; and the *Rubedo* phase, which is accompanied by "solar adorations, holy silence, and grounding."[58] This understanding of the AFR is in keeping with understandings of alchemical "transmutation" that have been adhered to by esotericists for centuries. Regarding the concept of spiritual "transmutation," and its relationship to initiation rituals, Faivre writes:

> Transformation would hardly be an adequate term because it does not necessarily signify the passage from one plane to another, or the modification of the subject in its very nature. "Transmutation," a term borrowed from alchemy in our context, seems more appropriate. It should also be understood as a "metamorphosis"...
>
> It seems that an important part of the alchemical corpus, especially since the beginning of the seventeenth century, had as its object...the figurative presentation of this transmutation according to a marked path: *nigredo* (death, decapitulation of the first matter or the old man), *albedo* (work in white), *rubedo* (work in red, the philosopher's stone)....It is often implied in such contexts that transmutation can just as well occur...in the experimenter himself.[59]

Faivre is discussing a long-standing tradition of esoteric exegesis that views alchemical symbolism as a means of describing an initiatory process that transforms, heightens, and rarifies the spiritual state of a human being. Alchemy historian Allison P. Coudert describes this interpretive approach as "spiritual alchemy," and she argues that it "was part of alchemy from its inception in the ancient world."[60] Spiritual alchemy is linked to the earliest expressions of Rosicrucianism, such as *The Chemical Wedding of Christian Rosenkreutz in the Year 1459* (1616), which uses alchemical symbolism to depict the transmutation process of Christian Rosenkreutz. The idea of correspondences between the transmutation of natural elements and human beings is also central to Hermeticism. The most often cited expression of Hermetic philosophy is probably "as above, so below," which is drawn from *The Emerald Tablet*. (*The Emerald Tablet*, which is legendarily attributed to the Thrice-Great Hermes, first appeared in Arabic in the tenth century and was translated into Latin by the twelfth century.)[61] Jeff and Abigail McBride post *The Emerald Tablet*[62] and refer to alchemical symbols on their website. In their discussions about the potential of the AFR to cause human transmutation, the McBrides draw from three old esoteric traditions: alchemy, Hermeticism, and Rosicrucianism.

On the other hand, when the McBrides identify the AFR as a healing practice rooted in shamanistic practices, they are taking part in an esoteric current that gained momentum in Western culture between the mid-twentieth century and the present. After acknowledging that the teachings and ritual practices of many of the great teachers of the Occult Revival have been "carried over and adapted in some forms of Neopaganism,"[63] Pearson goes on to explain that in the 1970s and 1980s in the United States, "Neopaganism increasingly became influenced by the emerging New Age Movement and feminist spirituality." The New Age Movement helped to transform neo-paganism "into a very different kind of religion, with a less formal and hierarchical ritual style, Native American influences such as shamanism and drumming, the increasing use of psychotherapy within Wicca, and Wiccan involvement in political and environmental activism." Like Hutton, who noted the rise of feminist witchcraft in the late 1960s, Pearson explains that Wicca "in particular...was adapted by the women's spirituality movement, resulting in the development of Neopagan goddess spirituality and feminist witchcraft traditions such as the Reclaiming collective, founded in San Francisco in 1980 by (among others) Starhawk."[64] The aspects of neo-paganism that are emphasized to a higher and more general degree than they were during the Occult Revival are sacred ecological activism, the emphasis of feminine spirituality, the heightened place of the goddess, an interest in indigenous cultures (especially shamanism), and the creation and use of esoteric ritual not only for magical ends but also for the purpose of psychological healing.

The connection of the work of the McBrides and of the Vegas Vortex with this contemporary neo-pagan current is clear when one looks over the website. VegasVortex.com includes a list of courses, events, and workshops offered by some of the members of the Vegas Vortex. Among the topics of those courses and events are several that relate to the primary interests of contemporary neo-paganism: drumming, shamanism, creativity, and women's mysteries.[65]

The policy of religious diversity of the Vegas Vortex and the AFR brings to mind the religious diversity of contemporary neo-paganism. The Vegas Vortex website states that different "spiritual leaders" and people of "many backgrounds, races, and religions" attend the AFR.[66] This description of diversity resembles the diversity policy of the Pagan Federation website, which describes "freedom of religion and equality of race, gender, and sexual orientation" as central to neo-pagan aims, objectives, and values.[67] Of course, the central place of performance, music, theatre, and dance within the AFR indicates that performance is essential to this practice. In

fact, establishing "a safe container to explore creative expression, intensive meditation, focused awareness, and spontaneous music" is described as the central purpose that is shared by all of the people who participate in the AFR.[68] This emphasis upon creative performance as an essentiality spiritual practice also indicates an affinity that exists between the AFR of the Vegas Vortex, and the creativity-driven neo-pagan movement.

OCCULT II

Just as many contemporary forms of neo-paganism have incorporated and adapted teachings and practices of the Occult Revival, so have practitioners who identify as members of Occult Revival organizations incorporated and adapted aspects of contemporary neo-paganism current into their work. Neo-pagan aspects are apparent, for example, in the annual *Occult* event, which occurred for the second time in Salem, Massachusetts, in September 2014. *Occult* is a coproduced and curated by Aepril Schaile (figure 6.1) and Sarah Jezebel Wood (figure 6.2). Schaile and Wood are Thelemites, but they are both involved with other esoteric traditions. Schaile is a professional astrologer and dance teacher, who holds an MFA in interdisciplinary arts. Schaile is also a member of the Exquisite

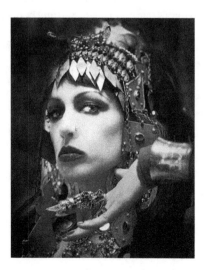

Figure 6.1 Aepril Schaile. Photo courtesy: Aepril Schaile.

Figure 6.2 Sarah "Jezebel" Wood. Photographer: Peter Paradise Michaels. Photo courtesy: Sarah "Jezebel" Wood.

Corpse Dance Theatre. Wood has a background in "Pagan earth based spiritualities including fire circle modalities." Wood is also the director of Lunaris, which is "a ritual based dance collective whose mission is to physically manifest the workings of the soul and spirit through the art of dance, ritual, and theater." [69] (This artistic mission brings to mind the purpose of Rudolf and Marie Steiner's Eurythmy, which was also created to reveal soul activities through movement.) For years, Wood worked at Alex Gray's Chapel of the Sacred Mirrors (CoSM), where "creativity" is equated with "sacred practice." [70] The *Occult* event is a gathering where creative people who are involved in esotericism, occultism, neo-paganism, etc. may share their work.

The *Occult* website describes it as a "the juxtaposition of beauty and magick of art and ritual." The Occult II event, which was held in September 2014, included several presentations, workshops, and performances. The lineup of presenters for *Occult* includes witches, scholars of esoteric history, dancers, occult authors, visual artists, and a psychologist.[71] The range of workshops and presentations at *Occult* included topics such as dance, ritual, the spiritual aspect of tattoo art, the artistic ideas of nineteenth-century Symbolist Joséphin Péladan, and the application of Aleister Crowley's symbolism to art making.[72] *Occult* is an "esoteric salon" demonstrating how "magick and art" are "rooted together" through workshops, presentations, and performances. For Schaile, this

is an interdisciplinary connection, and she would like to see practitioners of all magickal and esoteric backgrounds present work at *Occult* in the future. In fact, Schaile consciously points out connections between what she and Wood are doing with the *Occult* event and the larger community of occultists, esotericists, and pagans.[73]

Several different esoteric traditions—some of Occult Revival heritage and others stemming from neo-pagan sources—are represented at the *Occult* salon. The connections between the *Occult* event and the esoteric current of the Occult Revival are quite clear. In conversations with me, Schaile commented that the overall event was modeled to a certain degree upon the Parisian art salons at the turn of the last century, where artists and occultists often met to exchange ideas.[74] Of course, the links to Crowley in the *Occult* event also demonstrate a connection to the traditions of the Occult Revival. One of the key purposes listed on the *Occult* website is to achieve "full expression of the will"[75] and that language brings up core Thelemic principles.

At the same time, the creative values of the neo-pagan current are also apparent on the *Occult* website, which promises "a safe and challenging space to open and express" and opportunities for "free expression," "co-creation," and the "strengthening of network."[76] Schaile relates shamanism to art and creative work. In an interview with me, Schaile explained that the artist might operate as a shaman, if the works that the artist creates "mediate between worlds." Schaile acknowledges that there is a great deal of debate about whether one can truly be a shaman in the contemporary Western world, but, for her, this conceptualization of art-making has inspired her spiritual practice. When I asked Schaile what she thinks of when she hears the term "primordial tradition," her response was shamanism, which she describes as "the first form of religion" and "the first form of magic."[77] This understanding of shamanism first became prevalent among Western esotericists with the rise of the neo-pagan current.

Schaile and Wood both discussed the impact of the Internet and digital technology upon the practice and transmission of esoteric philosophy and practice. Wood notes:

The hidden is not so hidden anymore....we live in an Information Age where grimoires are now downloadable; anyone can be a magician for better or worse. I am an advocate for serious study though. The ability to access this information increases the potential collective knowledge we are able to indulge in and the bar is raised for all to ensure the integrity of the information we are presenting and receiving.[78]

Schaile agrees with Wood that websites such as Hermetic.com and Sacred-Texts.com have made many volumes of esoteric philosophy and practice available to unprecedented numbers of people. Schaile believes that this access to knowledge is a "wonderful privilege." She also believes that this accessibility to esoteric knowledge makes the old process of occult initiation more important than ever because, "no matter how much of the information is available you have to have some kind of context...some sort of intellectual, emotional,...structural, or formal initiation to understand what you're looking at."[79] With the advancement of digital technology, Schaile believes that the live, interpersonal relationship of guidance between the initiate and the initiator is still needed within magical communities. Even in today's digitized world, the long-established practice of initiation continues.

CONCLUSION

In the years following the establishment of Wicca, a different direction in esoteric practice seems to have emerged in Western culture. The Occult Revival saw the foundation of many large occult establishments with formalized methods of study and ritual practice, such as the Theosophical Society, the Ordo Templi Orientis, the Anthroposophical Society, and the Rosicrucian Order Crotona Fellowship. In the latter part of the twentieth century, practitioners of esoteric spirituality have moved away from large, formal organizational structures and toward the formation of smaller groups. The term "neo-paganism" does not refer to a specific organization, but to a diverse array of small spiritual groups, such as witch covens, druid groves, and heathen hearths. These bodies of modern pagans do not share a specific, formalized initiatory path; rather, they share principles and practices that are associated with the neo-pagan current. Among these are the celebration of seasonal events, the belief in male and female deities, a lack of official doctrines or creed, an interest in shamanistic and indigenous spiritual practices, and a reverence for nature.

Another unifying aspect of neo-paganism is the equation of creative art and performance with spiritual practice. Neo-paganism has spawned a diverse array of spiritual performance practices. This diversity of neo-pagan performance practices has inspired the development of an international tapestry of interdisciplinary gatherings and festivals where adept artists stage esoteric theatre, perform indigenous dance forms, present magical ceremonies, and display spiritual art. The Neopagan current of

performance and art is participatory in nature; it is not enough to sit and watch. To experience the spiritual realm in neo-paganism, one must create and participate. Creative ritual performance is a foundational aspect of the neo-pagan current. The contemporary current of neo-pagan performance has its roots in the theatre of the Occult Revival, and it will likely continue to thrive for many years into the future.

Conclusion ～

There is no clear line of demarcation that shows the point when the Occult Revival ended and neo-pagan performance began. Although occultists of the late nineteenth and early twentieth centuries emphasized things differently than many of the ceremonial magicians, witches, and pagans who appeared between the mid-twentieth century and the present, it would be historically false and overly simple to suggest that the current of the Occult Revival simply disappeared and gave way to newer currents. The leaders of the Occult Revival anticipated many of the trends of neo-pagan current, and the neo-pagan current has adopted and adapted many of the traditions of the Occult Revival. Also, contemporary members of societies formed during the Occult Revival, such as the Thelemites Aepril Schaile and Sarah Jezebel Wood, have incorporated neo-pagan elements into their practices and participated in events that include practitioners of neo-paganism. If there are any boundaries between the traditions of the Occult Revival and neo-paganism, they are highly permeable.

Several theatre and performance traditions created during the Occult Revival have continued into the present. Steiner's Mystery Dramas are still performed at the Goetheanum in Dornach, Switzerland. For instance, between December 27 and 31, 2014, the Goetheanum stage ensemble will perform all four of Steiner's Mystery Dramas as part of the 2014 Anthroposophical Christmas Conference.[1] Aleister Crowley's *The Rites of Eleusis* and *Gnostic Mass* are regularly performed today by OTO lodges, oases, and camps in the United States.[2] Practitioners of Gardnerian Wicca continue to perform the rituals that Gardner wrote and use the tools of Wiccan ceremonial magic, as is evidenced by the continued sale of swords, daggers, pentacles, wands, and cauldrons in occult supply stores and on the Internet. Of course, many of the tools of Wicca were already used in earlier forms of ceremonial magic, such as those practiced and promoted by Aleister Crowley and Eliphas Lévi. As neo-paganism rose to popularity in Europe and the United States, many practitioners of magic continued

to draw from the ideas and practices of the theatre of the Occult Revival. Of all the theatrical ideas that circulated during the Occult Revival, it is perhaps the idea that performance can create a link between the human being and the spiritual aspect in life that most profoundly informed the development of neo-paganism. When one considers that the symbols of Rosicrucianism were already being incorporated into the initiation rituals of speculative Freemasonry by the eighteenth century,[3] it becomes clear that practitioners of esoteric spirituality believed in the spiritual effectiveness of initiatory drama long before the onset of the Occult Revival in the late nineteenth century.

There is no way to prove the existence of a primordial tradition through which ancient occult knowledge has been passed down from time immemorial to the present, but there does exist in Western culture a body of esoteric literature and practice that reaches at least as far back as the medieval era. This collection of esoteric ideas and practices—which includes speculative Freemasonry, Hermeticism, Rosicrucianism, spiritual alchemy, ceremonial magic, and many other practices and philosophies—underpinned the development of the theatre of both the Occult Revival, as well as the later current of neo-pagan performance. The forms of esoteric theatre and performance that developed between the late nineteenth century and the present can therefore be viewed as a part of a much larger and older body of esoteric philosophy and practice. That body of esoteric material includes a great deal of theatre, drama, performance, and ritual. This under-researched area of study deserves more attention from theatre and performance scholars.

In the introduction to this book, I argued that esoteric performance practices that have been developed from the time of the Occult Revival till now indicate a shift in the relationship between theatre and religion in Western culture. Victoria Nelson observes this shift in her book, *The Secret Life of Puppets*:

> The turn of the millennium found Western societies experiencing a curious reversal in the roles of art and religion. Whereas religion up to the Renaissance provided the content for most high visual art and literature, art and entertainment in our secular era have provided...the content for new religion.[4]

This flow of creative energy from the realm of art to the realm of religion fueled the development of religious practices during the Occult Revival. Tingley, Steiner, Crowley, Mathews, and Gardner all viewed theatre as sacred art that could spiritually transmute the human being, and they all

gave performance a central place within the spiritual practices they promoted. The equation of creative performance with spiritual practice has remained prevalent in the era of neo-paganism, where diverse forms of theatre, performance, music, and dance are considered essential tools for experiencing the spiritual or divine aspect of life.

Wiccan author Judy Harrow shows that neo-pagans are enthusiastic about the construction of religion in her preface to the fiftieth anniversary edition of *Witchcraft Today*, where she writes that neo-pagans view religion as something that is "experimental" in "practice," "a living thing," and "an ongoing co-creation."[5] In contemporary neo-paganism, each solitary practitioner is given license to develop their own unique spiritual worldview and religious practice. This aspect of the Occult Revival and neo-paganism resembles what religious studies scholar Paul Heelas has described as "postmodern religion": that is religion that ignores religious "universals" and encourages individuals to create rituals that embody their own religious creeds. Heelas refers to these individualized religions as "micronarratives."[6] The solitary practitioner of neo-paganism might be described as a builder of esoteric micronarratives.

Joanne Pearson asserts "the attitude of 'being Neopagan' in opposition to 'being Christian' is growing more rare." Furthermore, the efforts of neo-pagans to find interfaith connections have resulted in "a less reactive posture" than were common during the Occult Revival, with its "false histories" and occasional (especially in the case of Aleister Crowley) "hatred of the Christian Church."[7] There has never been any uniform opposition to Christianity by neo-pagans or occultists. Consider occultists such as Rudolf Steiner, who incorporated Christian symbolism and characters into his worldview, or Gerald Gardner, who stated that he could "see no real reason why one cannot be a good enough though unorthodox Christian and a witch."[8] Christianity was not always the primary target of occultist criticism.

It is the concept of "religion"—when conceived as something closely associated with "restriction"—which most occultists avidly stand against. The word "religion" was so problematic that many of the spiritual leaders of the Occult Revival carefully distanced themselves from the word or rejected it altogether. Crowley, for instance, did not stop anyone from describing Thelema as a religion, although he warned that using this label "might easily cause a great deal of misunderstanding."[9] Blavatsky, on the other hand, stated that Theosophy is not a religion, but rather "the essence of all religion and of absolute truth, a drop of which only underlies every creed."[10] The distance that spiritual leaders of the Occult Revival placed

between themselves and the concept of religion bears a resemblance to the attitude of contemporary people who describe themselves as "spiritual but not religious." This distinction depends upon on an understanding of "religion," on the one hand, as something based upon "received theological doctrines and dogmas" and, on the other hand, an understanding of "spirituality" as something "more individual and subjective, reflecting personal practices and experiences that may diverge from religious orthodoxy or convention."[11] Some scholars of religion argue that current distinctions between religion and spirituality evidence a "growing desire for spirituality outside of institutionalized religion," which is rooted in a "distrust of religious organizations." This distrust of religious organizations has contributed to the "valorization of individual conscience over institutional religious teaching as the ultimate source and arbiter of moral judgment."[12] Today, religion is often thought of in institutional terms. Spirituality, on the other hand, is often understood in "personal or experiential terms," such as a relationship with a "Higher Power" or an "inner guide." This notion of spirituality suggests that the relationship between human beings and Higher Power is maintained through beliefs and methods that prove meaningful to an individual spiritual seeker through experimentation and practice.[13] In particular, the creation and performance of rituals, which is central to contemporary neo-paganism, seems to be rooted in this contemporary understanding of the spiritual as an individual experience.

The Occult Revival can be viewed as a point in time when an interest in drama, theatre, and performance intersected with a desire for religious experience and spiritual knowledge that exists outside of the bounds of traditional religions. This desire for alternative spirituality has not waned in the present. On the contrary, it has expanded and diversified since the emergence of neo-paganism, and there is nothing to indicate that the creative currents that came to the fore during the theatre of the Occult Revival will stop anytime soon. Occultists, witches, mystics, priests, priestesses, druids, shamans, pagans, heathens, Goddess worshippers, and other seekers of gnosis will continue to use drama, theatre, and performance to give shape and expression to their religious and spiritual worldviews in the future.

Notes ❧

INTRODUCTION

1. Richard Kaczynski, *Perdurabo: The Life of Aleister Crowley*, revised and expanded edition (Berkeley, CA: North Atlantic Books, 2010), 296.
2. Aleister Crowley, *The Complete Astrological Writings* (London: W. H. Allen, 1987), 90–91.
3. Ronald Hutton, *Triumph of the Moon: A History of Modern Pagan Witchcraft*, paperback edition (Oxford: Oxford University Press, 2001), 227, 247.
4. Paul Heelas, "Introduction: On Differentiation and Dedifferentiation," in *Religion, Modernity, and Postmodernity* (Oxford: Blackwell, 1998), 8.
5. John Patrick Deveney, *Dictionary of Gnosis and Western Esotericism*, ed. Wouter J. Hanegraaff (Leiden: Brill, 2005), 1077–1079.
6. Eliphas Lévi, *Dogme et ritual de la haute magie*, in *Secrets de la magie*, edited by Francis Lacassin (1856; reprint, Paris: Robert Laffont, 2000), 205–215.
7. Maria Carlson, *"No Religion Higher Than Truth": A History of the Theosophical Movement in Russia, 1875–1922* (Princeton, NJ: Princeton University Press, 1993), 29.
8. Carlson, *"No Religion Higher Than Truth,"* 28.
9. Antoine Faivre, *Access to Western Esotericism* (Albany: State University of New York Press, 1994), 37.
10. Faivre, *Access to Western Esotericism*, 19.
11. Arthur Versluis, *The Esoteric Origins of the American Renaissance* (Oxford: Oxford University Press, 2001), 4.
12. Wouter J. Hanegraaff, "Esotericism," in *Dictionary of Gnosis and Western Esotericism*, 337–338.
13. Wouter J. Hanegraaff, "Occult/Occultism," in *Dictionary of Gnosis and Western Esotericism*, 888.
14. Faivre, *Access to Western Esotercism*, 5.
15. Faivre, *Access to Western Esotercism*, 5.
16. Faivre, *Access to Western Esotericism*, 34–35.
17. Roger Dachez, "Freemasonry," *Dictionary of Gnosis and Western Esotericism*, 383.

18. Helena Petrovna Blavatsky, *The Key to Theosophy*, 2nd ed. (1889; reprint, Pasadena, CA: Theosophical University Press, 1995), http://www.theosociety.org/pasadena/key/key-hp.htm.

19. Blavatsky, *The Key to Theosophy*.

20. Michèle M. Schlehofer, Allen M. Omoto, and Janice R. Adelman, "How do 'Religion' and 'Spirituality' Differ? Lay Definitions among Older Adults," *Journal for the Scientific Study of Religion* 47 (2008): 412.

21. Eileen Barker, "New Religions and New Religiosity," in *New Religions and New Religiosity*, ed. Eileen Barker (Aarhus: Aarhus University Press, 1998), 16 (emphasis in the original).

22. Michèle M. Schlehofer, Allen M. Omoto, and Janice R. Adelman, "How do 'Religion' and 'Spirituality' Differ? Lay Definitions among Older Adults" *Journal for the Scientific Study of Religion* 47 (2008): 413.

23. Robert Lima, *Stages of Evil: Occultism in Western Theatre and Drama* (Lexington: University Press of Kentucky, 2005).

24. Daniel Gerould, "The Symbolist Legacy," *PAJ: A Journal of Performance and Art* 31 (January 2009): 81.

25. Ibid., 82.

26. See note 7.

27. Frantisek Deak, *Symbolist Theater: Formation of an Avant-Garde*, PAJ Books Series (Baltimore, MD: Johns Hopkins University Press, 1993), 48.

28. Jean-Pierre Laurant, "Lévi, Éliphas," in *Dictionary of Gnosis and Western Esotericism*, 691.

29. Maurice Maeterlinck, "The Tragical in Everyday Life," in *Dramatic Theory and Criticism: Greeks to Grotowski*, ed. Bernard F. Dukore (Fort Worth, TX: Harcourt Brace Jovanovich College Publishers, 1974), 730.

30. Lance Gharavi, *Western Esotericism in Russian Silver Age Drama*: *Aleksandr Blok's* The Rose and the Cross (Saint Paul, MN: New Grail, 2008), 4.

31. Daniel Gerould and Jadwiga Kosicka, "Drama of the Unseen—Turn-of-the-Century Paradigms for Occult Drama," in *The Occult in Language and Literature*, edited by Hermine F. Riffaterre (New York: New York Literary Forum, 1980), 6.

32. See Deak, *Symbolist Theater*; Gharavi, *Western Esotericism*; and Gerould and Kosicka, "Drama of the Unseen." See also Daniel Gerould, *Doubles, Demons, and Dreamers: An International Collection of Symbolist Drama* (New York: Performing Arts Journal Publications, 1985); and Sadakichi Hartmann, *Buddha, Confucius, Christ: Three Prophetic Plays* (New York: Herder and Herder, 1971).

33. Ray Stannard Baker, "An Extraordinary Experiment in Brotherhood: The Theosophical Institution at Point Loma, California," *American Magazine* 63 (January 1907): 235. Paul Kagan Utopian Communities Collection, Beinecke Rare Book and Manuscript Library, Yale University.

34. "An Amazing Sect," *The Looking Glass* (October 29, 1910); quoted in Keith Richmond, Introduction to *The Rites of Eleusis*, by Aleister Crowley, 38–40.

35. Robb Creese, "Anthroposophical Performance," *Drama Review* 22 (June 1978): 47–49.
36. J. L. Bracelin, *Gerald Gardner: Witch* (London: Octagon Press, 1960), 186.
37. Eileen Barker, "New Religions and New Religiosity," 12.
38. "Occult and Bizarre," ed. Michael Kirby, special issue, *Drama Review* 22 (June 1978).
39. See note 31.
40. See note 27.
41. See note 30.
42. R. Andrew White, "Radiation and Transmission of Energy: From Stanislavsky to Michael Chekhov," *Performance and Spirituality* 1 (2009): 23–46.
43. R. Andrew White. "Stanislavsky and Ramacharaka: The Influence of Yoga and Turn-of-the-Century Occultism on the System," *Theatre Survey* 47 (May 2006): 73–92.
44. Franc Chamberlain, *Michael Chekhov* (London: Routledge, 2004).
45. Anita Hammer, *Between Play and Prayer: The Variety of Theatricals in Spiritual Performance* (Amsterdam: Rodopi, 2010).
46. See note 9.
47. Wouter J. Hanegraaff Antoine Faivre, Roelof van den Broek, and Jean-Pierre Brach, ed., *Dictionary of Gnosis & Western Esotericism*, 2 vols. (Leiden: Brill, 2005).
48. See note 3.
49. See note 37.
50. Victoria Nelson, *The Secret Life of Puppets* (Cambridge: Harvard, 2001), vii.

1 THE OCCULT REVIVAL AND ITS THEATRICAL IMPULSES

1. Ronald Hutton, *Triumph of the Moon: A History of Modern Pagan Witchcraft*, paperback edition (Oxford: Oxford University Press, 2001), 70.
2. Eliphas Lévi, *Dogme et ritual de le haute magie* (Paris: Germer Baillière, 1856).
3. Hutton, *Triumph of the* Moon, 71.
4. Eliphas Lévi, *Transcendental Magic: It's Dogma and Ritual*, translated by A. E. Waite (1856; reprint, York Beach, MA: Weiser, 1986), 5, 10, 14.
5. Hutton, *Triumph of the Moon*, 72.
6. Hutton, *Triumph of the Moon*, 72.
7. Antoine Faivre, *Access to Western Esotericism* (Albany: State University of New York Press, 1994), 187.
8. Roland Edighoffer, "Rosicrucianism I: First Half of the 17th Century," in *Dictionary of Gnosis and Western Esotericism* (Leiden: Brill, 2005), 1009.
9. Edighoffer, "Rosicrucianism I: First Half of the 17th Century," 1009.
10. Edighoffer, "Rosicrucianism I: First Half of the 17th Century," 1009.

11. Faivre, *Access to Western Esotericism*, 173–175.
12. Faivre, *Access to Western Esotericism*, 164–169.
13. Hutton, *Triumph of the Moon*, 70.
14. Lévi, *Secrets de la Magie* (Paris: Robert Laffont, 2000), 205; See also Lévi, *Transcendental Magic*, 249.
15. Lévi, *Secrets de la Magie*, 212; See also Lévi, *Transcendental Magic*, 258.
16. Lévi, *Transcendental Magic*, 14.
17. Lévi, *Transcendental Magic*, 15.
18. R. Andrew White, "Stanislavsky and Ramacharaka: The Influence of Yoga and Turn-of-the-Century Occultism on the System," *Theatre Survey* 47 (May 2006): 77.
19. Helena Petrovna Blavatsky, *The Secret Doctrine: The Synthesis of Science, Religion, and Philosophy*, 2 vols. (1888; reprint, Pasadena, CA: Theosophical University Press, 1999).
20. James A. Santucci, "Blavatsky, Helena Petrovna," in *Dictionary of Gnosis and Western Esotericism*, 183.
21. Maria Carlson, *"No Religion Higher Than Truth": A History of the Theosophical Tradition in Russia, 1875–1922* (Princeton, NJ: Princeton University Press, 1993), 118.
22. Blavatsky, *The Secret Doctrine*, vol. 1, 253.
23. Blavatsky, *The Secret Doctrine*, vol. 1, 243, 643.
24. Blavatsky, *The Secret Doctrine*, vol. 1, 83.
25. Blavatsky, *The Secret Doctrine*, vol. 2, 312.
26. Blavatsky, *The Secret Doctrine*, vol. 2, 672–674.
27. Faivre, *Access to Western Esotericism*, 10–11.
28. Helena Petrovna Blavatsky, *The Key to Theosophy*, 2nd ed. (1889; reprint, Pasadena, CA: Theosophical University Press, 1995), http://www.theosociety.org/pasadena/key/key-hp.htm.
29. Faivre, *Access to Western Esotericism*, 131.
30. Wouter J. Hanegraaff, "Tradition," *Dictionary of Gnosis and Western Esotericism* (Leiden: Brill, 2005), 1126.
31. Edouard Schuré, *The Great Initiates: A Study of the Secret History of Religions* (1889; reprint, Hudson, NY: Steinerbooks, 1989), 337
32. Hanegraaff, "Tradition," 1126.
33. Schuré, *The Great Initiates*, 31.
34. Hutton, *Triumph of the Moon*, 71.
35. Schuré, *The Great Initiates*, 36.
36. Schuré, *The Great Initiates*, 36.
37. Schuré, *The Great Initiates*, 36–37.
38. Schuré, *The Great Initiates*, 37.
39. Schuré, *The Great Initiates*, 337
40. Schuré, *The Great Initiates*, 350.
41. Schuré, *The Great Initiates*, 351–352.
42. Schuré, *The Great Initiates*, 368.

43. Schuré, *The Great Initiates*, 368.
44. Schuré, *The Great Initiates*, 365–367.
45. Schuré, *The Great Initiates*, 369.
46. Schuré, *The Great Initiates*, 355.
47. Schuré, *The Great Initiates*, 355–356.
48. Schuré, *The Great Initiates*, 357.
49. Edouard Schuré, *The Genesis of Tragedy and The Sacred Drama of Eleusis* (New York: Anthroposophic Press, 1936), 245.
50. Schuré, *The Genesis of Tragedy*, 264
51. Schuré, *The Genesis of Tragedy*, 14.
52. Edouard Schuré, "Le Théâtre de L'Ame," in *Les Enfants de Lucifer (Drame Antique) & La Soeur Gardienne (Drame Moderne)* (Paris: Librarie Académique, 1922), xv.
53. Lévi, *Transcendental Magic*, 113; see also Lévi, *Secrets de la magie*, 111–112.
54. Schuré, *The Great Initiates*, 354.
55. Marvin Carlson, *Theories of the Theatre: A Historical and Critical Survey from the Greeks to the Present* (Ithaca, NY: Cornell University Press, 1993), 316.
56. Faivre, *Access to Western Esotericism*, 12.

2 KATHERINE TINGLEY AND THE THEATRE OF THE UNIVERSAL BROTHERHOOD AND THEOSOPHICAL SOCIETY

1. Emmett A. Greenwalt, *The Point Loma Community in California 1897–1942: A Theosophical Experiment* (Berkeley: University of California Press, 1955), 39.
2. Katherine Tingley, "My First Meeting with H.P. Blavatsky's Teacher," excerpts from Tingley's writings, published in *Sunrise: Theosophic Perspectives* (April–May 1998), 129.
3. Joseph H. Fussell, "The School of Antiquity: Its Meaning, Purpose, and Scope," *The Theosophical Path* 12 (January 1917): 14, 19, Theosophical Society Archives.
4. Greenwalt, *The Point Loma Community in California*, 39–40.
5. Greenwalt, *The Point Loma Community in California*, 12.
6. Katherine Tingley, in "Katherine Tingley Explains Her Work and Aims: An Interview," *Sunrise* (1913; reprint, April–May 1998): 109.
7. Tingley, in "Katherine Tingley Explains Her Work and Aims," 111.
8. Greenwalt, *The Point Loma Community in California*, 12.
9. Greenwalt, *The Point Loma Community in California*, 12.
10. Tingley, quoted in Grace F. Knoche, "Katherine Tingley: A Biographical Sketch," *Sunrise* (April–May 1998), 98.
11. Tingley, quoted in "Katherine Tingley: A Biographical Sketch," 98.
12. Arthur McCalla, "Romanticism," in *Dictionary of Gnosis and Western Esotericism* (Leiden: Brill, 2005), 1000–1001.

13. Greenwalt, *The Point Loma Community in California*, 13.
14. Greenwalt, *The Point Loma Community in California*, 13.
15. Greenwalt, *The Point Loma Community in California*, 14.
16. Greenwalt, *The Point Loma Community in California*, 14–15.
17. Katherine Tingley, "My First Meeting with William Quan Judge," *Sunrise: Theosophic Perspectives* 45 (April–May 1996): 193. See also Katherine Tingley, *The Gods Await*, 2nd ed. (1926; reprint, Pasadena, CA: Theosophical University Press, 1992), 62–66.
18. Katherine Tingley, quoted in "Katherine Tingley: A Biographical Sketch," 100.
19. Grace F. Knoche, "Katherine Tingley: A Biographical Sketch," 100.
20. H. P. Blavatsky, *The Key to Theosophy* (1889; reprint, Chennai, India: The Theosophical Publishing House, 1953), 34–35.
21. Blavatsky, *The Key to Theosophy*, 183, 196, 203.
22. Quoted in Fussell, "The School of Antiquity," 10.
23. Katherine Tingley, quoted in "A Few Facets of Katherine Tingley," by Raymond Rugland, *Sunrise* (April–May 1998): 124.
24. Fussell, "The School of Antiquity," 14, 19.
25. Greenwalt, *The Point Loma Community of California*, 39–40.
26. Katherine Tingley, "A New Light Among All," public address, June 7, 1896, Tremont Theatre, Boston Massachusetts. Republished *Sunrise* (April–May 1993): 117.
27. Tingley, "A New Light among All," 119.
28. Tingley, "My First Meeting with H. P. Blavatsky's Teacher," 129.
29. Greenwalt, *The Point Loma Community in California*, 18.
30. *New York Herald*, 17–18 May 1896.
31. Greenwalt, *The Point Loma Community in California*, 18.
32. Greenwalt, *The Point Loma Community in California*, 33.
33. Joseph H. Fussell, "The School of Antiquity," 12.
34. Photograph Collection, the Theosophical Society Archives.
35. Quoted in Fussell, "The School of Antiquity," 12.
36. Quoted in Grace Knoche, "The Vision—A Tribute to Katherine Tingley," *The Theosophical Path* 40.1 (July 1931): 49, the Theosophical Society Archives.
37. Quoted in Karl Heinrich von Wiegand, "Mystics, Babies, and Bloom," *Sunset* 23 (August 1909): 125, Paul Kagan Utopian Communities Collection, Beinecke Rare Book and Manuscript Library, Yale University [hereinafter cited as "Paul Kagan Utopian Communities Collection"].
38. *Theosophical Forum* 3 (July 1897): 46–47, the Theosophical Society Archives.
39. William McKinley to Katherine Tingley, September 24, 1898, the Theosophical Society Archives.
40. Ray Stannard Baker, "An Extraordinary Experiment in Brotherhood: The Theosophical Institution at Point Loma," *American Magazine* 63 (January 1917): 232, Paul Kagan Utopian Communities Collection.

41. Quoted in Greenwalt, *The Point Loma Community in California*, 48.
42. Greenwalt, *The Point Loma Community in California*, 50.
43. Greenwalt, *The Point Loma Community in California*, 48–51.
44. Greenwalt, *The Point Loma Community in California*, 48.
45. Greenwalt, *The Point Loma Community in California*, 48–50.
46. Greenwalt, *The Point Loma Community in California*, 80, 94.
47. *Prospectus of the Students Home or Community Called "Esotero": A Department of the School for the Revival of the Lost Mysteries of Antiquity, Founded in 1896 by Katherine A. Tingley, With Views of San Diego and Point Loma* (n.p., 1900), n.p., the Theosophical Society Archives.
48. Penny Brown Waterstone, *Domesticating Universal Brotherhood: Feminine Values and the Construction of Utopia, Point Loma Homestead, 1897–1920* (Ann Arbor, MI: UMI Microform, 1995), 295. See also Greenwalt, 80.
49. Greenwalt, *The Point Loma Community in California*, 80.
50. Greenwalt, *The Point Loma Community in California*, 80.
51. Greenwalt, *The Point Loma Community in California*, 80.
52. Baker, "An Extraordinary Experiment in Brotherhood," 232. *See also* Greenwalt, *The Point Loma Community in California*, 82.
53. Baker, "An Extraordinary Experiment in Brotherhood," 232.
54. Fussell, "The School of Antiquity," 14.
55. Program from a performance of *The Eumenides*, directed by Katherine Tingley, Music Hall, Buffalo, NY, December 3, 1898, Theosophical Society Archives (Pasadena, California). [Hereinafter this sources will be cited as Program, *The Eumenides*.]
56. *The Eumenides*, the Theosophical Society Archives.
57. From a pamphlet titled *Woman's Exchange and Mart of the International Brotherhood League: Women's Novelties, Costuming, Millinery, Art Novelties* (New York City: n.p., 1897), Theosophical Society Archives. See also Greenwalt, 85.
58. "Dramatic Activities at the International Theosophical Headquarters in Point Loma, California," *The Theosophical Path* 25 (July 1923): 78, the Theosophical Society Archives.
59. Unidentified newspaper clipping, the Theosophical Society Archives.
60. Fussell, "The School of Antiquity," 13.
61. Several volumes of these journals are held at the Theosophical Society Archives in Pasadena, California. Some of these issues are available at http://www.theosociety.org/pasadena/tup-onl.htm.
62. Basil Crump, "Art Department of Universal Brotherhood: Art in Daily Life," *New Century* 11 (December 1898): 3, the Theosophical Society Archives.
63. "New Dramatic Symposium: *The Conquest of Death*," *Universal Brotherhood Path* 16 (May 1901): 100, the Theosophical Society Archives.
64. *Katherine Tingley to Children's Department*, n.p., September 13, 1897, 1–2, the Theosophical Society Archives.
65. Quoted in Fussell, "The School of Antiquity," 12.

66. Quoted in Fussell, "The School of Antiquity," 5.
67. Greenwalt, *The Point Loma Community in California*, 85.
68. Greenwalt, *The Point Loma Community in California*, 85.
69. Quoted in Fussell, "The School of Antiquity," 15.
70. "The Art of Richard Wagner: His Life-Aim and the Inner Meaning of His Dramas," a lecture with musical and lantern illustrations (1897), the Theosophical Society Archives.
71. Program from an event titled "Lecture on Richard Wagner with Musical Illustrations," 1898, the Theosophical Society Archives.
72. Program from an event titled "The Art of Richard Wagner: His Life Aim and the inner meaning of his Dramas," 1897), the Theosophical Society Archives.
73. "The Rebirth of the Mysteries," *New Century* 11 (April 29 1899): 7, the Theosophical Society Archives.
74. "The Rebirth of the Mysteries," 7.
75. Daniel Gerould, "The Art of Symbolist Drama: A Re-Assessment," in *Symbolist Drama: An International Collection* (New York: PAJ Publications, 1985), 10.
76. Frantisek Deak, *Symbolist Theatre: The Formation of an Avant-Garde*, PAJ Books Series (Baltimore, MD: Johns Hopkins University Press, 1993), 117.
77. Deak, *Symbolist Theatre*, 118–119.
78. Edouard Schuré, *The Genesis of Tragedy and the Sacred Drama of Eleusis* (London: Rudolf Steiner, 1936), 90.
79. A. N. W., "Maeterlinck," *Universal Brotherhood Path* 14 (February 1900): 598, the Theosophical Society Archives.
80. A. N. W., "Maeterlinck," 599.
81. Joseph Downs, "Introductory Note," *The Greek Revival in the United States: A Special Loan Exhibition, November 9–March 1, 1943* (New York: The Metropolitan Museum of Art, 1943), n.p.
82. Downs, "Introductory Note," *The Greek Revival in the United States*, n.p.
83. Sheldon Cheney, *The Open-Air Theatre* (1918; repr. New York: Kraus, 1971), 36.
84. W. L. Sowers, "Some American Experimental Theaters," *Southwest Review* 2 (July 1916): 26.
85. Katherine Tingley, *The Voice of the Soul* (Covina, CA: Theosophical University Press, 1942), 220.
86. Tingley, "Drama," 217, 219.
87. Daniel Gerould, "The Symbolist Legacy," *PAJ: A Journal of Performance and Art* 31 (January 2009): 81.
88. Katherine Tingley's notes on *The Eumenides*, November 8, 1898, n.p., the Theosophical Society Archives.
89. Wassily Kandinsky, *Concerning the Spiritual in Art*, translated by M. T. H. Sadler (1911; reprint, New York: Dover, 1977).
90. Katherine Tingley to Miss Whitney, November 8, 1898, the Theosophical Society Archives.

91. Katherine Tingley to Miss Whitney.
92. Joseph H. Fussell, "*The Eumenides*' of Aeschylus—A Mystery-Drama: A Theosophical Interpretation," *Theosophical Path* 23 (November 1922): 481, the Theosophical Society Archives.
93. Fussell, "*The Eumenides* of Aeschylus," 429–430.
94. Katherine Tingley, "Dramatic Activities at the International Theosophical Headquarters Point Loma, California," *The Theosophical Path* 25 (July 1923):78, the Theosophical Society Archives.
95. H. M. Pierce, "Lessons in Occultism," *New Century*, November 5, 1898, 4, the Theosophical Society Archives.
96. *New Century*, December 25, 1897, 6, the Theosophical Society Archives.
97. "Reincarnation," *Theosophical Path* 10 (February 1916): 156–157, the Theosophical Society Archives.
98. Kenneth Morris, "Hidden Lessons in Shakespeare," *Theosophical Path* 3 (October 1912): 227–229, the Theosophical Society Archives.
99. *The New Century*, December 25, 1897, cover page, 6, the Theosophical Society Archives.
100. *The New Century*, December 25, 1897, 11.
101. Mrs. Richmond Green, "*A Winter's Tale*: A Mystical Interpretation," a series of articles published in *The New Century* (January 15, 1898; January 22, 1898; January 29, 1898; February 5, 1898; February 18, 1898), the Theosophical Society Archives.
102. E. Whitney, "A Fair View," *New Century*, December 25, 1897, 11, the Theosophical Society Archives.
103. *The New Century*, December 25, 1897, 6, the Theosophical Society Archives.
104. "Great Bazaar and Entertainment," *The New Century*, December 25, 1897, 11, the Theosophical Society Archives.
105. Katherine Tingley's Dramatic Work, an unpublished index, ca. 1906, Theosophical Society Archives.
106. *Los Angeles Herald*, April 26, 1907, the Theosophical Society Archives.
107. *Los Angeles Examiner*, April 26, 1907, the Theosophical Society Archives.
108. *Los Angeles Herald*, April 26, 1907, the Theosophical Society Archives.
109. *Los Angeles Graphic*, May 4, 1907, the Theosophical Society Archives.
110. *Los Angeles Examiner*, April 26, 1907, the Theosophical Society Archives.
111. Greenwalt, *The Point Loma Community in California*, 100.
112. Greenwalt, *The Point Loma Community in California*, 100.
113. *Universal Brotherhood Path* 15 (June 1900): 162, 171, the Theosophical Society Archives.
114. Descriptions of these performances are contained in volumes 15 and 16 of *Universal Brotherhood Path*, available at http://www.theosociety.org/pasadena/tup-onl.htm.
115. "Unity Congress at Point Loma," *Universal Brotherhood* 15 (June 1900): 165, the Theosophical Society Archives

116. "Unity Congress at Point Loma," 162–165.
117. Greenwalt, *The Point Loma Community in California*, 100.
118. Anonymous, *A Promise: A Greek Symposium by a Student of Esotero, Issued by the Approval of Katherine Tingley, Official Head of the Universal Brotherhood and Theosophical Society* (Point Loma, CA: Theosophical Publishing, 1901), title page, the Theosophical Society Archives.
119. *A Promise*, 8.
120. *A Promise*, 10.
121. "*The Conquest of Death*: The Play at Fisher Opera House" *San Diego Union*, April 9, 1901, the Theosophical Society Archives.
122. "*The Conquest of Death*: The Play at Fisher Opera House," 9
123. Waterstone, *Domesticating Universal Brotherhood*, 156.
124. *The Wisdom of Hypatia: A Dramatic Representation* (Point Loma: Theosophical Publishing, 1901): 5.
125. Waterstone, *Domesticating Universal Brotherhood*, 158.
126. Waterstone, *Domesticating Universal Brotherhood*, 157.
127. Bertha Hofflund, "The Revival of Ancient Greek Drama in America," *Theatre Magazine*, October 11, 1911, 18, the Theosophical Society Archives.
128. Bertha Hofflund, "The Revival of Ancient Greek Drama in America," 19.
129. Bertha Hofflund, "The Revival of Ancient Greek Drama in America," 19.
130. Cheney, *The Open-Air Theatre*, 37.
131. Horatio, review, *The Aroma of Athens*, March 17, 1911, supplement, *Century Path* April 2, 1911, n.p., the Theosophical Society Archives.
132. Horatio, review, *The Aroma of Athens*, n.p.
133. *The Little Philosophers*, n.p., n.d., 4–8, the Theosophical Society Archives.
134. "Reception and Entertainment to the Veterans of the Civil War: 47th Annual Encampment of the Departments of California and Nevada, Grand Army of the Republic, Katherine Tingley, Hostess" (reception that took place at Point Loma, California, May 7, 1914), the Theosophical Society Archives.
135. "Parliament of Peace and Universal Brotherhood" (program, congress that took place at Point Loma, California, June 22–25, 1915), n.p., the Theosophical Society Archives.
136. Katherine Tingley, excerpt from *The Gods Await*, *Sunrise* 47 (April–May 1998): 209.
137. Elizabeth Puttick, *Women in New Religions: In Search of Community, Sexuality, and Spiritual Power* (New York: Saint Martin's Press, 1997), 2.

3 THE ANTHROPOSOPHICAL THEATRE OF RUDOLF AND MARIE STEINER

1. Rudolf Steiner, *The True Nature of the Second Coming* (1904; reprint, London: Rudolf Steiner Press, 1971), 48. See also Rudolf Steiner, *Theosophy: An Introduction to the Supersensible Knowledge of the World and the Destination of*

Man (New York: Anthroposophic Press, 1971); Rudolf Steiner, *An Outline of Occult Science* (Spring Valley, NY: Anthroposophic Press, 1972).

2. Antoine Faivre, *Access to Western Esotericism* (Albany: State University of New York, 1994), 13.

3. Rudolf Steiner, quoted in Rex Raabe, Arne Klingborg, and Ake Fant, *Eloquent Concrete* (London: Rudolf Steiner Press, 1979), 31.

4. Virginia Sease, foreword to *A New Kind of Actor* (New York: Mercury Press, 1998), viii.

5. Frantisek Deak, *Symbolist Theater: Formation of an Avant-Garde* (Baltimore, MD: Johns Hopkins University Press, 1993), 171–177.

6. Sease, foreword to *A New Kind of Actor*, vii.

7. Maria Carlson, *"No Religion Higher Than the Truth": A History of the Theosophical Movement in Russia, 1875–1922* (Princeton, NJ: Princeton University Press, 1993), 177.

8. Carlson, *No Religion Higher Than the Truth*, 177.

9. Michael Chekhov, *On the Technique of Acting* (New York: Harper Perennial, 1991), 74–77.; see also Franc Chamberlain, *Michael Chekhov* (London: Routledge, 2004).

10. Carlson, *No Religion Higher Than the Truth*, 177.

11. Rudolf Steiner, preliminary note, *The Guardian of the Threshold*, in *Four Mystery Dramas* (London: Rudolf Steiner Press, 1997), 7.

12. Cees Leijenhorst, "Steiner, Rudolf," in *Dictionary of Gnosis and Western Esotericism* (Leiden: Brill, 2005), 1085.

13. Johannes Hemleben, *Rudolf Steiner: A Documentary Biography* (East Grinstead, Sussex: Henry Goulden, 1975).

14. Rudolf Steiner, *Goethe's Conception of the World* (New York: Haskell House, 1973), 189.

15. Carlson, *No Religion Higher Than the Truth*, 11.

16. Carlson, *No Religion Higher Than the Truth*, 33.

17. Rob Creese, "Anthroposophical Performance," *Drama Review*, Occult and Bizarre 22. 2 (June 1978): 46.

18. The International Theosophical Society had its headquarters in Adyar, India, and it is not the same as Katherine Tingley's Universal Brotherhood and Theosophical Society, which was located in Point Loma, California, between 1897 and 1929. Today, Tingley's organization is simply called The Theosophical Society, and it is located in Pasadena, California.

19. Carlson, *No Religion Higher Than the Truth*, 97–98.

20. Annie Besant to Wilhelm Hübbe-Schleiden, June 7, 1907, quoted in Rudolf Steiner, *Rosicrucianism Renewed: The Unity of Art Science and Religion,* edited by Joan deRis Allen (Great Barrington, MA: Steinerbooks, 2007), 24.

21. Carlson, *No Religion Higher Than the Truth*, 33.

22. Rudolf Steiner, "Virgin Sophia and the Holy Spirit," in *The Essential Steiner: Basic Writings of Rudolf Steiner*, edited by Robert A. McDermott (San Francisco, CA: HarperSanFrancisco, 1984), 283.

23. Roland Edighoffer, "Rosicrucianism I: First Half of the 17th Century," in *Dictionary of Gnosis and Western Esotericism* (Leiden: Brill, 2005), 1009.

24. Faivre, *Access to Western Esotericism*, 174–175.

25. "Rosicrucian Fundamentals," The Rosicrucian Fellowship: An International Association of Christian Mystics Dedicated to Preaching the Gospel and Healing the Sick, http://www.rosicrucian.com/rf_fund.htm (accessed January 1, 2012). This is the current website of the Rosicrucian Fellowship that Heindel founded in 1909.

26. "Rosicrucian Order, AMORC," Ancient Mystical Order Rosea Crucis English Grand Lodge for the Americas, www.rosicrucian.org (accessed June 23, 2011).

27. Rudolf Steiner, *Die Pforte der Einweihung*, in *Mysteriendramen*, vol. 1 (1910; reprint, Dornach, Switzerland: Rudolf Steiner Verlag, 1998), 9.

28. Rudolf Steiner, *Die Pforte der Einweihung*, 9.

29. Carlson, *No Religion Higher Than Truth*, 33.

30. Rudolf Steiner, "The Virgin Sophia and the Holy Spirit," in *The Essential Steiner*, 282.

31. Rudolf Steiner, *An Autobiography* (1923–1925; reprint, New York: Steinerbooks, 1977), 29.

32. Rudolf Steiner, "Theory of Human Nature," in *The Essential Steiner*, 115, 118

33. Rudolf Steiner, *Theosophy: An Introduction to the Supersensible Knowledge of the World and the Destination of Man* (New York: Anthroposophic Press, 1971), 79.

34. Robert A. McDermott, *The Essential Steiner*, 366n.

35. Steiner, *Theosophy*, 79–80.

36. Steiner, *An Autobiography*, 29.

37. Steiner, *Theosophy*, 102–103.

38. Faivre, *Access to Western Esotericism*, 13.

39. Steiner, *Theosophy*, 12.

40. Steiner, *Theosophy*, 16.

41. Steiner, "Theory of Human Nature," in *The Essential Steiner*, 120–122.

42. Steiner, *Theosophy*, 32.

43. Steiner, *Theosophy*, 32.

44. Steiner, *Theosophy*, 125.

45. Steiner, *Theosophy*, 126.

46. Steiner, "Virgin Sophia and the Holy Spirit," in *The Essential Steiner*, 270.

47. Steiner, *Theosophy*, 126–127.

48. Steiner, *Theosophy*, 126–127.

49. Ninian Smart, *The World's Religions: Old Traditions and Modern Transformations* (1989; reprint, Cambridge: Cambridge University Press, 1993), 215–216.

50. Rudolf Steiner, *The Influences of Lucifer and Ahriman: Human Responsibility for the Earth*, trans. D. S. Osmond, revised translation edition (Hudson, NY: Anthroposophic Press, 1993),17–26.

51. Creese, "Anthroposophical Performance," 47.
52. Steiner, *The Influences of Ahriman and Lucifer*, 23–24.
53. Georg Hartmann, *The Goetheanum Glass-windows*, 2nd ed. (Dornach: Philosophisch-Anthroposophischer Verlag, 1993), 27.
54. Carlson, *No Religion Higher Than Truth*, 134–135.
55. Rudolf Steiner, *The Influences of Lucifer and Ahriman*, 40.
56. Steiner, *The Influences of Lucifer and Ahriman*, 45–46.
57. Thomas Poplawski, Introduction, *The Influences of Lucifer and Ahriman*, 10–11.
58. Rudolf Steiner, *The True Nature of the Second Coming*, trans. D. S. Osmond and Charles Davy, 2nd ed. (1961; reprint, London: Rudolf Steiner Press, 1971), 32.
59. Steiner, *The Influences of Lucifer and Ahriman*, 65–66.
60. Steiner, *The Influences of Lucifer and Ahriman*, 87–88.
61. Carlson, *No Religion Higher Than Truth*, 101.
62. Creese, "Anthroposophical Performance," 46.
63. Creese, "Anthroposophical Performance," 46.
64. Hans Pusch, Introduction, *Four Mystery Dramas: The Portal of Initiation, The Soul's Probation, The Guardian of the Threshold, The. Soul's Awakening* (1973; reprint, London: Rudolf Steiner Press, 1997), 3
65. Rudolf Steiner, *The Soul's Probation*, in *Four Mystery Dramas*, 5.
66. Rudolf Steiner, *The Guardian of the Threshold*, in *Four Mystery Dramas*, 7.
67. Rudolf Steiner, *The Soul's Awakening*, in *Four Mystery Dramas*, 11.
68. Rudolf Steiner, *The Arts and Their Mission* (New York: Anthroposophic Press, 1964), 81.
69. Steiner, *The Portal of Initiation*, 5.
70. Steiner, *The Portal of Initiation*, 78, 87.
71. Steiner, *The Soul's Awakening*, 79.
72. Steiner, *The Soul's Awakening*, 79.
73. Steiner, *The Soul's Awakening*, 83.
74. Steiner, *The Soul's Awakening*, 83.
75. Steiner, *Theosophy*, 142–143.
76. Steiner, *Soul's Awakening*, 77.
77. Hartmann, *The Goetheanum Glass-windows*, 70.
78. Steiner, *Soul's Awakening*, 77.
79. Steiner, *Theosophy*, 125.
80. Steiner, *The Soul's Probation*, 17.
81. Steiner, *The Portal of Initiation*, 75.
82. Steiner, *The Portal of Initiation*, 129.
83. Steiner, *The Portal of Initiation*, 132–133.
84. Steiner, *Soul's Awakening*, 12.
85. Steiner, *Soul's Awakening*, 25.
86. Steiner, *Soul's Awakening*, 145–146.
87. Steiner, *Goethe's Conception of the World*, 27.

88. Rudolf Steiner, *The Threefold Social Order* (1966; reprint, New York: Anthroposophic Press, 1972). Originally published in 1919 as *Die Kernpunkte der socialen Fragen.*

89. Faivre, *Access to Western Esotericism*, 187.

90. Steiner, *Soul's Probation*, 80.

91. Steiner, *Soul's Probation*, 127–128.

92. Steiner, *Soul's Awakening*, 102.

93. Steiner, *Soul's Awakening*, 108–109.

94. Steiner, *Soul's Probation*, 74–75.

95. Steiner, *Soul's Awakening*, 110–111.

96. Steiner, *Soul's Probation*, 6.

97. Steiner, *The Influence of Lucifer and Ahriman*, 45–46.

98. Steiner, *Portal of Initiation*, 80.

99. Steiner, *Soul's Probation*, 116–119.

100. Steiner, *Soul's Awakening*, 55.

101. Steiner, *Soul's Awakening*, 147–148.

102. Steiner, *Soul's Awakening*, 149.

103. Steiner, *The True Nature of the Second Coming*, 33.

104. Steiner, *The True Nature of the Second Coming*, 33.

105. Steiner, *Soul's Awakening*, 149.

106. Rudolf Steiner, "The Character of Goethe's Spirit as Shown in the Fairy Tale of the Green Snake and the Beautiful Lily," trans. Adam Bittleston, in *The Time is at Hand! The Rosicrucian Nature of Goethe's Fairy Tale of the Green Snake and the Beautiful Lily and the Mystery Dramas of Rudolf Steiner* (Hudson, NY: Anthroposophic Press, 1995), 103, 160–161.

107. Steiner, "The Character of Goethe's Spirit as Shown in the Fairy Tale of the Green Snake and the Beautiful Lily," 161–162.

108. Steiner, "The Character of Goethe's Spirit as Shown in the Fairy Tale of the Green Snake and the Beautiful Lily," 162.

109. Rudolf Steiner, *The Guardian of the Threshold,* in *Four Mystery Plays,* trans. H. Collison, S. M. K. Gandell, and R. T. Gladstone, vol. 2 (New York, Knickerbocker Press, 1920), 6.

110. Waltraud Bartscht, *Goethe's "Das Marchen": Translation and Analysis* (Lexington: University Press of Kentucky, 1972), 38.

111. Steiner, "The Character of Goethe's Spirit as Shown in the Fairy Tale of the Green Snake and the Beautiful Lily," 163.

112. Steiner, "The Character of Goethe's Spirit as Shown in the Fairy Tale of the Green Snake and the Beautiful Lily," 162, 170.

113. Rudolf Steiner, *Entwürfe zu dem Rosenkreuzermysterium: Die Pforte der Einweihung* (Dornach: Steiner Steiner-Nachlassverwaltung, 1954), 11–12.

114. Steiner, "The Character of Goethe's Spirit as Shown in the Fairy Tale of the Green Snake and the Beautiful Lily," 162.

115. Johann Wolfgang von Goethe, *Das Märchen*, in *Goethe's "Das Marchen,"* 89–90.

116. Steiner, *Entwürfe zu dem Rosenkreuzermysterium*, 20–22.

117. Steiner, "The Character of Goethe's Spirit as Shown in the Fairy Tale of the Green Snake and the Beautiful Lily," 170.

118. Steiner, "The Character of Goethe's Spirit as Shown in the Fairy Tale of the Green Snake and the Beautiful Lily," 163.

119. Goethe, *Das Märchen*, 99.

120. Steiner, "The Character of Goethe's Spirit as Shown in the Fairy Tale of the Green Snake and the Beautiful Lily," 164.

121. Goethe, *Das Märchen*, 100.

122. H. Collison, addition to stage directions to *The Portal of Initiation*, in *Four Mystery Plays*, vol. 1, 74.

123. Rex Raab, Arne Klingborn, and Ake Fant, *Eloquent Concrete* (London: Rudolf Steiner Press, 1979).

124. Creese, "Anthroposophical Performance," 48.

125. Creese, "Anthroposophical Performance," 44.

126. Steiner, quoted in *Eloquent Concrete*, 31.

127. Hartmann, *The Goetheanum Glass-windows*, 17.

128. Hartmann, *The Goetheanum Glass-windows*, 20–25, 89.

129. Hartmann, *The Goetheanum Glass-windows*, 27.

130. Hartmann, *The Goetheanum Glass-windows*, 33.

131. Hartmann, *The Goetheanum Glass-windows*, 37.

132. Hartmann, *The Goetheanum Glass-windows*, 46–47.

133. Hartmann, *The Goetheanum Glass-windows*, 49, 55.

134. Hartmann, *The Goetheanum Glass-windows*, 64, 67.

135. Steiner, *The Arts and Their Mission*, 17.

136. Rudolf Steiner, *A Lecture on Eurythmy* (1967; reprint, London: Rudolf Steiner Press, 1977), 10.

137. Steiner, *A Lecture on Eurythmy*, 16–17.

138. Steiner, *A Lecture on Eurythmy*, 19.

139. Steiner, *A Lecture on Eurythmy*, 20.

140. Hans Pusch, *A New Kind of Actor* (New York: Mercury Press, 1998), 9.

141. "Das Goetheanum in Dornach," Goetheanum, http://www.goetheanum. org (accessed June 18, 2011).

142. Steiner, *Lecture on Eurythmy*, 9.

143. John Bowker, "Religion," in *The Oxford Dictionary of World Religions* (Oxford: Oxford University Press, 1997), xv–xvi.

144. Steiner, *Soul's Awakening*, 77.

145. Steiner, *The Soul's Awakening*, 83.

146. Steiner, *The Soul's Awakening*, 79, 81.

147. See *Marie Steiner Ihr Weg zur Erneuerung der Bühnenkunst durch die Anthroposophie: Eine Dokumentation* (Dornach: Rudolf Steiner Verlag, 1973). For photographs of later productions, see also *Mysteriendramen am Goetheanum: Rudolf Steiner und die Neue Bühnenkunst* (Dornach:

Philsophisch-Anthroposophischer Verlag, 1973); Creese, "Anthroposophical Performance," *TDR.*

148. Creese, "Anthroposophical Performance," 52.
149. Richard Rosenheim, *The Eternal Drama: A Comprehensive Treatise on the Syngetic History of Humanity, Dramatics, and Theatre* (New York: Philosophical Library, 1952), 269.
150. Rosenheim, *The Eternal Drama*, 270.
151. Steiner, *Über die Mysteriendramen: Die Pforte der Einweihung und Die Prüfung der Seele* (Dornach: Verlag der Rudolf Steiner-Nachverwaltung, 1964), 21.
152. Steiner-von Sivers to Steiner, October 9, 1924, in *Correspondence and Documents 1901–1925* (New York: Anthroposophic Press, 1988), 227.
153. Edouard Schuré, *The Genesis of Tragedy and the Sacred Drama of Eleusis* (New York: Anthroposophic Press, 1936), 251.
154. Gerould and Kosicka, "Drama of the Unseen—Turn-of-the-Century Paradigms for Occult Drama," in *The Occult in Language and Literature* (New York: New York Literary Forum, 1980), 14.
155. Deak, *Symboolist Theater,* 171–177.
156. Steiner, *The Arts and Their Mission*, 112.
157. Steiner, *The Arts and Their Mission*, 111.

4 ALEISTER CROWLEY'S THELEMIC THEATRE

1. Richard Kaczynski, *Perdurabo: The Life of Aleister Crowley* (Berkeley, CA: North Atlantic Books, 2010), 224.
2. Quoted in Kaczynski, *Perdurabo,* 225.
3. Aleister Crowley, *The Book of the Law* (1904; reprint, n.p.: Ordo Templi Orientis, 2007), 17.
4. Kaczynski, *Perdurabo,* 127.
5. For more information on Neitszche's distinctions between "master morality" and "slave morality," see Friedrich Nietzsche, *Beyond Good and Evil*, e-book version (Oxford: Oxford University Press, 1998), 154–155..
6. Israel Regardie, introduction, *The World's Tragedy* (Scottsdale, AZ: New Falcon, 1991), vii.
7. Aleister Crowley, *The Confessions of Aleister Crowley: An Autohagiography,* corrected edition (London: Routledge & Kegan Paul, 1983), 52–53.
8. Aleister Crowley, preface to *The World's Tragedy*, xvi–xvii.
9. Israel Regardie, *The Golden Dawn: A Complete Course in Practical Ceremonial Magic* (St. Paul, MN: Llewellyn, 1995), xvii–xxx, 1–25, rear cover; see also Mary K. Greer, *The Women of the Golden Dawn: Rebels and Priestesses* (Rochester, VT: Park Street Press, 1995), xx; see also Lawrence Sutin, *Do What Thou Wilt: A Life of Aleister Crowley* (New York: St. Martin's Press, 2000), 23.

10. Lawrence Sutin, *Do What Thou Wilt: A Life of Aleister Crowley* (New York: St. Martin's Press, 2000), 5.
11. Brenda Maddox, *Yeats's Ghosts: The Secret Life of W. B. Yeats* (New York: Perennial, 1999), 12.
12. Aleister Crowley, introduction, in *The Book of the Law* (1938; reprint, Tumwater, WA: Capital City Press, 1989), 5.
13. Kaczynski, *Perdurabo*, 130.
14. Crowley, *The Book of the Law* (1904; reprint, Tumwater, WA: Capital City Press, 1989), 9.
15. Crowley, *The Book of the Law*, 9.
16. Aleister Crowley, *Magick in Theory and Practice* (1929; reprint, New York: Dover, 1976), xiv–xv.
17. Crowley, Introduction, in *The Book of the Law*, 9.
18. Crowley, *Magick in Theory and Practice*, xxi.
19. "About OTO," *US Grand Lodge, Ordo Templi Orientis*, http://www.oto-usa. org/about_oto.html (accessed January 1, 2012).
20. Crowley, "Introduction," in *The Book of the Law*, 10.
21. Crowley, *Magick in Theory and Practice*, xii–xiii, xv, xix.
22. Lon Milo DuQuette, *Magick of Thelema* (York Beach, MA: Samuel Weiser, 1993), 133.
23. DuQuette, *Magick of Thelema*, 134, 136–137.
24. DuQuette, *Magick of Thelema*, 135–136.
25. DuQuette, *Magick of Thelema*, 139.
26. DuQuette, *Magick of Thelema*, 141.
27. Isreal Regardie, introduction to *The Law is for All*, by Aleister Crowley (Scottdale, AZ: New Falcon, 1991), 37.
28. Kaczynski, Perdurabo, 175, 296, 424.
29. Crowley, *Confessions*, 582.
30. Crowley, *Magick in Theory and Practice*, xi.
31. Aleister Crowley, preface, in *The World's Tragedy*, xxxi, xxxiv.
32. Kacynzski, *Perdurabo*, 295.
33. Kacynzski, *Perdurabo*, 252.
34. Keith Richmond, introduction to *The Rites of Eleusis*, by Aleister Crowley (Thame and Oxon: Mandrake Press, 1990), 25.
35. Anthony Kubiak, "Cyber-ecstasy and the Visionary in American Politics," *PAJ: A Journal of Performance and Art* 31 (January 2009): 113.
36. Crowley, *Confessions*, 184.
37. Crowley, *Confessions*, 416.
38. Aleister Crowley, epilogue and dedication to *Works of Aleister Crowley*, vol. 3 (Foyers: Society for the Propagation of Religious Truth, 1907; reprint, n.p.: Yogi Publication Society, n.d.), 222.
39. Georg Feuerstein, *Holy Madness: The Shock Tactics and Radical Teachings of Crazy Wize Adepts, Holy Fools, and Rascal Gurus* (New York: Arkana, 1990), 59.

40. John Symonds, *The Great Beast: The Life and Magick of Aleister Crowley* (1971; reprint, Frogmore, St. Albans: Mayflower Books, 1973), 13.
41. Crowley, *Magick in Theory and Practice*, 12–13.
42. Crowley, *Magick in Theory and Practice*, 13–15.
43. Crowley, *Magick in Theory and Practice*, 13–15.
44. Crowley, *Magick in Theory and Practice*, 177–178.
45. I. B., preface to *Works of Aleister Crowley*, vol. 1 (Foyers: Society for the Propagation of Religious Truth, 1905; reprint, n.p.: Yogi Publication Society, n.d.), n.p.
46. Aleister Crowley, "Aceldama, A Place to Bury Strangers In," in *Works of Aleister Crowley*, vol. 1, 1.
47. Crowley, *Aceldama, A Place to Bury Strangers In*, 1.
48. Aleister Crowley, *Jephthah*, in *Works of Aleister Crowley*, vol. 1, 88.
49. Aleister Crowley, *Jephthah*, 88n.
50. Ronald Hutton, *Triumph of the Moon: A History of Modern Pagan Witchcraft*, paperback edition (Oxford: Oxford University Press, 2001), 79.
51. Aleister Crowley, preface, *Tannhäuser*, *Works of Aleister Crowley*, vol. 1, 224.
52. Crowley, preface, *Tannhäuser*, 224–225.
53. Crowley, *Confessions*, 539.
54. Crowley, in *Works of Aleister Crowley*, vol. 2 (Foyers: Society for the Propagation of Religious Truth, 1906; reprint, n.p.: Yogi Publication Society, n.d.), 130.
55. G. K. Chesterton, book review, *London Daily News*, June 18, 1901, quoted in Sutin, 88.
56. Aleister Crowley, "Dedicatio Extraordinaria," in *Why Jesus Wept*, *Works of Aleister Crowley*, vol. 3, 21.
57. Crowley, "Dedicatio Extraordinaria," 21.
58. Aleister Crowley, "Dedicatio Maxima," in *Why Jesus Wept*, *Works of Aleister Crowley*, vol. 3, 21.
59. Aleister Crowley, *Why Jesus Wept*, in *Works of Aleister Crowley*, vol. 3, 40.
60. Crowley, *Why Jesus Wept*, 49.
61. Hutton, *Triumph of the Moon*, 44–49.
62. Aleister Crowley, preface, *The World's Tragedy*, xxxi.
63. Aleister Crowley, *The World's Tragedy*, 3.
64. Crowley, *The World's Tragedy*, 17.
65. Crowley, *The World's Tragedy*, 49.
66. Crowley, *The World's Tragedy*, 64–65.
67. Crowley, *The World's Tragedy*, 66.
68. Crowley, *The World's Tragedy*, 70.
69. Crowley, *The World's Tragedy*, 83, 87, 89.
70. Crowley, *The World's Tragedy*, 99–100, 114.
71. Aleister Crowley, preface to *The Worlds Tragedy*, xxxiv.
72. Jane Goodall, *Artaud and the Gnostic Drama* (Oxford, Clarendon Press, 1994), 8–11.

73. Kaczynski, *Perdurabo*, 261.
74. Crowley, quoted in Kaczynski, *Perdurabo*, 261
75. DuQuette, *The Magick of Aleister Crowley*, 223.
76. Aleister Crowley, *The Ship: A Mystery Play*, e-text, www.hermetic.com (accessed May 16, 2014).
77. Aleister Crowley, *Ecclesiae Gnosticae Catholicae Canon Missae* (*The Gnostic Mass*), in *The Magick of Aleister Crowley*, 238–239.
78. Lon Milo Duquette, *The Magick of Aleister Crowley: A Handbook of the Rituals of Thelema* (York Beach, MA: Weiser, 2003), 25.
79. Crowley, *The Gnostic Mass*, in *The Magick of Aleister Crowley*, 226.
80. Crowley, *The Gnostic Mass*, 241.
81. Crowley, *The Gnostic Mass*, 229.
82. Crowley, *The Gnostic Mass*, 226–227.
83. Kaczynski, *Perdurabo*, 125.
84. Kaczynski, *Perdurabo*, 231.
85. Kaczynski, *Perdurabo*, 231–232.
86. Crowley, *Magick in Theory and Practice*, 177.
87. Kaczynski, *Perdurabo*, 223–224.
88. Kaczynski, *Perdurabo*, 216.
89. Richmond, introduction to *The Rites of Eleusis*, 17.
90. Kaczynski, *Perdurabo*, 218.
91. Richmond, introduction to *The Rites of Eleusis*, 24.
92. DuQuette, *The Magick of Aleister Crowley*, 55.
93. Richmond, introduction to *The Rites of Eleusis*, 25–26.
94. Kaczynski, *Perdurabo*, 218.
95. *The Sketch*, August 24, 1910, quoted in Richmond, 25.
96. Crowley, *Confessions*, 635–636.
97. J. F. Brown, "Aleister Crowley's *Rites of Eleusis*," *Drama Review* 22 (June 1978): 16.
98. Crowley, *Confessions*, 636.
99. Crowley, *Confessions*, 636.
100. Brown, "Aleister Crowley's *Rites of Eleusis*," 17.
101. Brown, "Aleister Crowley's *Rites of Eleusis*," 20.
102. Crowley, *The Rites of Eleusis* (Thame and Oxon: Mandrake Press, 1990), 66.
103. Aleister Crowley, *The Rite of Luna*, in *The Rites of Eleusis*, 183.
104. Richmond, in *The Rites of Eleusis*, 292–293, n. 6.
105. Brown, "Aleister Crowley's *Rites of Eleusis*," 19, 21.
106. See Brown, "Aleister Crowley's *Rites of Eleusis*"; see also Crowley, *The Rites of Eleusis*.
107. Brown, "Aleister Crowley's *Rites of Eleusis*," 13.
108. Crowley, *The Rites of Eleusis*, n.p.
109. Aleister Crowley, *Book 4* (1980; reprint, York Beach. MA: Samuel Weiser, 1996), 60, 70.

110. Kaczynski, *Perdurabo*, 224.
111. Richmond, introduction to *The Rites of Eleusis*, 34–35.
112. Aleister Crowley, *The Rite of Saturn*, in *The Rites of Eleusis*, 71, 75.
113. Richmond, introduction to *The Rites of Eleusis*, 37–38.
114. "An Amazing Sect," *The Looking Glass*, October 29, 1910, quoted in Richmond, 40.
115. "The Black Mass Idea," *PIP*, November 5, 1910, quoted in Richmond, introduction to *The Rites of Eleusis*, 41.
116. "Is A New Smyth-Pigott among Us," *John Bull*, November 5, 1910, quoted in Richmond, 42.
117. Richmond, introduction to *The Rites of Eleusis*, 44–46, 50.
118. Richmond, introduction to *The Rites of Eleusis*, 17.
119. DuQuette, *The Magick of Aleister Crowley*, 191, 196.
120. "*Rites of Eleusis* Anniversary," *Agape: The Official Organ of the U.S. Grand Lodge of Ordo Templi Orientis* 11 (Spring 2011): 1, http://lib.oto-usa.org/agape/agape.11.1.pdf.
121. DuQuette, *The Magick of Aleister Crowley*, 192.
122. Crowley, *Magick in Theory and Practice*, 178, n. 2.
123. Crowley, *Confessions*, 636.
124. Aleister Crowley [A. Quiller, Jr., pseud.], "The Shadowy Dill-Waters; or Mr. Smudge the Medium," in *Gems from the Equinox*, 869–872.

5 ROSICRUCIAN THEATRE AND WICCAN RITUAL

1. Ronald Hutton, *Triumph of the Moon: A History of Modern Pagan Witchcraft* (Oxford: Oxford University Press, 205–206.
2. Gerald B. Gardner, *Witchcraft Today* (1954; reprint, New York: Citadel Press, 2004), 82.
3. Gardner, *Witchcraft Today*, 83.
4. J. L. Bracelin, *Gerald Gardner: Witch* (London: Octagon Press, 1960), 164.
5. Quoted in Philip Heselton, *Wiccan Roots: Gerald Gardner and the Modern Witchcraft Revival* (Berks, UK: Capall Bann, 2000), 54.
6. Heselton, *Wiccan Roots*, 56.
7. John Patrick Deveney, "Spiritualism," in *Dictionary of Gnosis and Western Esotericism* (Leiden: Brill, 2005), 1077.
8. Maitre l'Inconnu, *The Rosicrucians*, Leaflet No. 4, (Liverpool: Behemian Press, n.d.), 7. Rosicrucian Collection. Special Collections, Hartley Library, University of Southampton, Southampton, UK.
9. Rudolf Steiner, "Christian Initiation," in *The Essential Steiner: Basic Writings of Rudolf Steiner* (San Francisco, CA: HarperSanFrancisco, 1984), 258.
10. *Rosicrucian Philosophy: The Invisible World*, 2. Rosicrucian Collection. Special Collections, Hartley Library, University of Southampton, Southampton, UK.
11. Steiner, "Theory of the Nature of Man," in *The Essential Steiner*, 124.

12. *Rosicrucian Philosophy: The Invisible World*, 2.
13. *Rosicrucian Philosophy: The Invisible World*, 7.
14. Rudolf Steiner, "The Path of Knowledge," in *The Essential Steiner*, 82
15. *Rosicrucian Philosophy: Pointers for Students* (Liverpool: Bohemian Press, n.d.), 6. Rosicrucian Collection. Special Collections, Hartley Library, University of Southampton, Southampton, UK.
16. *Rosicrucian Philosophy: Pointers for Students*, 2.
17. Heselton, *Wiccan Roots*, 63.
18. Heselton, *Wiccan Roots*, 64.
19. Heselton, *Wiccan Roots*, 64.
20. "Academia Rosae Crucis," *Christchurch Times*, August 21, 1937.
21. "Academia Rosae Crucis," *Christchurch Times*.
22. Ronald Hutton, *Triumph of the Moon: A History of Modern Pagan Witchcraft*, paperback edition (Oxford: Oxford University Press, 2001), 213.
23. "Academia Rosae Crucis," *Christchurch Times*.
24. A description of the Academia Rosae Crucis in *The Uplifting Veil* 1. (1936): n.p.
25. "Academia Rosae Crucis," *Christchurch Times*.
26. "Academia Rosae Crucis," *The Uplifting Veil*, 2.1 (1939): 12.
27. "Academia Rosae Crucis." *Christchurch Times*.
28. Bracelin, *Gerald Gardner*, 163.
29. Bracelin, *Gerald Gardner*, 163.
30. "Rosicrucian Players and Drama Festival Week," *Christchurch Times* September 4, 1937.
31. Wouter J. Hanegraaff, "Tradition," in *Dictionary of Gnosis & Western Esotericism* (Leiden: Brill, 2005), 1127.
32. George A. Sullivan [Alex Mathews, pseud.], *Pythagoras* (Christchurch: Bohemian Press, n.d.), 5. Rosicrucian Collection. Special Collections, Hartley Library, University of Southampton, Southampton, UK.
33. Sullivan, *Pythagoras*, 5.
34. *Rosicrucian Philosophy: Pointers for Students*, 5.
35. Sullivan, *Pythagoras*, 22.
36. Sullivan, *Pythagoras*, 22.
37. *Rosicrucian Philosophy: Pointers for Students*, 6.
38. Vale, A Frater of the Rosy Cross, *Secrets of the Rosicrucians* (Liverpool: Bohemian Press,) 9–10. Rosicrucian Collection. Special Collections, Hartley Library, University of Southampton, Southampton, UK.
39. Deveney, "Spiritualism," 1075.
40. "Spirit Pictures," *Christchurch Times*, January 15, 1938; "Christchurch Spiritualist Mission," *Christchurch Times*, March 16, 1939.
41. Sullivan, *Pythagoras*, 24.
42. *Rosicrucian Philosophy: Pointers for Students*, 2.
43. *Rosicrucian Philosophy: Pointers for Students*, 1.
44. *Rosicrucian Philosophy: Pointers for Students*, 3.

45. George A. Sullivan, [Alex Mathews, pseud.], "A Warning," *The Uplifting Veil*. 2.1: 4.

46. "Academia Rosae Crucis," *Christchurch Times*.

47. "Festival Theatre for Christchurch," *Christchurch Times*, February 19, 1938.

48. Bracelin, *Gerald Gardner*, 162.

49. Bracelin, *Gerald Gardner*, 162.

50. Bracelin, *Gerald Gardner*, 163.

51. Bracelin, *Gerald Gardner*, 162–164.

52. "Rosicrucian Player's Stage a Theatre Innovation," *Christchurch Times*, December 25, 1937.

53. "Rosicrucian Player's Stage a Theatre Innovation."

54. "Rosicrucian Player's Stage a Theatre Innovation."

55. "The Truth About the Somerford Theatre: A Saga of Determination," *Christchurch Times*, May 25, 1940,

56. George A. Sullivan [Muser, pseud.], *Mind Undying* (Liverpool: Bohemian Press, n.d.), 5. Rosicrucian Collection. Special Collections, Hartley Library, University of Southampton, Southampton, UK.

57. Sullivan, *Mind Undying*, 8.

58. Sullivan, *Mind Undying*, 8.

59. Sullivan, *Mind Undying*, 12.

60. Sullivan, *Mind Undying*, 12.

61. "Rosicrucian Players Present Two Morality Plays," *Christchurch Times*, January 1, 1938.

62. Bracelin, *Gerald Gardner*, 163.

63. Sir Edward Bart Sullivan, *Verulamania: Some Observations on the Making of a Modern Mystery* (London: Bedford Press, 1904), 9. Rosicrucian Collection. Special Collections, Hartley Library, University of Southampton, Southampton, UK.

64. Bracelin, *Gerald Gardner*, 13.

65. "The Rosicrucian Society: What It Represents," *Christchurch Times*, March 26, 1938.

66. George A. Sullivan [Alexander Mathews, pseud.], *Henry VII, Part I* (Christchurch: Bohemian Press, n.d.), 5. Rosicrucian Collection. Special Collections, Hartley Library, University of Southampton, Southampton, UK.

67. "Rosicrucian Players Present First Theatre Festival," *Christchurch Times*, August 6, 1938.

68. "Rosicrucian Players Present First Theatre Festival."

69. "Rosicrucian Players Present First Theatre Festival."

70. Sullivan, *Henry VII, Part I*, 36.

71. "Rosicrucian Players Present First Theatre Festival."

72. "Garden Theatre Festival: *Henry VII., Part Two* Success." *Christchurch Times*, August 13, 1938.

73. Heselton, *Wiccan Roots*, 85.
74. George A. Sullivan [Alexander Mathews, pseud.], *The Demon Monk* (Christchurch: Bohemian Press, n.d.), 34.
75. Sullivan, *The Demon Monk*, 35
76. Sullivan, *The Demon Monk*, 36.
77. Gardner, *Witchcraft Today*, 82–92.
78. Gardner, *Witchcraft Today*, 27, 83, 90.
79. Gardner, *Witchcraft Today*, 22, 30, 43, 73.
80. Gardner, *Witchcraft Today*, 21.
81. Hutton, *Triumph of the Moon*, 205.
82. Hutton, *Triumph of the Moon*, 205, 207; see also Bracelin, *Gerald Gardner*, 162–164.
83. Hutton, *Triumph of the Moon*, 209–210.
84. Hutton, quoted in Ian Stevenson, "Christchurch Garden Theatre,", *Journal of Christchurch Local History Society* 15 (2009): 20.
85. Ian Stevenson "Christchurch Garden Theatre," 20. (See note 84)
86. Hutton, *Triumph of the Moon*, 239.
87. Joanne E. Pearson, "Neopaganism," in *Dictionary of Gnosis and Western Esotericism* (Leiden: Brill, 2005), 830.
88. Hutton, *Triumph of the Moon*, 205.
89. Hutton, *Triumph of the Moon*, 205.
90. Bracelin, *Gerald Gardner*, 67.
91. Bracelin, *Gerald Gardner*, 192, 198.
92. Bracelin, *Gerald Gardner*, 192, 198.
93. Bracelin, *Gerald Gardner*, 163.
94. Heselton, *Wiccan Roots*, 89.
95. "Remembrance of Past Phases of Existence," *The Uplifting Veil* 1.2 (1936): 14.
96. Gardner, *Witchcraft Today*, 40.
97. Bracelin, *Gerald Gardner*, 163.
98. Bracelin, *Gerald Gardner*, 102–103.
99. Hutton, *Triumph of the Moon*, 241.
100. Margaret Anne Murray, *Witch Cult in Western Europe: A Study in Anthropology* (Oxford: Clarendon Press, 1921; reprint, Whitefish, MT: Kessinger, n.d.), 12.
101. Hutton, *Triumph of the Moon*, 206–207.
102. Margaret Alice Murray, introduction to *Witchcraft Today*, 15–16.
103. Hutton, *Triumph of the Moon*, 207.
104. Gardner, *Witchcraft Today*, 23–24.
105. Gardner, *Witchcraft Today*, 24.
106. Robert C. Fuller, *Spiritual, But not Religious: Understanding Unchurched America* (Oxford: Oxford University Press, 2001), 4, http://ebooks.ohiolink.edu/.

107. Gardner, *Witchcraft Today*, 40.
108. Gardner, *Witchcraft Today*, 40.
109. Gardner, *Witchcraft Today*, 18.
110. Gardner, *Witchcraft Today*, 40.
111. Gardner, *Witchcraft Today*, 40.
112. Gardner, *Witchcraft Today*, 40.
113. Gardner, *Witchcraft Today*, 41.
114. Gardner, *Witchcraft Today*, 41.
115. Hutton, *Triumph of the Moon*, 230.
116. Gardner, *Witchcraft Today*, 41.
117. "Remembrance of Past Phases of Existence," 16.
118. Rudolf Steiner, *The True Nature of the Second Coming*, 2nd ed. (London: Rudolf Steiner Press, 1971), 126–127.
119. Gardner, *Witchcraft Today*, 41.
120. Gardner, *Witchcraft Today*, 41.
121. Gardner, *Witchcraft Today*, 24.
122. Murray, introduction to *Witchcraft Today*, 16.
123. Gardner, *Witchcraft Today*, 46.
124. Gardner, *Witchcraft Today*, 43.
125. Murray, introduction to *Witchcraft Today*, 16.
126. Gardner, *Witchcraft Today*, 22, 24, 26, 27.
127. Gardner, *Witchcraft Today*, 16.
128. Hutton, *Triumph of the Moon*, 234.
129. Hutton, *Triumph of the Moon*, 242–244.
130. Doreen Valiente, *The Rebirth of Witchcraft* (Custer, WA: Phoenix, 1989): 37–47; quoted in Hutton, 241–242.
131. Gardner, *Witchcraft Today*, 51–52.
132. Gardner, *Witchcraft Today*, 53.
133. Gardner, *Witchcraft Today*, 21.
134. Gardner, *Witchcraft Today*, 20.
135. Doreen Valiente, *Witchcraft for Tomorrow* (Blaine, WA: Phoenix, 1978), 73.
136. Valiente, *Witchcraft for Tomorrow*, 73.
137. Gardner, *Witchcraft Today*, 23.
138. Gardner, *Witchcraft Today*, 21.
139. Gardner, *Witchcraft Today*, 20.
140. Valiente, *Witchcraft for Tomorrow*, 98.
141. Valiente, *Witchcraft for Tomorrow*, 98.
142. Bracelin, *Gerald Gardner*, 67.
143. Bracelin, *Gerald Gardner*, 67.
144. Heselton, *Wiccan Roots*, 26; See also Bracelin, *Gerald Gardner*, 155.
145. Vittorio Macchioro, *The Villa of the Mysteries in Pompeii* (Naples: Richter, 1931).
146. Gardner, *Witchcraft Today*, 82.

147. Macchioro, quoted in Gardner, *Witchcraft Today*, 82.
148. Gardner, *Witchcraft Today*, 82.
149. Macchioro, quoted in Gardner, *Witchcraft Today*, 86.
150. Macchioro, quoted in Gardner, *Witchcraft Today*, 86.
151. Macchioro, quoted in Gardner, *Witchcraft Today*, 86.
152. Macchioro, quoted in Gardner, *Witchcraft Today*, 87.
153. Macchioro, quoted in Gardner, *Witchcraft Today*, 87.
154. Gardner, *Witchcraft Today*, 88.
155. Colin Wilson, *The Occult* (New York: Vintage, 1977), 455.
156. Gardner, *Witchcraft Today*, 42.
157. Gardner, *Witchcraft Today*, 42.
158. Aleister Crowley, *The Book of the Law*, in *The Law is for All*, edited by Israel Regardie (1975; reprint, Scottsdale, AZ: New Falcon, 1991), 50.
159. Gardner, *Witchcraft Today*, 47.
160. Valiente, *Witchcraft for Tomorrow*, 41
161. Hutton, *Triumph of the Moon*, 216.
162. Valiente, *Witchcraft for Tomorrow*, 14–17.
163. Hutton, *Triumph of the Moon*, 206, 247.
164. Gardner to Crowley, June 14, 1947. Warburg Institute, Gerald Yorke Collection, University of London, London, UK.
165. Gardner, *Witchcraft Today*, 47.
166. Gardner, *Witchcraft Today*, 21.
167. Bracelin, *Gerald Gardner*, 186–187.
168. Wilson, *The Occult*, 455.
169. Gardner, *Witchcraft Today*, 89.
170. Gardner, *Witchcraft Today*, 90.
171. Hutton, *Triumph of the Moon*, 397.

6 THE NEO-PAGANISM PERFORMANCE CURRENT

1. Joanne E. Pearson, "Neopaganism," in *Dictionary of Gnosis and Western Esotericism* (Leiden: Brill, 2005), 828.
2. Pearson, "Neopaganism," 830.
3. Ronald Hutton, *Triumph of the Moon: A History of Modern Pagan Witchcraft* (Oxford: Oxford University Press, 1999), 247.
4. Hutton, *Triumph of the Moon*, 247.; see also John Symonds, *The Great Beast: The Life and Magick of Aleister Crowley* (1954; reprint, Frogmore, UK: Mayflower, 1973).
5. J. L. Bracelin, *Gerald Gardner: Witch* (London: Octagon Press, 1960), 172; see also Hutton, 247.
6. Hutton, *Triumph of the Moon*, 234.
7. Hutton, *Triumph of the Moon*, 248.

8. Pearson, "Neopaganism," 833.

9. Margaret Adler, *Drawing Down the Moon*, 2nd ed. (Boston, MA: Beacon, 1986), 179; see also Hutton, *Triumph of the Moon*, 345.

10. Zsuzsana Budapest, *The Grandmother of Time* (San Francisco, CA: Harper and Row, 1989), 168.

11. Starhawk, *The Spiral Dance: A Rebirth of the Religion of the Great Goddess* (San Francisco, CA: Harper and Row, 1979).

12. Starhawk, *The Spiral Dance*, 22, 25, 91, 95, 109, 111.

13. Hutton, *Triumph of the Moon*, 348.

14. Hutton, *Triumph of the Moon*, 346.

15. Elizabeth Puttick, *Women in New Religions: In Search of Community, Sexuality, and Spiritual Power* (New York: St. Martin's Press, 1997), 2.

16. Puttick, *Women in New Religions*, 2.

17. Hutton, *Triumph of the Moon*, 371.

18. Hutton, *Triumph of the Moon*, 371.

19. Pearson, "Neopaganism," 828.

20. Aidan Kelly, *Crafting the Art of Magic* (St. Paul, MN: Llewellyn, 1991), ix.

21. Hutton, *Triumph of the Moon*, 400.

22. Shahrukh Husain, *The Goddess: Power, Sexuality, and the Feminine Divine* (Ann Arbor: The University of Michigan Press, 2003), 151.

23. Husain, *The Goddess*, 151.

24. "Starwood Festival XXXII," Association for Consciousness Exploration, http://www.rosencomet.com/starwood/ (accessed January 1, 2012).

25. "The 34th Annual Starwood Festival," Association for Consciousness Exploration, www.rosencomet.com/starwood/2014 (accessed May 6, 2014).

26. "List of Pagan Festivals," Linda's Faerie Faith Page, www.faeriefaith.net/festival.list.html (accessed May 6, 2014).

27. Hutton, *Triumph of the Moon*, 390.

28. Robert S. Ellwood, *Religious and Spiritual Groups in Modern America* (Englewood Cliffs, NJ: Prentice-Hall, 1973),188.

29. Pearson, "Neopaganism," 833.

30. Hutton, *Triumph of the Moon*, 403.

31. Pearson, "Neopaganism," 833.

32. Pearson, "Neopaganism," 828.

33. Pearson, "Neopaganism," 829.

34. Pearson, "Neopaganism," 828.

35. Pearson, "Neopaganism," 828.

36. Ellwood, *Religious and Spiritual Groups in Modern America*, 189.

37. Hutton, *Triumph of the Moon*, 397.

38. Gretchen Brown, "The Serpent & The Moon," www.susunweed.com/herbal_ezine/april04/menopausal.htm (accessed January 1, 2012).

39. "Press Reviews," Jehan's Goddessdance, http://www.goddessdance.org/about.htm (accessed January 1, 2012).

40. Eva Yaa Asantewaa, "Hot! Hot! Hot! Summer and Smoke in Alternative Spaces," *Village Voice* 26 (August 2002).
41. Brown, "The Serpent & the Moon."
42. Husain, *The Goddess*, 108.
43. Brown, "The Serpent & The Moon."
44. Hutton, *Triumph of the Moon*, 399.
45. Hutton, *Triumph of the Moon*, 399.
46. Hutton, *Triumph of the Moon*, 36–37.
47. Husain, *The Goddess*, 151.
48. Eugenio Barba, introduction to *A Dictionary of Theatre Anthropology: The Secret Art of the Performer* (1991; reprint, New York: Routledge, 1999), 8.
49. "Press Reviews," Jehan's Goddessdance.
50. Antonin Artaud, *The Theatre and Its Double* (1958; reprint, New York: Grove Press, 1985), 49–50.
51. "Vortex FAQ," Vegas Vortex, www.vegascortex.com/pages/faq (accessed May 8, 2014).
52. Michael Wall, Abigail Spinner McBride, Joshua Levin, and Jeff McBride, "AlchemiFire Ritual Orientation," Vegas Vortex, www.vegascortex.com/pages/orientation (accessed May 8, 2014).
53. "AlchemiFire Ritual Orientation."
54. Pearson, "Neopaganism," 831.
55. Jeff Magnus MacBride and Abi Spinner McBride, "Universal Fire Circle Alchemy," Vegas Vortex, www.vegasvortex.com/pages/universalalchemy (accessed May 9, 2014).
56. Jeff Magnus McBride and Abigail Spinner McBride, "The Magic of the Fire Circle," Vegas Vortex, www.vegasvortex.com/pages/FireCircleIntro (accessed May 9, 2014).
57. J. McBride and A. McBride, "The Magic of the Fire Circle."
58. J. McBride and A. McBride, "The Magic of the Fire Circle."
59. Antoine Faivre, *Access to Western Esotericism* (Albany: State University of New York Press, 1994), 13.
60. Allison P. Coudert, "Alchemy IV: 16th-18th Century," in *Dictionary of Gnosis and Western Esotericism* (Leiden: Brill, 2005), 46.
61. Antoine Faivre, "Hermetic Literature IV: Renaissance-Present," in *Dictionary of Gnosis and Western Esotericism*, 536.
62. "The Emerald Tablet," *Vegas Vortex*, www.vegascortex.com/pages/emerald-tablet (accessed May 9, 2014).
63. Pearson, "Neopaganism," 829.
64. Pearson, "Neopaganism," 831.
65. "Vortex FAQ," Vegas Vortex, www.vegasvortex.com/pages/faq (accessed May 11, 2014).
66. "Events," Vegas Vortex, www.vegasvortex.com/pages/events (accessed May 11, 2014).

67. Pagan Federation, http://paganfed.org/ (accessed January 6, 2012).
68. "Events," www.vegasvortex.com (accessed May 11, 2014).
69. "Presenters/Artists," Occult: The Juxtaposition of Beauty and Magick of Art and Ritual, http://www.occultartssalem.com/p/our-presenters.html (accessed May 12, 2014).
70. CoSM: The Chapel of Sacred Mirrors, www.cosm.org (accessed May 12, 2014).
71. "Presenters/Artists," Occult: The Juxtaposition of Beauty and Magick of Art and Ritual, http://www.occultartssalem.com/p/our-presenters.html (accessed May 12, 2014).
72. "Workshops/Schedules," Occult, www.occultartssalem.com/p/schedule.html (accessed May 12, 2014).
73. Jason Pitzl-Waters, "Interview with Aepril Schaile: Esoteric Salons and Magickal Art," *Wild Hunt* (August 29, 2013), www.wildhunt.org (accessed May 12, 2014).
74. Lance Gharavi, *Western Esotericism in Russian Silver Age Drama*: *Aleksandr Blok's* The Rose and the Cross (Saint Paul, MN: New Grail, 2008), 4.
75. Occult, accessed May 12, 2014, www.occultartssalem.com.
76. Occult.
77. Aepril Schaile, interview with author, May 5, 2014,
78. Sarah "Jezebel" Wood, interview with author, May 7, 2014.
79. Aepril Schaile, interview, May 5, 2014.

CONCLUSION

1. "Mysteriendramen," Goetheanum-buehne, Goetheanum-buehne.ch (accessed April 17, 2014), http://www.goetheanum-buehne.ch/Alle-Infos.3575.0.html.
2. *"Rites of Eleusis* Anniversary," *Agape: The Official Organ of the U.S. Grand Lodge of Ordo Templi Orientis* 11 (Spring 2011): 1, http://lib.oto-usa.org/agape/agape.11.1.pdf.
3. Antoine Faivre, *Access to Western Esotericism* (Albany: State University of New York Press, 1994), 191.
4. Victoria Nelson, *The Secret Life of Puppets* (Cambridge: Harvard, 2001), vii.
5. Judy Harrow, "Foreword to the Fiftieth Anniversary Edition," *Witchcraft Today* (New York: Citadel Press, 2004), 10–11.
6. Paul Heelas, "Introduction: On Differentiation and Dedifferentiation," in *Religion, Modernity, and Postmodernity* (Oxford: Blackwell, 1998), 8.
7. Joanne Pearson, "Neopaganism," in *Dictionary of Gnosis and Western Esotericism* (Leiden: Brill, 2005), 829.
8. Gerald Gardner, *Witchcraft Today* (1954; reprint, New York: Citadel Press, 2004), 121.

9. Aleister Crowley, "Is Thelema a New Religion?" in *Magick Without Tears* (Temple, AZ: New Falcon, 1994), 219.
10. Helena Petrovna Blavatsky, *The Key to Theosophy* (1889), Theosophical University Press Online Edition, http://www.theosociety.org/pasadena/key/key-hp.htm#preface (accessed May 13, 2014).
11. Jiexia Elisa Zhai, Christopher G. Ellis, Charles E. Stokes, Norval D. Glenn, "'Spiritual, But Not Religious': The Impact of Parental Divorce on the Religious and Spiritual Identities of Young Adults in the United States," *Review of Religious Research* 49 (2008): 380–381.
12. Zhai et al., "Spiritual, But Not Religious," 381.
13. Michèle M. Schlehofer, Allen M. Omoto, and Janice R. Adelman, "How do 'Religion' and 'Spirituality' Differ? Lay Definitions among Older Adults," *Journal for the Scientific Study of Religion* 47 (2008): 413.

Bibliography ∾

SPECIAL COLLECTIONS & ARCHIVES

Christchurch Local History Society (Christchurch, UK).

Ordo Templi Orientis Headquarters.

Rosicrucian Collection. Special Collections, Hartley Library, University of Southampton, Southampton, UK.

The Theosophical Society Archives. Theosophical Library Center (Pasadena, CA).

Yorke Collection. Warburg Institute, University of London (London, UK).

PRIMARY SOURCES

Adler, Margaret. *Drawing Down the Moon*. 2nd ed. Boston, MA: Beacon, 1986.

Agape: The Official Organ of the U.S. Grand Lodge of Ordo Templi Orientis 11 (Spring 2011). http://lib.oto-usa.org/agape/agape.11.1.pdf.

Allen, Paul Marshall, and Joan Deris Allen. *The Time Is at Hand! The Rosicrucian Nature of Goethe's Fairy Tale of the Green Snake and the Beautiful Lily and the Mystery Dramas of Steiner Steiner*. Hudson, NY: Anthroposophic Press, 1995.

Anon. *The Finding of the Gnosis; or, Apotheosis of an Ideal: An Interior Life Drama Wherein is Brought to Light the Inmost Secret of All Religion*. Boston, MA: Occult, 1890.

Ancient Mystical Order Rosae Crucis English Grand Lodge for the Americas. www.rosicrucian.org (accessed January 1, 2012).

Artaud, Antonin. *Antonin Artaud: Selected Writings*. Translated by Helen Weaver. Berkeley and Los Angeles: University of California Press, 1988.

———. *The Theatre and Its Double*. 1958. Reprint, New York: Grove Press, 1985.

Asantewaa, Eva Yaa. "Hot! Hot! Hot! Summer and Smoke in Alternative Spaces." *Village Voice* 26 (August 2002).

Baker, Ray Stannard. "An Extraordinary Experiment in Brotherhood: The Theosophical Institution at Point Loma, California." *America Magazine* 63 (January 1907): 227–240.

Beth, Rae. *Hedge Witch: A Guide to Solitary Witchcraft.* London: Hale, 1990.

Bingen, Hildegard von. *Ordo Virtutum.* Edited by Audrey Ekdahl Davidson. Kalamazoo: Medieval Institute, 1984.

Blake, William. *The Complete Illuminated Books.* London: William Blake Trust, 2001.

Blavatsky, Helena Petrovna. *The Key to Theosophy.* 2nd ed. Pasadena, CA: Theosophical University Press, 1995. http://www.theosociety.org/pasadena/key/key-hp.htm.

———. *The Secret Doctrine: The Synthesis of Science, Religion, and Philosophy.* 1888. Reprint, Pasadena, CA: Theosophical University Press, 1999.

Bartscht, Waltraud. *Goethe's "Das Marchen": Translation and Analysis.* Lexington: University Press of Kentucky, 1972.

Brown, Gretchen. "The Serpent & The Moon." http://www.susunweed.com/herbal_ezine/april04/menopausal.htm (accessed January 1, 2012).

CNN. "New Waco Probe Ordered." http://www.cnn.com/US/9908/26/fbi.waco.03/.

———. "Raelian Leader: Cloning First Step to Immortality." http://archives.cnn.com/2002/HEALTH/12/27/human.cloning/28.

CNN Interactive. "One Year Later, Heaven's Gate Suicide Leaves Only Faint Trail." US News Story Page. http://www.cnn.com\US\9803\25\heavens.gate/.

Chekhov, Michael. *On the Technique of Acting.* New York: Harper Perennial, 1991.

Collins, Mabel, and Hoffman Maud. *Sensa: A Mystery Play in Three Acts.* Covina, CA: Theosophical University Press, 1950.

———. *The Story of Sensa.* N.p., n.d.

CoSM: Chapel of Sacred Mirrors. www.cosm.org. (accessed May 15, 2014).

Crowley, Aleister. *Book 4.* 1980. Reprint; York Beach, MA: Samuel Weiser, 1996.

———. *The Book of the Law.* 1904; Reprint, n.p.: Ordo Templi Orientis, 2007.

———. *The Book of the Law.* 1938. Reprint, York Beach, MA: Samuel Weiser, 1989.

———. *The Book of Thoth: A Short Essay on the Tarot of the Egyptians.* 1944. Reprint, New York: Samuel Weiser, 1975.

———. *The Complete Astrological Writings.* London: W. H. Allen, 1987.

———. *The Confessions of Aleister Crowley.* 1969. Reprint, London: Routledge and Kegan Paul, 1983.

———. *Gems From the Equinox: Instructions by Aleister Crowley for His Own Magical Order.* Compiled by Israel Regardie. Las Vegas, NV: Falcon Press, 1988.

———. *Magick in Theory and Practice.* 1929. Reprint, New York: Dover, 1976.

———. *Mortadello.* First Impression Series, vol. 4. 1911. Reprint, Edmond: Holmes, 1992.

———. *The Rites of Eleusis* Thame and Oxon, Mandrake Press, 1990.

———. *The Ship: A Mystery Play.* 1913. www.hermetic.com (accessed May 15, 2015).

————. *The Works of Aleister Crowley.* 3 vols. 1905–1907. Reprint, n.p.: Yogi Publication Society, n.d.

————. *The World's Tragedy.* 1910. Reprint, Scottsdale, AZ: New Falcon, 1991.

Crowther, Patricia, and Arnold Crowther. *The Witches Speak.* Douglas: Athol, 1965.

DuQuette, Lon Milo. *Magick of Aleister Crowley,* 1993. Reprint, Boston: Samuel Weiser, 2003.

————. *The Magick of Thelema: A Handbook of the Rituals of Aleister Crowley.* York Beach, MA: Samuel Weiser, 1993.

Gardner, Gerould Brosseau. *High Magick's Aid.* London: Michael Houghton, 1949.

————. *Witchcraft Today.* 50th anniversary ed. New York: Citadel Press, 2004.

————. "Press Reviews." http://www.goddessdance.org/about.htm.

Goethe, Johann Wolfgang von. *Das Märchen.* In *The Age of Goethe: An Anthology of German Literature, 1789–1832.* Edited by Stuart Atkins. Boston, MA: Houghton Mifflin, 1969.

"Goetheanum Bühne." http://www.goetheanum-buehne.ch/72.html.

Grace F. Knoche, ed. Special Issue: *Katherine Tingley, 1847–1929, Sunrise: Theosophic Perspectives* 47 (April–May 1998).

————. Special Issue: *William Q. Judge, 1851–1896, Sunrise* 45 (April–May 1996).

Hartmann, Georg. *The Goetheanum Glass-windows.* 2nd ed. Dornach: Philosophisch-Anthroposophischer Verlag, 1993.

Hoffman, Maud. "Taking the Life Cure in Gurdjieff's School: An Intimate Description of The Russian's Institute in France, Whose Aim is the All-Round, Harmonious Development of Man." *New York Times,* February 10, 1924.

Hugo, Victor. *Les Fantômes de Jersey.* Edited by Francis Lacassin. Monaco: Editions du Rocher, 1991.

Jacquet, Hélène, ed. *Christmas Plays from Oberufer: The Paradise Play, The Shepherds Play, The Kings Play.* Bristol: Rudolf Steiner Press, 1993.

Kandinsky, Wassily. *Concerning the Spiritual in Art.* New York: Dover, 1977.

Knoche, Grace F. *The Mystery Schools.* Pasadena, CA: Theosophical University Press, 1999.

Knowles, George. "S.L. MacGregor Mathers (1854–1918) and 'The Hermetic Order of the Golden Dawn.'" Sybelline Order. http://sibyllinewicca.org/voices/bio-mathers.htm.

Lawrence, D. H. *Apocalypse.* London: Heinemann, 1931.

————. *The Man Who Died.* London: M. Secker, 1931.

Lévi, Eliphas. *Secrets de la magie.* Paris: Robert Laffont, 2000.

————. *Transcendental Magic: It's Dogma and Ritual.* Translated by A. E. Waite. York Beach, MA: Weiser, 1986.

l'Inconnu, Maitre. *The Rosicrucians.* Liverpool: Behemian Press, n.d. Rosicrucian Collection. Special Collections, Hartley Library, University of Southampton, Southampton, UK.

Longsworth, Robert. *The Cornish Ordinalia: Religion and Dramaturgy.* Cambridge, MA: Harvard University Press, 1967.

McIntosh, Christopher. *Eliphas Lévi and the French Occult Revival.* Albany: State University of New York Press, 2011. http://muse.jhu.edu/ (accessed May 19, 2014).

Machen, Arthur. *The Great God Pan and The Inmost Light.* Boston, MA: Roberts Bros.,1894.

Maeterlinck, Maurice. "The Tragical in Daily Life." In *Dramatic Theory and Criticism: Greeks to Grotowski*, edited by Bernard F. Dukore, 726–730. New York: Harcourt Brace Jovanovich College Publishers: 1974.

Mallarmé, Stéphane. *Works.* Paris: Flammarion, 1983.

Sullivan, George [Alex Mathews, pseud.]. *The Demon Monk.* Christchurch: Bohemian Press, n.d. Rosicrucian Collection. Special Collections, Hartley Library, University of Southampton, Southampton, UK.

———. [Muser, pseud.]. *Mind Undying.* Liverpool: Bohemian Press, n.d. Rosicrucian Collection. Special Collections, Hartley Library, University of Southampton, Southampton, UK.

———. [Alex Mathews, pseud.]. *Pythagoras.* Christchurch: Bohemian Press, n.d. Rosicrucian Collection. Special Collections, Hartley Library, University of Southampton, Southampton, UK.

Mirrors to the Past: Ancient Greece and Avant-Garde America. Exhibition held at the New York Public Library of the Performing Arts, October 15, 2004–January 8, 2005.

Murray, Margaret Anne. *Witch Cult in Western Europe: A Study in Anthropology.* Oxford: Clarendon Press, 1921. Reprint, Whitefish, MT: Kessinger, n.d.

Neuss, Paula, ed. and trans. *The Creacion of the World: A Critical Edition and Translation.* New York and London: Garland, 1983.

Occult. www.occultartssalem.com (accessed May 15, 2014).

Performance Group. *Dionysus in 69.* New York: Noonday, 1970.

Pitzl-Waters, Jason. "Interview with Aepril Schaile: Esoteric Salons and Magickal Art." www.wildhunt.org (accessed May 19, 2014).

Pusch, Hans. *A New Kind of Actor: Letters About Steiner-von Sivers Steiner and Her Work With the Actors on the Goetheanum Stage in the 30s.* New York: Mercury Press, 1998.

Rabelais, Francois. *Gargantua and Pentagruel.* New York: Knopf, 1994.

Ratliff, George. *Hell House,* Cantina, 2002, 85 min., motion picture.

Regardie, Israel. *The Golden Dawn: A Complete Course in Practical Ceremonial Magic.* St. Paul, MN: Llewellyn, 1995.

Roddick, Amy Redpath. *The Seekers: An Indian Mystery Play.* Montreal: John Dougal, 1920.

The Rosicrucian Fellowship: An International Association of Christian Mystics Dedicated to Preaching the Gospel and Healing the Sick. http://www.rosicrucian.com (accessed January 1, 2012).

Rosicrucian Philosophy: The Invisible World. Rosicrucian Collection. Special Collections. Hartley Library, University of Southampton, Southampton, UK.

Rosicrucian Philosophy: Pointers for Students. Liverpool: Bohemian Press, n.d. Rosicrucian Collection. Special Collections, Hartley Library, University of Southampton, Southampton, UK.

Sachs, Nelly. "Eli: A Mystery Play of the Sufferings of Israel." In *Plays of the Holocaust: An International Anthology*, edited by Elinor Fuchs. New York: Theatre Communications Group, 1987.

Scarlet Woman Lodge Ordo Templi Orientis. http://www.scarletwoman.org (accessed January 1, 2012).

———. "About Us Events and Projects." http://www.scarletwoman.org/aboutus_events.html.

———. "About Us Lodge Timeline." http://www.scarletwoman.org/aboutus_timeline.html.

Schuré, Eduard. *The Genesis of Tragedy and The Sacred Drama of Eleusis.* Translated by Fred Rothwell. New York: Anthorposophic Press, 1936.

———. *The Great Initiates: A Study of the Secret History of Religions.* New York: Steinerbooks, 1989.

———. *Les Enfants de Lucifer & La Soeur Gardienne.* Paris: Librarie Académique, 1922.

Starhawk. *The Spiral Dance: A Rebirth of the Religion of the Great Goddess.* San Francisco, CA: Harper and Row, 1979.

"Starwood Festival XXXIV." Association for Consciousness Exploration. http://www.rosencomet.com (accessed May 15, 2014).

Steiner, Rudolf. *A Lecture on Eurythmy.* 1967. Reprint, London: Rudolf Steiner Press, 1977.

———. *An Autobiography.* 1923–1925. Reprint, New York: Steinerbooks, 1977.

———. *The Arts and Their Mission.* Translated by Lisa D. Monges and Virginia Moore. New York: Anthroposophic Press, 1964.

———. *Entwurfe zu dem Rosenkreuzermysterium: Die Pforte der Einweihung.* Dornach: Rudolf Steiner-Nachlassverwaltung, 1954.

———. *The Essential Steiner.* Translated by Robert A. McDermott. San Francisco, CA: Harper Collins, 1984.

———. *An Esoteric Cosmology* Blauvelt, NY: Spiritual Science Library, 1987.

———. *An Outline of Occult Science.* Spring Valley, NY: Anthroposophic Press, 1972.

———. *Four Mystery Plays.* Translated and Edited by H. Collison, S. M. K. Gandell, and R. T. Gladstone. 2 vols. New York: Knickerbocker Press, 1920.

———. *Geisteswissenshaftlische Erläuterungen zu Goethes Faust.* 1931. Reprint, Dornach: Verlag der Rudolf Steiner-Nachlassverwaltung, 1967.

———. *Geschichte des Mittelalters bis zu den gross Erfindungen und Entdeckungen.* Dornach: Philosophisch-Anthroposophischer Verlag, 1936.

———. *Goethe's Conception of the World.* New York: Haskell House, 1973.

————. *The Influences of Lucifer and Ahriman: Human Responsibility for the Earth.* Revised translation edition. Hudson, NY: Anthroposophic Press, 1993.

————. *The Story of My Life.* New York: Anthroposophic Press, 1928. http://wn.rsarchive.org/Books/GA028/TSoML/GA028_index.html.

————. *Theosophy: An Introduction to the Supersensible Knowledge of the World and the Destination of Man.* New York: Anthroposophic Press, 1971.

————. *The Threefold Social Order.* 1966. Reprint, New York: Anthroposophic Press, 1972.

————. *The True Nature of the Second Coming.* 2nd ed. London: Rudolf Steiner Press, 1971.

————. *Über die Mysteriendramen: Die Pforte der Einweihung und Die Prüfung der Seele.* Dornach: Verlag der Rudolf Steiner-Nachverwaltung, 1964.

————. *Vier Mysteriendramen.* 2 vols. Dornach: Rudolf Steiner Verlag, 1998.

————. *Was ist und will die neue Bewegungskunst Eurythmie?* Dornach: Rudolf Steiner Verlag, 1979.

Steiner, Rudolf, and Marie Steiner-von Sivers. *Correspondence and Documents 1901–1925.* New York: Anthroposophic Press, 1988.

Sullivan, Bart., Sir Edward. *Verulamania: Some Observations on the Making of a Modern Mystery.* London: Bedford Press, 1904. Rosicrucian Collection. Special Collections, Hartley Library, University of Southampton, Southampton, UK.

"Summer Schedule." http://www.bodhiyoga.com/.

Tingley, Katherine. *The Voice of the Soul.* Covina, CA: Theosophical University Press, 1928.

US Grand Lodge, Ordo Templi Orientis. http://www.oto-usa.org (accessed May 19, 2014).

University of Brighton and Sallis Benney Theatre. "Venue Hires Booking the Sallis Benney Theatre and Gallery." http://www.brighton.ac.uk/gallery-theatre/venuehires.html.

Vale. *Secrets of the Rosicrucians.* Liverpool: Bohemian Press. Rosicrucian Collection. Special Collections, Hartley Library, University of Southampton, Southampton, UK.

Valiente, Doreen. *Witchcraft for Tomorrow.* 1978. Reprint, Blaine, WA: Phoenix, n.d.

Vegas Vortex. http://vegasvortex.com (accessed May 15, 2014).

"Die Vier Mysteriendramen." Performances of Rudolf Steiner's Mystery Dramas that took place at the Goetheanum in Dornach Switzerland between 24 December 2000 and January 2001.

Villiers de l'Isle-Adam. *Axel.* Translated by Marilyn Gaddis Rose. Dublin: Dolmen Press, 1970.

Weiss, Jeffrey. "*Hellhouse!* Pokes Fun at Fundamentalists' Horror Shows." *Dallas Morning News,* September 4, 2004.

"The Wickedest Man in the World." *John Bull,* 24 March, 1923. Lashtal. http://www.lashtal.com/nuke/index.php?module=subjects&func=viewpage&pageid=18.

The Wild Hunt. "Samhain Full Moon Sabbat 18th October 2002, 491Gallery Leytonstone London." http://www.crossroads.wild.net.au/wildhunt.htm.

SECONDARY SOURCES

Adams, Henry Hitch. *English Domestic or Homiletic Tragedy, 1575–1642.* 1943. Reprint, New York: B. Blom, 1965.

Arnold, Walter. *Religions in Four Dimensions: Existential and Aesthetic, Historical and Comparative.* McGraw-Hill, 1976.

Bacon, Thomas. *Martin Luther and the Drama.* Amsterdam: Rodopi, 1976.

Baker, George Towne, and Jacob Needleman, eds. *Understanding the New Religions.* New York: Seabury Press, 1978.

Baker, Stewart. *Bernard Shaw's Remarkable Religion: A Faith that Fits the Facts.* Gainsville: University Press of Florida, 2002.

Balmforth, Ramsden. *The Ethical and Religious Value of the Drama.* London: G. Allen & Unwin, 1925.

Balthasar, Hans Urs von. *Theodramatik.* Einsideln: Johannes Verlag, 1973–.

———. *Theodramatik und Theatralität : Ein Dialog mit dem Theaterverständnis von Hans Urs von Balthasar.* Berlin: Duncker & Humblot, 2000.

Barba, Eugenio, and Nicola Savarese. *A Dictionary of Theatre Anthropology: The Secret Art of the Performer.* 1991. Reprint, New York: Routledge, 1999.

Barker, Eileen, ed. *New Religious Movements: A Perspective for Understanding Society.* New York: Edwin Mellen Press, 1982.

Barker, Eileen, and Margit Warburg, eds. *New Religions and New Religiosity.* Aarhus: Aarhus University Press, 1998.

Barr, Alan P. *Victorian Stage Pulpiteer: Bernard Shaw's Crusade.* Athens: University of Georgia Press, 1974.

Barrett, David. *Sects, Cults, & Alternative Religions.* 1996. Reprint, London: Cassell PLC, 1998.

Bates, Alfred. *Religious Drama.* 1903. Reprint, New York: AMS Press, 1970.

Batson, Beatrice. *Shakespeare and the Christian Tradition.* Lewiston, NY: Edwin Mellen Press, 1994.

Beckford, James A., ed. *New Religious Movements and Rapid Social Change.* Beverly Hills, CA: Sage, 1986.

———. "Some Questions about the Relationship between Scholars and the New Religious Movements." *Sociological Analyst* 44 (1983): 11–32.

Bednarowski, Mary Farrell. *New Religions and the Theological Imagination in America.* Bloomington: Indiana University Press, 1989.

Beit-Hallahmi, Benjamin. *The Illustrated Encyclopedia of Active New Religions, Sects, and Cults.* New York: Rosen, 1998.

Bennetta, Jules Rosette, ed. *The New Religions of Africa.* Norwood, NJ: Ablex, 1979.

Behrendt, Eva. "Die letzten Goetheaner." *Theater*heute (June 2004).

John Boardman. *The Great God Pan: The Survival of an Image.* New York: Thames and Hudson, 1997.

Bowker, John. "Religion." In *The Oxford Dictionary of World Religions.* Oxford: Oxford University Press, 1997.

Bracelin, J. L. *Gerald Gardner: Witch.* London: Octagon Press, 1960.

Brion-Gufrry, Liliane. "Le Premier Goetheanum: Forme Utopique ou Forme Exemplaire?" n.p., n.d.

Brown, J. F. "Aleister Crowley's *Rites of Eleusis.*" *The Drama Review.* Occult and Bizarre Issue. 22.2 (June 1978).

Budapest, Zsuzsana. *The Grandmother of Time.* San Francisco: Harper and Row, 1989.

Brockett, Oscar G., and Franklin J. Hildy. *History of the Theatre.* 9th ed. New York: Allyn & Bacon, 2003.

Brownwell, Viriginia Anne. *Views of Religion in Contemporary Spanish American and Brazilian Drama.* Ann Arbor, MI: Xerox University Microforms, 1977.

Bryant, James C. *Tudor Drama and Religious Controversy.* Macon, GA: Mercer, 1984.

Bühnenkunst am Goetheanum. Dornach: Philosophisch-Anthroposophisten Verlag am Goetheanum, 1936.

Carlson, Maria. *"No Religion Higher than Truth": A History of the Theosophical Tradition in Russia, 1875–1922.* Princeton, NJ: Princeton University Press, 1993.

Carlson, Marvin. "The Eternal Instant: Some Thoughts on Theatre and Religion." *Assaph C* 12 (1997): 33–44.

———. *Theories of the Theatre.* Expanded edition. Ithaca, NY: Cornell University Press, 1993.

Chamberlain, Franc. *Michael Chekhov.* London: Routledge, 2004..

Chapman, Raymond. *Religious Drama: A Handbook for Actors and Producers.* London: Published for the Religious Drama Society of Great Britain by S. P. C. K., 1959.

Cheney, Sheldon. *The Open-Air Theatre.* New York: Mitchell Kennerly, 1918.

Christian Drama. London: Published for the Religious Drama Society by the Society for Promoting Christian Knowledge: 1946

Christchurch Times. Christchurch Local History Society, Christchurch, UK.

Close, Francis. *The Stage; Ancient and Modern; Its Tendencies on Morals and Religion: A Lecture Delivered in the Town Hall, Cheltenham, on Thursday evening, October 24, 1850.* London: Hatchard and Son, 1850.

Creese, Rob. "Anthroposophical Performance." *The Drama Review.* Occult and Bizarre Issue. 22.2 (June 1978).

Cultic Studies Journal. http://www.csj.org/pub_csj/csj_home.htm.

Davis, Derek. *New Religious Movements and Religious Liberty in America.* Waco, TX: J. M. Dawson Institute of Church-State Studies, Baylor University Press, 2002.

Deak, Frantisek. *Symbolist Theater: Formation of an Avant-Garde.* Baltimore, MD: Johns Hopkins University Press, 1993.

Desmond, Marylinn, and Pamela Sheingorn. *Myth, Montage, & Visuality in Late Medieval Manuscript Culture: Christine de Pizan's* Epistre Othea. Ann Arbor: University of Michigan Press, 2003.

Davis, Derek, ed. *New Religious Movements and Religious Liberty in America.* Waco, TX: J. M. Dawson Institute of Church-State Studies, Baylor University Press, 2002.

Dillon, Michael. *Religious Minorities and China.* London: Minority Rights Group International, 2001.

Dollimore, Jonathan. *Radical Tragedy: Religion, Ideology, and Power in the Drama of Shakespeare and His Contemporaries.* Chicago: University of Chicago Press, 1984.

Downs, Joseph. *The Greek Revival in the United States: A Special Loan Exhibition, November 9–March 1, 1943.* New York: Metropolitan Museum of Art, 1943.

Dukore, Bernard, *Dramatic Theory and Criticism: Greeks to Grotowski.* New York: Harcourt Brace Jovanovich College Publishers, 1974.

Earhart, H. Byron. *The New Religions of Japan: A Bibliography of Western Language Materials.* Tokyo: Sophia University, 1970.

Eaton, Thomas Ray. *Shakespeare and the Bible: Showing How Much the Great Dramatist was Indebted to Holy Writ for his Profound Knowledge of Human Nature.* London: J. Blackwood, 1860.

Edet, Rosemary N. *The Resilience of Religious Tradition in the Dramas of Wole Soyinka and James Ene Henshaw.* N.p., 1983.

Ehrensperge, Harold A. *Religious Drama: Ends and Means.* New York: Abingdon Press, 1962.

Eliot, T. S. *Religious Drama: Mediaeval and Modern.* New York: House of Books, 1954.

Elliot, Spencer Hayward. *Religion and Dramatic Art.* London: Student Christian Movement, 1927.

Ellis, Bill. *Satanism, New Religions, and the Media.* Lexington: University Press of Kentucky, 2000.

Ellwood, Robert S. *The Eagle and the Rising Sun: America and the New Religions of Japan.* Philadelphia, PA: Westminster Press, 1974.

———. *Religious and Spiritual Groups in Modern America.* Englewood Cliffs, NJ: Prentice-Hall, 1973.

Esoterica. http://www.esoteric.msu.edu/main.html (accessed May 15, 2014).

Espantoso-Foley, Augusta. *Occult Arts and Doctrine in the Theatre of Juan Ruiz de Alarcón.* Genève: Droz, 1972.

Faivre, Antoine. *Access to Western Esotericism.* Albany: State University of New York Press, 1994.

Feeney, D. C. *Literature and Religion at Rome: Cultures, Contexts, and Beliefs.* Cambridge and New York: Cambridge University Press, 1998.

Feuerstein, Georg. *Holy Madness: The Shock Tactics and Radical Teachings of Crazy Wize Adepts, Holy Fools, and Rascal Gurus.* New York: Arkana, 1990.

Fichter, Joseph H., ed. *Alternatives to American Mainline Churches*. Barrytown, NY: Unification Theological Seminary, 1983.

Fränkl-Jundborg, Otto. *What is Anthroposophy?* 1925. Reprint, Fair Oaks, CA: Steiner Steiner College Press, 1977.

Fröböse, Edwin, compiler. *Marie Steiner, Ihr Weg zu Erneuerung der Bühnenkunst durch die Anthroposophie: Eine Dockumentation*. Dornach: Rudolf Steiner Verlag, 1973.

Fuchs, Elinor. "The Apocalyptic Century." *Theatre* 29 (1999).

Fuller, Robert C. *Spiritual, But not Religious: Understanding Unchurched America*. Oxford: Oxford University Press, 2001. http://ebooks.ohiolink.edu/.

Ganim, John M. "The Myth of Medieval Romance." In *Medievalism and the Modernist Temper*. Edited by Howard R. Blochs and Stephen G. Nichols. Baltimore, MD: Johns Hopkins University Press, 1996.

Gaster, Theodor Herzl. *Thespis: Ritual, Myth, and Drama in the Ancient Near East*. New York: Schuman, 1950.

Gerstinger, Heinz. *Theater und Religion heute: Aspekte und Profile*. Wien: Bergland Verlag, 1972.

Gerould, Daniel. *Doubles, Demons, and Dreamers: An International Collection of Symbolist Drama*. New York: Performing Arts Journal Publications, 1985.

———. "The Symbolist Legacy." *PAJ: A Journal of Performance and Art* 31 (January 2009).

———. "Witkacy and the Spiritualistic Séance—Ghosts at a Séance: Witkacy's Theatre of Death." Unpublished article.

Gerould, Daniel, Bettina Knapp, and Jane House, eds. *Sacred Theatre*. Saline, MI: McNaughton & Gunn, 1989.

Gerould, Daniel, and Jadwiga Kosicka. "Drama of the Unseen—Turn-of-the-Century Paradigms for Occult Drama." In *The Occult in Language and Literature*. Edited by Hermine Riffaterre. New York: New York Literary Forum, 1980.

Gharavi, Lance. *Western Esotericism in Russian Silver Age Drama: Aleksandr Blok's The Rose and the Cross*. Saint Paul, MN: New Grail, 2008.

Gibson, Gail McMurray. *The Theatre of Devotion: East Anglican Drama in Europe in the Later Middle Ages* (Chicago: University of Chicago Press, 1989).

Glatzer, Bernice Glatzer, ed. *The Occult in Russian and Soviet Culture*. Ithaca, NY: Cornell University Press, 1997.

Goodall, Jane. *Artaud and the Gnostic Drama*. Oxford: Oxford University Press, 1994.

Green, Marian. *A Witch Alone*. London: Aquarian, 1991.

Greer, Mary K. *The Women of the Golden Dawn: Rebels and Priestesses*. Rochester, VT: Park Street Press, 1995.

Greenwalt, Emmett A. *The Point Loma Community in California, 1897–1942*. Berkeley and Los Angeles: University of California Press, 1955.

Gunn, Giles. *Literature and Religion*. New York: Harper and Row, 1971.

Haining. Peter. *The Magicians: The Occult in Fact and Fiction*. New York: Taplinger, 1973.

Hall, Grace R. W. *Tempest as Mystery Play: Uncovering Religious Sources of Shakespeare's Most Spiritual Work*. Jefferson, NC: McFarland, 1999.

Hammer, Anita. *Between Play and Prayer: The Variety of Theatricals in Spiritual Performance*. Amsterdam: Rodopi, 2010.

Hanegraaff, Wouter J., Antoine Faivre, Roelof van den Broeck, and Jean-Pierre Brach, eds. *Dictionary of Gnosis and Western Esotericism*. Leiden: Brill, 2005.

Harney, Scott. *Esoteric Guide to New York*. New York: Esoteric Guides, 2003.

Hardacre, Helen. *Kurozumikyo and the New Religions of Japan*. Princeton, NJ: Princeton University Press, 1986.

Hardison, O. B. *Christian Rite and Christian Drama in the Middle Ages: Essays in the Origin and Early History of Modern Drama*. Baltimore, MD: Johns Hopkins University Press, 1965.

Harris, Max. *Theatre and Incarnation*. New York: St. Martin's Press, 1990.

Harshav, Barbara. *Discovering Religious History in the Modern Age*. Princeton, NJ: Princeton University Press, 2001.

Heath, Virginia Shropshire. *Dramatic Elements in American Indian Ceremonials*. New York: Haskell House, 1966.

Heelas, Paul, David Martin, and Paul Morris, eds. *Religion, Modernity, and Postmodernity*. Oxford: Blackwell, 1998.

Heilman, Samuel C. *The People of the Book: Drama, Fellowship, and Religion*. Chicago: University of Chicago Press, 1983.

Heller, Herbert Jack. *Penitent Brothellers: Grace, Sexuality, and Genre in Thomas Middleton's City Comedies*. Newark: University of Delaware Press, 2000.

Hemleben, Johannes. *Rudolf Steiner: A Documentary Biography*. East Grinstead, Sussex: Henry Goulden, 1975.

Heselton, Philip. *Wiccan Roots: Gerald Gardner and the Modern Witchcraft Revival*. Berks, UK: Capall Bann, 2000.

Hess, Rainer. *Das romanische geistliche Schauspiel als profane und religiose Komodie: 15 und 16 Jahrhundert*. München: W. Fink, 1965.

Hexham, Irving. *The Pocket Dictionary of Cults and New Religions*. Downers Grove, IL: InterVarsity Press, 2002.

——— and Karla Poewe. *Understanding Cults and New Religions*. 1986. Reprint, Vancouver: Regent College Press, 1998.

———. *New Religions as Global Cultures*. Boulder, CO: Westview Press, 1997.

Hole, Donald. *The Church and the Stage: The Early History of the Actor's Church Union*. London: Faith Press, 1934.

Holland, Peter. *Shakespeare and Religions*. Cambridge and New York: Cambridge University Press, 2001.

Hollis III, Daniel W. *The ABC-CLIO World History Companion to Utopian Movements*. Santa Barbara, CA: ABC-CLIO, 1998.

Hornblow, Arthur. *A History of the Theatre in America From Its Beginnings to the Present Time*, vol. 2. 1919. Reprint, New York: Benjamin Blom, 1965.

Hughes, Ann Nickerson. *Religious Imagery in the Theatre of Tirso de Molina.* Macoin, GA: Mercer, 1984.

Husain, Shahrukh. *The Goddess: Power, Sexuality, and the Feminine Divine.* Ann Arbor: University of Michigan Press, 2003.

Hutton, Ronald. *The Triumph of the Moon: A History of Modern Pagan Witchcraft.* Oxford: Oxford University Press, 2001.

Ingram, Rex. *The Magician.* MGM, 1926; 71 min.; 35 mm.

Innes, Christopher. *Holy Theatre: Ritual and the Avant-Garde.* Cambridge: Cambridge University Press, 1981.

Jenkins, Philip. *Mystics and Messiahs: Cults and New Religions in American History.* New York: Oxford University Press, 2000.

Johansson, Bertil. *Religion and Superstition in the Plays of Ben Jonson and Thomas Middleton.* New York: Haskell House, 1966.

The Johns Hopkins Guide to Literary Theory and Criticism. Baltimore, MD: Johns Hopkins University Press, 1994.

Journal of Religion and Film. http://www.unomaha.edu/jrf/.

Judah, J. Stillson. *The History and Philosophy of the Metaphysical Movements in America.* Philadelphia, PA: Westminster Press, 1967.

Kaczynski, Richard. *Perdurabo: The Life of Aleister Crowley.* Berkeley, CA: North Atlantic Books, 2010.

Kelly, Aidan. *Crafting the Art of Magic.* St. Paul, MN: Llewellyn, 1991.

Kendall, Ritchie D. *The Drama of Dissent: The Radical Poetics of Nonconformity, 1380–1590.* Chapel Hill: University of North Carolina Press, 1986.

Knapp, Bettina. *Theatre and Alchemy.* Detroit, MI: Wayne State University Press, 1980.

Kolve, V. A. *The Play Called Corpus Christi.* Stanford, CA: Stanford University Press, 1966.

Kundert-Gibbs, John L. *No-thing is Left to Tell; Zen Chaos Theory in the Dramatic Art of Samuel Beckett.* Madison, NJ: Fairleigh Dickinson University Press, 1999.

Lawton, George. *The Drama of Life after Death: A Study of the Spiritualist Religion.* New York: H. Holt, 1932.

Leeds, Josiah W. *The Theatre: An Essay Upon the Non-Accordancy of Stage-Plays with the Christian Profession.* Philadelphia, PA: Published for the Author. 1886.

Levy, Shimon. *Theatre and Holy Script.* Brighton, UK: Sussex Academic Press, 1999.

Lewis, James R. *The Encyclopedia of Cults, Sects, and New Religions.* 2nd ed. Amherst, NY: Prometheus Books, 2002.

———. *The Gods Have Landed: New Religions from other Worlds.* Albany: State University of New York Press, 1995.

———. *Odd Gods: New Religions and the Cult Controversy.* Amherst, NY: Prometheus Books, 2001.

———. *Peculiar Prophets: A Biographical Dictionary of New Religions.* St. Paul, MN: Paragon House, 1999.

Lewis, James R., and J. Gordon Melton, eds. *Perspectives on the New Age.* Albany: State University of New York Press, 1992.

———. *The Bible as Theatre.* Brighton, UK: Sussex Academic Press, 2000.

Liepe, Wolfgang. *Das Religionsproblem im neueren Drama von Lessing bis zur Romantik.* Halle: M. Niemeyer, 1914.

Lima, Robert. *Stages of Evil: Occultism in Western Theatre and Drama.* Lexington: University Press of Kentucky, 2005.

Lindsay, Jack. *The Clashing Rocks: A Study of Early Greek Drama and Culture and the Origins of Drama.* London: Chapman and Hall, 1965.

Lingan, Edmund B. "Reincarnation and Individuality: Rudolf Steiner's 'Mystery Dramas' in the New Millenium." *Western European Stages* 13 (Spring 2001): 73–78.

Literature and Theology. http://litthe.oxfordjournals.org/.

Macchioro, Vittorio. *The Villa of the Mysteries in Pompeii.* Naples: Richter, 1931.

Maddox, Brenda. *Yeats's Ghosts: The Secret Life of W. B. Yeats,* New York: Perennial, 1999.

Marcel, Gabriel. *Théâtre et religion.* Lyon: E. Vitte, 1959.

Marshall, Cynthia. *Last Things and Last Plays: Shakespearian Eschatology.* Carbondale: Southern Illinois University Press, 1991.

McCabe, William H. *An Introduction to the Jesuit Theatre: A Posthumous Work.* Edited by Louis J. Oldani. St. Louis, MO: Institute of Jesuit Sources, 1983.

Melton, J. Gordon. *Encyclopedic Handbook or Cults in America.* New York: Garland, 1986.

Mercier, Alain. *Les sources esoteriques et occultes de la póesie symboliste.* 2 vols. Paris: Nizet, 1969–1974.

Merivale, Patricia. *Pan the Goat-God: His Myth in Modern Times.* Cambridge, MA: Harvard University Press, 1969, vii.

Mikalson, Jon D. *Honor Thy Gods: Popular Religion in Greek Tragedy.* Chapel Hill: University of North Carolina Press, 1991.

Miller, Donald Eugene, Graydon F. Snyder, and Robert W. Neff. *Using Biblical Simulations.* Valley Forge, PA: Judson Press, 1973.

Mills, David. *Recycling the Cycle: The City of Chester and its Whitsun Plays.* Toronto: University of Toronto Press, 1998.

Milward, Peter. *The Catholicism of Shakespeare's Plays.* Southampton: Saint Austin Press, 1997.

Mullany, Peter F. *Religion and the Artifice of Jacobean and Caroline Drama.* Salzburg: Institut für Englische Sprache und Literatur, Universitat Salzburg, 1977.

Murphy, G. Ronald. *Brecht and the Bible: A Study of Religious Nihilism and Human Weakness in Brecht's Drama of Mortality and the City.* Chapel Hill: University of North Carolina Press, 1980.

Nakamura, Hajime. *Ways of Thinking of Eastern Peoples: India, China, Tibet, and Japan.* Honolulu, HI: East West Center, 1964.

Needleman, Jacob. *The New Religions.* Garden City, NY: Doubleday, 1970.

Nelson, Victoria. *The Secret Life of Puppets.* Cambridge, MA: Harvard University Press, 2001.

Newman, Barbara. *Sister of Wisdom: St. Hildegard's Theology of the Feminine.* Berkeley: University of California Press, 1987.

————, ed. *Voice of the Living Light: Hildegard of Bingen and her World.* Berkeley: University of California Press, 1998.

Nielsen, Inge. *Cultic Theatres and Ritual Drama: A Study in Regional Development and Religious Interchange between East and West in Antiquity.* Aarhus: Aarhus University Press, 2002.

O'Donnell, Elliot. *Strange Cults and Secret Societies of Modern London.* London: Allan, 1934.

Obuh, Sylvanus Onwukaike Stanley. "The Theatrical Use of Masks in Southern Igbo areas of Nigeria." PhD diss., 1984.

Palmer, Susan J., and Charlotte E. Hardman, eds. *Children in New Religions.* New Brunswick, NJ: Rutgers University Press, 1999.

Palmer, Susan J. *Moon Sisters, Krishna Mothers, Rajneesh Lovers: Women's Roles in New Religions.* Syracuse, NY: Syracuse University Press, 1994.

Parente, James A. *Religious Drama and the Humanist Tradition: Christian Theatre in Germany and in the Netherlands, 1500–1680.* Leiden and New York: Brill, 1987.

Philomene, Marie. *The Biblical Theme in Modern Drama.* Quezon City: University of Phillipines Press, 1978.

Pinciss, G. M. *Forbidden Matter: Religion in the Drama of Shakespeare and His Contemporaries.* Newark: University of Delaware Press, 2000.

Pineas, Rainer. *Tudor and Early Stuart Anti-Catholic Drama.* Nieuwkoop: De Graaf, 1972.

Powers, Richard Gid, and Hidetoshi Kato. *Popular Culture in Japan.* New York: Greenwood Press, 1989.

Puttick. Elizabeth. *Women in New Religions: In Search of Community, Sexuality, and Spiritual Power.* New York: St. Martin's Press, 1997.

Raab, Rex, Arne Kingborn, and Ake Fant. *Eloquent Concrete: How Rudolf Steiner Employed Reinforced Concrete.* London: Steiner Steiner Press, 1979.

Ravicz, Marilyn Ekdahl. *Early Colonial Religious Drama in Mexico: From Tzompantli to Golgotha.* Washington, DC: Catholic University of America Press, 1970.

Redmond, James, ed. *Themes in Religion.* Drama and Religion Issue. Volume 5 (1983).

Reid, Hazel E. *Ritual for a New Liberation Covenant.* New York: United Brothers Communications Systems, 1976.

Reitz, Bernhard, ed. *Race and Religion in Contemporary Theatre and Drama in English.* Papers given on the occasion of the Seventh Annual Conference of the German

Society for Contemporary Theatre and Drama in English / edited for the society by Bernhard Reitz. Trier: WVT, Wissenschaftlicher Verlag Trier, 1999.

"Religion and the Arts." http://www.bc.edu/bc_org/avp/cas/relarts/.

Richardson, James T., ed. *Conversion Careers: In and Out of the New Religions.* Beverly Hills, CA: Sage, 1978.

———. *Money and Power in the New Religions.* Lewiston, NY: Edwin Mellen Press, 1988.

Richmond, Velma Bourgeois. *Shakespeare, Catholicism, and Romance.* New York: Continuum, 2000.

Robbins, Thomas. *Cults, Converts, & Charisma.* London: Sage, 1988.

Rosenheim, Richard. *The Eternal Drama: A Comprehensive Treatise on the Syngetic History of Humanity, Dramatics, and Theatre.* New York: Philosophical Library, 1952.

Russell, Jeffrey B. *A History of Witchcraft: Sorcerers, Heretics, and Pagans.* London: Thames and Hudson, 1980.

Sargent-Bauer, Barbara Nelson. *Brothers of Dragons: Job Dolens and Francois Villon.* New York: Garland, 1990.

Schechner, Richard. *Between Theatre and Anthropology.* Philadelphia: University of Pennsylvania Press, 1985.

———. *Dionysus in 69: The Performance Group.* New York: Noonday Press, 1970.

———. *The End of Humanism: Writings on Performance.* New York: Performing Arts Journal, 1982.

———. *Environmental Theatre.* New York: Applause, 1994.

———. *Essays on Performance Theory, 1970–1976.* New York: Drama Book Specialists, 1977.

———. *Performance Theory.* New York: Routledge, 1988.

Schlehofer, Michèle M., Allen M. Omoto, and Janice R. Adelman. "How do 'Religion' and 'Spirituality' Differ? Lay Definitions among Older Adults." *Journal for the Scientific Study of Religion* 47 (2008).

Segal, Charles. *Sophocles' Tragic World.* Cambridge, MA: Harvard University Press, 1995.

Senior, Matthew. *In the Grip of Minos: Confessional Discourse in Dante, Corneille, and Racine.* Columbus: Ohio State University Press, 1994.

Shaheen, Naseeb. *Biblical References in Shakespeare's Plays.* Newark: University of Delaware Press, 1999.

Shaughnessy, Edward L. *Down the Nights and Down the Days: Eugene O'Neill's Catholic Sensibility.* Notre Dame: University of Notre Dame Press, 1996.

Shepherd, Leslie. A. *Encyclopedia of Occultism and Parapsychology.* 2nd ed. Detroit, MI: Gale Research Company, 1985.

Shupe, Anson D., Jr., and David G. Bromely. *The New Vigilantes: Deprogrammers, Anti-Cultists, and the New Religions.* Beverly Hills, CA: Sage, 1980.

Shupe, Anson D., compiler. *Six Perspectives on New Religions: A Case Study Approach.* New York: Edwin Mellen Press, 1981.

Smart, Ninian. *Dimensions of the Sacred: An Anatomy of the World's Beliefs.* Berkeley: University of California Press, 1999.

———. *Reasons and Faiths.* London: Routledge & Kegan Paul, 1958.

———. *The World's Religions.* Englewood Cliffs, NJ: Prentice Hall, 1989.

Sowers, W. L. "Some American Experimental Theaters." *Southwest Review* 2 (July 1916).

Spanos, William V. *The Christian Tradition in Modern British Verse Drama: The Poetics of Sacramental Time.* New Brunswick, NJ: Rutgers University Press, 1967.

Speight, Robert. *Christian Theatre.* New York, Hawthorn Books, 1960.

Stark, Rodney, and William Sims Bainbridge. *A Theory of Religion.* New York: Peter Lang, 1987.

———. *The Future of Religion, Secularization, Revival and Cult Formation.* Berkeley: University of California Press, 1985.

———. *The One True God: The Historical Consequences of Monotheism.* Princeton, NJ: Princeton University Press, 2001.

Stein, Stephen J. *Alternative American Religions.* New York: Oxford University Press, 2000.

Stevenson, Ian. "Christchurch Garden Theatre." *Journal of Christchurch Local History Society* 15 (2009).

Street, J. S. *French Sacred Drama from Beze to Corneille: Dramatic Forms and Their Purposes in the Early Modern Theatre.* Cambridge: Cambridge University Press, 1983.

Suszynski, Olivia C. *The Hagiographic-thaumaturgic Art of Gonzalo de Berceo: Vida de Santo de Silos.* Barcelona: Edicianes Hispam, 1976.

Sutin, Lawrence. *Do What Thou Wilt: A Life of Aleister Crowley.* New York: St. Martin's Press, 2000.

Symonds, John. *The Great Beast: The Life and Magick of Aleister Crowley.* 1971. Reprint, Frogmore, St. Albans: Mayflower Books, 1973.

Symons, Arthur. *The Symbolist Movement in Literature.* New York: AMS Press, 1980.

Thompson, Elbert Nevius Sebring. *The Controversy between the Puritans and the Stage.* New York: H. Holt, 1903.

Thomsen, Harry. *The New Religions of Japan.* Rutland, VT: C.E. Tuttle, 1963.

Turner, Victor. *The Anthropology of Performance.* New York: PAJ, 1986.

———. *By Means of Performance: Intercultural Studies of Theatre and Ritual.* Cambridge and New York: Cambridge University Press, 1990.

———. *Dramas, Fields, and Metaphors: Symbolic Action in Human Society.* Ithaca, NY: Cornell University Press, 1974.

———. *Celebration: Studies in Festivity and Ritual.* Washington, DC: Smithsonian Institution Press, 1982.

———. *From Ritual to Theatre: The Human Seriousness of Play.* New York: PAJ, 1982.

———. *Revelation and Divination in Ndembu Ritual.* Ithaca, NY: Cornell University Press, 1975.

Valiente, Doreen. *Witchcraft for Tomorrow.* Blaine, WA: Phoenix, 1978.

———. *The Rebirth of Witchcraft.* Custer, WA: Phoenix, 1989.

Van Zanten, John. *Caught in the Act: Modern Drama as Prelude to Gospel.* Philadelphia, PA: Westminster Press, 1971.

Varadpande, Manohar Laxman. *Religion and Theatre.* New Delhi : Abhinav, 1983.

Vasudha, Dalmia. *Representing Hinduism: The Construction of Religious Traditions and National Identity.* New Delhi: Thousand Oaks, CA: Sage, 1995.

Veevers, Erica. *Images of Love and Religion: Queen Henrietta Maria and Court Entertainments.* Cambridge and New York: Cambridge University Press, 1989.

Versluis, Arthur. *The Esoteric Origins of the American Renaissance.* Oxford: Oxford University Press, 2001.

Vince, Ronald. *Ancient and Medieval Theatre: A Historiographical Handbook.* Westport, CT: Greenwood Press, 1984.

Waite, Gary K. *Reformers on Stage: Popular Drama and Religious Propaganda in the Low Countries of Charles V, 1515–1556.* Toronto and Buffalo, NY: University of Toronto Press, 2000.

Waugh, Frank A. *Outdoor Theaters: The Design, Construction and Use of the Open-Air Auditoriums.* Boston, MA: Richard Badger, 1917.

Waterstone, Penny Brown. *Domesticating Universal Brotherhood: Feminine Values and the Construction of Utopia, Point Loma Homestead, 1897–1920.* PhD diss., University of Arizona, 1995.

Weaver, Michael S., and James Vernon Hatch. *Church and Theatre.* Terre Haute: Indiana State University, 1991.

Webb, James. *Occult Establishment.* La Salle, IL: Open Court, 1985.

Wellwarth, George E. *Modern Drama and the Death of God.* Madison: University of Wisconsin Press, 1986.

White, Paul Whitfield. *Theatre and Reformation: Protestantism, Patronage, and Playing in Tudor England.* New York: Cambridge University Press, 1993.

White, R. Andrew. "Radiation and Transmission of Energy: From Stanislavsky to Michael Chekhov." *Performance and Spirituality* 1 (2009). http://www.utdl.edu/ojs/index.php/pas.

———. "Stanislavsky and Ramacharaka: The Influence of Yoga and Turn-of-the-Century Occultism on the System." *Theatre Survey* 47 (May 2006).

Wiebe, Donald. *The Politics of Religious Studies.* New York: St. Martin's Press, 2000.

Wiles, David. *A Short History of Western Performance Space.* Cambridge: Cambridge University Press, 2003.

Wilson, Bryan, ed. *Religion: Contemporary Issues.* London: Bellew, 1992.

———. *The Social Impact of New Religious Movements.* Barrytown, NY: Unification Theological Seminary, 1981.

Wilson, Colin. *The Occult.* New York: Vintage, 1973.

Wilson, Edmund. *Axel's Castle: A Study in the Imaginative Literature of 1870–1930.* 1931; Reprint, New York: Charles Scribner's Sons: 1959.

Wood, William Carleton. *The Dramatic Method in Religious Education*. New York and Cincinnati: Abingdon Press, 1931.

Young, Dudley. *Origins of the Sacred: The Ecstasies of Love and War*. New York: St. Martin's Press, 1991.

Young, Karl. *The Drama of the Medieval Church*. 2 vols. Oxford, 1933.

Zaehner, R. C., ed. *The Concise Encyclopedia of Living Faiths*. London: Hutchinson, 1959.

Zhai, Jiexia Elisa, Christopher G. Ellis, Charles E. Stokes, and Norval D. Glenn. "'Spiritual, But Not Religious': The Impact of Parental Divorce on the Religious and Spiritual Identities of Young Adults in the United States." *Review of Religious Research* 49 (2008).

Index ✒

CPSIA information can be obtained
at www.ICGtesting.com
Printed in the USA
LVHW080816110520
655298LV00005B/16

9 781137 451309